PHOTOGRAPHY YOUR WAY

Chuck DeLaney

ALLWORTH PRESS
NEW YORK

05 04 03 02 01 00 5 4 3 2 1

Published by Allworth Press
An imprint of Allworth Communications
10 East 23rd Street, New York, NY 10010

Cover design by Douglas Design Associates, New York, NY

Page composition/typography by SR Desktop Services, Ridge, NY

ISBN: 1-58115-024-5

Library of Congress Cataloging-in -Publication Data

DeLaney, Chuck.
 Photography your way / Chuck DeLaney.
 p. cm.
 Includes bibliographical references.
 ISBN 1-58115-038-5 (pbk.)
 1. Photography--Vocational guidance. I. Title.

TR154 .D37 1999
770'.23--dc21 99-089558

Printed in Canada

Contents

Dedications

Writing a book is a big job that involves lots of hours spent alone. For me, the sense of isolation and solitude that is part of that job is mitigated by a chance to reflect on the people who have made my life worthwhile.

To that end, this book is dedicated to:

My daughter, Lily Mira Mason DeLaney, and my wife, Sara Brenner DeLaney, who have each brought me back in touch with a lot of great things I had left behind, and shown me a lot of new stuff that I would have otherwise missed;

The late Eugene Santomasso, art historian and probably the single greatest classroom teacher with whom I ever studied, who gave me some of my first (and some of the best) photo assignments;

My neighbors, the missing couple Michael Sullivan and Camden Sylvia, whose unexplained and unsolved disappearance has taught me that life is precious in ways we can scarcely imagine, and that there are worse things than death.

Thanks and Acknowledgments

Most of all, I thank my wife and daughter for their support and allowing me the time to finish this book. We spent a lot of time missing each other while I was holed up here and there. Chunks of this book were written in the air, on the rails, and in hotels in Las Vegas, Los Angeles, New Orleans, Notre Dame, Moscow, and half a dozen other locations.

The entire staff at the New York Institute of Photography (NYI) has been helpful in many, many ways.

Thanks to Tad Crawford, the publisher of Allworth Press, who is a class act and as patient and understanding as only another author can be; and to Nicole Potter, who edited the manuscript with respect and gave it shape.

Since, as you will read, I believe there's no one way of being, there are a lot of people I have to thank for helping me find my way of being. My late parents, Glover and Dorothy DeLaney, my sisters Susan Graybill and Shawn Hartfeldt and their families, and two great photographers, Maggie Sherwood and T.J. "Andy" Marino, who gave me my start in photography. Also, old friends and advisors, most notably Ed Gray, John Bellamy Taylor, Adrienne Leban, Don Sheff, Michael Baron, and Brian Sweeney.

I take full responsibility for any and all errors of fact. I should note that the opinions expressed in this book are strictly my own and don't necessarily reflect the policy or views of the NYI, although a few topics were originally developed as articles for the NYI Web site, *www.nyip.com*.

About the Photographs in this Book

From its inception, this book was planned to have only black-and-white photographs. This is the case for most Allworth Press books. Short-run color printing is expensive. That's one of the things that makes the Internet such a great way to present color photographs: While the files are a little bigger for a color photo, there's no cost difference between color and black-and-white.

In the several years I actually spent writing this book, I had ample time to think about what photographs would make sense as illustrations. I concluded that I would only use black-and-white photos and a few images that might have been shot in color but that were truly monochromatic. This meant that most everything I've photographed in the last twenty years or so was out of consideration since that work was made in color. While I could easily convert some of those photos to black-and-white digitally, I saw them as color images and photographed them that way.

I've selected an eclectic bunch of photos, and they wouldn't hang together as a portfolio. Some images are from my personal collection and were taken by other photographers. If there's no photographer listed, I took the photo. The photographs taken by me were made over a span of thirty-plus years. A number of those were taken using the Diana-F "toy" 120 film camera. In the 1970s, we used these a great deal in the Floating Foundation prison programs. After all, many of our students had stolen or fenced high-quality cameras during their life on the streets with no idea of their potential, so it seemed fitting to make them start with humbler tools. The actual camera sequence in the FFP Basic Photography Course was Polaroid, 120 Diana-F, 120 Yashicamat twin-lens reflex, and finally Pentax K-1000 35mm and the old Calumet 4 × 5 view camera. Almost all the photos of mine in this book were made using Kodak Tri-X film, processed in D-76 or HC-110. Just thinking about all those hours in the darkroom years ago makes me nostalgic. I don't get the same sense of experimentation, peaceful isolation and craftsmanship from the electronic darkroom.

I welcome any and all comments about the photographs, ideas, and suggestions that I've offered in this book. Feel free to write to me care of Allworth Press, 10 East 23rd Street, New York, NY 10010, or you can e-mail me at *CDNYPhoto@aol.com*.

Self-portrait, handstand, ca. 1974.

Introduction

The idea for this book occurred to me about ten years ago as I gazed out an airplane window down onto the snow-capped Rocky Mountains.

I was en route from New York to Los Angeles to connect with a flight that would take me halfway around the world for a month-long photo assignment in the Philippines. My travel companion, who was also my client, awoke from a brief nap stretched out across a row of vacant seats in the half-empty plane. She had been up very late the night before, having her portrait taken for *Vogue* magazine.

Although we had never worked together, based on two interviews before leaving New York, I was confident that this was going to be a pleasant and exciting assignment that would take me to a part of the world I had never visited. Best of all, the job had just fallen into my lap.

She sat up for a moment. "Oh, before I forget, let me give these to you." She handed me an envelope of cash for expenses and a first-class, round-trip ticket from Los Angeles to Manila. She returned to her nap.

At that moment, staring down at the massive mountains below me, I realized that nothing could excite me more than interesting assignments

that allowed me to travel and take photographs. Now, I was starting a month-long assignment to an exotic location. How could I be so lucky?

Reflecting back, I realized that things had just fallen into place—a common event in my life as a freelance photographer. Oddly, I had inadvertently prepared for this assignment—working as the still photographer for a television crew—by doing several photo jobs years before as favors.

Those jobs involved taking location photographs for friends who were producing documentary films on low budgets. Although I had never worked professionally as a unit photographer with a film or television crew, I had the experience (and the portfolio) to get this job because of those assignments.

I CHOSE MY WAY

I'd enjoyed those documentary film jobs. I've always been happy to undertake an interesting photo assignment for a friend, even for little or no pay. I had filed the negatives and forgotten the experience. Now, those jobs had unexpectedly paved the way for this opportunity. Some payback. I wasn't only flying over the Rockies; I was on top of the world!

Like most of us, I have moments when I feel apprehensive about a new experience or the unknown. This job had come up quickly and I hadn't had a full briefing on what was planned. I hadn't even met the crew—we would link up with the director and producer in Manila, since they were based in Hong Kong. The rest of the crew would be hired in the Philippines.

I hadn't met any of the people I'd be living with for the next month, nor was I sure whether we would be working in cities, remote villages, or jungle surroundings: My client had been too busy for much explanation. Plus, the producer had been making the arrangements from Hong Kong.

My doctor had given me several strange shots, some pills for malaria, advice about when to take them, and a warning not to go swimming in Philippine rivers. Several friends had expressed apprehension about my traveling to a country where there was still considerable political unrest, since the tyrant Ferdinand Marcos had been toppled not long before.

I'd packed the gear I thought was appropriate for all the different photo possibilities, but how do you prepare mentally for the unknown? For that matter, when I had first been offered the job—just two weeks before we departed—I had thought, *the Philippines* . . . how odd. Until I started to read up on the country, it hadn't even been on the list of foreign destinations I was longing to visit.

As it turned out, I had a wonderful time and few problems. There were some exciting moments, but not the kind that I had anticipated. I'd never jumped out of a helicopter hovering a few feet over a soggy rice paddy, as I would do shortly. Nor had I been stung by a high-voltage jellyfish like the one that snuck up and nailed me while I was snorkeling and

photographing coral off the Island of Palawan in the South China Sea. The jellyfish I knew from the Atlantic and Caribbean were merely irritating; I had no idea to be on guard for the high-voltage variety.

Best of all, I took some great photographs, made several good friends, and developed an appreciation for a young country with enormous potential for progress and a bright future in the coming century. It was also interesting to be in a country where political democracy was a new and heady experience. It struck me that it must have been a bit like living in the American colonies in the years just after King George had been toppled. Hope was in the air, and the intoxicating possibilities of democracy were discussed everywhere, by all types of citizens.

WHAT IS CAREER PLANNING?

So, on that flight en route to Manila, looking back, I realized I had unintentionally prepared for a job that I had not anticipated nor sought, which was ill-defined but which I knew would be a lot of fun.

What kind of career planning was this? It seemed haphazard, but on the other hand, I wondered—could there be a pattern?

As I sat looking at the magnificent Rockies below me, I started to think how wonderful—and unexpected—it was that a variety of different experiences and interests of mine had combined to put me in that airplane seat. I realized that I had come upon a winning combination for me.

ASSIGNMENTS COUNT

A big portion of the fun for me in photography is having an assignment, and as I have always allowed myself to take assignments that I found interesting, I have swung from job to job a little like Tarzan traversing the jungle vine by vine. There was always something interesting within reach, which took me a little way in one direction. Then something else interesting came up that usually led in another direction. There wasn't an obvious design to my travels. I just let my camera lead me.

Now, since I work as dean of the New York Institute of Photography (NYI), I can truly pick and choose the jobs I take. But it wasn't always that way. For fifteen years I supported myself as a freelancer. Sometimes I took well-paying jobs to cover the bills, but I always tried to find something interesting in each of those. Sometimes I took low-budget, interesting jobs like the ones I had done for my filmmaker friends.

CREATIVE FIELDS AND HAPHAZARD CAREERS

It's not so unusual for freelance photographers (as well as writers, filmmakers, actors, and artists) to go from job to job. The trick is to have a little insight, be lucky, and make the most of the opportunities that come your way. And, to walk away from any flops with enough insight and confidence to avoid repeating the same mistakes.

WHAT'S YOUR WAY?

I thought there might be a way that I could assist students and other photographers in assessing their skills, interests, and desires so that they too could reach their peak experiences in photography and enjoy a sense of success, and perhaps also have the chance to plan their careers with a little more foresight than I had exercised.

Don't think that I advocate a rigid career plan; I don't. But it was hard for me—at times I was unsure where I was heading and didn't really see how things were fitting together. I worried I was doing it wrong. That I might fail. That I might have to abandon the life of a photographer and take a real job! A slightly clearer idea of my pathway would have made for a lot less anxiety.

That's the genesis of this book. I am going to cover a lot of issues that people getting started in the field should consider, and hopefully this book will make their tough choices easier. In addition, I hope that the book can be helpful to those who have gotten started but find themselves blocked, or at a loss as to how to proceed with their photography careers.

In part, this is also a book about dealing with negative emotions, staying in the game, learning more about yourself, and finding your way in photography. If those negative emotions aren't held in check, you can't see anything clearly. They act like a fog filter, or worse yet, some kind of crazy distortion filter. I've also included lots of information about the business aspects of photography, the way the industry views you as a consumer, and as much information as possible about sales techniques.

If you're a little confused about what you're doing with photography and where you're going in the field, you're not alone. Lots of photographers that I talk with—both students and others—are puzzled about how to put the pieces together and find the right trail through the many possible pathways in photography. I wrote this book to help you chart your way. It's broken into three parts—a look at you and the tradition, topics related to preparation, and finally, because no photographer can escape it, subjects related to "the business."

Since that trip to the Philippines, my camera has taken me back to Asia twice and allowed me to crisscross the U.S.A. and travel abroad regularly. The trick is making it happen (whatever that means for you) the first time. And once it happens, moving forward, finding what's positive, and growing.

My vantage point on the business and art of photography is unique. That's not because I'm the best (or the smartest) photographer. I assure you that I'm not. My unique viewpoint comes from working as a photographer *and* teaching photography—in prisons as well as colleges, in retirement homes, and in mental hospitals. Along the way, I've learned things while hanging exhibits, tending a gallery, doing graduate work in art history, and talking to hundreds and hundreds of photographers and photography students.

Most of all, I benefit from being dean of NYI. It allows me to think about what's going on in photography without having to put it to an immediate use. It allows me to pick up the telephone and ask questions of almost anyone whose brain I need to pick. And most of all, it lets me think about the education and development of photographers. How we could change what we teach, what we don't teach that we should, and how we can do our job better.

I know I can help you move down the pathways to find success in photography on your terms—photography your way. I know this book will assist you.

Ready to start? Let's go!

Two students in photo program for prison guards, Bedford Hills Correctional Facility, 1975.

Photo student and photographer Lisette Model, Green Haven Correctional Facility, 1974.

Part One

YOU AND THE TRADITION

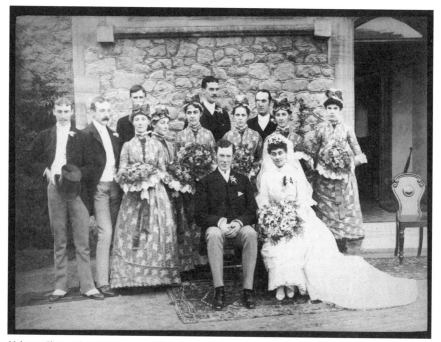

Unknown Photographer, Wedding Group Portrait, ca. 1900.

Chapter 1: Careers in Photography

Having an idea for a book bouncing around in your head for ten years is quite an experience. When I went to the Philippines and started thinking about how careers in photography are shaped, I was forty, and I finished this book—reluctantly—after I turned fifty.

Over that period, the concept of the book's structure and content has changed considerably, but my basic notions about how you can get what you want out of life and photography remain essentially the same.

WHAT IS A CAREER?

In my library, I have a number of books that are traditional career guides in photography. Most of these books survey various fields such as portraiture, medical photography, photojournalism, commercial and industrial photography, and discuss the requirements, job opportunities, and financial prospects of each area.

That's not the approach of this book. I firmly believe that photography is a passion and that, during one photographer's lifetime, career activities are likely to meld into one another. If you were going to be a doctor,

you would need to choose a specialty, such as cardiology or nephrology or psychiatry, and probably devote many years of training to that specialty. In all likelihood, you would practice that specialty for the rest of your life.

Similarly, if you want to make a lot of money, you might go to business school or law school, but probably not both. After that training, you would go out and have a career "in business" or "in law." Then you'd (hopefully) get old, retire, and then die.

PHOTOGRAPHY IS DIFFERENT

To me, that's not what a lifetime in photography is about. Sure, it can be a way to make money, but there's also a lot of fun and adventure to be had, a lot of opportunities to express yourself and your unique point of view, and the chance to change what you do as you go along. Why do one thing all your life? If you want to do that, it's fine, but even if you train to become, say, a medical photographer, and then work in hospitals for your entire work life, that's no reason you cannot involve yourself with all sorts of other photographic endeavors at night, on weekends, and on vacation.

That's the beauty of photography—the vocational goals are hazy, and the training in photography technique and technology doesn't need to be that extensive in most fields. You can be a medical photographer during the workweek and pursue fine art or animal photography on the weekend. Try being a lawyer during the week and a brain surgeon on weekends—it won't work. The requirements, and limits, of many fields are set in stone.

To that end, I view photography more as a lifestyle than as a career. This book will cover information about different types of photography, and investigate the skills and temperament required for each, but there's no sense of either/or. You can be a medical photographer and a wedding photographer. You can be a photojournalist and a child photographer. It's up to you.

PHOTOGRAPHY AS A CREATIVE OUTLET

And, let's not write off all those doctors, lawyers, and MBAs either. There are lots of professionals in a host of fields who turn to photography to get the creative and expressive satisfaction that their "profession" may not be able to deliver. At NYI, some of our most excited students are professionals in other fields who turn to photography to relax and enjoy the freedom it offers.

So let's start with the basics. We're photographers and we're involved with a very powerful force—photography. And, we have the opportunity to shape our careers as we go along. But before you can bask in the potential of photography and locate your interests and find success in one or more fields, it is essential to address three things:

First, the nature of this magical medium;

Second, what you really want to get out of photography and what skills you bring to the table; and

Third, what holds you back—as a photographer and as a human being—the negative emotions that may confuse and inhibit you.

THE NATURE OF PHOTOGRAPHY

I love photography. I make images almost every day, and I respect the power, science, art, and magic of the medium. I once took a Christmas-greeting portrait on Polaroid film for a young man who was in prison. It took me three minutes at most. Six weeks later the prisoner told me that he had sent it to his deathly ill grandmother who hadn't seen him in the ten years he'd been in prison. Shortly after the photo arrived, she died. Among her last requests was to be buried with the portrait I made of her grandson.

To me, that's powerful. I make images. I show people things. I capture their emotions and expressions, their memories, their past, the things they love. Sometimes I try to express my emotions in my photographs. Maybe one of my photos will help change something in the world for the better.

And, people pay me to do this!

Another key part of what I love about photography is that it is so democratic and accessible. The equipment isn't that expensive, and you don't need much equipment anyway. There are lots of ways to get the training you need, and there's opportunity for you regardless of sex, race, or physical ability.

I know photographers who work from wheelchairs. There are photographers who are legally blind. At NYI, we always have students in our course who are recovering from serious illness or injuries and who turned to photography as a second career, or as a way to reconstruct their lives. Photography can help you grow. And, I know from experience, it can help you heal.

And people looking at your photos won't necessarily know if you're black or white, female or male, or whether you used a Canon or a Nikon.

I recall a television interview with the late Danny Kaye, a performer with many talents. In talking about his interests, he made a very simple but profound statement: "If you can find the form of self-expression that's best for you, then you've got it made."

A CAREER TO THE END

There's one other great aspect of photography. There's no need to retire. Opera singers, supermodels, athletes—even the sharks and traders on Wall Street—all have a prime, and when they can't take the rigors or hit the high notes, or when the "new" (and younger) face retires the supermodel who may be "over the hill" in her mid-twenties, it's time to move on.

Not so with photography. You can take great photos balanced on a cane. Photography will never desert you. How many of us are lucky enough to find a lifelong friend?

For me, that's photography. My guess is, it's photography for you too. Now that you've found your method of expression, the trick is to move forward and stay optimistic. Perhaps, as you grow, you may find photography is not for you, or that there's something better. Then the trick is to move on to that better something. This is not unheard of in creative professions. The great artist Marcel Duchamp, for example, gave up making art altogether and turned his passion to chess in his later years. The wonderful French photographer Jacques Lartigue turned to painting in midlife. Not long ago I read the obituary of Myron "Scottie" Scott, who started out as a news photographer for an Ohio paper and happened to take a few feature photographs of some kids who had made a toy car out of a soapbox and a set of buggy wheels. He went on to become the founder and guiding light of the Soapbox Derby.

WHAT DO YOU WANT FROM PHOTOGRAPHY?

Knowing what areas of photography are of interest to you isn't always that easy. One problem is that the world of photographic specialties and professional practitioners is very segmented, particularly in the way photography is taught. There isn't a lot of crossover. For the most part, those in fashion know of their predecessors and peers but are clueless in the history of photojournalists or portraitists. The couple who run a portrait studio in Des Moines probably don't know the names of the hotshot fine-art photographers from New York and Los Angeles.

There's no career guide better than looking at the lives and works of others who devoted their lives to the pursuit of photography. To that end, the first portion of this book is devoted to looking at the biographies and accomplishments of some photographers—both the famous and the lesser known. The many powers that photographs can possess will also be explored.

Michelangelo, known to most of us for his skills as a sculptor and painter, also wrote poetry. One of his sonnets muses on the potential in a block of marble. Every sculpture is contained within that block; the sculptor need only remove the bits of marble that aren't part of the sculpture!

Photography is like that block of marble. It offers everything you could possibly desire. Sometimes it may be easier to determine what you don't want, and then make your way toward the areas that are left.

THE NEGATIVE STUFF

We're all susceptible to negative feelings, but until those emotions are examined and either eradicated or put in their place, the good stuff is hard to access in a sustained, trustworthy way. And those despairing gremlins do have a way of popping up again and again, for all of us.

That's important to remember. There may be a few enlightened souls who have put the dark stuff behind them forever, conclusively, and with no hitches. But for most of us, those negative feelings are like houseflies—

you never get rid of every single one of them, you just keep them under control.

Over my career, I've slowly come to realize how many people—not just photographers, but all kinds of people—take themselves off the playing field, fold their hand, and ask to be dealt out of the game. They end up bitter, befuddled, or beaten. Or, if they're lucky, just depressed. And they did it to themselves! Well, the hell with that!

A lot of our emotions come out as anger when dealing with customers and suppliers. As you'll see, there are a few situations where you can go ahead and blow your top, and other times when you have to take it easy. There are times to talk, and times when the trick is to stay silent.

Occasionally, as you go along, you may find yourself thrown to the ground. Maybe you can pull this book out and reread a few sections and get up, brush yourself off, get back in the game, and get even with those who threw you.

The portion of this book that deals with negative stuff is written with the wish that it will help you stay in the game right up to the end. I hope it will help you absorb the bumps, learn to analyze the self-inflicted ones so you keep them to a minimum, and learn how to handle those dealt you by others.

FIGHTING THE "IF ONLYS"

Photography is an elusive undertaking. As a form of self-expression it can fool lots of people. It's easy to become good, to take technically well-done photographs, to get a sharp, well-exposed image of something on film.

But it's a lot harder to become really good and, for the gifted, even harder to become great. It's hard to get other people to take your photography seriously. Business and finances may interfere. There are lots of rejections along the way. Any of these factors can lead to distracted, depressed thinking—a lot of "if onlys":

- If only I had better equipment
- If only I had her contacts
- If only I had his sales technique
- If only I had gone to that school
- If only I could be published in that magazine
- And—one of the worst—If only I hadn't screwed up that job

You can fritter away an entire lifetime dealing with the "if onlys," but this seduction must be avoided. Fighting the "if onlys" is not that hard once you see them for what they are, but they are one of the reasons that, if you're not careful, photography can make you crazy.

IT'S ATTITUDE, NOT SUCCESS, THAT COUNTS

In fact, I know lots of successful photographers who are still hounded by "if onlys"—what they haven't accomplished, or the people who don't

respect them—rather than basking in their considerable achievements. And these aren't just run-of-the-mill photographers. I know of one fabulously successful commercial and editorial photographer who is obsessed with getting major shows for his work in recognized fine-art museums. He won't rest until he's secured that reputation. I've also met a very successful nature photographer who expressed to me his need to prove himself to his colleagues although he has legions of admirers. "They still think I'm a techno-geek," he told me.

As we'll explore shortly, I believe that there is no one way of being. If that's what these photographers want to do, if those are goals of their choosing, and as long as it is a choice and not an obsession, then that's OK.

And, while it can be obsessive at the top, it can be lonely when you're starting out. Photographers spend a lot of time alone—working, traveling, in the darkroom, or in front of a computer screen. The world is usually on one side of your lens and you're on the other. You need to make certain that you have enough input from the outside world. It's dangerous to get too isolated.

The fact that photography is a democratic medium, with accessibility for all, does have some drawbacks. There's a real potential for deluding yourself, pretending to be a better photographer than you are, or obsessing that you're not as good as you actually are.

Other forms of art and expression are much quicker to discourage people who seek to master them. For example, the performing arts can be downright cruel. If you wish to make your mark as a singer, musician, dancer, actor, or comedian, but have little or no talent, your limitations are likely to be made painfully clear very quickly. Maybe that's good, because you can move on.

After all, it's your lifetime (chapter 3) and as it passes, you'll realize a lifetime isn't a long time, it's a short time. There's no benefit wasting any of it.

Like the performing arts, the traditional visual arts—the "fine arts" of painting, sculpture, and architecture—also require talent that many of us lack. You're not likely to paint for very long if you have no skill at all.

If lack of talent weren't a big enough obstacle, many art forms impose financial barriers as well. Authors, poets, and playwrights may curse the lack of a publisher. All filmmakers may lament the high cost of producing a motion picture. Worst off may be architects, some of whom must kiss up to the likes of developers such as Donald Trump to get their works realized.

But film is cheap, and anyone can push that shutter. That's a blessing and a possible drawback. You'll have to trust the honest feedback of the people whose opinion you value most to determine whether your sense of your work is on target.

ANYONE CAN TAKE A PICTURE

In the last two decades, technology has made photography even easier. It used to be that you had to have a modicum of understanding of exposure calibration to get the image properly exposed, and you needed sufficient eyesight and a steady hand or tripod to get a sharp image. Now even those requirements are gone—computer chips assist with exposure and focus. *Anyone* can take a photograph.

I remember years ago there was a chimpanzee that lived on Manhattan's upper West Side who took Polaroid photographs at parties, if you hired him and his trainer. Not only could he take photographs, he was a pro!

My daughter started taking photographs when she was eighteen months old. Now that she's nearly three, I'm comfortable putting the strap of an expensive single lens reflex (SLR)—or better still, a digital camera—around her neck. She's still a little puzzled by the LCD viewfinder on my digital camera, but I'm sure she'll figure it out soon.

Make sure that you have a reasonably accurate estimation of your weaknesses and your strengths. That can require a rigorous self-examination. Is it worth it? It is if you want to be a photographer.

THE GAME PLAN

As I've noted, the starting point to understanding how best to fit photography into your life is to take a look at the tradition and the roles of photographers and make a rigorous examination of yourself, your interests, skills, and fears, and the photographs you might like to make. After that, we will examine the equipment, the training, the subject matter, and finally, the stuff of a career—business, money, selling, growing, changing. That's the basic outline of this book.

In a sense, this book is a manual to help you find what matters to you in the many pathways that photography offers each of us who become smitten and to reflect a bit on what a special craft and profession this is.

This book is not an exhaustive catalog of picture buyers. There are several good guides of that type readily available. I've noted them in appendix II. If you need one, get one.

Similarly, this book is not going to provide thorough information about pricing, legal issues, or business practices. Although I will touch on a few basics in each of these areas, there are very good books devoted to each of these matters. I've listed my preferences in appendix II.

This is also not a book about technique, although a few tips may sneak through.

LET'S END WITH THE POSITIVES

One last point. It is fair for the reader to ask, "What are the benefits of the effort to banish those negative emotions? If the goal is photography *without* negatives, then photography *with* what?"

The answer is multifaceted:

Photography with choice, with a sense of play, with assignments, with confidence, and with a plan of roughly defined goals that work for you.

Photography with freedom, with a respect for the tradition, and with an eye on the pitfalls that come with that tradition. Photography with no regrets, with the right to experiment, and *with the right to make mistakes*.

There's another difference between photography and brain surgery or rocket science—it's OK to make mistakes. Sometimes, mistakes are part of the discovery and excitement. Mistakes can show you the way.

H. Arnoux, Sphinx et les trois pyramides, ca. 1870.

Chapter 2: The Power of Photography

From its beginnings in 1839, there's been no denying the power of the photographic medium. We also cannot overlook the baggage that the history and tradition of photography and the image of the photographer have piled up over the past 160 years.

AT THE START

They were lucky, the people who were around when photography started. In the same way that some of us experienced the advent of the new medium of television, and as most of us experienced the recent arrival of another new medium—the Internet—these people had the opportunity to approach photography in the medium's infancy as something new.

But not us. There's an accepted academic history of photography, a succession of styles and movements, a pantheon of "great" photographers. There's also a popular notion of the photographer. We've been dropped into a tradition. A tradition that is rich with interesting characters and anecdotes, but also a tradition that I find seriously divided at this time into two branches:

- A fine-art/academic branch overloaded with names, dates, and careers, obscured by critical baggage and inbred jargon, and maintained by a cadre of people who need to be right.
- A commercial/documentary branch that is besieged with issues regarding the subject's right to privacy, the public's appetite to know, and the shifting sense of "truth" in photography. Oddly, this branch also suffers from a lack of study by the academics who have stultified the other branch.

It is my hope that the next century will see these two branches beginning to mingle. It would be very beneficial. Despite the fact that some of the critics and academics fly up into etheric heights with their ideas, it's all just photography.

The thing that these branches share is the power of photography and the excitement we all feel about it. So that's where we start—with the power of the photographic medium.

We are involved in a medium of human expression that possesses immense power and potential. Greater, I believe, even than what we've seen to date.

We feel the pull of photography. That is, the urge to make images. That is natural, since we are, after all, photographers. We are enthralled by the gleam of the latest camera, the potential that awaits us every time we load a new roll of film into a camera, the moment when we behold the results of our efforts.

But the real power of photography doesn't stem from our passion. Our numbers are few—there are perhaps half a million "serious" photographers in America, those we would call "advanced amateurs," and less than one hundred thousand full-time professionals. Rather than from the passion we feel, the real power of photography comes from the power our images exert on the rest of the world.

IMAGES EXPAND THE WORLD

Most people don't feel the pull of photography as an activity, and most people aren't photographers. Yet photography has a potent effect on the lives of nearly everyone on the planet. That's true now more than ever before, and that potency will definitely grow in the next decade or so. We are moved by photographs. Photographs become the icons of our lives, the way we remember our children, our friends, and our experiences. Photographic images teach us about the world, influence who we admire, and show us what we can't live without.

Photographs have led us into war, and led us out. Photographs tell us about places in the world we'll never visit. Photographs connect us to our personal past, sell us all manner of products, and move us as art. They arouse us, depress us, and inform us. We're bombarded with photographs, and all of us have in our minds a vast visual library of images that includes

the things we've actually seen, and lots of things we haven't. For example, I've never actually seen the Taj Mahal, but based on many photographs that I've seen, I have a picture of it in my head. It's the same for me with Mount Everest, the moon, the inside of an emergency room, and the morgue.

These pictures that we all have in our head are part of the "sensorium commune," things we accept as known by most people and therefore unnecessary to explain. When I say I'm cold, I don't have to tell you what I mean by "cold." Cold is part of the sensorium commune, as is orange juice, Elvis Presley, the Eiffel Tower, and the bald eagle. So, in addition to its powers of communication, photography is also a crucial part of our mental filing system and our collective consciousness.

But if that weren't enough, cameras can go where the human body and unassisted eye cannot. I have an image in my mind of the embryo inside the uterus, the interior of a nuclear reactor, and the view from the foot of a rocket engine as it ignites. The camera can be tiny and venture where I cannot. So, too, it can observe situations too dangerous for me. And, because there are hardworking souls who choose to do so, there are photographs that show me places I wouldn't want to go—war-ravaged Rwanda, or the suicidal aftermath inside the home of the deluded souls of the Heaven's Gate cult.

If all *that* weren't enough, photography can even show us things our magnificent eyes and nervous systems can't even perceive although they're "in plain sight."

For example, photographer Eadweard Muybridge is credited with solving a debate that had raged for years (admittedly mostly among the horsey set, painters of horses, and the admirers of their work) regarding whether or not a running horse ever had all four hooves off the ground at the same time. His early motion studies proved beyond a doubt that they did. We just can't see the movement because it's too fast.

Muybridge solved this problem over one hundred years ago. Since that time, humans have improved many aspects of our physical performance. We can run faster, jump higher, and live longer. But we still can't see the hooves of a galloping horse without the camera's assistance.

And much faster movements can yield their secrets to the camera with the right technique. No one had ever seen bullets and exploding objects the way the first stroboscopic photographs of Harold Edgerton revealed them to exist at the instant of violent kinetic action. And no one ever saw trains pass through the American countryside at night the way we see them in the "big shot" train photos of O. Winston Link.

A MOMENT FIXED IN TWO DIMENSIONS

The photograph fixes a moment in time, and reduces three-dimensional reality to a representation in two dimensions. Those "fixed moments" matter not just for their revelation of the amazing, the surprising, and the unknown. There's a more intimate value. Professional photographers know

full well that when fires or floods threaten residential areas and people have a few minutes to grab things before they flee their homes, photographs are among the "valuables" that the unfortunate evacuees most often take with them.

And perhaps in part because photographs have become so powerful, the public has developed a fascination with the people who take or make them. Photographers turn up frequently as fictional characters in literature and film, television series, and even comic books.

Adding to this fascination with photographers as characters in fiction is the fact that, again, anyone can be a photographer! You don't even have to *be* one! Just call yourself "a photographer." Like "model," "artist," "actor," and "therapist," there's no licensing or clear-cut standards that are understood by the public (except for a few technical positions like medical and forensic photography). Just wave a camera in the air, explain that you just shipped your portfolio by air courier to a new client, and fast-talk your way into the job!

Sound far-fetched? Not really. If you did that, you wouldn't be the first. Not long ago I heard the great Gordon Parks recall his first photo assignment. He was hired to take some fashion photographs after exaggerating his prior experience and persuading the wife of the owner of the local department store that he could do the job.

WE START BY LOVING THE TOOL

And what a tool the camera is! It's the reason anyone can take a great photograph, either a prize-winning scenic, or a stunning news photograph, or "just" a great photo that brings joy to family and friends.

As a tool, the camera brings the novice much closer to a high-quality "master" image than any other artist's tools. I can buy the finest brushes and world-class oil paints of the same type used by the best painters, or the violin or guitar that belonged to a great musician, but without years of training and practice, the likelihood of my producing a great "work" is slim.

I believe that the photograph (sometimes with some explanatory words) is the most powerful communication medium available today—more powerful than film or television or words without pictures.

FLUID VERSUS FROZEN

While moving images can also be extremely powerful, they take too long to experience. I believe we store visual information in our minds as still images, and we can linger over a single photo for a period of time or take in many images very quickly.

Motion has its benefits, to be sure. There's a big, fenced-in yard I sometimes drive past that is the domain of a very frisky pup. One deliciously mild, early spring day, I drove by that yard to see the pup happily chasing his tail in the middle of the yard. It would be much easier to catch

that sense of springtime exuberance on video. By the time I mount a 200mm lens on a tripod and get a decent angle over the fence, the dog is likely to be chasing me rather than his tail.

Admittedly, there are times that video (particularly when it's candid) can capture amazing things. Not long ago, the local New York City cable news channel caught a scene at a city council hearing. Confronting a council member who had voted against the mayor on a separate issue, a mayoral staffer is clearly seen and recorded snarling to the defiant council member: "You can forget your fucking Beacon school."

I'll spare you the details, but the point is that council members fight hard to bring these special schools into their districts; and for the public to see education (and children's futures) reduced to a bare-knuckle political payback was an eye-opener to some of the city's finer folk, who have never experienced the way the cards get dealt in the back rooms. A still photo with a caption might convey the situation accurately, but there would be denials about exactly what was said, about why it was said, about when it was said. With videotape, there's no waffling. He was caught.

However, the actual tape of that event was seen by relatively few people. Most folks read about it in the newspaper along with a photo of the individuals involved. But the evidence was there for anyone who wished to take the time to view it.

That kind of video documentation isn't limited to just reporters with broadcast equipment. The videotape of the Los Angeles police beating Rodney King is an example of an effective documentation job done with an amateur camcorder. Even though there's no sound, the appalling nature of the images was extremely powerful.

FILM TAKES TIME

If you have the time, there's a lot of great stuff you can watch on film and video. But it takes time, whereas looking at photographs doesn't have to take time. Studies show that most home video taped by amateurs is not even watched once by anyone, not the videotaper nor his or her family and friends.

And if *that* weren't enough, there's the power of the photograph to record things that are important, or are discovered to be important later, but were insignificant or disregarded at the time as unimportant artifacts by either the photographer, the subject, or both. Months after the double murder of Nicole Simpson and Ronald Goldman and the acquittal of O. J. Simpson on murder charges, a Buffalo freelance photographer by the name of E. J. Flamm, Jr., released photos taken years before of Simpson wearing a specific model of Bruno Magli shoes that had been identified as the source of bloody footprints. While choosing not to testify in his defense, Simpson had been quoted as telling the public that he never would be caught wearing an "ugly ass" pair of shoes like that particular model.

In Michelangelo Antonioni's film *Blow Up,* the photographer is haunted by a crime scene and finally finds clues in enlargements of his work.

SLO-MO IS STILL PHOTOGRAPHY

History's most famous piece of amateur movie film, the Abraham Zapruder black-and-white recording of the JFK assassination, is a gripping film clip when we see it played, but it has really been reduced to a series of still photographs by those seeking to study what actually happened on November 22, 1963.

This ability to break movies down into still photographs underlies another way of seeing that I attribute to photography rather than motion pictures, namely, slow-motion (or slo-mo to the editors). We all know the trick behind the movies: A series of still photographs, when shown at a rapid rate, stimulate our persistence of vision, and we "see" the sequence as a single moving image rather than a series of still images.

Once a moving picture, whether recorded on film or as magnetic or digital "frames" on tape, is slowed down (or, I would even argue, when it is played faster), it starts to become a series of still photos. The illusion of seeing something moving is broken. You're looking at a string of still photos and you know it.

Movement that is created by time-lapse photography owes the same sort of debt to still photography. It's really just a way of viewing still photos in rapid succession.

Critic Ron Rosenbaum, writing in the New York *Observer* a few years ago, pointed out that the first great use of slow motion to show action was not in theatrical movies, as it is often credited, such as the slo-mo shooting sequence in *Bonnie and Clyde*. Rather, the revelation of action slowed down to a new way of seeing can be credited to the *NFL Weekly Highlight* television shows in the early 1960s, which first made creative use of slow motion to dissect fast-moving plays of extreme grace or brutality.

WAIT! THERE'S MORE

Photographs give a sense of design and style to the lives of millions. They motivate us to buy, to care, to love.

Photographs can speak for us when we're unable to express profound emotions. I was moved when the nation watched, some years ago, the weekend memorial service for the nearly two hundred victims of the Oklahoma City Federal Building bombing. As the surviving family members entered the auditorium awaiting the beginning of the ceremonies and as a large percentage of the nation watched on television, people in the front rows held photographs of their family members who had been killed in the blast. It was a powerful testament to their loss, their sadness, and their anger. And, once again, to the power of the photograph.

In fact, loved ones holding photographs of the missing and dear departed is really a stock photojournalistic image that appears frequently

in magazine and newspaper coverage of these types of tragedies. We're far more likely to see the departed recalled by a photograph than to see a grieving family member hold a favorite sweater or other possession. A portrait, even of someone we've never seen, gets to that person's essence in a unique way.

Not long ago, there was a pathetic story in the New York area, where a fugitive implicated in a shooting in New Jersey ultimately committed suicide with his own gun after he crashed into a toll barrier at a bridge at the end of a high-speed car chase. Before he shot himself in the head, he swallowed a small photograph of his family.

More often, the power of the photograph is related to the happy growth of families. I once had the opportunity to open an envelope that had been sent overnight to my wife and me. It contained a standard $4'' \times 6''$ photograph, taken several weeks before, halfway around the world. Those twenty-four square inches showed a room, a nurse, and a ten-week-old baby, our daughter Lily. I cannot imagine that there is any silver halide C-print that has been more closely and lovingly studied, except for photos that have been provided to thousands of other people as a way to get a first look at a new member of their family.

The power of the photograph is certainly not lost on those authoritarian regimes that seek to maintain strict control over individuals. Recently, the Chinese-controlled government of Tibet made it a crime for any individual to possess a photograph of His Holiness, the Dalai Lama. Although living in exile, the Dalai Lama remains the spiritual leader of the Tibetan people, despite decades of Chinese occupation of Tibet designed to eradicate his influence. Imagine—a crime to carry a photograph of a religious figure.

The persuasive power of photographs, when coupled with the charisma of celebrities isn't lost on the corporate world either. As I'm writing this, lots of Americans are carrying around pictures of the Dalai Lama, Ansel Adams, Frieda Kahlo, Albert Einstein, and Amelia Earhart, printed on the backs of their magazines (they're on lots of billboards, too). It's part of an "insta-classic" image campaign for Apple Computer that has a set format: a big black-and-white photo of the celebrity with tiny type that reads "Think Different" and a tiny Apple logo. But be careful: That magazine cover could get you arrested in Tibet.

PHOTOGRAPHY AND THE MEDIA BARRAGE

The power to immortalize our heroes has a drawback, an ugly side that has recently come to the fore. We've entered a world of media, news, and celebrity overdose and the payback is starting to occur. We're the messengers, and we're being blamed. We're feeding an appetite and being castigated because of the fodder that the public is gobbling down. When Princess Diana died in 1997 and the craven father of the young Fayed first

tried to pin all blame on the pursuing photographers, there were scattered reports of photographers being abused and harassed in various parts of the world.

After Diana's death, uninvolved limelight-loving loudmouths such as Donald Trump blasted all paparazzi on the radio, labeling them "scum." Editorial writers and cartoonists had a heyday, legislators in New York State and elsewhere introduced legislation to curb intrusive photographers with long lenses. Yet the public eats up the images that photographers provide. Every tabloid newspaper has a celebrity page; the supermarket weekly tabs are filled with the cellulite-ridden thighs of some actress caught walking the beach, and photographs of aging celebrities like Bob Hope and Elizabeth Taylor command hefty sums. Whatever the subject, someone is going to take the picture, and sell it. Will you? Don't worry. If you won't, someone else will.

The experts can fight endlessly about whether the public really wants this stuff or if the media is forcing it on us, and why celebrities crave media attention yet need to be protected from the very photographers who make their faces so well known.

The fact is that all of us who choose to participate in modern life are glued together in an endless media surveillance barrage. Unless you've carved out the life of a rustic, you get a big dose even if you don't participate. The radio or television is blaring in the deli, the airport, the hospital waiting room, and the county jail. It's hard to avoid the "Star Busted with Hooker" story or the other pratfalls and backsides of the roster of important entertainment, media, political, and sports celebrities. As the stage manager observes in Thornton Wilder's marvelous play Our Town, "In our town we like to know the facts about everybody."[1]

We're a part of it. We photographers have a huge market seeking images of whomever, looking good or looking bad. Cellulite on a starlet's thighs and the drunken movie tough guy are part of "the facts" we—the public—like to know in our global village. Oddly, some segments of the celebrity elite get tougher scrutiny than others. For my taste, the current crop of sports figures aren't getting the full range of attention they deserve. And if all this weren't enough, I've saved one of the best powers of photography for last—the power to fool us and to make us laugh.

PHOTOGRAPHY'S POWER TO FOOL

Years ago, I taught a class in Green Haven Correctional Facility, a massive maximum security "joint" in the New York State prison system. For years, K Gallery there had been New York's death row. A few years before I arrived, New York's existing death penalty had been struck down by the U.S. Supreme Court and the dozen or so men on death row at the time were released into the general population. The massive oak electric chair had not been removed from K Gallery. Two of the students in our class made a mock-up of the chair, using a Mission-style wooden chair, some belts for wrist and

leg straps, and a coffee can and some electrical bx-cable. They put battling Bobby Halpern, an inmate who had been a professional boxer, in the chair, lit the set deviously well, and shot from a crooked, high angle.

We hung the photo in a show in a nearby town because we thought it was very good. A few days after the show went up, my teaching partner was paid a surprise visit by state criminal investigators. Seems the wife of a corrections officer had seen the photo and told him. He viewed it and reported to the warden that our photo class had broken into K Gallery and taken a picture of someone forced to sit in the actual electric chair!

We had to give the investigators a guided tour of the photo to assure them that the whole thing was a fake.

A few years ago, the newspapers reported that there was a newly invented toy that had created all the preshow buzz before the start of the big annual spring toy-industry trade show held in New York. Someone had invented a puzzle that consisted of clear plastic parts that when correctly put together formed a perfect sphere and instantly became invisible!

Not only did the toy sound great, but there was a news release with two photos: Bill Clinton in the White House playing with one of the toys, and Bill Gates congratulating the inventors at a computer show. On the eve of the toy show's opening day, it was revealed that the whole thing was a hoax. A good idea, a little Photoshop, and the hot toy of the season was born.

The camera has been making us laugh since its invention. There are lots of set-up and gag photographs from the early days of photography, but if you're unfamiliar with the photographs the French photographer Jacques Lartigue took in his youth, you owe yourself the pleasure of looking at them. The playful humor of many of his subjects comes across in a way that could not have been captured without the camera.

For most of photography's history, great value was placed on the photograph as evidence. Most methods of tampering with a negative or print were so crude as to be easily detected. Obviously, with the advent of digital imaging technology in the 1980s, the absolute credibility of photography has been discredited. All photographic "evidence" must be approached with a great deal of caution.

Photography's Power Has Grown Steadily

There are those who will argue about whether photography is a science or an art. To me, it is irrefutably both. In fact, the scientific, technological end of photography has accounted for a tremendous growth in the power of photography. In many different dimensions, technology has extended photography's overall reach.

Think about it. Painting and sculpture haven't experienced exponential technological development in the past five hundred years. The masterpieces of centuries, even millennia ago, still have the same punch and exist in much the same form as the efforts of today's painters and

sculptors, at least the works that are presented to us in galleries and museums. Even painting's pictorial revolutions, such as cubism and abstract expressionism, are still composed of paint on flat surfaces.

In today's galleries we also see several forms of "idea art" that would not have been deemed worthy of display decades ago. But by in large, whether it's with tempera, oil, or acrylic, and whether it's placed on a wall, canvas, or other surface, painting is painting.

It's not just photography that has benefited from technical advances. Architecture has been affected by technology as well. Buildings today can be bigger, made of different materials, and offer better environments to their inhabitants than they could five hundred or more years ago.

But technology has transformed photography. There are certainly many sublime images in the early technologies. There are wonderful daguerreotypes and great early Talbotypes and albumen prints. The images, the world they recorded, and the art and expressive side of early photographs are in no way diminished or surpassed by the images that have followed.

In recent times, technical innovations have significantly increased the vocabulary of the medium. It's as if new letters and sentence parts had been made available to a language. This is one of the main reasons why it's so important to study the history of photography. A basic study of visual literacy, particularly in photography, should be as mandatory as civics or math classes in high school.

IMPROVED EQUIPMENT

In recent decades, we've enjoyed the development of faster films and shutters, smaller cameras and better-designed lenses, and high-speed strobe illumination replacing flash power and flash bulbs. These new tools have changed not only *how* we photograph, but *what* we photograph.

Photographer Monte Zucker once told me that in school he had his class photo taken by flash powder! It's not that long ago that photographers were mired in very undeveloped technologies. Monte points out that flash powder gave off great light, it was just unwieldy and impractical.

Photos from the early eras are not in any way deficient, but there was no candid photography, no micro, astro, macro, or color photography. The new technologies have given photographers more options and greater opportunities to show more subjects in more ways. That's an increase in power.

IMPROVED DISTRIBUTION

It's vital to realize another important point. As great as the growth of power in photography has been, the ever-improving means of distribution of photographs has probably played an even greater role in bringing photography to the level of impact it now has over everyone in the world.

Photographs existed only as isolated images for decades after the invention of photography. It wasn't until techniques of photogravure and photolithography were developed, toward the end of the nineteenth century, that the printing press was able to be used to reproduce photographs so they could be distributed as part of newspapers, books, and magazines.

Photographs did not become the norm in newspapers and magazines until well into the twentieth century. Not only did the technology for printing photographs need to be perfected and disseminated, but the photograph still had to get from where it was taken to the place where it would be printed for publication.

To see how far we've come in recent years, consider that it was only in 1935 that the Associated Press began to use telephone lines to transmit "wire photos" to customers in twenty-five cities.

Motion pictures and television technology has also enhanced the distribution of the photograph in different, important ways, but it is with the dawn of the computer era that we see another quantum leap in the distribution potential of the photograph. Thanks to the Internet, anyone can now create a library of images, store them on a computer server somewhere, and anyone else from anywhere in the world can visit that library in an instant and view or even duplicate what he sees there anytime, seven days a week, twenty-four hours a day.

PHOTOGRAPHY ON THE INTERNET

For several decades, the Internet served merely as a curious way for academics to transmit words and for military personnel to communicate with each other on a multiroutable security network. When the Internet was enabled for transmission of photographs and graphics, as well as sound and moving images, the Web evolved into a genuinely new communications medium. The Internet has already started to reshape the stock photography business, the notion of copyright, and lots of other things that photographers and the photo industry take for granted as being a certain way. We'll discuss the Internet at length in chapter 10. The Internet adds a new dimension to the power of photography. But we're getting ahead of the story. The key thing to remember is that the ability to publish or distribute a photograph is an essential part of the power of photography.

As the technology that created the Internet and the Web moves forward, and as color printing methods get better and more varied, as color television images get bigger, and as we teeter into the world of high-definition television transmission and DVD computer storage—in essence, as the computer collides head-on with the television, stereo, and telephone in your home—the power of photography will continue to grow.

And the growing power of photography increases the power of photographers. It increases *our* power.

THERE WILL ALWAYS BE PHOTOGRAPHERS

However much the distribution outlets grow, no matter how the speed of transmission increases, someone has to take the picture. All the digital manipulation possible at the back end of the process still requires image capture. It's going to be a long time before robots take better pictures than people.

I wrote earlier that anyone can take a picture, but my young daughter, any photography student, even the chimp from West End Avenue has a lot more on the ball in terms of what's interesting to try to record visually than a machine. That brings us to an interesting axiom about technological innovation.

SUPPORT STAFF COME AND GO

Years ago, the sports photography team from a major newspaper included people in the lab to process the photos when the film was rushed to the paper by motorcycle. Drivers picked up the photographers' exposed film every couple of innings and rushed it back to the paper.

When satellite uplinks at ball stadiums became the rule, the motorcycle drivers lost their jobs. The lab technicians moved with their darkroom to the stadium. The film went from the photographer to the developer to the uplink.

When film was replaced by CCD chips in high-end digital cameras perfect for sports photography, the lab staff got the boot and the darkroom in the stadium was closed. Now the photographers either do their own downloads and transmissions, or there are a few technical people to handle that chore.

In part, this means that some aspects of photographers' work is primitive and best performed by humans, like blacksmithing or fish mongering. I live near New York's big fish market where years ago the fish came to the market iced on boats, and now they arrive iced in "reefers," big refrigerated trucks. But the best way to move a big fish out of that ice and into the buyer's truck is to give a man a hook and have him hoist the fish on his back.

Someone has to take the picture. And unlike the blacksmith and the fish monger, our power, our options, and, I suppose, our responsibilities continue to grow.

NOTES
1. Thorton Wilder. *Our Town*, 1938, Act One.

Unknown photographer, J.L.H. Mason III, Dorothy Mason DeLaney, Weyland Mason, Ella Mason Ahearn, Dr. J.L.H. Mason IV, ca. 1948.

Chapter 3: A Lifetime in Photography—Yours!

Fall 1992: I travel to South Carolina to see my Aunt, Ella Mason Ahearn, ninety-two and getting weak. In her heyday she was an innovative and well-known piano teacher who authored many instruction books for piano and violin. It will be the last time I ever see her. One question I have is about her brother, my Uncle, Weyland Mason, who I had been told was the black sheep in a family that had a lot of odd sheep. Ella was my mother's sister, and my mother, already dead twenty years, had rarely spoken of Weyland. I want to learn more.

It takes Ella quite a while to realize who I am. Her memory is fading, and she often closes her eyes for brief periods, her lids fluttering. Her in-and-out consciousness reminds me of the LCD panel on an electronic camera as the batteries are about to run out.

"Tell me about your brother Weyland," I ask, with no preface. The power surges. She becomes more alert than she has been since our visit started.

"Weyland. I remember. We would play on Mother's bed. He would push me and the others off. 'I'm king of the hill,' he would exclaim."

That's about all I learned about Weyland. I still have it in mind to do some digging in the last town where he was known to have lived. I think I have some cousins somewhere I've never met. But once Ella connected with that long-ago period, stories of things that happened between 1905 and about 1915 poured out, until she got tired and our visit ended. The last thing I did was make a photograph of her.

A lifetime is long and it's short. It's linear and it's not. What's important is that you live it to the fullest. Your photos will help record your lifetime and those of the people around you to the enrichment of all. It's your lifetime that we're talking about. And since you only get one lifetime (or at least only one at a time) and since you're involved with photography, the first step in choosing photography as a "career" is to treat photography like a good friend that can be a lifelong companion. What do I mean by treating photography like a good friend? Three things: Do not expect too much, be patient, and don't get too frustrated.

Don't Expect Too Much

Just as you don't expect your friends to become great or famous, don't feel that photography has to deliver you to the pinnacle of stardom. Chances are, it won't. It's also unlikely that your friends will become millionaires and give you large gifts of cash. Should some of them succeed and get rich, they may forget all about you. But photography won't go away. Instead, it continues to reinvent itself and offer those of us who pay attention new possibilities while maintaining its old charms.

Accept photography for what it is—an excellent means of communication between all the people of the world. It isn't your guaranteed passport to fame, world travel, and riches.

Be Patient

I think the most important thing to help you keep the right perspective is to avoid feeling that you have to do everything now. I've talked to many young photographers and students who get dismayed because they don't have as much equipment as they would like to or because they haven't had the chance to photograph a certain type of subject matter or travel to exotic lands.

While you may not have as much equipment now as you'll be able to buy later on in your life, everyone with an adjustable camera and lens and a few rolls of film has all the equipment that is really necessary. There are many famous photographers—David Hamilton comes to mind—who work almost exclusively with a "normal" 50mm lens on a 35mm SLR camera.

It is true that certain kinds of photojournalists and nature photographers need long-focal length, large-aperture lenses that are very expensive. Perhaps someday you'll own those. But you don't need them to take great pictures of most subjects.

If you let it, the "special need" list can go on and on: medium-format cameras, underwater gear, studio lighting, radio-controlled slaves. All in due time—remember, this is a lifelong relationship.

There are also experiences you have not had yet. That's OK too. Don't be impatient. There are experiences none of us have had. Enjoy the ones you're encountering now. For example, you may have never entered a photographic darkroom. In fact, the traditional "wet" darkroom may not interest you whatsoever at this point in your life.

Don't confuse your lack of interest with a belief that you don't need to have a working knowledge of basic darkroom procedure. Read up a little bit about the darkroom. You may find that it's more interesting than you thought. While we'll turn to technology later, I've observed that many photographers who are familiar with traditional variables in a photographic print—contrast, brightness, color, hue, and selective exposure—are more adept at learning how to control images in the digital darkroom than those who attempt to learn the variables initially on the computer without a grounding in traditional darkroom experience.

It's also possible that ten or twenty years from now, when your time demands may be different, you may start working in the wet darkroom. Some photographers go through phases that see them in the darkroom and then using a custom lab. As with a lifetime friend, there's plenty of time to experience the different aspects that photography offers you.

ONE EXCEPTION

Not everything should be left for later. It's not OK to have a mind that's sealed shut. Sometimes I get letters from beginning students that read something like this: "I've been serious about photography for a few years now, but I'm only interested in nature photography and have no desire to study anything about portraiture, photojournalism, or darkroom work." That's like being interested in words but only in poetry, not short stories, or nonfiction.

Don't let your current interest in one type of subject matter lead you to avoid other photographic subjects and techniques entirely. It's important to dabble. You never know where dabbling will take you. In fact, one of the most famous (and best) wedding and portrait photographers I know, Monte Zucker, maintains that it is necessary for him to continually change what he does and how he does it. He feels that if he's not changing, he's not growing as a photographer.

Many of us change our work or our style of photography because we are seeking a formula for success. That's not what motivates Monte. He's got the success. He's widely acknowledged as being at the pinnacle of his field. He has a fabulous clientele who pay a handsome price for his wedding photography and portrait work, and his style is very accomplished and highly distinctive. He travels all around the world to work. Yet Monte continues to tinker with every aspect of his work—his ideas about posing

and lighting, as well as his business practices. He's also been an early adopter of the new digital technology. Unlike some well-established photographers who are ignoring the Web and ducking digital, Monte's enthralled and totally involved.

As I have heard Monte explain many times in lectures to other photographers, he feels that if he weren't constantly changing what he does, photography might become less fascinating to him. So one reason to change, explore, and dabble is simply to avoid any kind of boredom that you might encounter. Plus, as I've suggested, you may find that your interests change over time. They may not, but it's important that you view your relationship to photography like a human relationship, and the odds are that it will develop over the years and you may end up discovering different aspects of that relationship that become very valuable to you.

Don't Get Frustrated

Occasionally I speak with a student who is downcast because her teacher has not heaped unqualified praise on her work. That's an attitude that requires adjustment. Very little work merits unqualified praise, and until you get to be pretty good, you're not likely to bask in such praise much of the time. In fact, you shouldn't. The real goal of evaluation of a student's work, or of any photograph for that matter, should be evaluating what it says and how it could work better, rather than finding fault or heaping praise upon an image.

Years ago I was tending the houseboat gallery of the Floating Foundation of Photography when it was docked on a pier in Lower Manhattan. There was a newly built luxury yacht berthed along the same pier during its maiden voyage to New York. The yacht was owned by a very successful Long Island housing developer and his new trophy wife, after whom the craft was named. (Needless to say, all this has passed, the couple divorced, the developer is dead, and the renamed luxury yacht belongs to some Middle East oil baron. See postulate 12 in the upcoming list: Things don't last.)

The newspapers, spurred on, no doubt, by the developer's press agent, had taken an interest in the arrival of this floating bauble, so press photographers dropped by frequently to photograph the yacht. Since a two-story purple-and-white houseboat photography gallery was an interesting sight to encounter along the way to the yacht, the photographers would always stop and visit. One particularly successful photographer talked to me about the scarcity of really great images. He maintained: "If after years of taking pictures, you go over all your work, and you find more than ten really great photographs, you're probably fooling yourself." He was applying a very high standard, to be sure.

There's no need to split hairs here about how great a photo has to be to be called great. Suffice it to say that most photographs can be critiqued and possible improvements suggested. That's no reason to get frustrated;

critiquing isn't bashing. Ignore nasty or harsh comments. They say more about the commentator than about you.

Don't let your lifetime in photography be hampered by unreasonable expectations, impatience, or frustration. Accept photography as it is. If you follow these simple rules, you'll have a good friend with whom you can grow old.

Photography isn't going to desert you. As I noted earlier, you can take to your chair, your hands can shake with palsy, but you'll still be able to take photographs. Edward Weston was in pretty bad shape near the end of his life, but he kept photographing as long as possible. Your range of subject matter may be limited, but the possibilities of what you can do with that subject matter will remain endless.

A few years ago, we enrolled a student at NYI who was already in his eighties. He came to visit me at a trade show. He was neither clear of eye nor steady of hand, but he was packing a Hasselblad and a special wooden brace that he'd had a friend make out of a rifle stock and some other gizmos. I told him that since Hasselblads last forever, he should show his innovation to the people at Hasselblad, since there might be other people interested. After all, a Hasselblad is a relatively heavy camera. "Where's their booth?" he asked, and off he went. So when you need to walk with a cane, rig it as a unipod and just keep making photographs.

WHAT IS SUCCESS?

I define success in photography, first and foremost, as the ability to make wonderful photographs that please you as the creator of the image, and that bring joy and pleasure to the people with whom you share those photographs. Actually, the longer I've worked in the field, the less difference I see between the so-called professional and the amateur. We are all makers of photographs.

As you read this book, don't be overly concerned with how the information can help you get to where you want to end up in photography. Rather, imagine that you are on a trip that doesn't have a guaranteed destination. Anticipate that you may experience a number of different directions at different times in your career, and that they may all be perfectly valid.

DO YOU NEED A GOAL TO FIND SUCCESS?

Many of us find that as our life unfolds we go to unexpected places, we do unanticipated things, we meet people that we never could have guessed would cross our paths. Perhaps you have the sense that you want to end up in a particular field of photography. Perhaps you love making outdoor and landscape imagery. Perhaps you want to be a photojournalist in the midst of all the action. If you have a goal, that's fine. But don't rule out the other possibilities that may lie before you as your journey unfolds.

On the other hand, if you don't have a specific goal for your own passion about photography, don't worry at all. Things will evolve as you

match your other interests with your love of photography. Chances are, your relationship with photography makes you a little bit crazy at times. It is wonderful and exciting, but also sometimes frustrating and heartbreaking.

And another thing: It can be expensive. Even without sinking money into hardware and travel, it's easy to spend hundreds of dollars each year on film and processing. In time, for some photographers, film and processing may be replaced by computer storage and manipulation that may cause that cost to drop. Regardless, all but a lucky few of us will always crave more hardware than we can afford.

IT'S NOT FAIR

And, if that weren't enough, there's one thing about success that appears to make no sense. One only need look at the photography "scene" to see that there are lots of small talents with big reputations. Excuse me, people are being rewarded unfairly here! Can't we get a little order in the field? Shouldn't cream rise to the top?

ONE INGREDIENT FOR SUCCESS

At the risk of startling you, however, things never change. Those old career books in my library—I have two from the 1940s and another from the 1960s—look funny and have a lot of strange ways of saying things, but one central fact hasn't changed at all. For all the progress in technology and all the changes in the world, success in photography requires just one magic ingredient. The magic ingredient is you. Or rather—you, unleashed.

You, on your way and on your terms. You, the king of your hill.

That's why, before we go on to survey the ingredients of photography, the world of picture viewers, photo buyers, subjects, and publishers that you may encounter, we are going to start by considering you, the photographer, and your forebears.

What I've learned about photographers comes from several areas, including more than twenty years' experience as a freelancer. But my perceptions are also formed by the dozens of photographers I have as friends, and the hundreds and hundreds of students I have worked with at NYI and the other teaching situations I have enjoyed.

Spring 1971: I am admitted to the graduate school in Art History at a very famous university. I go to visit the school and meet with one of the faculty advisors. I explain that I am considering postponing starting my graduate studies for one year. "That's a big mistake," he bluntly responds. "You'll shorten your career by a year."

That was enough for me. I went elsewhere to study art history. But it brings us to a fact you should consider as you contemplate a "career" in photography—the average NYI photography student is between thirty-five and forty-five.

You won't find many fifty-year-olds in medical school, but the zest for learning photography is not exclusively reserved for younger students. Lots of people get interested in photography in midlife and go on to have marvelous careers. You're never "too old" to begin a career in photography, and you may have lots of advantages to bring to your photography based on your life experiences. Just because your aim is to make photography your lifelong friend doesn't mean the relationship has to start in your youth. You're never too old to fall in love with photography.

As with any love, there are rocky moments. I have encountered those. I have dropped cameras. I have ruined exposed film. I have tripped on cameras while running to keep up with "the candidate," and I have been jostled by the some of the more aggressive members of the press pack. I've made great photographs with no film in my camera, and scratched negatives in the darkroom. I've made mistakes and had to do some fast explaining to clients. I've had to reshoot jobs at my own expense. You'll make mistakes too. That's part of life and the journey that we share.

EVERY MISTAKE ONLY ONCE

A critical piece of advice: Try to avoid making the same mistake over and over. You will find your life will be a lot richer if you go on and make new and different mistakes! Often mistakes can provide the best learning experiences.

There's a wonderful lecturer on the photography circuit who, in the course of an evening's talk about his career in photography, will say several times during the lecture, "If you remember one thing from this talk, please remember this." At the end of the lecture, the attentive listener may realize that there have been six or more "one things" that got the "If you remember only one thing, remember this" preface, but it gets the key points etched clearly in the audience's minds. So, if you're reading this book and you come away with only one piece of information, whatever you do, remember this:

It is essential that you keep a positive attitude about who you are and what you are doing with your photography. Don't beat up on yourself. Don't worry about the equipment you don't have. Do respect your craft and this marvelous young art form. Do treat each experience as an opportunity to learn. Take criticism when it is offered, and rejection when it comes, as an opportunity. Be reasonable and realistic about what constitutes a "victory" or a "defeat." And, if you get rewards out of photography, give some back to your community, your subjects, or to students of photography.

As you'll discover, sometimes people like or dislike your work for reasons that are totally outside your control. That's part of the reason you have to maintain a positive attitude about yourself. Believe me, no one's going to do it for you.

YOUR TURN IS COMING

There's a strange game you find in some casinos and occasionally at street fairs. Under a glass top, there are three or four steps covered with quarters. Little levers at the back of each step make inefficient back-and-forth strokes that have the effect of occasionally pushing some of the quarters off one step onto the step below. At the top of the machine is a slot into which you—the player—can drop quarters. At the bottom of the machine is a slot where quarters, once they're pushed off the bottom step, tumble out into your lap.

The goal of the game is to drop quarters into the machine in such a way that more tumble into your lap than you put into the top of the machine. I've never played this game, because if it's in a casino, the house must know the odds aren't in my favor.

The game interests me because it resembles life. We, the current denizens of the planet, are like the quarters. And whether we like it or not, we are all being slowly, unpredictably nudged toward the abyss.

That means things change. Today's titans die. As Mark Twain is reputed to have said (I can't find the quote), "Graveyards are full of people the world couldn't live without." The opportunities will appear, no matter how crowded the way you choose may seem. You just need to keep plugging away.

GETTING STARTED

Let's suppose that you've only recently become serious about your photography. You may be wondering where to begin. I think the answer is very simple: Begin with the equipment that you have, pick two or three film stocks that you feel comfortable using, and begin to ask yourself what it is you want to do with your photography.

What do you want to photograph now? What do you want to do with those photographs? Who do you want to see them?

You should also bear in mind that photography doesn't fill your entire life. No matter how you fit it in, there's other stuff as well. You probably have hobbies and other interests. There are things you know about from work or other activities. These things may be very closely connected to your photographic interests, or they may seem entirely unrelated. As we'll discuss, those interests are likely to be important in designing your departure point.

ART OR PRODUCT?

Back to success and how to define it. What spot would you like photography to occupy in your life? Is it for money? That's a big question. At NYI, we ask right at the start of our course: "Why not make a career out of doing what you love?" For some the answer is simply, "Right. How do I do that?" For others, the question is more introspective, "Do I want to do that?"

For some photographers, part of what they love about photography is that they do *not* have to do it commercially. For others, the satisfaction varies with the size of the check. For some individuals, accepting commercial assignments starts out as fun, but leads to disenchantment with photography, because they find that the business aspects of the profession, coupled with the need to please a paying customer, detract from the enjoyment and sense of freedom that they have when they're just photographing on their own.

There are famous artists who made their living doing something other than making art, and many artists who were remarkably unsuccessful throughout their entire lifetime. Eugène Atget's work was rescued from near oblivion by the interest of photographer Berenice Abbott. Painter Vincent Van Gogh was tormented and considered himself an utter failure. His work had a tiny audience and absolutely no sales potential during his lifetime. You certainly do not have to be a professional or rely on photography for your income in order to call yourself a photographer.

CAREER STEPS AREN'T JUST FOR PROFESSIONALS

The blurry line that separates the vocation of photography from the avocation mandates that you take some businesslike steps even if you intend to remain an "amateur" all your life. In the business section later in the book, we'll discuss why, for example, you should have a business card, even if you have no intention of ever entering "the business."

Before we can examine further the possible pathways for your life in photography, I have to set out some basic postulates. It took me a long time to learn, understand, and appreciate these. They are important because I'll come back to these principles time and again in this book. I believe in them, and I think they will be helpful to you, too.

CHUCK'S THIRTEEN BASIC POSTULATES

1. There is no one way to be in the world. In short, no one way of being.
2. If there is no one way of being, then there's no one way of seeing.
3. No one type of success is better than any other.
4. In photography there is never a single "right way" of doing things.
5. The virtual split, and attendant ignorance and mistrust, between most "fine art" photographers and most commercial photographers should not exist, and the split is harmful.
6. The need to master photographic technique is on a par with the need to master your own emotions and gain insight into yourself. Most of us have a better chance of learning technique after we learn a bit about ourselves.
7. American education, particularly in the arts and culture, is imperiled as never before.

8. Don't be afraid to sell. Learn to love it.
9. Don't avoid big problems. Deal with them.
10. You've got to reward yourself. Others may do so as well, but no one can do as good a job as you can.
11. The unfamiliar becomes familiar very quickly. Don't wait too long to record what strikes you as unusual. Your perception may fade.
12. Things don't last: Nothing lasts forever and what goes around comes around. That also means that the breaks even out.
13. Your way of being is likely to change over time.

Whew! That's a lot of postulating and declaring. How'd I do? Let's try an experiment. Before we go forward, I would like you to reread this list and consider each statement to be a true or false question. Can you read my list and answer anything but "True" to each of my postulates? You know what? It doesn't matter! (See postulate 1.)

Feel free to send me comments about which of the above postulates is wrong and why. I promise I'll read every comment I get.

I'm not going to elaborate on each of them now, but I am going to examine the first four before we move ahead.

1. There is no one way to be in the world. No one way of being.
Did I already tell you that if you only remember one thing from this book remember this one thing? If I did, I've changed my mind. Instead: Remember *this* one thing: There's no one right way of being in the world.

It took me a long time to learn this. I thought everybody was interested in the same stuff that interested me. That what made me angry angered others. That my emotions were wired pretty much like everybody else's.

To a certain extent, during one's youth and school years it's common to spend so much time with people who share your age and background and who see things the same way you do, that it's easy to think your way is *the* way. It isn't.

In fact, consider how much trouble this type of thinking has created in the history of the world. How many battles, big and small, were started because someone believed we would all be better off if we were citizens of the Roman Empire, or a master race, or worshiped this god or that deity? Or that it's better to be a vegetarian than an omnivore? Or that Dodge pickups are better than Fords?

As we look at history, it's one thing to look at wars and violence perpetrated by greed and lust for money or power. In a way, those motives are understandable. But lots of the worst damage is done by people who are motivated not for profit but by the desire to subjugate others to their beliefs or kill them in the process.

It's scary how low we humans can sink. And you don't have to look back into history too far. Recall the past decade of people of various faiths

or ethnicity killing, raping, and torturing each other in Bosnia and other parts of the former Yugoslavia and the bitter battles and displacement of tens of thousands of Hutu and Tutsi people in Rwanda? It made for great photojournalism of human suffering and savagery, but it made no sense. Some Bosnian plunderer claimed he could "tell" Moslems from Christians by the shape of their thumbs.

Let's just take a more mundane example—food and diet. I have found that by their own account, there are people who appear to be better off eating a controlled vegetarian diet. There also seem to be people who thrive on a high-fat diet. Some people should not drink coffee, others probably should. Ditto red wine.

For a couple of years, I participated in regular group discussions with some people with the common goal of sharing our experiences and trying to help each other gain more satisfaction in our lives. It was astounding for me to realize that people who seemed on the surface to be a lot like me actually reacted very differently to things than I did.

That means I'm different from you. And I don't have to be like you.

The Dutch painter Piet Mondrian bitterly broke with his longtime associate Gerrit van Rietveld when the latter introduced curvilinear forms into his work. If I recall correctly, they never spoke again.

I could go on and on, but it's not necessary. At this point I only wish to establish that there are forks in the road where each of us has the right to choose how to proceed based on self-knowledge. There are many valid paths, and the ones you choose are fine if they're right for you and don't cause harm to others.

One more example. I call a friend, painter Joseph Marioni, in the early afternoon. His voice croaks. He sounds like he just woke up. I ask if that's so. "No," he explains, I've been up for hours, I just haven't used my voice."

That, to me, is inconceivable. I get up, I talk. I talk to the family, to the mirror, to the cat, to the coffee pot. I cannot imagine not babbling on all day long. I also can't meditate. Should Marioni be forced to change? Should I? No.

No one way of being.

That gives you a lot of latitude. But let's look at the flip side of this assertion.

It gives "them" a lot of latitude too.

It gives them (everyone else in the world) the right not to care about the same things you do. Not to like the same food, same films, not to get excited about your lifestyle, about your photographs, about your passions. If they're your customers, it gives them the right not to see things your way. You've got to sell them. You've got to show them why things excite you. How you see them, how you feel them.

It hasn't always been this way. For centuries, it wasn't this way anywhere. La Droit du Seigneur, the whim of the Pope, or the alpha-male

Medici Prince, or some other "Big Stick" set down Orthodoxy. That was the way it was. There *was* a way to be. You had better be down with the program or be ready to be an exile.

Today: More Individuals, More Ways to Be

The fact that the individual is probably more highly prized and given more latitude today than at any other time in the history of the world as we know it, is partially bound up with innovations and new technology. The computer, the transistor radio, and the electric guitar have all played a part in promoting a culture of individual choice around the world that Marshall McLuhan dubbed a "global village" over thirty years ago. All we've done since that time is wired the village for better bandwidth. Now, to paraphrase Gertrude Stein, "There's no there, there" almost everywhere. And, as a corollary, CNN is everywhere.

In this book, when I close out an examination of different approaches with "No one way of being," it isn't intended as a cop-out. I'm not ducking a recommendation. Rather, I simply find that we've examined the choices and now it's up to you to pick the one that's best for you.

2. If there is no one way of being, then there's no one way of seeing.
I used to mount exhibits of photographs taken by the prison inmates in photography classes taught by the Floating Foundation of Photography. You will hear more in this book about the FFP. It was a creature of its time—the 1970s and early 1980s—a nonprofit photo gallery located on a two-story, purple-and-white houseboat powered by a used 100-horsepower outboard motor.

The FFP was officially classified by the Coast Guard as a hazard to navigation. It was run by a brilliant and wonderful photographer named Maggie Sherwood, who taught me a tremendous amount about photography and life in general, and for whom I giddily risked my life more than once while working as a mate on the purple houseboat.

One of the Foundation's goals was to bring photography to isolated communities, and that meant that our mission was to put up photo exhibits wherever we could: churches, schools, delicatessens, anywhere.

Some exhibitions were of the prints of photographers who brought their work to Maggie with an eye toward exhibiting on the houseboat's gallery. Many shows, including the ones we mounted in community settings, featured the work of the photography students in the photo workshop programs the Floating Foundation ran in prisons, hospitals, and other venues in New York and New Jersey.

In mounting such shows, we wanted to get a dialogue going between the prisoners inside "the joint" and the regular citizens "on the street." Hanging the remarkable views of prison life made by our inmate photo students was a key part of that strategy.

I could mount an exhibit in just a few hours. I would bring fifty to sixty photos and hang as many as I could fit in the space allocated for the exhibit, slap up some signs, and there it was. The photos were very interesting, so most of the exhibits looked pretty good. We always listed all the photographers' names by their work. Particularly for prisoners who had mostly had their names on rap sheets and police blotters, having their name on the wall next to their creative effort was just as important as for anyone else.

Once I mounted an exhibit in a church in New York, and it was an important show because a lot of ex-inmates and prison guards were going to visit the show and their presence would help promote the type of dialogue we wanted to foster.

I laid out the show and had room for all the prints but two or three. As I looked over the layout, the "excess" photos that I did not plan to use were propped on a windowsill. A couple of former inmates who had been students of mine came by early. As I fiddled with spacing and leveling the photographs on display, the inmates studied the photos intently. These images had been taken at a different prison from the one where the visitors had been incarcerated, but there's a lot that's common to all joints.

As I worked, I heard them commenting on various photos. All of a sudden I heard one say, "This really says it all. That picture really takes me back."

I turned to see what photo had moved him so. It was one of the prints I had eliminated from the show! I thought it was a weak picture. But the photo was the favorite of a recent student, and the first 8″ × 10″ print he had ever made.

What did I really know? I had only been a frequent visitor to half a dozen prisons, but not an inmate. I went home at night. The photo, a horizontal black-and-white print, was a simple still life of a small stainless steel bowl containing three slices of white bread propped in the corner of a barred windowsill in a prison mess hall. "You know," my visitor continued, "I bet that guy was back in the feed-up line trying to hustle more bread. God I used to get hungry at night."

I quickly made room and hung the photograph. And I learned a lesson: No one way of being, no one way of seeing.

So what? Well, it follows that if we're different, then we see things differently. A few photographs may achieve near-universal admiration, but most will appeal to a smaller audience. If you don't like motorcycles, you're not going to pore over images of them the way an aficionado would. Within the body of work on any given theme, you may prefer understatement while your neighbor may favor that something garish and over the top.

No one way of being, no one way of seeing.

Another example: Twenty years after that prison photography show, I'm hanging another show composed of prints by NYI students at a

statewide federation of camera clubs in New Jersey. The exhibit is in relation to a talk I'm going to give about opportunities in photography.

I'm hanging a dramatic photo of the nighttime Dallas skyline with a host of illuminated buildings. It had been taken by an NYI student for his first assignment. There's a long story behind the photo, but the bottom line is that the student sold over $200,000 of prints of it over the course of two years. Suffice it to say that it's a great photo as well as one that's eminently marketable.

As I was hanging the photo, a woman from one of the clubs remarked: "That photo would score very low in our club's competition because the horizon line is dead center and we're always told to obey the rule of thirds."

How could a print that commanded nearly one-quarter of a million dollars get low marks in judging at a camera club?

There's no one way of seeing.

Probably the most emotionally moving example of someone who saw things and presented them in a way that was fresh, unique, and compelling is the painter Van Gogh. Unfortunately, no one at the time he was painting could grasp his way of seeing.

Reading his letters to his brother, Theo, reveals a man who yearned for recognition and positive reinforcement in his lifetime and got none. His work didn't sell, it wasn't appreciated. His letters are heartbreaking. His self-portraits are among the most compelling—and tortured—ever made by any artist in any medium.

Yet, one hundred years later, the work is fresh and bold, and presents a vibrant view of the world. A large show of his work turns a blockbuster exhibition that can run lines around a museum in any country in the world. His paintings sell for tens of millions of dollars. We'll return to his work later as an exercise in "seeing."

That there is no one way of seeing is another double-edged sword. It gives you great latitude in your choice of how to express yourself, but it also gives your audience the right to see it another way—and have no interest in your work.

3. No one type of success is better than any other.

What'll it be: Make art, make money, change the world? Be a bohemian? Get laid? Become famous? All of the above?

I've already set out the only basic definition of success—to be able to make photographs that please you and communicate in a positive way to your audience. Beyond that, I think it's up to you, although there are certainly some issues that are hard to ignore.

I've already touched on the rampant celebrity worship we're facing in our society, and I think one of the most pernicious parts of it all is the degree to which the values of celebrity, beautiful people, and material comfort have come to the fore.

Success should be open to personal definition, and there should be a way to celebrate our triumphs without the twisted yardsticks that abound. So many times I've heard people speak of relatives in the hospital and express thanks that they're in a "good room, not in some ward." Well, there are lots of people in the wards of hospitals everywhere, some in the halls, and some lying ill in the streets outside the hospitals. There always will be have-nots. We shouldn't have to feel better off than the down-trodden in order to feel good about our state in life.

One example: Occasionally, as will happen on the streets of Manhattan, one encounters Donald Trump. My most recent sighting was Trump and his second wife heading into a fashion show by a "major" designer during New York's fashion week. He was sporting a bloated face and a tan that looked like it had been dabbed on out of a bottle. Sure Trump's rich, he's self-confident, he's been up and down, he owns a lot of property, and he's built some garish buildings and insists on using his name on each one. Now he's split from wife number two and is seen in the papers with various young female escorts. Most recently, he's announced his intention to get into the business of running a modeling agency. He's a player.

Hey, no one way of being: Let Trump do his thing. But the public's reverence and fascination should be rethought. There's nothing about this guy that has anything to do with my vision of success. He's starting to look like an aging tycoon longing for a vanishing youth and fighting a losing battle with the inevitable.

Fame Versus Success Versus Greatness

There are several points that get crossed when we think of success. There's a confusion between fame, success, and greatness that suggests if you have any one of the three, you possess all three in the eyes of today's media.

The important thing is for you to define success for yourself. Don't rush to follow someone else's path out of envy. It may not provide enough nutrition for you down the line. You have to tap into what you want.

If I volunteer as a photographer for the weekly community paper and I get my photos published but I don't get paid, can I consider myself a success? Sure.

If, as a volunteer photojournalist for the local community paper, I photograph the pain of a minor traffic accident at a corner near the local elementary school, and my photos help prod the local officials to put in the stop light that the community has been seeking for several years, then I'm a big success.

Success Can Be Less

I don't want to dwell on success as being accomplishment driven. Sometimes (and this is for all of us, every single one of us) success is just staying in the game and not giving up. We'll return to this theme fre-

quently throughout this book. Sometimes success is keeping the destructive and negative emotions in check and staying on the playing field.

I don't know much about boxing, but my father used to watch the Saturday night fights on television and I've always enjoyed stories about boxers and their lives. Apparently, one way that referees are supposed to gauge whether to stop a fight when one fighter is taking a beating is to assess if the unfortunate individual knows what's going on.

I recall the story of some champ who was pummeling a little-known opponent. When the referee separated the fighters for a second and inquired of the hapless opponent what was going on, the boxer lucidly explained, "I'm getting the daylights beaten out of me by so-and-so." The ref let the fight continue.

I wish I could tell you that fighter went on to win, but I don't recall. The key point is that he knew what was happening and he was still hanging in there.

4. In photography, there is never a single "right way" of doing things.
If we accept postulates 1, 2, and 3, this should be evident. I concede that there is probably "one right way" to do most procedures in brain surgery and "one right way" to fly a 747 passenger jet through a turbulent storm. But the camera is a tool that lends itself to play and exploration. Even on the business side of photography, I don't think there can be a single right way of conducting your affairs.

I know photographers who use only 35mm cameras at weddings, others who wouldn't dream of doing so. Similarly, some photographers never shoot more than 300 frames of film at a wedding; others shoot 1,000 or more.

Contrast that "take" with Alfred Stieglitz, who is reported to have made 1,500 negatives in his entire life, or Edward Weston, who, according to the estimate of his son Cole, made between 4,000 and 6,000 exposures.

If the customers are happy, does it matter? It matters that the product is good and hopefully the best that you can make it. If it works for you, that should be enough.

Stress What You Do Right

I think there's nothing wrong in promoting your way of doing things and trying to persuade others to follow you. But it should be done by offering a positive demonstration of your methodology. It is harmful to the field and to young photographers for respected veterans to heap scorn and negative comments on other valid approaches, trying to build themselves up by tearing others down.

The problem with this kind of "I'm right and the others are idiots" approach is that the student can't win. Even if the technique being advanced is good, it's entwined with poison that runs through the photographer's entire attitude. Get away from anyone who tells you that his way is the right way and the other ways are for jerks and losers.

"Going negative" seems to be working, at least temporarily, in political advertising. In the arts and in teaching, I think it's not only a bad practice, but an unethical one, in that it takes advantage of students who have placed their trust in you.

Not long ago I reread one of the books on photography written by photographer Andreas Feininger in the 1950s, *The Creative Photographer*. The book has a humorless tone that I find a bit overbearing and dated. But I do agree that people who get seriously hooked on photography almost inevitably end up playing with the business side of it to some degree. You can't really avoid it. If you don't seek people out, they'll come to you.

Not long ago, I stumbled across the work of a nature photographer who has been working for years and who has had lots of his work published, but with whom I was previously completely unfamiliar. (I'm reasonably conversant with photographers of the past and present but I'm astounded at how often I come across someone who is new and exciting to me. There's a very rich lode out there.) This photographer took great pains to point out how much Feininger's *Creative Photographer* had inspired him when he got started.

No one way of being.

Your Motive Doesn't Show

We're going to discuss how to match your interest in photography with your personal traits a little later on. Right now, the main point to bear in mind—if you remember one thing from reading this book—is that the camera doesn't know and the audience doesn't know what motivated you to make the picture.

A beautiful photograph that is widely admired, even if it were taken on a professional basis and the photographer was paid for it, may have been created in a certain way because of the photographer's personal vision or philosophy rather than the specifications of the customer. When it's time to click the shutter, hope for a good image. You can figure out how to put it to the right use later on.

As I've noted already, I think far too big a distinction is made between "commercial art" and "fine art." In some fields, such as painting, the distinctions may be more apparent. The so-called commercial artist who paints billboards, murals over bars, or even the sides of houses, may be quite different than the fine artist who goes out with canvas and oils and paints beautiful scenes for exhibit in galleries and museums or portraits commissioned by patrons.

There was a time in colonial America when the painter painted both signs and portraits. When the country was new and artisans with any painting skill were few and far between, "limners" or sign painters, would also accept portrait commissions as they traveled from town to town.

Photography, for the most part, is still that way. Perhaps the basic distinction between fine-art photography and commercial photography

should not turn on whether or not you are being paid for taking a specific photograph, but rather whether you are selecting the subject and mood of that photograph at another person's direction or not.

If I shoot a still life using antique items because I find them beautiful and interesting, and wish to see if I can structure the objects in a physical arrangement that is pleasing to the eye and light that scene in a way that enhances its beauty, I may take exactly the same steps that I would take if I were given those very same objects by a client who owns an antique store and wants a photograph of them to run in a magazine advertisement.

Photography that might be supplied to a stock photography agency gives a clear example of how hard it is to draw the line between fine-art photography and commercial work.

If you are unfamiliar with stock agencies, these are businesses that market images, supplied to them by photographers with whom they have a working arrangement, to clients who are seeking a particular type of image for a given purpose.

If I specialize in nature and scenic work, I may have hundreds of beautiful landscapes that I've shot purely for my own pleasure, but one day I can still decide to place them with a stock agency that may be very successful at selling them. Another photographer might have photographed those same or similar landscapes without any joy in creating those images but merely with the desire to place them with a stock house for the resulting sales. As I noted before, the camera doesn't know, and the viewer probably can't tell, what the true motivation of the photographer was for any given image.

Don't get hung up on the distinction between photography for pay and photography for pleasure. Try to make sure that the photography you do gives you pleasure. If you are paid for it, particularly if you need to be paid for it, so much the better.

Staten Island Ferry Terminal, Manhattan, 1976.

Chapter 4: Sixteen Questions—The Often-Avoided Self-Examination

It's time to undertake one of the most difficult parts of this book—an attempt to narrow down the way that you are, a sense of your "way of being." This exercise is not intended to limit you or peg you but, rather, to give you a sense of location. And with that knowledge, you will have a better chance to decide whether to stay put where you are or whether to change. And if you attempt the latter, you will have an idea of which direction to head.

I call this self-examination "often avoided" because a lot of people, including photographers, go through life without asking themselves these questions. For certain professions, perhaps this sort of self-study isn't as necessary as I feel it is for photographers.

It's also a chance to find out if fear or other negative emotions are hobbling you, and if they are, what to do about that.

Also, based on your examination of your skills and interests, you may find that directions that lay before you are either confirmed or modified. New doors may open from connections you haven't made before.

A word before we get started. The answers to these questions aren't for big brother, they're just for you.

That's because the real focus of this examination is you. You as a photographer. You as a human being. You as a citizen of your community. You with something to say that might endure beyond your own time. You with a camera in your hand. You and your emotions. If you think it would be helpful, then I suggest you jot down written answers to each question. If you don't like that kind of exercise, just reflect on each question in your head. I've included my own answers to these questions, just as an example.

Before we start with the real list, here's a warm-up question:

How Did You Discover Photography?

My own experiences began with snapshots and an affection for the power of my Brownie Hawkeye. I was the family photographer. Then school and my limited allowance intervened. Plus, for a while I wanted to be a chemist, then I wanted to be a writer. Later on, I decided to become an art historian, but I *knew* that I really wanted to be a photographer. I later used parts of everything I learned in pursuit of all those other possible careers in the areas I've explored in photography.

In my last years of college, while hitchhiking cross country, I bought an old, roll film camera in a pawnshop in Spokane, Washington. I've never been without a camera since.

Alan Dumoff, a friend and NYI graduate who is a photographer with interests as varied as fire and evidence photography and big cats, once told me his father gave him a camera and told him his photo album would be his "Scrapbook of the World." Sounds like a great dad.

You did so well with that warm up, here's Warm-up Question Number Two:

Who Are You?

It wasn't long ago that I really came to terms with the haphazard nature of who I am—who anyone is. Despite the efforts of philosophers and psychologists to help college students get a handle on these things, until I hit midlife I certainly felt that there was a "little Chuck" inside me somewhere, like the operator of a large crane, who was controlling things. "Little Chuck" liked bananas and baths, he didn't like opera or the sight of blood or anyone getting an injection.

I'm not talking about a soul or a spirit, but just some ill-defined, poorly thought-out notion that there was some sort of controlling little "me" inside me.

Now to admit that my body and the person that I think of as "me"— my tastes, talents, fears, wishes, thoughts, and memories—is principally governed by three or four pounds of gloppy tissue with a lot of nerve ends and a bunch of low-voltage circuitry is kind of scary. Isn't there more to me than that?

Those of us with strong religious leanings (no one way of being) may argue that there is a lot more than that, that we humans have an immor-

tal soul. But those of us without such articles of faith are faced with accepting this as all there is.

In fact, sometimes I think of humans not as a "higher" life form that is superior to the other animals, but as a very challenged life form fettered with all kinds of hang-ups, projections, and paranoia that would make members of most species crazy. Do chipmunks fret about their looks? Do black bears have esteem issues? I don't think so. Chipmunks, for example, have it better than us in many ways. They enjoy a much simpler emotional life pegged to real-life issues: gathering nuts in the fall, hibernating in winter, eating shoots in the spring and berries in the summer, having sex for procreation, and no danger of running out of money in old age. No worry about Social Security going bust. Sounds pretty good to me, other than the absence of photography and red wine.

Now, however old you currently are, whatever your experiences, you are physically a body with a few pounds of brain that, depending on your emotional makeup, is more or less in control of the system. What are the pluses and minuses? To repeat the question: Who Are You?

This brings us to the "real" set of questions.

I can't talk definitively about you, here. I can only present the questions I suggest that you ponder, and I present a little of my own inventory, my own sense of me, and encourage you to develop a picture for yourself along the same lines. Let's start with a few externals:

1. What things interest you that you know a lot about?
A bit of my list: photography, prisons, politics and organizing, psychology, art history.

2. What things interest you that you know a little about?
A bit of my list: parenting, chemistry, cats, food, wine, the pleasures of money, gardening, writing, antiques, auctions.

3. What are the things that don't interest you and you don't care about?
A bit of my list: professional sports, television dramas, soap operas, sitcoms, cigars, downhill skiing.

It's time for you to get started making your own lists. What you'll find about this external stuff is that most objects, activities, and bodies of knowledge don't appear on any of your lists. That means there are some areas where you have an interest and a body of knowledge that might be interesting to try to couple with your interest in photography if you haven't already done so. There are also some areas of your interests that you haven't been able to develop as much as you might like. That's probably a list that you should actively try to couple with your photography.

The list of stuff that you don't like and find boring to hear people talk about might have a few entries that would be good for a "hit list" assignment.

Let me give an example. Today's cigar bars and the denizens who will do anything to be trendy are probably worth a photo study. I think there will always be a few cigar smokers, but I think a lot of the people currently enamored of this trend look ridiculous and don't really enjoy what they're doing. A possible photo subject.

The work of photographer Larry Fink comes to mind. He's done lots of photographs of people at society parties, yet he obviously has a rather jaundiced view of his subjects. He doesn't manipulate the subjects to ridicule them, but his work seems to let them make fools of themselves. Some of the portraits of the renowned photographer and teacher Lisette Model also give the subjects enough rope to hang themselves.

What about everything else?

The vast majority of things that don't appear on any of these three lists are probably not prime subject matter for you. But things that interest you, or actively antagonize you, generally make good subject matter. In the fields where you have an active interest, you're also likely to have some contacts that might make it easy to get some assignments.

Now, let's address a few internal issues.

4. What are the little things that aggravate you out of all proportion? What are your hot buttons?

A bit of my list: people who cut in line, drivers who cut in line, people who litter, people who work for companies that can't deliver the level of service promised, people who are know-it-alls, people who interrupt, people who are loud . . . I'd better stop here. But it's clear: Selfish people aggravate me.

I think in making your list, the specifics probably aren't as important as the number of items and the acuteness of the feelings. If your list is less than fifty or so things, and they just aggravate you, then it's probably not a big deal. But if there are hundreds of things that aggravate you, and if you go over the top when you get upset, then you'd better recalibrate your meter.

For example, if you go ballistic when you get stuck in traffic, that's worth examining; it may show a problem. It's bad for your health to get too angry about things over which you have no control. Sure, there are times when a traffic jam is really inconvenient, and times when you blunder into a jam when you should have known enough to avoid it, but if you find yourself enraged at little things like this when they are outside your control, an adjustment is required.

I'm not advocating banishing anger from your life, I'm just suggesting that you learn how to harness it and how to realize when there's too much of it or when it's coming up for the wrong reasons. There is certainly legitimate anger, and there are times when it's therapeutic to tee off on someone even if the circumstances don't warrant it.

October 1991: My companion and I return to a hotel room to discover that while we were out to dinner a precious item of hers was stolen. She's very upset and angry, and we're in a country where petty thievery is common. I take time off from consoling her to explore the room. The only change I can see is that the minibar has been restocked. A call to the front desk and a word with the manager leads me to suggest to him that if the stolen object is returned by the next morning, the police and the press will not be called. Indeed, the object is returned the next morning with the manager's apology.

To modify the saying of the Kennedy brothers, "Don't get angry, get even," I've felt here the key was "Don't get angry, get it back." There's always time to be angry or to react. Don't lose the ability to think and observe.

5. What are the things that you can't even think about, that scare you, or that you fear you can't handle?

A bit of my list: blood and guts; dying; the thought of surgery; the thought of anesthesia; losing a child, a family member, or a beloved pet. I've never taken a medical photography job, and I doubt I ever will. I once passed on covering the funeral of a jazz great because I was told there was an open casket. Not the job for me.

6. What is your opinion of yourself?

The danger here is in the extremes. I think it's best if you feel OK about yourself most of the time, and there may be moments when you feel elated and a few when you feel way down. However, a steady succession of highs and lows can be dangerous.

Similarly, if you feel really great about yourself all the time, you're probably out of touch. And if you feel awful most of the time, you're headed for depression.

When the courtiers Rosencrantz and Guildenstern drop in on Hamlet, in answer to Hamlet's query about how they are, the response is as follows:

Rosencrantz:	As the indifferent children of the earth.
Guildenstern:	Happy in that we are not over-happy. On Fortune's cap we are not the very button.
Hamlet:	Nor the soles of her shoe?
Rosencrantz:	Neither, my lord.

Hamlet goes on to turn this into a smutty joke linking fortune's waist with "the middle of her favors."

It's one of my favorite scenes in the play. Suffice it to say, in matters of self-esteem, I think that's the place to be.

A Professional View

A friend of mine, psychologist and therapist Brian Sweeney, has recently advocated a simple measuring system to replace the complicated structure of the *Diagnostic and Statistical Manual IV* that mental health professionals use to classify mental conditions. Rather than complicated diagnoses, he prefers assessing a person's well-being based on three simple criteria: the breadth of things that may unhinge a person; how far someone is thrown off balance once upset; and, once enraged, how readily the individual bounces back.[1]

What kinds of things get to you? How strongly do you react? How quickly do you recover?

7. How do you think you appear to others?

This is an important question. I think a lot of people, including photographers, are off base in their assessment of how the world views them. I once heard a radio news account of an interesting experiment. Psychologists at a university asked their student test subjects to wear a very degrading item of clothing, namely a Barry Manilow Fan Club T-shirt (I swear I am not making this up!) and to keep a journal recording how the people they encountered treated them.

Student after student recorded that the people with whom they had interacted had looked at them oddly, that they felt self-conscious wearing the T-shirt, and that it made other people look down on them.

The researchers then tracked down the students with whom their subjects had interacted. When questioned if there was anything odd about their conversation with the subject, they said there was not. When asked what the subject was wearing, most of the time they couldn't recall.

The Barry Manilow T-shirt hadn't even registered with most of the people who spoke with the subjects who were wearing it! The subjects reported feeling awful and felt that wearing the shirt had an effect on the way people regarded them, but the people said it hadn't.

As I write this, I have a pimple on the very tip of my nose. Dead center. No one notices it as much as I think they do, and while I can fret as to why I have such a youthful complexion at such a ripe age, it really doesn't matter as much as I think it does.

There's a tremendous emphasis on bodily appearance in our society at this time. Some time back, I read an article in the *Wall Street Journal* about new trends in plastic surgery, including surgical enlargement of the penis. What was interesting to me was that many of the "beneficiaries" of this surgery (the epicenter of which, at least at the time the article was written, was Los Angeles, specifically Hollywood) reported the greatest satisfaction came not in showing or using that enlarged organ but, rather, in walking into business meetings and social situations just knowing what was in their underwear. I swear I'm not making this up either.

Most people are far more caught up in their own lives than they are in yours. We all have a fear of looking foolish, but most of the time, folks aren't paying attention to us, so we can probably get away with more than we think and go a bit easier on ourselves. As Monte Zucker observes, "In a group photo, the first person you look at is yourself, and if you look good, you like the photograph."

It's important that you feel good about what you do as well. I once telephoned a student who had sent in a great studio photo, creative in its design and technically excellent in its execution. I asked him for a little information about himself and his first comment to me was in the form of an apology, "I'm only a blue-collar worker." Later in our conversation I admonished him for the "only." Someone, either he or a family member, was telling him to feel bad about being a blue-collar worker. Or maybe he thought I would look down on him. There's a Paul Klee drawing roughly titled *Two men bowing to each other, each believing the other to be of higher station*. You get the idea from the title alone, but if you ever get the chance to track down a reproduction of it, do so.

Remember that the esteem issues have nothing to do with your present status. There's that big photographer who still worries about proving himself to his peers. The esteem issues that bother you will not go away unless you work on them.

8. How do you view others?

Here's another place where it's easy to be off base. Even though we're photographers, and even though we frequently train our deft recording device, our camera, on other people, we may not see people as clearly as our camera does. That's because there's a real danger of projecting things onto people that just aren't there.

Here's an example of how off base I can be. I had a membership at a health club located in a hotel near NYI. I often saw a handsome fellow swimming there. He seemed to know everyone and he radiated a sense of self-confidence and high self-esteem. I heard him speaking one time in a foreign language that sounded Nordic. He was obviously very outgoing and comfortable in these surroundings. Since the school is near the United Nations and I like to play deduction games, I finally decided that this fellow was a diplomat from one of the Scandinavian countries, probably from a well-to-do family.

Imagine my surprise one day when I went for a swim and found my "diplomat" standing outside the front of the hotel in a uniform. Of course he knew everybody; he was the hotel doorman!

I know a very good photographer who is one of the toughest business people I've ever met. Negotiating with him to shoot a job is a job in itself. He's vigilant (as all photographers should be) in making sure his work is only used by clients in accordance with the terms of their agreement.

When someone uses a photo of his in an unauthorized way, he's all over them, in their face, up front and personal, and very, very angry.

Even if a compromise is reached, or even if the usage was a mistake, this guy is so hard-nosed with the world that everyone I've ever met says: "So-and-so, I know him. He's a great photographer. I used him once. I would never hire him again."

The world of photography buyers has its share of thieves and chiselers. Every business does. But to go at everybody as if they're going to screw you, or as if they have screwed you, is symptomatic of not having a clear view of the world.

This photographer isn't seeing clearly; he's projecting some sort of anger and mistrust on everyone with whom he comes into contact.

That brings us to a simple question that you may never have considered:

9. How does your mind work?

Remember, it's not you, it's just a bunch of tissue glop, but the way you are in the world has a lot to do with how your mind approaches things. For example, having spent a good deal of time examining my head, I've learned that I have limited powers of concentration, tend to think about things superficially, and have a keen eye for detail. None of these characteristics are bad in themselves, and I've learned that I'm very good in situations where there's a lot of juggling involved.

I like having a lot of freelance things going on simultaneously. I enjoy the workday at NYI precisely because there are lots of interruptions and various themes unfolding at the same time. Someone else might find that combination life threatening, but for me, it's life enhancing. No one way of being.

I also have a strong aversion to looking foolish, and a tendency to play with things in my mind rather than make rapid decisions.

Are any of these things inherently good or bad? I don't think so, it's just the way I am. No one way of being.

As we'll discuss in the chapter on training, there are different ways of learning. Some people "get it" best reading a printed lesson, others need to see something done and will do much better learning from a video, CD, or Internet presentation. Some need to have the instructions read to them. There's no one way. Surprising?

10. What skills do you have? Which do you lack?

The goal here is to make an honest list. Some skills are innate, others acquired. For example, my eye for detail isn't something I can control. It's acute, all the time. Just walking down the street, I can't even turn it off. I see a Band-Aid on an arm that signals a recent blood test, notice a little scar on a knee that's had arthroscopic surgery, and spot the hair on the back of a cat owner's coat, and I always notice car license plates from

Virginia because Virginia plates are the only U.S. plates with serif type that I've ever seen.

I think a lot of photographers have this knack for spotting details, and it helps when you try to visualize what to add or take away from a set.

Similarly, I have a good rapport with animals, and like to collect things. This is particularly helpful for commercial and advertising photography, because you never know what gizmo or prop you may need to fashion.

What Other Skills?

Your skills might include the ability to write, or make music. I know many skills elude me—I can't sing, can't play an instrument, and have a devil of a time learning any language other than English. I'm not terribly strong and not terribly graceful, but I can get up in front of a large audience and talk on a number of topics without notes and without fear. Take your own inventory. There's no right combination, but the more you think about where your talents lie (and where they don't) the more likely you are to find the right path for you in photography.

11. *What would you like to do that you haven't done, and what do you do that you would like to do more of?*

The point of this list should be evident. Photography can be your passport to spending time among musicians and celebrities, or to travel. On the other hand, you might want to spend more time by yourself composing studio advertising images.

12. *What do you have to do now that you would like to be free from doing in the future?*

There's no reason not to let your camera take you in the directions suggested by your answer to questions 11 and 12. As I've noted, I like having assignments, travel, and adventure. For you it might be other things—money and fame, or the adulation of your friends, or a permanent display of your best photographs in your home.

Not long ago, I spoke with an NYI student, a veterinarian who didn't like animals. His goal was to become a stock photographer specializing in scenic work. A few weeks later, I heard from a doctor who wanted out of medicine and sought to become a film unit still photographer. They wanted photography to lead each of them away from something.

On the flip side, we have a graduate who is a very successful animal photographer. She confided in me that she was discouraged from becoming a vet by the administrators of her state university's veterinary program because she was a woman. She decided photography would bring her close to both well animals and sick ones. She not only does great portraits of all kinds of animals, but also photographs operations and other medical procedures for veterinary publications.

13. What was your best moment or assignment so far?

My answers to the few remaining questions could take up a lot of space, so I'll try to keep them short. I think my trip to the Philippines still stands out as one of the most exciting jobs I ever had, although a month-long assignment in Japan runs a close second. One of my best assignments was a job where I wasn't allowed to photograph. The musicians' union had sent me to cover the funeral of recording giant John Hammond. It turned out that the family asked that no photographs be taken, but I stayed for the funeral. Among the many musicians who spoke or performed was one Hammond had discovered—Bruce Springsteen—who sang Bob Dylan's "Forever Young," accompanying himself on acoustic guitar and harmonica. And I was being paid to attend!

14. What was your worst moment or assignment so far, and what was the really bad part for you?

May 1968: The student uprising at Columbia University is in full swing. Students occupy five academic buildings, cops ring the campus, and a still little-known West-coast band, The Grateful Dead, has turned up on campus to play at a rally. Running toward the concert with a borrowed Pentax Spotmatic with a 135mm Super Takumar lens mounted, I trip and damage the lens.

The awkwardness was the worst part. Paying back the person from whom I'd borrowed the gear was much less painful. The scrapes on me didn't matter at all.

15. List the five favorite photos you've taken to date.

My list changes frequently. Right now, it includes a self-portrait taken twenty-five years ago, a portrait of jazz trombonist Benny Powell playing in a club about five years ago, a portrait of my father taken just before his death, a photo of my daughter with a bag on her head taken last year, a recent photograph of my wife, and a formal portrait of my cat. Wait a minute—that's six! That's OK.

We've already discussed that there's no one way of seeing. Just recently, I had the pleasure of attending a talk by the eminent portrait photographer Arnold Newman, who discussed his long career in photography and showed some of his favorite work. Interspersed with portraits of the world's greatest leaders and celebrities were pictures of his grandchildren. Of one photo, he remarked to the audience, "This is one of my wife's favorite pictures, so I don't care whether or not you like it. She does."

It should be much the same with your list of your favorite photographs. They don't have to be the ones your clients love, or the ones your family praises. They should be the ones that matter most to you.

ADDING IT UP

I've posed questions to you in a number of categories. I'm sure a professional psychologist would break all of this down differently, but I think

that if you make these lists and possibly ask a few of your close friends whether there is anything you should add or subtract, you can start to reach a few conclusions about where you're at and where you might like to go.

One psychologist, Abraham Maslow, advanced a theory of different levels of human needs. According to Maslow, human needs form a pyramid, and only when the issues at the lower levels are addressed can an individual move upward to grapple with other, higher issues. Like lots of theories in psychology, it has some weak spots, but it's a good simple paradigm.

First come the physiological needs (hunger and thirst) that must be met. Then we move on to safety needs, then to the need for a sense of belonging and love, then on to esteem needs, and finally—at the top—those who get there can grapple with self-actualization, including creativity and the arts.

But what if you do need to work on changing a few things? Suppose you do get too angry too often? Or what if you are prone to periods of depression? My advice is to get some help. Start by talking with someone, a friend or a family member or a professional. It has been my experience that talk therapy is very helpful, and I don't regard it as "medicine" for someone who is "sick," but rather as "fertilizer" for people who wish to grow.

So part of making the most of your lifetime in photography requires making some lists and seeking a little insight. This will be an aid, and you may well decide that there's no adjustment work to be done, but that you merely need to do a little planning on how to put the pieces together so that photography fits into your interests, helps you do the things you want to do, and helps you get away from the things you would rather not do.

Patience Isn't a Virtue, It's a Necessity

It's also true that in our teens and twenties, it's hard to see that there is an inevitable succession. My mother used to tell me, "Your day will come." She was right; it has. But I wanted to know *when* it would come, and *how* I would know when it did. She said she couldn't tell me, for she didn't know, but when it did, I would know it. She was right.

It took a while. But things change, and options become available if you're feeling good enough to be able to see them when they do. The greats move on, jobs open up, possibilities that no one contemplated bloom before our eyes. There is an inexorable progression of generations, and a succession of career openings. But you have to have your head out of the muck to see what's happening. If you're too lost in your own misery, it's probably of your own making, and you may not even recognize your time when it comes. It also requires a little patience.

In closing this chapter, I realize that there's one very important question that I haven't asked.

16. *How important are people to you? Is having a mate important to you? A family?*

Cheeky question, I admit, but a very important one. There are fields of photography—photojournalism comes to mind first—that are very tough on interpersonal relationships. I'm not referring solely to the international photo corps that spends its time at sites of war and disaster. Consider, too, the photographers who work for small and midsized newspapers who may get stuck at a court trial awaiting a verdict, a hostage situation, or a disaster assignment with no prior notice. They suffer from the stress even more than their internationally renowned counterparts. The phone will ring in the middle of the night, most often on the night that the baby is sick and going to work means all the responsibility falls on your spouse. It can be very tough.

In a cover story on Sabastiao Salgado that ran in the Sunday *New York Times Magazine* in 1991, when the world was discovering Salgado's work, it was reported that he spends about eight months of the year on the road, despite having a wife and two children in Paris.[2] In the eighteen years prior to the profile, he had worked on assignments in more than sixty countries. His wife, who trained and worked as an architect, now tends to the children and organizes books and projects related to Salgado's work.

Clearly, here's a family that has had to make a lot of accommodations to allow Salgado the freedom and time to pursue his vision. That wouldn't work for lots of photographers or for lots of families.

There are some areas of work where you'd better really like people. I know wedding photographers that don't like the people they photograph, and sometimes it shows. On the other hand, I know wedding photographers who have been working in the field thirty years or more who are still brought to tears at many a ceremony.

Is your idea of a vacation leaving the family at home and taking a serious trek to a great nature photography spot? Is that your family's idea of what your vacation should be like?

Photographers inherently separate themselves from the events they photograph by putting a lens between themselves and the world as it happens. The advertising photographer can (for the most part) put in a demanding day at the studio and then enjoy family and social relations in the evening and on weekends. On the other hand, the wedding photographer will work many, many weekends out of the year and take days off during the week, out of sync with family and neighbors.

In many ways, the wedding photographers who form the bulk of the members of Wedding and Portrait Photographers International (WPPI), and a large part of the Professional Photographers of America (PPA) have strong reasons to be active members of a professional organization. They don't have normal hours and often work weekends when the other families in the neighborhood enjoy recreation. I'll discuss WPPI and PPA at greater length in appendix I.

For me, family and vacation time without a camera around my neck has become increasingly important. I am not prepared to miss too much family time in pursuit of photographs.

WHAT DOES IT MEAN?

If you've read this chapter with the expectation of a conclusive wrap-up, I have to break the news to you that there isn't one. There really cannot be. Rather, you have to take away those insights that you've gained by examining your answers to the questions I've posed. There are too many different implications and conclusions for me to attempt to encapsulate them in any way.

The goal is for you to learn about you, so that you can get the most out of your lifetime in photography.

NOTES

1. Brian J. Sweeney, Ph.D. "An Alternative System: The Demise of the D.S.M." *The Independent Practitioner*, Bulletin of the Division of Independent Practice, Division 42, American Psychological Association, Summer 1999, Volume 19, Number 3, pp. 162–163.

2. Matthew Wald. "The Eye of the Photojournalist." *New York Times Sunday Magazine*, June 9, 1991.

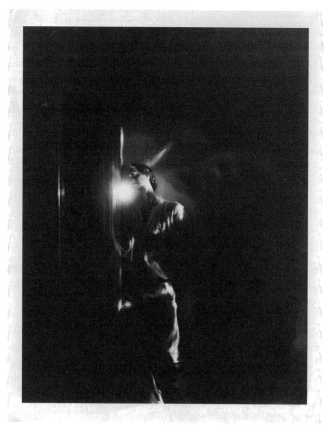

Self-portrait, 1975.

Chapter 5: What Does It Take to Be a Photographer?

"My camera could easily have a love affair with you . . . Would you like to have dinner with me? I don't mean right away . . . how about tomorrow?"
—A FICTIONAL PHOTOGRAPHER[1]

"If I had not loved my work more than sex—would I not have commercialized my business and afforded half-a-dozen mistresses and a wine cellar?"
—EDWARD WESTON, IN A LETTER TO HIS FAMILY, SEPTEMBER 1, 1923, SHORTLY AFTER HE LEFT HIS FIRST WIFE AND FOUR CHILDREN AND MOVED TO MEXICO WITH ARTIST TINA MODOTTI[2]

There's no escaping it. Before we can move on to your options in the real world of photography, we have to start with an examination of the image of the photographer in popular culture.

This image has been shaped by two kinds of photographers, real ones and fictional characters designed to captivate the public. I've decided that the two contribute roughly equally to the mix.

How many common traits can we ascribe to photographers? After all, if there's no one way of being, how can there be one way that all photographers are? There isn't *a single way*, but because of the tradition that has come before us, we can sketch in some general aspects of photographers' lives, and the public's perception of who we are and what we do.

Let's start with an exercise. You meet someone and tell him you're a photographer. His response is: "Oh. You're a photographer." Is it said with an "aha" tone? A withering tone? A seductive tone?

See how many ways you can say that line of dialogue. Imagine yourself in a series of movie scenes. Imagine that you're not a photographer, and you're saying this line to a person who is. Imagine yourself saying it to a photographer of the opposite sex. Imagine yourself as a member of the opposite sex saying it to a photographer of either gender. Imagine that you are a photographer who has just met another photographer.

I don't know about you, but I can inflect that line about a dozen different ways without even reaching for a prop. Now let's try one other line: "You want to be a photographer?"

Imagine that line being said by one or more members of your family after you tell them of your career choice. Is there a tone of encouragement, disappointment, or incredulity? These exercises come down to one central issue. What do the people around you think about your being a photographer? How much do they know about photographers, and how much do they know about you?

January 1990: I've come out to California to present first prize—a Hasselblad—to the winner of NYI's Worldwide Photo Contest to commemorate the 150th anniversary of Daguerre's "invention" of photography. The young man, named Joseph, who won the prize, had left his native Vietnam shoved aboard a boat a decade before. He has just changed his college major to fashion photography from pre-medicine. It has been hard going for him at home. "Chuck, you may not know this, but Asian parents want their children to be doctors and lawyers, not photographers," Joseph earnestly explains.

I was more interested in Joseph's story than in telling him how many times I had heard variations on the theme of children being discouraged from entering photography (and other creative art forms as well) by their parents.

But heard it I have. Over and over again. Why is it that so many people will express their dislike of doctors and lawyers, yet want their child to go into one of those professions? I think it's partly the money, partly the prestige, and partly the guarantee of work no matter what on earth happens in the future.

It's true that careers in any art form—including photography—are competitive, not a guarantee of steady employment or a pension, and not necessarily the path to a high income.

However, the real tragedy of this sort of parental advice (and a lot of professional career counseling), is that very talented people are steered away from having a chance to find out what they could do in their field of choice if they had a few years to pursue it intensively.

Don't let that happen to you. If you want to try for a career in photography, be reasonable, listen to your family and friends, but if you decide to go for it, find a supportive environment, outside the home if necessary.

Not long ago, I was sent some spectacular photos of a serious airline accident where the plane had skidded off the runway and struck a series of buildings. The student called a week later to tell me he had sold his photos to a major tabloid. Many people don't know it, but it is very hard to get photos of an airline accident of any sort, anywhere. The Federal Aviation Administration (FAA) takes quick control of the area and even photographers with police press passes find themselves shut out of the crash site for hours or days while the investigation is conducted.

We'll leave the wisdom of this FAA policy for discussion at another time. Talking to the student, I wanted to know how he had obtained these photos. "I work for an airline," he explained. I asked if he always carried a camera. "No," was the answer. "In fact, I was at home having dinner when I heard the radio news about the accident and I grabbed my camera and went back to the airport."

The student then digressed to tell me that since he enrolled in the NYI photography course, his wife had been critical of his efforts to improve his photography. He wasn't disciplined enough for a home study course, he was told. He would waste money, and he was too lazy to apply himself seriously to photography.

When the breaking news came over the radio while he and his wife were having dinner, he told me that he politely excused himself to his wife and son.

"Where are you going?" she asked.

"To do what you said I was too lazy to do," he replied.

I've heard dozens of stories of jealous, controlling spouses who felt threatened when their partner enrolled in our career photo course. The story above is atypical in that most often the student is a woman and the negative partner a man.

But, if you really believe that some type of photography is what you want to do, you have to do what the student did and politely excuse yourself from an environment that does not support your efforts and allow yourself to give photography a try. You can always turn to a different direction later if things don't work out.

What is it that propels us down the path to photography? It all starts,

always, with the camera. Everything else may differ, but there's always a camera.

THE CAMERA IS AT THE CORE

Everyone who is a photographer must master some degree of proficiency with the camera. Most of us are comfortable with cameras, many of us love using one, while a few of us are just able to overcome the anxiety enough to get some photos down on film before recoiling. But if you want to call yourself a photographer, you must use a camera. If you don't deal with the camera, if you're a darkroom magician or a Photoshop virtuoso, you may be an artist, you may be very talented, you may be a great collaborator, but, to me, you're not a photographer.

To find common traits and character styles for photographers I've used five approaches in my research:

1. Self-examination of the type we covered in the last chapter
2. Talking with lots of photographers
3. Talking with lots and lots of photography students
4. Studying the careers of real photographers, trying to read their writing, and pulling press clips and obituaries about them
5. Collecting as much material as I can about the imaginary photographers created in fiction and popular entertainment

I should add that this is a very sloppy process. My office is covered with mounds of clips and notes and letters and such. For the past five years, I've been stockpiling this information. Patterns about photographers have emerged.

I also try, usually with only limited success, to read formal criticism of photography, but, as I've confessed, my powers of concentration are limited. Moreover, a lot of the written criticism is hard to read, and some of it is utter hogwash.

For a long time, in planning this book, I had real and fictional photographers in two separate chapters, but as I continued my research, I found the two streams of information merged. There was so much in common that I decided we all belong together—fact or fiction, there's only one photographic tradition.

PHOTOGRAPHERS: REAL OR IMAGINARY?

Let me just quickly demonstrate that with a pop quiz. I give a brief description of a photographer. It's your job to decide if this a thumbnail bio of a real photographer or a fictional one. For extra credit, name the photographer.

1. Grizzled veteran news photographer loses job on big city daily in union strife, then gets a photo exclusive of a mass shooting on a bridge. The veteran takes half a roll, stops, rushes to his old paper

and instead of selling the shots for big money, says they can have them free if he can have his old job back.

2. Portrait and fine-art photographer leaves wife and four kids to join his mistress and make photos in another country. In later years, wife sends him money, son rationalizes that his mother "knew that Dad was a great man, and she let him have his freedom."

3. Top New York–based rock photojournalist works for *Vanity Fair* and *Rolling Stone*, among other clients. Steeped in the life of sex, drugs, and rock and roll, amid the concerts, parties, and intimate relationships with the world's top stars, she fears someone is trying to kill her, leading her into a love affair with a detective.

4. Nearsighted photographer, well known in the field, uses assistants to fine-tune his subjects' poses. Runs lavish studios in New York and Washington, D.C.

5. College graduate starts as a freelancer in Cleveland and soon lands staff job with major publisher. In her mid-twenties, she takes the cover photo for the first issue of *Life*. Becomes first woman photographer attached to the armed forces.

6. Young photographer wins Pulitzer Prize for Spot News Photography covering famine in the Sudan. A few months later, he becomes deeply despondent and commits suicide.

7. Photographer with major fine-art career takes up with a man twenty years younger than she and relapses into a heroin habit. Photos of the affair and her drug involvement dominate her next major gallery show.

8. Photographer gets magazine assignment to photograph a young painter, who becomes a regular subject. The photographs bring notoriety to the painter's work, then the two have a bitter falling-out and the painter takes to drinking and dies in a car crash six years later. Many of the painter's friends feel the photographer's images doomed the painter.

9. *National Geographic* photographer takes assignment to photograph bridges for major magazine. Drives pickup truck to Iowa, meets a farmer's wife, has an affair and returns home.

10. Self-taught fashion photographer and college dropout works for major fashion magazines and also designs sets and costumes for ballets and theatrical productions. Wins three Academy Awards, is knighted, and designs hotel lobbies and clubs in his spare time.

11. Penniless immigrant makes a fortune in the 1920s selling picture postcards, takes up aviation and flies his own plane across the Atlantic, and gets knighted by the King of Denmark.

12. German-born photographer abandons professional tennis career in favor of photography. Her work, considered "painterly" sells in galleries and she also works for magazines, moving from New York to Woodstock.

Answers:

1. Real. New York news photographer Lou Liotta, who was rehired by the *New York Post* after that incident.
2. Real. Edward Weston.
3. Imaginary. Catherine Saint, heroine of *Shameless*, a novel by Judy Collins.
4. Real. Mathew Brady.
5. Real. Margaret Bourke-White.
6. Real. Kevin Carter. He won the 1994 Pulitzer Prize for spot news photography for a picture first published in the *New York Times* of a starving Sudanese girl who collapsed on her way to a feeding center while a vulture waited nearby. He told friends that, after making the prize-winning picture, he "sat under a tree and cried and chain-smoked. I couldn't distance myself from the horror of what I saw." After visiting New York City to receive his award, Carter returned to his native South Africa. Shortly after his return, he ran a hose from the exhaust pipe of his pickup truck into the cab and killed himself with carbon monoxide. His suicide note bemoaned his lack of money and the demons he could not escape: "I am haunted by the vivid memories of killings & corpses & angers & pain . . . of starving or wounded children, of trigger-happy madmen."[3]
7. Real. Nan Goldin.
8. Real. Hans Namuth. The painter was Jackson Pollock.
9. Imaginary. Robert Kincaid, from Robert James Waller's bestseller *The Bridges of Madison County*.
10. Real. Sir Cecil Beaton
11. Real. Otto Hillig, the preeminent photographer of the Catskills in the first decades of this century.
12. Real. Lilo Raymond.

There are so many interesting characters in photographic history that I could go on with this game forever. If you have never read a history of photography, I'd like to digress a bit here to strongly suggest that you do so. For years, *The History of Photography: From 1839 to the Present Day* by Beaumont Newhall was the standard text. The late Lee Witkin, who opened the pioneering Witkin Gallery in New York in the 1970s, took a different approach by compiling an alphabetical listing of many of the best-known photographers with information about each in *The Photograph Collector's Guide*, written with Barbara London. If historical linkages don't interest you, you can meet the same photographers in a more haphazard order in Witkin's volume.

Since Newhall's pioneering work, other authors have also published historical overviews. Among the best known are *A World History of Photography*, by Naomi Rosenblum (1997 Revised Edition, Abbeville Press),

and Helmut Gernsheim's *A Concise History of Photography* (1986, Dover). Gernsheim has also written a number of other historical texts on photography. Visit your card catalog or search one of the online booksellers for additional titles.

In fact, a search of "History of Photography" on one of the online booksellers produces a list of over one hundred books, including some specialized, but intriguing titles such as *Battle Eye: A History of American Combat Photography* by Norman B. Moyes, et. al. (1996); *Bystander: A History of Street Photography* by Colin Westerbeck and Joel Meyerowitz (1994); and, who could resist *To Photograph Darkness: The History of Underground and Flash Photography* by Chris Howes (1990)?

In suggesting that you read one of the historical overviews, I stress that they are based on the known photographers. There are still characters popping up in photography's past and present who have been able to make their photos while staying under the radar of the growing legions of photo critics and historians. As I noted earlier, Atget was little known until he was "discovered" by Berenice Abbott, who raised funds to purchase his life's work. The remarkable train photos of O. Winston Link did not become widely known until years after he made them.

WHAT ARE PHOTOGRAPHERS REALLY LIKE?

I find that real-life photographers tend to be observant, sometimes a bit more withdrawn than other people, and often, like pack rats. After all, we're all forced to save all those negatives, transparencies, and prints. I know lots of studio photographers who also tend to keep bits and pieces of old props and tools at the ready. When you're working on a tabletop photo, you never know exactly what gizmo you're going to need to put the pieces together just so.

Since photographers are always putting a lens between themselves and what's happening in front of the camera, there are probably a lot more photos without them in the picture than photos showing them as part of the group.

Fictional photographers are often portrayed as loners, travelers, and sexually adventurous characters. Sometimes they are poseurs—people using photography as a cover when they are actually spies or criminals or even superheroes. Other times, fictional photographers are seekers of truth. Some of them use a lot of drugs or alcohol.

PHOTOGRAPHERS' ROLES

But, whether we like it or not, when someone remarks, "Oh, you're a photographer?" there is baggage, both good and bad, that comes with that identification—assumptions and preconceived notions that must be addressed.

The trick, I've come to learn, is to make that baggage—the expected roles of photographers—work for you. In lots of circumstances when

you're making photographs, slipping into a role may be an easy way for you to make the necessary contact with your subjects and get the job done. In fact, assuming some of these roles can help you modify the way you relate to others to a modest degree.

ONE HUNDRED CHEFS

Let me give you an example of what I mean by role playing. Not long ago a two-day job fell into my lap at the last minute: a major trade show and tasting event for chefs. The photographer hired for the job had been incapacitated. I was called two days before the event. There was no time to plan or prepare. Day One required taking standardized portraits of about one hundred top New York City chefs. Day Two called for eighty "grip-and-grin" shots (with captions) at a late-night party featuring gourmet food manufacturers who had won awards from the same society that was honoring the chefs. For the hundred chefs, I would be given two hours to do the whole job. For the eighty award-winners, I would have at most an hour and a half. That's a hectic pace, but the money was good and the job sounded interesting.

Grip-and-Grin

Let's take one second for any reader who may not be familiar with the term "grip-and-grin." It's photographer's slang for photos of one person congratulating another person, perhaps a winner or award recipient of some sort. Grip-and-grins come in two basic clichés: Hearty Handshake and Check/Plaque Presentation.

Now running one hundred big-name chefs through a photo studio set up on location in two hours isn't a situation that allows me time to meet each one and get a sense of everyone's true personality, bang off a couple of rolls of film, and then pick one or two of the best from the proofs. Nope, the deal was wham, bam, four frames of film per chef.

Posing on the Fly

That meant all I could do was quickly decide whether to turn each chef to one side, raise or lower the camera a little bit, and then try to make the chef look thin and encourage a smile. I should point out that the chefs were very cooperative and presented very little difficulty. There were a number of American cuisine superstars in the pack, and they were among the nicest.

Still, for me to run important people in and out like cattle, I needed patter, a role. So, I would grab each one by the shoulders, and ease the subject onto a posing stool, all the while telling the chefs how good I was going to make them look, conveying to all that *they* were lucky that the association had hired such an important and gifted portrait photographer as myself to take their picture. I had become the Great Portraitist and felt free to exercise all the authority that came with the title.

Nobody Knows about Photographers

For all the chefs knew, I was a "famous" portrait photographer. I've mentioned earlier that even photographers in different portions of the field often don't know about their colleagues who work on other subjects or in different parts of the country. That means that ninety-nine times out of a hundred, nobody knows who's important and who's not, although this formula breaks down in the fashion world, where knowing who's important is itself of paramount importance. But if you're working, whatever the gig, the chances are that you can pass yourself off as a success. Try it. It's fun.

Who is So-and-So?

Every now and then, someone will come up to you and say something like, "Oh, you're a photographer. Do you know so-and-so? He's a very well-known (some kind of) photographer." I guarantee, you will have never heard of this person. I have found that this is one of those social situations where a little falsification is in order. After all, the person asking you about so-and-so is trying to relate, and since she doesn't know many photographers or much about what we really do, this is her best shot.

I say, "The name sounds familiar, but I don't know him (or her) personally." Then I try to get back to the work at hand.

At this food event, the work at hand was for me to play the role of the (slightly) pushy great portrait photographer.

Now, I'm not a great portraitist, and even in areas of photography where I'm pretty good, I'm not likely to present myself with such bravado and chutzpah in regular situations. But this was war. One hundred chefs in two hours—that's fifty every hour, barely a minute for each. So this situation called for complete control.

I can't even afford to eat often at the places where these chefs cook. But that was no reason for me to be deferential, because that deference would have slowed things down.

So I grab the chef from the Major Hotel, shake her hand and ease her onto the posing stool. As I tell her how lucky she is, blah, blah, I turn her to a pose and start plucking pens and a thermometer out of the breast pocket of her chef's tunic. I may even flick a lock of hair out of her eyes without asking permission: "In fact, they spent so much to hire me that they couldn't afford a hair stylist, so let me just tuck that lock back where it belongs." Flick.

Pop, pop. "Toss your head back and give me a smile like I'm the *Times* food critic." Pop. "Now, chef. Look serious. That's it!" Pop. "Thank you."

"Next."

"Hello, chef, today's your lucky day, tonight you may be lucky in your kitchen, but now you're in my studio and I'm going to make you look great! Sit right here. Turn a little this way."

And so the cycle would repeat, with very little variation and no extra time except for the most difficult facial problems. Pop, pop, pop, pop. "Thank you." "Next."

The brash swaggering confidence isn't me, but I'm comfortable doing it and people are comfortable dealing with a photographer acting that way under such circumstances.

Would I do the same with a bridal portrait or an executive portrait sitting? Maybe. It depends. I've done executive portraits where I'm only given a few minutes because the executive is the Great CEO. In that case, you can be sure he is going to meet the great portraitist.

Another point: Not only do I touch these people's shoulders, arms, hands, head, and chin, but I do it without asking permission or giving advance notice. There simply isn't time. Plus, they're queued up waiting their turn and watching me work, so they should know what to expect. But I wouldn't do that with Mr. Triple Chin, the Great CEO, or a bride, without alerting the subject first.

We'll cover other possible roles in a moment, but one thing should be clear—there are all kinds of roles, but you can only get away with these affectations if you select a role that is appropriate to the job at hand and the people you're dealing with, and you've thought it through sufficiently to pull it off.

Photography Traffic Cop

The second day of the job was the night party. That required getting grip-and-grins at a party while people all around me were eating and drinking in a penthouse hotel suite. The conditions were terrible. I had been required to set up in a room that I was told wouldn't be used for any other purpose. That was true, except that because the entryway into the suite was so jammed with revelers, the serving staff was using the back door from the kitchen and walking right through my set all night. They weren't exactly using it, just passing through.

To make matters worse, the current cigar fad caused the cigar-wielding biggies to select this vacant room—my studio for the night—as the smoking room. Plus, the purveyors weren't as nice as the chefs so, as the wine and liquor flowed, I had my hands full.

At the last minute the client told me he didn't have anyone to assist me, as he had originally stipulated, so I had to find the subjects, pose them, and get their names. I didn't have time to plead, so I just had to grab and pose while dealing with occasional hecklers and a few drunks. It was more like being a combination of a stand-up comic, traffic cop, and bouncer than a portrait photographer. I yelled, I posed, I snatched drinks out of hands and grubbed business cards. I earned my fee that night and was hoarse for two days after.

So I worked a tough two-day job and spent most of my time on two different sets being someone I'm not. For the chefs, I was a braggart and a

"hands-on" photographer who purported to be just as important as they—grab them, photograph them, and forget them. The next night, I was pushing and pulling and showing an edge, wagging my finger and lecturing about manners.

I should add that not one person objected to either display. Had anyone done so, I would not have acted any differently; I couldn't have done so. I wouldn't have had the time to get the job done if I had gone about it any other way.

THE ELEGANT PORTRAITIST

The other end of the portrait spectrum is one I can only guess at. Fifteen or so years ago, I saw a one-inch ad in the *New Yorker* that the great Canadian portraitist, Yousuf Karsh, would be in New York later that year and if one were interested in arranging a sitting please drop a line.

Out of curiosity I did just that, and got back a simple but elegant brochure listing a basic sitting fee of $3,000. I'm sure the equivalent today might be $7,500. Now, we all know that Karsh photographed many of the world's great individuals during and after World War II, and that he lugged around enough lights to illuminate a football field and used a large-format camera. If you've never looked at any of his portraits, you should do so.

I also guess that unless you were world renowned and Karsh had already formed an opinion of who you were, he would most likely spend a little time with you to get at least a sense of you and your facial expressions before he'd make a few lighting adjustments and pop off a few frames. At least, I would expect that you would get a little time and interplay with the photographer for a sitting that costs thousands of dollars.

I recall a book of Karsh's portraits of world-famous celebrities that was in my parents' home. As a teenager I read with interest his vignettes about meeting these singular individuals and how and what he sought to capture on film. But how did Karsh work with the businessperson he had never met who was putting up thousands of dollars for a sitting? I don't know.

ROLE PLAYING IS PART OF LIFE

Ultimately, role playing isn't really a choice. The more I ponder the matter, the clearer it is to me that most of us play roles a lot of the time, the major difference being that some of us are able to select the roles we'll play, while others are cast "against their will" to play roles they can't control and don't fully understand. Worst of all, some end up playing roles without even knowing what they're doing, a lonely position at best, and one that makes genuine human contact very limited.

Not only is it OK to take on these roles, it can be helpful. And, I have to admit that I find it fun. I like being able to lose myself for a period of time in acting, being someone else and feeling free of my own inherent character and inhibitions.

Let's consider some of the basic types of roles—all based on real life—that might be available to the average photographer, without elaborating on the specifics.

THE REMEMBER-EVERY-NAME WEDDING PHOTOGRAPHER

Good wedding photographers are always upbeat and jolly. My friend Richard Rader, a successful pro from Nebraska, was visiting NYI one day. I was squashed in the back of a crowded elevator one morning, and Richard was the last to squeeze into the car. He didn't see me. The NYI office is near the United Nations, and several small countries have diplomatic offices in the building. In fact, that morning there were five or six delegates from a small African country in the elevator, all in tribal garb. By the tone of their conversation, it was apparent that their leader was telling a joke to the others, in a strangely inflected form of French.

When he got to the punch line, all his associates laughed. Richard turned to the leader, gave him a big laugh and a Nebraska smile, stuck out his hand and said, "Sir, I've never heard that story told better." The leader paused for a moment, then gave a big smile, pumped Richard's hand and started to speak again in French, a language that, of course, Richard does not understand. When they exited on their floor, Richard, still oblivious to my presence, shook each of their hands and clapped the leader on the back.

OTHER ROLES

We've already discussed the cliché of the paparazzi. As I mentioned earlier, one cannot lay the blame for the public's taste for sensational images solely on the shoulders of "soulless and immoral" photographers. However, there was a recent episode in New York that illustrates how callous covering the news can make you.

A man was arrested in a series of vicious, surprise assaults on women. He had killed one woman and grievously injured two others. In these attacks, originally not connected, the m.o. (modus operandi) was the same. The attacker had repeatedly slammed the victim's head on the sidewalk. The crimes had stunned New York for several weeks a few summers ago.

There was a lot of evidence that the guy who was arrested was the right guy, so when it came time to take him from the station house, where he was booked, to criminal court in Manhattan, the local cops arranged for the longest "perp walk" anyone could remember in recent times.

Do you recall when Timothy McVeigh was identified as the suspect in the Oklahoma City bombing? For months, all the world saw of him was that one short video clip as he walked from a detention center after he was first arrested and charged, to a car that would whisk him into federal custody.

No long parade before the cameras for McVeigh; the authorities rightly feared that someone might try to have at him. He was visible to the camera for a few seconds at most, as he came out a door, down some steps,

and was put in the back seat of a vehicle. That short segment was all the press was allowed to get and it was shown over and over in slo-mo, transformed into a series of still photos.

Well, the NYPD wasn't going to deprive the world of a good long look at John Royster, the alleged killer. They practically paraded him around the block before putting him in the car. The press even noted the treatment; I remember hearing a radio news version where the sound of the press photographers during the extended perp walk became its own scary sound bite.

"Johnny, hey Johnny boy." "Johnny, over here." "Johnny, Johnny, Johnny. Look at me." Having been at other perp walks, I'm sure there was some judicious editing, because I didn't hear: "Johnny, hey Johnny you fuck. Look at me you bastard."

As it was, it was revolting to listen to, but I know that had I been on that job, I would have joined the pack and done exactly the same thing. There's no choice, and I'm sure there was a bit of a mob mentality brewing among the photographers, video camera operators, and other press.

Time Out for a Perp Photo Technique Tip

When people arrested for serious (and sensational) crimes come out of the station house, they are usually handcuffed. That means that, unless they get special treatment, they have no way of hiding their faces other than ducking their heads. If you have to get the picture and you have limited access, start from a crouch and shoot up at your subject. The low angle will give you the best chance to catch a glimpse of the individual's face.

In what may signal the end of an era, just as I finish this book, a federal judge in New York has ruled that in one instance, an excessive perp walk of a suspect was an unconstitutional invasion of the suspect's privacy. This ruling cleared the way for a lawsuit against the city by the individual. The judge ruled that the walk was intended to humiliate the suspect and had "no legitimate law enforcement objective or justification." Nevertheless, suspects and people who have been arrested do have to be transported in public on occasion, and someone will be there to take the picture if there is public interest.

STUDY OTHER PHOTOGRAPHERS AT WORK

As you meet working photographers, try to gauge who they really are, and watch how they present themselves when they work. You'll find elements of most individuals' outgoing persona that are exaggerated or that fall into the category of role play. You can also see this in people in other walks of life, from the swaggering parking lot attendant to the brusque police sergeant and the avuncular physician. The more you study how others present themselves to the world, the more ideas you'll have for ways that you can sometimes be someone a little different than the "real" you.

NOTES

1. This quote is verbatim from a little-shown film in which Jimmy Stewart plays a photographer. I just didn't write down the name of the film. Would someone who knows the answer please let me know?

2. Ben Maddow. *Edward Weston, His Life and Photographs*. New York: Aperture, Inc. Revised Edition, 1979, p. 46.

 From the afterword by Cole Weston: "Mom never really had a chance to express herself. She was sensitive; she knew that Dad was a great man, and she let him have his freedom, even though it meant knowing that he was involved with other women." p. 288.

3. Judith Matloff. "The Legacy of Kevin Carter, Eye on Apartheid." *Columbia Journalism Review*, November/December 1994.

Michael Sullivan Dance Company, Michael Sullivan (r), 1978.

Part Two

PREPARATION
AND INSPIRATION

Unknown photographer. The caption on the back of the mount reads: "Washington's Headquarters, Newburg, New York. July 7, 1899." The round print indicates that this image was taken with the first *Kodak* model introduced by George Eastman in 1888. Like today's single-use camera, photographers bought the camera loaded with film and returned the entire camera to Kodak in Rochester for processing. The prints were then sent to the customer.

Chapter 6: Equipment—Why Is There a Clock in My Camera?

Earlier, I argued that you must deal with the camera to call yourself a photographer. Since it all starts with one piece of equipment, and a fairly expensive one at that, there are a lot of issues that relate to cost, fragility, care, and maintenance.

It's important to put equipment in perspective. At NYI, we have a saying that we repeat frequently to all students: "It's not the violin, it's the violinist." As many times as I've questioned this, I do believe it to be true. A good photographer can handle most assignments with almost any equipment. If you have a reasonable sense of the exposure range of your favorite film, you should be able to get good results with a thirty-year-old, all-manual camera without a light meter.

I've already made clear my conviction that you don't need scads of equipment and that having the "tip-top very best gear" isn't going to get

you the photographs you want. By the way, this isn't to say that you should be hard on your equipment or abuse it. It does need to be working, and there's nothing worse than shooting a job and having a piece of equipment go bad during the job, particularly if you don't notice it during the shoot.

Still, particularly when the number of dollars you have in your pocket is limited, and especially when you're getting started, what you need, which brands to select, and how to shop can raise lots of questions.

There's lots of good news about equipment. Almost everything you end up purchasing is likely to be very well made. Technology has made tremendous improvements in everything—cameras, lenses, and film—in the past two decades. Because the photo market has not grown wildly over the past decade, there's fierce competition for market share and every major manufacturer puts a lot of effort into quality control. And it shows. There's hardly a piece of equipment out there that is a "lemon."

Contrast this with the computer industry, where the "acceptable" failure rate of new items under warranty is in the double digits. My first laptop burned up a power pack the third month I owned it. I was trying to finish my first book while on location in Cincinnati; instead, I had a smoking power pack. Upon complaining about the delay and inconvenience of getting a new unit, I was told by customer service not to be upset, that "The industry norm for power pack failure is 15 percent and we're close to that."

That's not the way it is with photography. You can reasonably expect to open the box (nowadays), put in the batteries correctly, and take great photographs. Well, maybe not *great* photographs, but images where something is sharp and where the frame is accurately exposed. I'm going to take up equipment in two parts—first, the camera and then everything else.

CAMERAS

To understand the cameras that are available to you, you have to know a bit about the photo industry.

Over the past twenty years, the pattern of camera sales has changed drastically. Only a few camera manufacturers have a big stake in producing top-quality professional equipment. The numbers explain why.

For the past few years, annual sales of single-use cameras soared past 75 million units. Point-and-shoot sales hover near 10 million units per year, and American annual sales of 35mm SLR's have crawled back toward 1 million units after bottoming out at about 700,000 in the early 1990s.

In the mid-1970s, American SLR sales were over 2 million cameras a year, the modern point-and-shoot hadn't been invented, and the single-use camera didn't exist. Amateurs either struggled with SLRs or dealt with Kodak 110 Instamatics and the like.

Fundamentally, in the past twenty years manufacturers have developed models to make photography easier for snap shooters and professionals alike, and switched amateurs over to 35mm film. All this innovation

has also allowed people to purchase as much camera as they want. And most amateurs are comfortable with a modern point-and-shoot camera.

That means some companies that used to put a lot of effort into producing professional gear have realigned their efforts to make and sell point-and-shoots. That's where the market and the big profits reside.

Consumer (under $1,000) digital cameras have exceeded the million unit annual sales volume and various experts predict sales of those will climb past 2 million per year in a year or two, principally at the expense of the point-and-shoot camera market.

For the amateurs, auto-focus, auto-exposure technology makes for more photos that come out well focused and exposed. It doesn't mean the pictures are any better.

For serious photographers who use SLRs, similar technological developments in professional cameras have been staggering since Minolta brought out the first auto-focus Maxxum in 1985. SLRs now automatically solve problems that required lots of work just a few years ago. For example, fill flash used to require balancing the natural light with the power of a flash unit to find an aperture size that would allow the ambient light to provide the principal exposure for the scene and a matching shutter speed slow enough to synchronize with the flash, but not so slow as to blur the subject.

That used to be a higher math problem for a lot of photographers, but in much the same way that calculators have made it unnecessary to know how to find the square root of a number using just pencil and paper, the dedicated flash, TTL (through the lens) flash metering, and the auto-exposure camera have made fill flash a simple technique that most photographers can now use without any need to calculate the proper exposure. The chips do it all.

For years, our approach at NYI was to advise students to start with an inexpensive, all-manual SLR such as the venerable Pentax K-1000 or the Minolta X-700. Both had production runs for twenty years or more, and both gave the student an opportunity to experiment with the full range of exposure options.

THE PROPER VIOLIN FOR THE BEGINNER

I've changed my thinking recently and feel that beginners are best off with one of the lower-priced auto-exposure, auto-focus models offered by the key SLR manufacturers. Just as when calculators first appeared they were viewed as a "crutch," for a long time photography teachers feared that auto exposure and auto focus were aids that would prevent the student from getting a feel for the range of exposure options that a professional should be able to readily employ to give each image the best mix of shutter speed consequences and depth of field optics through aperture control.

There is a very real danger that the photographer who learns with the assistance of auto exposure and auto focus will take lots of flawed

images because the camera allows exposures using shutter speeds of 1/15 or 1/30 without calling these dangerously slow speeds to the photographer's attention.

There's also the danger that the photographer will fail to use the extremes of aperture size to exploit narrow depth of field and maximum depth of field to their best advantage in a variety of photographic situations, since auto-exposure software will tend to use midrange shutter speeds and apertures unless a program mode of some sort is used to force the auto exposure to behave in a way that the photographer desires.

However, the awareness of these essential creative photographic options can be learned in other ways, and today's fully automated SLR can enable the beginner to capture a variety of types of images that would be tough to grab with that all-manual K-1000.

I'm particularly enamored of the SLR models that have a small, built-in, pop-up flash. While for professional applications I prefer a more powerful add-on dedicated unit, there are lots of situations where that little flash will provide just enough "pop" to make a portrait in shade look much better, or illuminate a small floral subject in deep shadow.

The technology offers so many possibilities now that I think it's more fair to encourage the beginner to "step back" and learn what the older, all-manual cameras would have forced them to learn, while allowing them the luxury, and the fun, of the automated models that now dominate camera sales.

Turning to brands, Canon and Nikkon are the two manufacturers that offer the most extensive range of professional camera accessories, and certainly if you're considering building an elaborate system of 35mm lenses and accessories for an SLR, you're probably going to end up using one or the other. The working pros seem to be about evenly divided at this point. I do notice that Canon devotees seem to be more adamant and outspoken about loving their brand, but I'm not sure why.

Pentax and Minolta also make great SLRs. If you're the type of photographer who needs just one or two camera bodies and a few lenses, both these lines have models worth considering. They just aren't as extensive in lens offerings and other accessories.

There are other manufacturers, such as Leica and Contax, that still have passionate devotees and produce precision instruments. They also have a smaller market share than the four companies I've mentioned earlier.

For the most part, your final decision boils down to personal preference. What feels better in your hand? The new Canon models tend to operate very quietly. Does that matter in the work you plan to do?

I should add that there are a number of 35mm rangefinder cameras that have devotees as well. Sebastio Salgado uses a rangefinder Leica. Others swear by Contax. Particularly for situations where it's essential to use a quiet camera, rangefinder models have a place in the professional's arsenal. There is no one way, and there's no wrong decision.

MEDIUM-FORMAT CAMERAS

Here there are fewer manufacturers and the number of units sold in America each year is somewhere around 30,000 to 40,000. Once again, the quality of everything out there is very good, despite the smaller market.

As to brands, we all know that the Hasselblad was the first camera on the moon, but the popular view that the Hasselblad is the choice of discerning professionals has been challenged in recent years by Mamiya. While sales figures are elusive, the consensus of observers is that these two cameras dominate the marketplace. Yet, I know lots of working pros who swear by their Bronica or their Pentax, and in recent years, Fuji has taken the lead in introducing some interesting medium-format designs and concepts. There's also a lot of innovation in the medium-format field right now. The twin lens reflex (TLR), long a staple of models made by Rollei and Mamiya, is nearly extinct. To my knowledge, only the Seagull TLR made in China and Russia's Lubitel are still in production. However, several manufacturers, including Fuji and Mamiya, have brought out rangefinder, medium-format models that function almost like overgrown point-and-shoot cameras with the benefit of a giant negative. They're pretty tempting; I find myself playing with them at the trade shows.

While we'll talk about film shortly, a few years back I had a conversation with the head of one of the major medium-format manufacturers who explained to me that fine-grain films had actually enhanced medium-format camera sales in his opinion because a lot of images that pros used to shoot on sheet film could now be rendered just as richly on medium-format film.

I think using a medium-format camera can add a great deal to your photography. For one thing, those additional billions of silver-halide grains can record a lot more information about your subject. For wedding and portrait photographers, the medium-format negative makes mechanical retouching by the lab feasible.

Certainly one question you should ponder is whether you're interested in either a model that produces a 6 × 4.5cm or a 6 × 7cm image rather than the traditional square 6 × 6cm image produced by the Hasselblad. The variables are pretty straightforward. With any 6 × 6cm camera, you never have to think about turning the camera. With a 6 × 7cm model you get an even bigger image, but less frames on a roll of film. And with the 6 × 4.5cm model, you get a little less image size but more frames on a roll. However, you have a camera that makes a rectangular image in your hand, and there will be times that you will have to turn the camera to match the frame aspect ratio to your subject matter. Depending on the viewing system in the camera, this can be unwieldy.

Once again, the right choice will probably be dictated by what you wish to do with the camera. Not long ago, in the space of one week I lis-

tened to my friend Archie McDearmid, a Virginia-based wedding photographer who is also a past president of the PPA, tell me that he and his wife were both switching to 6 × 4.5cm cameras for their wedding work, away from their 6 × 7cm models.

Then I did a consulting job for a large utility company that was switching away from the exact same model Archie had just bought. The camera's handling was perfect for my friend, but the electronics shut down in humid situations, which meant the utility company couldn't use the camera to photograph accidents or general conditions in its steam-delivery situations.

A few years ago, I heard an interview with a professional recording engineer who assessed a key change in that industry which also holds true in the photo industry: Innovation used to start in the top models of professional equipment and then trickle down to the consumer. Now, the innovations generally turn up first in consumer gear (where the sales volume resides to justify the expenditure) and trickle upwards.

That means that there's been very little automation of medium-format equipment until recently. But it is starting to happen.

LARGE-FORMAT CAMERAS

Whether in the studio of a commercial photographer or out in the field, there will always be photographers who enjoy making an image on 4″ × 5″ or 8″ × 10″ sheet film. The slow and contemplative pace is appealing, and the potential for manipulation of the image using camera movements is almost exclusively reserved for the realm of the view camera.

I own one view camera, and it was the cheapest one on the market twenty-five years ago when I bought it. The results it gives are wonderful, even though I am the type who's constantly messing up—did I pull the dark slide before I made the exposure? Did I remember to put it back? Which side of this holder has the unexposed film?

If an SLR is like a violin, then the view camera is like a cello, and, once again, it's not the cello but the cellist.

Working with a view camera is a wonderful experience and one I recommend you try. This might be the perfect reason to visit a rental shop and see what kind of rate you could get for a week or a month to rent a view camera, a lens or two, and a dozen film holders. Make sure to rent a proper tripod as well. Chances are the one you use with your 35mm SLR won't support the weight and bulk of a view camera.

DIGITAL CAMERAS

Many people in the photo industry are praying that these cameras will reinvigorate the photography hobbyist marketplace, which has been stagnant or shrinking over the last two decades. Aside from the sales of point-and-shoot and single-use cameras, photography as a popular hobby has been on the decline.

While high-end digital cameras have been used for more and more applications by professionals over the past decade, the consumer models appeared as a trickle in 1996. Perhaps half a dozen such cameras were exhibited that year at the annual PMA show. The next year there were nearly one hundred models at the show. (PMA stands for Photo Marketing Association, an organization I discuss in appendix I. Suffice it to say here that the PMA show is the biggest gathering of industry players each year and its trade show is the focal point around which products are introduced to store owners and dealers in America.)

At this writing, digital capture of images still presents a lot of technical problems. While the professional photographer has entered a world where it's necessary to master the computer-age electronic darkroom, for many photographers it still makes sense to capture the image on film and convert it to a digital file by scanning later on.

The collision between photography and the computer is the subject of an entire chapter (see chapter 10). There are some powerful forces driving it. There are still raging debates about how much the amateur market will embrace digital cameras. In February 1997, at PMA, I heard one pundit predict that in fifty-four months—August 2001 if I count right—film will "vanish from stores overnight, the way CDs pushed vinyl records out of music stores."

In 1996, I bought a little Casio digital model, one of the first models on the market. I quickly discovered two things—first it's a great conversation starter and party toy, and second, people view its cost and value entirely differently than traditional cameras.

I was at the PMA show in Vegas when I bought the camera and as I played with it taking pictures around Caesar's Palace, everybody—kids, employees, even slot players—asked me what it was. They were fascinated that it was a camera with no film but a computer chip inside. Naturally, they wanted to know how much it cost. I had paid $500 for it, and every single person's reaction was: "Oh, that's not much."

Today, you get a lot more pixel power for $500 and the venerable Casio I bought has vanished from the market, but the perception remains the same.

We're *conditioned* to costs (something we'll cover in great detail later), and anything computer-related that sells for around $500 doesn't seem that expensive. But what would those people think of a $500 point-and-shoot traditional camera? Naturally, that would seem like a lot of money to those same people. And they're right, because I can buy a point-and-shoot that is a lot better camera than that little Casio for about $200.

Low Margins on Cameras

This raises a point that should be examined before we go on. It is simply a fact of life that there is a very small "margin" (that is markup or profit) for retail sellers of cameras. Perhaps years ago, when there were fewer types of

outlets selling cameras, there was more profit built into the price. Now, thanks to the rise of giant discount stores, photo specialty chains, and the American photography superstore, B&H Photo-Video, the amount that any seller can mark up the camera over the manufacturer's "wholesale" price is slim.

Compare this to buying a car. There's lots of profit to be spread around in cars, although the dealership system that has dominated car sales in the United States is starting to break down. When it does, watch margins drop. That will be good for the consumer.

For those of you who are pondering purchasing a new camera, the next few pages address the issue in great detail. That's because I think it's important. If you take everything here to heart, it will help you get the best camera and save money and stay out of trouble. Even if you're not considering a camera purchase right now, reading this will give you some ideas about where and how to shop and how to negotiate for other products and services that are part of the photography process.

Police and protestors, 116th Street and Broadway gate, Columbia University, New York, 1968.

Chapter 7: Equipment II—How to Buy a Camera

If you're considering buying a new camera, you can make the process a lot easier and guarantee that you'll get the right camera at a good price if you take just two simple steps:

First, take the time to answer five easy questions *before* you set foot in a camera store.

Second, obey the Cardinal Rule of Camera Shopping.

Here are the questions:

1. What type of camera do you want: a point-and-shoot model or an SLR? Or a medium-format camera?
2. How much are you willing to pay?
3. What brands interest you?
4. What type of store would you like to use to make your purchase and what is a "good" price for the camera in which you are interested?
5. Do you care about a USA Warranty?

Why should you know the answer to these five questions *before* you enter a camera store? Because, the sad fact is that *almost* all the stores that

sell cameras—and nowadays those range from photo specialty stores (which are dwindling in number) to department stores, consumer electronic stores, and mass discount stores—want to sell you a specific camera, one that's in stock and that has the fattest profit margin for them. Naturally, they want to sell you a camera they have in stock. Otherwise, there's no sale.

These two desires are at the heart of the Cardinal Rule of Camera Shopping. It is: *Avoid the bait-and-switch*. For those of you who don't know, I'll explain what "bait-and-switch" is and how to avoid it in a moment.

First, back to the stores. While *almost* all stores want to sell you a specific camera based on *their* needs, there are some photo specialty stores that will sell you a camera based on listening to you and getting to know your needs. Stores of this type are rare. They are stores that cater to serious photographers and therefore they want to make you a regular customer. This type of photo store requires people at the sales counter who know about cameras and a management that has a good business plan. There are other photo specialty stores that will "sell down your throat" like all the other outlets.

In most of the outlets, particularly mass merchandisers and department stores, you're likely to run into a staff that doesn't even care what you want, and wouldn't know enough to help you if they did care. They just want to move product.

Does this mean that you should only shop at a good photo specialty store? No, but that's not a bad idea. It does mean that wherever you shop, you need to make some basic decisions based on the five questions I've listed above before you start hearing sales pitches.

Not that all sales pitches are bad. You may even change your mind about a few points if you get a thoughtful presentation from a good (and honest) salesperson. However, you'll be a lot better off if you have a working plan in mind, and a lot less susceptible to the old "bait-and-switch" if you have a brand or model in mind.

What is "Bait-and-Switch?"

While I call avoiding bait-and-switch the Cardinal Rule of Photo Shopping, the risk of bait-and-switch sales operations extends to electronics and computer sales as well. Here's what it's all about: You enter a store, or call a mail-order dealer, with a specific product in mind. Perhaps you were drawn to that seller because of an advertisement offering a great sale price on a particular item.

The advertisement has "baited" your interest, and you visit the store because you intend to buy that item. In a bait-and-switch, what happens next is that the salesperson "switches" you to a different product, one that will make the seller more profit and in all likelihood, won't be as good as the product you originally sought to purchase.

If it's a great sale price that has drawn your attention, you'll be told you're too late, they're "sold out" of that model, but, lucky for you, they have something "just as good." It may even be a little cheaper than the item that caught your eye, but it won't be *as good* and the seller's markup will be bigger.

That's the old bait-and-switch.

Here's an example. A while back, a friend of mine asked for my help in selecting a camera. She and her boyfriend were going to Africa for a wildlife safari. I met her at the local camera store, and she quickly decided she preferred a compact point-and-shoot over an SLR. At that time, I didn't know too much about point-and-shoots, but I suggested a couple of name brands that had garnered good reviews in the photo magazines.

The guy behind the counter strongly recommended a model by a smaller manufacturer. He told us that it performed as well as the others and showed us a feature that he said he liked. My friend bought the model he suggested.

Shortly after she came back from Africa, she called me to lament that her photographs came out poorly. Sure enough, after I inspected them, it was clear that the camera had consistently underexposed her images. I shrugged it off as a manufacturing problem and cautioned her that she shouldn't have waited until the last minute to purchase a camera. She should have bought it earlier and tested it.

Only years later, long after that store had closed, did I find out the truth. A former salesperson from that store explained to me that the store's owner pushed one manufacturer's line because he got a big rebate based on sales volume. The model that his associate had sold to my friend was well-known to be a lemon. There had been a conscious choice to go for the fast buck and stick it to the customers! Right under our noses.

THE FIVE QUESTIONS FOR CAMERA BUYERS

That's why it's important to know what you want before you start shopping. That brings us back to our five questions. Let's start at the top of our list and work our way down:

1. What type of camera do you want?

Few people enter a car dealer's showroom without a clue. Do you want a convertible or a truck? American or foreign? Any color preference?

To the contrary, most people have a brand of car and model in mind when they enter an auto dealership. But for many people, a camera is a camera, and only a few names are familiar. With the exception of shoppers who pore over the photo-enthusiast magazines and read reviews, few people have a clear idea about the differences between types of cameras or the features of various models.

So, the first question is: Do you want a point-and-shoot or an SLR? Years ago, this wasn't even a question, the single lens reflex was king, and it was the only choice for serious photographers.

Point-and-Shoot Cameras

Now there are lots of very good point-and-shoot models with street prices starting under $200. They're light, easy to carry, and fun to use, and they're so small you're likely to take your camera with you more often. That's important because a camera is no good at home when you're out and about.

If you're considering a point-and-shoot camera, I suggest you look at models with a zoom lens, so you have a choice of focal lengths, and make sure the camera has a screw-threaded hole in the bottom into which you could mount a tripod. Almost every point-and-shoot model comes with a flash, but I strongly suggest that you buy a model that lets you exercise some control over the flash; namely, you should be able to turn it off when you want to and make the flash fire even when the camera's exposure "brain" tells it not to.

Don't think point-and-shoot cameras are only for amateurs. Not long ago, I read a profile of a celebrity paparazzo who makes a handsome living crashing society events and photographing his subjects with a point-and-shoot when they least expect it. Always clad in a tuxedo, his subjects think he's a harmless, well-to-do fan, not a working pro. An SLR would blow his cover. I often use a point-and-shoot for street photography; my subjects think I'm a tourist.

Single Lens Reflex Cameras

As good as the new point-and-shoot models are, there are things that point-and-shoot cameras can't do. For example, you can't change lenses or use filters, you can't see for sure what you're getting in the frame, and you can't be absolutely certain that your subject is the object upon which the camera is focusing.

With an SLR, you can do all those things. SLRs remain the cameras used by most professionals. They allow you to look through the lens that will take the picture to make sure the image is focused and composed correctly. There are lots of different lenses and accessories available. You can buy an entry-level SLR with a 28–70mm or 28–80mm zoom lens for under $400.

Medium-Format Cameras

As I mentioned before, medium-format cameras are particularly appealing to professionals for several reasons. Most importantly, they have a lens with fine optics, which, when coupled with modern medium-format film, will yield an image that is "richer" to the eye than any that can be produced by a 35mm camera. It's just better, and you can see the difference. It's also true that it's easier to perform conventional retouching on a medium-format piece of film, which is very important for portrait and wedding photographers.

There are some interesting models that work almost like point-and-shoots, and Fuji has a great panoramic model that I'm itching to try.

2. How much are you willing to pay?

As I noted above, you can get a good point-and-shoot for under $200 and you can get a beginning SLR with a medium-length (28–70mm) zoom lens for under $400. But, you can spend close to $2,000 on a point-and-shoot and perhaps twice that for a few of the top-of-the-line SLRs. And for lenses, the sky's the limit. For a big telephoto zoom made by Nikon or Canon, you can expect to pay several times the cost of those manufacturers' top-of-the-line camera bodies.

Realize that very few photographers need a top-of-the-line camera with all sorts of bells and whistles. At the same time, if you're interested in a special feature and you spend a little more for a camera that offers that feature, don't feel bad. Here's why: Photography is like shaving and cameras are like razors.

What do I mean by that? Simply that the big money in the shaving business lies in selling an ongoing supply of razor blades and shaving cream to the shavers. In fact, if you make both razors and blades, the best bet is to make your razor really cheap and incompatible with any other manufacturer's blades, so the customer who uses your razor has to buy your razor blades. That's where the profit center lies.

How does this work in photography? Let's do the numbers. If you shoot twenty rolls of film a year, your cost for film developing and processing (figure $5 for film and $15 for processing—and that's conservative) is $400! If you shoot forty rolls of film, then you'll spend $800 or more. That means that in a couple of years you will have spent far more on film and processing than the cost of your camera.

If you're the type who's prone to losing things or breaking them, you may need to think differently, but for most of us, a camera is a long-term investment. Chances are your camera will outlast your car! Why not spend a few extra dollars on good equipment?

When we get to where to shop, I'll suggest ways you can stretch your dollars if you need to do so. At this point, I suggest you pick a dollar figure you're prepared to spend, in increments of $100, and budget no less than $200 and no more than $1,500. If you want to spend more than that, make sure you have a good reason to do so.

I suggest $1,500 as a top limit because you can buy a professional-quality SLR and zoom lens from one of the "big four" manufacturers for that much. You could even get a less expensive SLR body and two zoom lenses for that amount.

Don't be crestfallen. Remember: That's the top of the line. You can own a great SLR and lens from a famous maker for $400 or less. There will always be a better camera than you can afford right now, but don't let that bother you. Nitpickers will always tell you their lens is sharper or they really need the titanium shutter and the ten-frames-a-second capability, but the truth is, most of us don't.

3. What brands are you interested in?

Point-and-shoot cameras are made by many companies, major players and smaller houses, and some of the new electronics companies are getting into the competition as well. For example, cameras made by Samsung, a name best known for consumer electronics, are among the top ten sellers in the United States.

In addition to new players, the "usual suspects" (i.e., reputable camera manufacturers) include: Canon, Olympus, Nikon, Minolta, and Pentax. The two major film companies, Kodak and Fuji, make point-and-shoot models. Rollei, Contax, Konica, and Ricoh have had hit point-and-shoot models as well.

There are fewer manufacturers of SLRs. Earlier, we referred to the "big four," namely Canon, Minolta, Nikon, and Pentax. When I see pros at work, the people using Canons and Nikkons are the vast majority and about evenly split between the two brands. There are a fair number of rangefinder Leicas out there among the photojournalists as well.

4. What type of store would you like to use?

This is a very important question. While this is a subject that I could discuss at great length, the short version is that you have three basic choices—the photo specialty store, the discount store, or the mail-order operator. There are advantages and drawbacks to each. Let's weigh them all.

Photo Specialty Stores

Chances are, you will pay more if you buy from a specialty store. But you may wish to form a good relationship with your local photo store, and it is certainly the place to go to handle the models they have in stock before you make your final decision about purchasing. The owner is usually around, and hopefully the sales staff is knowledgeable. However, because the specialty store is often a small independent business, it is likely to have to charge more than the discounters and mail-order outfits.

Bear in mind that not all photo stores are what are known as "stocking dealers" of every major brand. Usually a store will carry an on-premises inventory of a few brands and have to purchase other items from suppliers. And as you get into more specialized equipment, the number of dealers who carry what you want will continue to shrink. An executive from one of the medium-format camera companies told me not long ago that there were only "about 150" dealers in the United States that really sold much of his product.

Discount Store

If the brand you want is a popular one, you may be able to find it at the local discount store and get a great price. As I've warned you, don't expect anyone there to know very much about the product, however.

You will find a limited selection and get little sales help. You're there to save money, but watch out—you don't always get such a good price. Here's why. Many discount stores and chains offer astoundingly low prices on just a *fraction* of the items they sell—perhaps one item in a hundred. They offer these big discounts on the "price sensitive" items—items for which most consumers have a sense of price—like cans of Coca-Cola, light bulbs, potato chips, and the like. Often, the big discount stores "seed" their offerings with a few really cheap items to lull you into thinking *everything* in the store is really cheap, when it isn't. When it comes to photographic or video equipment, you have to know prices. You may not be saving more than a penny or two!

Mail-Order and Online Dealers

Now, what about mail order? Can mail-order dealers be trusted? The bad news is that you can't trust them all. The good news is that there are good ones that are trustworthy. Buying a camera by mail (or even online) should be no less risky than buying an airline ticket or a sweater through the mail. My general advice? If the price of a mail-order firm is by far the best you can get, you're usually safe with one of the large firms that advertises in the back of one of the major photo magazines such as *Popular Photography* or *Petersen's Photographic*. For medium-format and used equipment, *Shutterbug* has small specialty dealers as the backbone of its advertising.

I can talk to the publishers of those magazines, and, in candor, most will admit that a few of those back-of-the-book, mail-order advertisers generate a lot of complaints to the magazine while others have mainly satisfied customers. You don't know who is who, so when you call a mail-order dealer, be careful, as follows:

First, specify the exact piece of equipment you want, including the model number, and make sure you understand exactly what comes with it. Tell the clerk on the phone that you expect it to come in the manufacturer's original, unopened package, with all the accessories the manufacturer supplies—including an instruction book in English, lenses, batteries, straps, and so on. If the clerk won't confirm this, don't order. You'll also want to ask about the warranty, which we will discuss next.

Second, if the clerk will confirm the points listed above, find out if the item is in stock and will be shipped within twenty-four hours. If the clerk says it's temporarily out of stock and the company expects to get it in stock in a day or two, tell the clerk you will call back within two days and order if it's in stock. When you call back, if it's still out of stock—don't order. Hang up. That mail-order house wants to sell the item to you and then buy it from someone else for a lower price. You don't need to pay someone in the middle. Go find a store that has the camera you want in stock and buy it for the better price.

Third, verify the mail-order house's check-refund policy and warranty. As to refund policy, make sure the firm will take back any item you get in less-than-perfect condition. You don't want to have to deal with the manufacturer under warranty on an item you got that was defective. You paid for a new working model. You should get a new working model.

If you decide to purchase from a mail-order outfit, don't forget to reconfirm all prices with the clerk and get the name of the clerk. Write it down. If possible, use a credit card rather than a check for the purchase; this will give you the option of not paying if there's a problem. If possible, ask the mail-order company to fax you a copy of the sales receipt.

The last part of question 4 is: How do you determine what is a "good price?"

You can find this out just by making one toll-free telephone call. The benchmark for pricing these days is how much B&H Photo-Video charges for any given product.

B&H is unique among photography stores in America. Located on the west side of Manhattan, it is the single biggest photo retail store in America, and also has a very big mail-order operation. There are other good photo specialty stores in Manhattan and around the country, but none have the vast inventory that B&H maintains, and few can match the low prices that B&H can offer. B&H Photo-Video, for anyone who doesn't know, has become the largest camera store in New York and probably in the United States. Having moved into a giant new store recently, B&H has become a pleasant place to shop. It used to be small, impossibly crowded, and the sales staff was a tad abrupt. It's now large, only moderately crowded, and the sales staff is highly professional.

I don't know if it's a good thing or not, but B&H continues to grow into an entity the likes of which I've never seen before. At this point, it must sell a respectable percentage of all the photo equipment traded in the United States. It is certainly a force to be reckoned with.

Just call and ask B&H what its price is on a specific make and model of camera. The phones are busy, and the store is closed on Friday afternoons, all day Saturday, and on all Jewish holy days. But when you get through, the sales staff will tell you the store's price on virtually any piece of photo equipment that is made by anyone, anywhere.

Knowing what you could buy it for from B&H will give you an idea how much more you'll pay if you shop at a discount store or photo retailer. Now you can make an informed decision about where to shop. There's just one last question.

5. Do you care about a USA Warranty?

This is a confusing point for many people. Let's start with an explanation.

A camera that has a USA Warranty has been imported by the manufacturer and is qualified for any necessary repairs during the warranty period and for any rebate programs offered by the manufacturer. A camera

that does not have a USA Warranty is part of the "gray market" of hardware that was not made and intended for distribution in America by the manufacturer.

Some stores sell only USA Warranty items, others sell only gray market, and others stock both. As you might guess, the gray market item is cheaper, but the risk is that if the camera is not perfect and needs repair, you'll have to pay the cost rather than have it covered under the warranty.

There are two points to stress. First, know what you're getting. Ask, "Does this camera have a USA Warranty?" and expect a direct answer. If the salesperson is vague, shop elsewhere.

Second, my advice is to get the USA Warranty on today's sophisticated auto-focus, auto-exposure cameras. Here's why: Even though today's cameras are uniformly well made, there's always the danger that a computer chip or other electronic part may not be perfect. In the old days, when cameras were all mechanical, it was easy for the technicians at the inspection bench to check each spring, lever, and gear before the camera was put in the box. With today's electronic gizmos, it's hard for even the most conscientious manufacturer to inspect each unit so thoroughly as to make certain that everything works perfectly on every unit. If you happen to have a problem, it can be very costly, and that's why I think it's worth a few extra bucks for the certainty of a USA Warranty.

Here's an example of how the numbers play out at this moment. Realize that these dollar figures can vary, but in late 1998, if you called B&H Photo-Video to get the price of a Nikon N-90s body, which is a popular (but not top-of-the-line) model used by many pros, the price B&H would charge was $940 for a USA Warranty model and $690 for an "imported" (i.e., gray-market) model.

That's a big difference, but to protect its USA Warranty, Nikkon at that time was offering a $150 rebate on the USA Warranty version, so the price difference was really between $790, the final cost for a USA Warranty N-90s, versus $690 for the import.

That's a $100 spread, although if you figure in sales tax it would be a bit more. That's five rolls of film and processing. I think it's worth the piece of mind.

Now you've answered all the questions, you've selected the model you want, and you know the price you should pay. I suggest that, before you buy, you visit your local photo store and ask the owner or counter clerk if she can meet or beat the benchmark price. She may be able to do so or, at least, she may be able to come very close. The worst that can happen is that the store will say no. The manager won't throw you out.

Also, ask if there's a student discount or a senior-citizen discount or any other discount. Perhaps you qualify for one of these discounts. But even if you don't, don't give up. If the store gives discounts to students, seniors citizens, or for any other reason, ask the staff to give you their top discount too, even though you don't qualify. Obviously, they have enough

profit margin in their pricing to allow for the discounts they offer. Why shouldn't *you* get their best price?

One more tip concerning whether you should shop at a store or by mail order—avoid packages. Generally, when a store offers a kit that includes a flash, filter, and cleaning kit—or what have you—the accessories are being marked up to compensate for a low cost on the camera. My advice: Get only the camera you want. You can always buy accessories as you need them.

OK. If your local photo store can match (or even come close to) the price in the mail-order ad or at the discount store, I suggest you buy from the neighborhood store. The local store usually has a wide selection, the staff offers knowledgeable advice, and if you ever need repairs, service, or special-order items, you're likely to end up there anyway. So it pays to support your local store and have a good relationship with the people there.

Congratulations, you've completed every step. Enjoy your new camera!

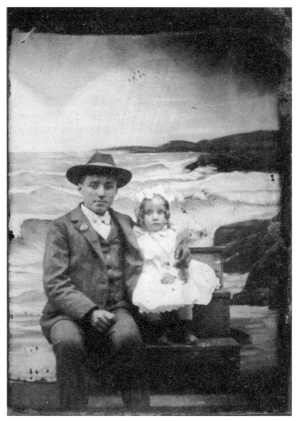

Unknown photographer, Tintype of man and child, date unknown.

Chapter 8: Equipment III— Film, Used Equipment, and Lenses

As dramatic as the advances in camera hardware (and software) have been, perhaps the innovations in color and black-and-white films have had even greater impact on the images that photographers can record. T-grain film structure, self-masking film layers, and other chemical and physical developments have resulted in color negative and transparency films that surpass the decades-old benchmark of Kodachrome 25. The chemists have also created high-speed color negative films in the ISO 800 to 1600 range that can even be pushed, if necessary. Particularly for the amateur snapshot market, the tolerance in exposure latitude of today's color negative films results in many more well-exposed photos in each roll.

SLIDE FILM OR NEGATIVE?

I find that lots of photography students have not tried enough transparency film. It is understandable that most people start with film that produces negatives, since that is the type of film that dominates the amateur market.

Among professionals, news, portrait, and wedding photographers are likely to shoot negatives in order to produce prints to sell to their customers. Slides (or transparencies—I use the terms interchangeably) are usually produced by photographers who shoot lots of scenics or nature photos, photographers who take commercial and still-life images, or make photos for stock agencies.

Years ago, all photographers who shot for publication used slides because photo editors preferred them, owing to the nature of printing preproduction. Nowadays, most publications are comfortable using either slides or negatives or prints, since color images are usually scanned, rather than made into traditional color separations, which were more easily made using slides.

SLIDES ARE CHEAPER

If you shoot lots of film, you may find another benefit to switching to slides—cost. A roll of slide film may cost a dollar or two more than a roll of negative film, but the cost of processing a roll of slides is much less than the cost of having prints made of every frame of a roll of negatives. Starting with slides, you can have prints or scans made from the best images and just file the rest of the slides without paying for prints. A roll of thirty-six exposures of color negative film and a set of 4″ × 6″ prints could cost between $18 and $25, while thirty-six exposures of slide film and processing will run about $10 to $15. If you shoot one hundred rolls of film a year, that could become a big difference.

CHROMOGENIC FILMS

For years, Ilford produced a black-and-white film, XP-2, that could be processed in the same chemistry as color negative films. For years, teachers at NYI counseled students not to use the film because it did not have the potential for longevity of traditional black-and-white film. However, I have started using Ilford's film and the competitor that Kodak makes, TCN-400, for two reasons. First, it can be hard to find decent black-and-white processing in a lot of areas, but any one-hour lab can handle these films since they're compatible with the color chemistry they traditionally use. Secondly, I have fun making photographs and then asking the lab to give the images a sepia-line tone. I understand that these negatives may be more susceptible to image degradation, but I'm enjoying using the films occasionally.

TRADITIONAL BLACK-AND-WHITE FILM

Despite the number of new black-and-white film emulsions that have been introduced in recent years, I still use Tri-X principally, along with T-Max 3200 for low-light work. I find T-Max 100 and 400 difficult to use. I know lots of photographers who disagree with me, but I also know that anytime I'm out with the press pack, after the crowds clear out, the scene of a busy press conference is littered with Tri-X cartons.

I should point out that there are also legions of photographers who swear by Ilford's black-and-white films. I haven't used them enough to have my own opinion. I have such fun with Tri-X that I've never had need to stray.

LIGHT METERS

Although I'm comfortable with the meter in my camera most of the time, I own several handheld light meters. I think any serious photographer should own (and learn to use) either a good reflected light meter and a gray card, or an incident meter. My personal preference is for an incident meter, and the model I use doubles as a flash meter. Anyone trying to do studio lighting with electronic flash without using a good flash meter is in danger of driving himself nuts.

There is no better way to learn about lighting than to learn how to take accurate readings of light in a variety of situations.

USED EQUIPMENT

I buy a lot of equipment that is used, and, for the most part, I have had good luck doing so. In particular, I think used darkroom equipment is a safe purchase, because it's not likely to have taken much of a beating.

I'm not talking about shopping for fifty-year-old Leicas or other collector's items. Those are out there, too, but this advice is for the photographer who would like to purchase good secondhand equipment for use.

In addition to cameras taken in trade, at a good photo store you may find used lenses, meters, and darkroom equipment. Individuals may sell cameras via newspaper want ads, online, or at a flea market or garage sale. If the seller is an individual, chances are you're dealing with someone who has bought new equipment or who has lost interest in photography and wants to cash out.

Solid, Metal-Body Cameras

Since Minolta introduced the first auto-focus model of the Maxxum in 1985, camera manufacturers have brought out hundreds of auto-focus models. Nikon still produces the F-3, but all Canon and Pentax models currently in production are auto-focus, auto-exposure models with the option of manual override.

But in the world of used equipment, you can still find Nikon F-2s, the long-in-production Pentax K-1000, and a slew of Canon A model

cameras. These are metal-body workhorse cameras, and although they're ten, fifteen, or more years old, if they haven't been abused, they're likely to be capable of giving you years of reliable service.

One potential problem with certain older models is that the mercury-based batteries they used are out of production because of new environmental regulations. However, there are one or two battery manufacturers that specialize in making modern-style batteries that will drive cameras that used the 1.35 old batteries.

If you want to learn about the models that dominated the market ten, fifteen, or twenty years ago, visit your local used-magazine store and pick up a December issue of *Popular Photography* from yesteryear. For years, *Pop* has featured a comprehensive camera roundup in its December issue. For detailed reports on old cameras, there's no better source.

Darkroom in Decline

Sadly, the listing of people offering used darkroom equipment represents not trade-ins, but abandonment. Since the mid-1980s, the interest in darkroom work has plummeted. The upside is that you can get a great deal on a used enlarger and other darkroom equipment. While there's no question that the computer-based electronic darkroom is here to stay, there will be a resurgence in traditional wet darkrooms in the future, I suspect. There's no more pleasant place to spend time than listening to your favorite music under the red-orange glow of a dim safelight while making photographic prints.

WHERE TO FIND USED EQUIPMENT

There are six principal places you'll find used camera equipment—your local specialty store, mail-order dealers that advertise in magazines, pawn shops, flea markets and garage sales, newspaper classified ads, and online auction services. Each has its own possible benefits and potential pitfalls.

Obviously, you must be careful wherever you buy used equipment. If you buy from a specialty shop or a mail-order house, you will want to ascertain that you are dealing with a reputable merchant. If you buy from a pawn shop, flea market, or classified ad, you must scrutinize the equipment meticulously before you take it home. If you are interested in buying equipment through an online auction, you should probably get to know the particular service before you start bidding.

The online auction is a hot new growth area on the Internet. Online auction services—such as eBay and Amazon.com—have attracted lots of people to the auction concept. Naturally, the problem with a virtual auction is that you the buyer haven't had the opportunity to physically examine the items that are being offered by the seller.

The online services are working hard to insure that there are adequate safeguards to prevent abuse. For example, eBay offers an escrow service that allows the purchaser to receive and inspect the equipment before

payment is released to the seller. In addition, most services supply some reference information about sellers, so you can find out whether the person from whom you are buying an item has had favorable reviews or negative ratings from past customers.

My friends who are eBay addicts suggest asking as many questions as possible of the person offering the equipment. Obvious examples: How much have you used the camera? Has it ever been dropped? Has it ever been repaired? Also, specific questions about the camera's features will clue you in as to whether the buyer is legitimate and has the camera to sell.

SIZING UP USED EQUIPMENT

Assuming you can physically inspect the equipment you may purchase, first look closely at the exterior. Are there signs that the camera has been dropped or suffered severe physical shock? Don't be concerned about a few chips in the finish or minor dents, although those do indicate that the camera has traveled quite a bit.

It's unreasonable to expect that the camera was owned by a collector who never used it. In fact, it's better if a camera had light use during its lifetime since that tends to keep the lubricants spread over the mechanical parts. What you want to avoid is a camera that has been mistreated by a clumsy owner or used heavily by a professional. Sooner or later, every camera will experience failure of some system after heavy use.

Open the camera. Is it clean inside? Look at the chamber where the film cassette is placed (assuming it is a 35mm or medium-format camera). Are there signs of wear? That suggests a lot of film was loaded into the camera.

Hold the camera to your ear and listen to the shutter mechanism while you discharge the shutter. Set the camera's shutter control to run at different speeds. How does the shutter sound at 1/4 second? At 1/60? At 1/500? If you hear rough noises or different sounds at different speeds, that's a reason to be suspicious.

When you inspect a camera lens, feel how the focusing mechanism responds as you run through it. Are there any rough spots? Hold the lens to your ear and listen while you adjust the focus. You shouldn't hear any strange noises. If you're looking at a zoom lens, run through the zoom range. Feel and listen for any abnormalities.

With enlargers and other darkroom equipment, I don't anticipate much damage from use. Check to make sure the enlarger head is aligned, that the enlarger lenses are clean, fit properly, and aren't scratched and that the electrical system that runs the light doesn't have a short in it.

TERMS OF PURCHASE AND WARRANTY

When you buy from an individual at a flea market or from your local newspaper's classified, you're not likely to get any guarantee or offer of warranty. Same from a pawn shop or an online auction service. In these instances,

you need to trust your own assessment of the equipment you are considering. If possible, ask if you can shoot a roll of film using the camera (or lens) and ask that the seller hold the item for twenty-four hours while you get the film processed. This will give you a chance to determine whether there is anything wrong with the camera.

If you do get a chance to shoot a test roll, make sure that you test the response of the built-in meter if the camera has one, and use a wide range of different shutter speeds and aperture sizes to test the full range of the camera's function.

If you purchase via mail order, many reputable dealers state their warranty policy. For example, the B&H Monthly Catalog and monthly advertisements state that all used equipment is guaranteed to work, regardless of cosmetic condition. Used photo items are guaranteed for ninety days and there's a fourteen-day return period. B&H also states in writing that "mechanics and optics are assumed to be excellent."

B&H offers a cosmetic grading system that runs from ten to six.

- 10=100% Like New
- 9=90–99% Minor Wear
- 8=80–89% Average Wear
- 7=70–79% More Than Average Wear
- 6=60–69% Well Used, In Working Condition

Some advertisers in *Shutterbug* use a system that runs from "Mint" and "Mint/box," to "exc++, exc+, exc, vg++, vg+, vg," and so on. If you're unfamiliar with this shorthand, "Mint/box" means like new in the original box, "exc" means "excellent," and "vg" is "very good."

Many of these mail-order dealers have been in business for many years and value their reputations highly. Others can be less than satisfactory. I suggest that you ask for references of other customers, make sure you understand what warranty or guarantee is included, and pay with a credit card, if possible, so you have some protection if there is a problem.

When you buy from a photo retailer, you should make sure that you get a written confirmation of the terms. You should be able to expect a sixty- or ninety-day guarantee and possibly a short period when you can return the item if it does not meet your expectations.

If you follow the advice I've offered in this section, you should have no problem getting great value when you shop for used photo equipment.

LIGHTING EQUIPMENT

Too many photographers never use any form of lighting other than an on-camera flash. I urge every photographer, even people who have no interest in anything other than outdoor photography, to try their hand at studio lighting. Otherwise, you will never know whether you have an aptitude for it, and you may miss a very important aspect of photography.

I own two 500-watt quartz hot lights that probably cost me $150, including stands, and I have probably billed $30,000 from jobs I shot using just those two lights, principally making slides for artists of their paintings and sculpture and various types of copy work.

When it comes to electronic flash units, my advice is that you shouldn't be put off by the high price tags on some units. Start simply with two or three lights and decent stands. I don't care whether you opt for heads that run off a power pack or select monolights that have their own charger. However, you want lights with slave capacity and good modeling lights. For me, a good modeling light is one that is bright enough to show clearly the highlight and shadow areas on your subject in regular room light.

Some models are lighter than others, which may be a consideration for you if you plan much traveling. Lots of companies make low-cost units, but I can personally vouch for those made by Photogenic, White Lightning, and SP Studio Systems.

At NYI, in addition to our saying that "It's not the violin, it's the violinist," we also say, "Light is light." When the shutter is tripped and the flash fires, the light put out by an inexpensive unit is essentially the same as that generated by the most expensive one. What counts is your ability to manipulate the light and place it properly. Naturally, bigger, more powerful units put out more light, but most of the time you won't need lots of power. For most people-photos, a low- or medium-power head will suffice.

With many flash units, manufacturers have a tendency to overstate their power. That means that if you try to calculate exposure using guide numbers provided by the manufacturer, you may end up underexposing many subjects. That's another reason you'll need a flash meter.

Lenses

One of the great attractions of 35mm SLRs as well as most medium- and large-format cameras is that you can use the camera body with a variety of lenses. Today, photographers have the ability to choose between a great variety of lenses, including those made by the camera's manufacturer as well as models made by companies that specialize in making lenses for cameras that were manufactured by another company.

I don't have a lot of suggestions for you about lenses because this is a matter of personal choice. I certainly think that most photographers should have a wide-angle lens, either a midrange lens or a zoom in the 28–70mm or 28–80mm range, and at least one longer lens.

Renting Lenses

I would caution that you shouldn't go out and spend $1,000 or more on a telephoto lens or a perspective-control lens or any other special piece of gear if you need it for a single job. Under those circumstances, I suggest that you consider renting the lens. There are lots of rental houses in the big cities that will even ship a rental item to you. It is customary that you

secure the value of the lens by letting the rental house put a hold for an agreed-upon amount on your credit card until the rental is completed and the lens (or other piece of equipment, for that matter) is returned to the rental house in good condition.

I've had good luck renting equipment, and renting has given me the opportunity to use a variety of gear that I would have never been able to purchase.

Lens Maximum Aperture

If, on the other hand, you know that you need to purchase a specific type of lens because it is essential to the type of work that you do, then you should do some research before you buy. One key question is whether you need a large-aperture lens, such as an f/2.8, or whether a lesser maximum aperture will do the job. Obviously, the two benefits to a lens with a maximum aperture of f/2.8 is that it will allow you to use higher shutter speeds in a given situation than an f/4 or an f/5.6 lens, and, used at f/2.8, you'll be able to count on a shallow depth of field that will throw your background out of focus and enable you to isolate your subject. This is very helpful for sports and photojournalism subject matter. Naturally, faster lenses cost more. They generally have more complicated designs and use larger glass elements to enhance their light-gathering ability. Compare, for example, the cost of any manufacturer's 80–200mm zoom lens that has a constant maximum aperture of f/2.8 with the much lower cost of a model by the same manufacturer that might have an aperture range of f/4 to f/5.6.

Zoom Lenses

My predecessor as dean at NYI, the late T. J. Marino, hated the early SLR zoom lenses manufactured in the 1960s and 1970s. He used to say, "I'm afraid if I die on a photo job, someone will stick a zoom lens in my hand and people will think I used the damn things." Andy, as everyone called him, died quietly at home, but nowadays zoom lenses have lost the stigma they once had. This is due to improved designs and manufacturing techniques. Years ago, if you bought an SLR, the dealer supplied it with a 50mm lens and tried to sell you a 135mm telephoto. Now, almost all SLRs are sold with a medium-range (35–70mm or 28–80mm) zoom lens. Most zooms are very well made.

However, I still enjoy using a prime lens. I recently bought a used 105mm 2.8 micro Nikkon and it got me back on a kick using prime lenses. I still think many of the sharpest images are made using a good prime lens and a camera on a tripod. Plus, you'll find most prime lenses have larger maximum apertures than zooms. This means you'll be able to work in lower light, and easily use selective focus with your longer lenses.

Zoom Lenses with Varying Apertures

I frequently get questions from students with regard to why zoom lenses often have varying apertures. For example, you'll get a 28–70mm zoom

lens with your camera and the aperture reading on the lens barrel might be something like "28–80mm 1:3.5–5.6," or "70–210mm 1:4–5.6." Simply stated, most inexpensive zoom lens designs do not give a uniform light transmission at all focal lengths. In the first example above, the lens barrel notation tells you that when you have the zoom lens set at 28mm, the maximum aperture is f/3.5; when the lens is at 80mm, the maximum aperture has dropped to f/5.6. When you have the lens set to intermediate settings in between those two extremes, the maximum aperture will be somewhere in between.

Prior to the advent of auto-exposure cameras, this change in light transmission used to require compensation by the photographer. Now, under most circumstances, using either automatic exposure or shutter or aperture priority, the camera will compensate automatically for the drop in light transmission at longer focal lengths. That's one of the reasons that zoom lenses have become both popular and practical with today's automatic cameras.

As an aside, this same change in aperture takes place in zoom point-and-shoot models as well, although the shift can be even more dramatic. For example, a point-and-shoot model with a zoom range of 38–115mm may see the maximum aperture go from f/5.6 at 38mm to f/11 or even f/16 at 115mm! That means that hobbyists who shoot at 115mm are going to end up with a very slow shutter speed, unless they use ISO 400 or 800 speed film to compensate for the relatively small aperture that such cameras use.

Aftermarket Zoom Lenses

Before leaving the subject of lenses, let me address one more question. Not long ago I got a call from a very talented student who had called the school to ask his student advisor whether he should buy a 300mm lens made by the manufacturer of his camera, or whether he should purchase a lens from one of the aftermarket manufacturers for about one-fifth the price of the "name" lens. The student had found the advisor's answer a little skimpy and he wanted a more detailed answer.

We get this question all the time, and any NYI student advisor could probably spend half an hour answering it in detail. Let me give you the detailed answer here. Particularly if you want a long telephoto lens or a zoom lens in the telephoto range, you will see that you can buy one from Canon, Nikkon, or the other big manufacturers for several thousand dollars or more. A lens with the same focal length, and with the same aperture size, can be purchased from an "aftermarket" manufacturer such as Sigma, Tamron, or Tokina for less than $1,000.

Is the lens that costs a fraction as much just as good? Put the other way around, what are you getting if you spend five times as much for a name lens? The answer to the first question is, "It depends." The answer to the second question is, "A few things." Let me explain.

In the electronics industry, there are lots of aftermarket manufacturers. You can buy a Sony camcorder, for instance, and buy extra batteries made by Sony, or, you can buy batteries made by an aftermarket manufacturer that will fit your Sony camcorder and cost you a lot less.

In photography, the main aftermarket is in lenses for 35mm SLR cameras. The three companies I named earlier, Tamron, Sigma, and Tokina, all make very good lenses. In fact, since the companies that make optical-quality glass in Japan sell to all the manufacturers, it's possible that the glass you purchase in a "name" lens is exactly the same as the glass in an aftermarket lens. The difference is that the major manufacturer may assemble the lens using higher-quality rings, fasteners, and lubricants. Quality control and testing at the major manufacturer may be more demanding.

The reason that "It depends" is the answer to whether the lens is just as good is that it depends on who you are and what you're going to do with that lens. If you need a long lens or a long zoom because you plan to photograph eagles three times a year when the weather is nice, you'll be fine with an aftermarket lens. If, on the other hand, you're going to use that lens seventy-five times a year in lots of nasty weather, and it will be traveling in the luggage compartment of a lot of airplanes, then you'll probably be better off with the lens that has been assembled by the name manufacturer with professional wear and tear in mind.

On the other hand, even if you plan to give the lens a real workout and use it under trying conditions, if you can't afford the name lens, then buy an aftermarket model and hope for the best. It's my opinion that there are no free rides in photography any more than anywhere else.

The most important piece of information I can give you is that I have been very satisfied with the aftermarket lenses I've used and owned. They are very well made and I've seen them stand up under heavy use. For more money, with the name lens, you will get a product that is a bit "better" in some respects, but the truth of the matter is that the aftermarket lenses by the major manufacturers I've mentioned are in most respects "good enough."

TRIPODS

I own half a dozen low- and medium-cost tripods. One resides in my car at all times, and others are at the ready at the office and in my studio. To an extent, I've changed my thinking about tripods. My advice used to be to use the sturdiest model you could handle. The problem with that is that too often I found I was leaving that sturdy model behind. Instead, I've decided that when you need a tripod, any tripod is better than none. That's why I try to carry a flimsy one with me most of the time. When I know I've got a job that will require a good one, I pack a heavier model.

CLEANING EQUIPMENT

When I clean cameras and lenses, I try to keep it simple. I've heard too many stories about people damaging their camera by cleaning it. Most of

the time, I use just three tools to clean my camera—a sable artist's brush, a rubber squeeze bulb that I use to blow dust off the lens and out of the inside of the camera, and a microfiber cloth.

The microfiber cloth is a relatively new invention. It will remove dust, grit, and even the oil left by fingerprints without the use of any solvent. I avoid solvents, treated lens tissues of the type sold to eyeglass wearers, and compressed air blowers of all types, whether they are powered by propellants or not.

Solvents I find risky and likely to spill. Treated lens tissues I find unreliable in terms of quality, and compressed air is often too strong, particularly for today's very delicate shutter mechanisms. In addition, some types of "canned air" use a propellant that, if you turn the can upside down, shoots out a burst of frozen, solid stuff. Who needs that in your camera or on your lens?

In addition to a general cleaning of the camera body, viewfinder, and lens with a microfiber cloth, I'll use the sable brush to flick off any particularly stubborn bit of dust, and I use the blower to clean out the side of the camera. The type of blower squeeze bulb that I use is one that I purchased at a drugstore, the kind used for cleaning ears and such. The bulb is about two or three inches in diameter and tapers down to a tiny opening. It provides a concentrated "puff" of air, but not the overly powerful gush that some types of canned air provide. The little blowers sold in camera stores with the brush on one end are useless as far as I'm concerned.

In a pinch, if I don't have a microfiber cloth handy, I'll use a well-worn cotton T-shirt or an often-washed cotton handkerchief to clean a lens. The more used the piece of cotton, the more likely it is to be soft and lint-free. Occasionally, if there's a really stubborn fingerprint, I'll breathe gently on the lens to let a little of the moisture from my breath settle on the lens.

When I was very young and just getting started, I was overly nervous about my equipment. Sure, your camera and lenses are precision equipment, but it's not as if they're parts of a pacemaker that you're going to implant in a human chest. They need to be clean, but not sterile. If you use the gentle types of equipment I've described and some common sense, you'll keep your gear clean and you won't damage it.

CAMERA REPAIR

September 1998: Since I let my daughter use my camera, she knows to put the strap over her neck. One day, while I am completing a job in the studio, she is attracted to the sound of the auto-rewind system of the camera I am using. She watches as I open the back of the camera. I show her the rewound roll of exposed film. I say, "Will you take it out for me?" Her two-and-a-half-year-old hand reaches steadily for the film, her thumb and index finger outstretched. Mimicking the movement I have just shown her, she reaches in and firmly grabs the 35mm film cassette. As she plucks it out, she gives a twist of the wrist, and, with a

flourish, removes the film as her middle and ring fingers accidentally twist and bend the metal hinged shutter. She holds out the roll of film and smiles. I close the camera and congratulate her on the job she has done well. I do not mention the shutter she has mutilated, since that was entirely my fault.

It cost me $300 to repair the shutter of the Nikon N-90s I had been using. I learned a lesson—modern shutters really are as fragile as the instruction book says. I can't blame my daughter since I had given her no warning.

In New York City, there are some good camera repair shops. I take a lot of equipment directly to an outfit that is an authorized service center for many major manufacturers and that also takes work directly from the public. I have also had reasonable luck with work performed by the manufacturer's technicians. There are some good repair shops that will take items sent by mail. You should ask professionals that you know whom they have used and would recommend. You can also find advertisements for repair outfits in *Photo District News* and *Rangefinder.*

If you're in need of major repairs, it's worth getting an estimate before you proceed and also an explicit description of the guarantee on the repaired parts offered by the company. I have heard lots of horror stories about repair outfits, but I've been fortunate and had good luck.

SECURITY TIP

Before closing this chapter, I have two important tips regarding your equipment. As you'll read elsewhere in this book, I'm not fastidious or particularly well organized. However, when I first fell in love with photography and owned one body and a few lenses and a light meter, I kept everything together in my camera bag, at the ready, so I could just grab it and go. Great idea. The problem was that a burglar grabbed it and went. Now, when I have a lot more equipment, I keep a body and a few lenses here, my view camera in another room, and other odds and ends in a variety of locations. I might lose some stuff, but no one but me could find everything. Don't make it too easy for a burglar.

In the same vein, I work with a dark cloth camera bag. I shudder at the thought of carrying around gear in a bright metal case. To me, those shout, "Steal me!" If you want to protect your gear from bumps and bruises, line your bag with high-density foam rubber or some other cushioning material. When it comes to bags, when you work on the street or have to travel in rough neighborhoods, the funkier the better.

I always keep two or more small flashlights in each camera bag that I use. There are lots of times when I find myself in the dark, or working in low light and I need to see what I'm doing. This way, when you're on location and there's a power failure, you'll be able to find a flashlight quickly.

In addition to a flashlight, I always keep a large plastic garbage bag in my gear. I don't carry waterproof cases unless I really think they're necessary, but a heavy rainstorm can crop up anywhere, any time. When it

does, there's nothing like a large garbage bag to prevent equipment from getting ruined.

DIGITAL AND COMPUTER EQUIPMENT

Throughout this chapter I've focused exclusively on traditional photographic equipment, and avoided any discussion of digital cameras, scanners, hardware, or software. Do you need a laptop as a photojournalist? Will Macintosh continue to retain a large share of the photography and graphic arts computer market or will Windows wipe them out? What kind of scanner should you buy?

I've avoided discussion of this type of equipment because it doesn't seem appropriate to grapple with these topics while the equipment is going through such rapid innovation and change. In chapter 10, where I offer some general thoughts about the digital revolution, I make a few observations about digital cameras and scanners. But for now, up-to-the-moment product information on digital imaging equipment is the realm of magazines and Web sites, not books. There really is a revolution going on, and we're in the midst of it.

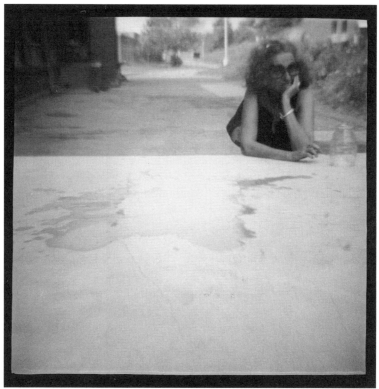

Maggie Sherwood killing time at Bedford Hills Correctional Facility, 1976. The murky, square image is characteristic of the Diana F. Waiting for the inmates to be released for afternoon classes and trying to think of new subject matter, Maggie said to me: "Maybe we can make pictures of puddles," and proceeded to use a jar of water to produce one.

Chapter 9: Training— Photography Education

W*hen the curtain came down on the night of her Broadway debut in the 1930 hit Girl Crazy, George Gershwin is reported to have beseeched Ethel Merman: "Never, but never go near a singing teacher."*[1]

Photography education is one of the topics in this book that is dearest to me. After all, I've spent much of my adult life teaching photography. At NYI, I oversee the curriculum of America's oldest photography school, speak frequently with enthusiastic photography students, and I have the responsibility to make certain that the content of our printed lessons, audiotapes and videotapes, and our Web site is accurate and up-to-date.

At other points in my career, I've also had the pleasure of teaching in lots of different classrooms with all types of students—college level, kids, seniors, patients in mental hospitals, and prison inmates. I also lec-

ture frequently at professional meetings. I'm interested in sharing what I know about photography.

But I'm also interested in learning more. Surprised that I'm interested in learning *more* about photography? Don't be. I could take a course or two every semester and frequently go to workshops, but I still probably wouldn't be able to learn everything that interests me about photography. Plus there are new developments in technology to fathom, and sometimes it's fun to have familiar information presented all over again by a great teacher. If I live to be 180, I still won't have enough time to investigate everything in photography that fascinates me.

That doesn't mean that I have to keep studying. I'm interested in learning more because I choose to, not because I have to. There's a danger in thinking you need to be a student for too long.

I'm also interested in how other photographers developed their technique. To that end, whenever I can, I ask photographers how they learned photography, and I've heard about lots of different ways that photographers have broken into the business.

The truth of the matter is that there is no best way ("no one way") to learn photography, and there's no way that can't work. You must find out about the avenues available to you, decide exactly what it is that you wish to learn, and set out on the method that you think is best for you.

Be prepared for digressions, and, when possible, welcome them. Don't be unwilling to change methods or to modify your plans as you go along. You may learn things about yourself, or about what you really want to learn, that will cause you to change course for very good reasons.

You also may find that you've started in with a teacher (or method) that's wrong for you, possibly even harmful for you, and then it's time to cut your losses (both financial and psychic) as soon as possible and take a different tack.

No One Way of Learning

I suppose this is a corollary to postulate 1. Before we get to the specific methods you could use to learn more about photography, let's spend a moment on the phenomenon of learning anything. Studies show that there are some people who learn better by reading about something, whereas others learn better and more quickly by watching a demonstration or listening to a lecture. Similarly, experts now recognize different types of intelligence, such as spatial, musical, bodily, or intrapersonal. Who you are, what types of intelligence you possess, and your best methods of learning will all factor into what kind of training makes sense for you.

Let's list the basic methods of studying photography that are available.

Traditional High School and College Training

Whether you're looking for a full-time degree program or wish to study on a course-by-course basis, there are lots of good college courses and a lot of

great teachers working in college and high school settings. Residential programs tend to be expensive, and make the most sense for full-time students who have the time and the money to invest.

In fact, the discrepancy between the dollars-per-credit for education that leads to a high school diploma or a college degree and the much lower cost of good vocational training is one that I think will be called into question in the next decades of the expansion of education in the United States.

May 1962: I'm called in for a meeting with my vocational guidance counselor at Highlands Senior High School in North Sacramento. He asks what I plan to do after high school. I tell him I want to go to college and become either a writer or a chemist. He suggests I might be setting my sights too high and recommends that I consider a two-year refrigeration engineering program at Tulane University.

One aspect of high school education that should be taken into consideration is the generally poor level of career counseling. I didn't bring up that odd career advice to make fun of the counselor, but he hadn't asked me anything about what I wanted to do, or anything else. I'm sure there have been a lot of successful careers in air conditioning and refrigeration engineering that were launched at Tulane, but I just left and wrote him off as a buffoon and the notion of career counseling as a waste of time.

I hope the field has improved since then. Obviously, it's a little difficult to expect high school–age people to have a clear idea of what they want to do when they "grow up," but I did meet some interesting people years later who did career counseling at Columbia University. Their idea of a job search was to start by taking a hard look at what it was you really wanted to do.

A colleague of mine, Tom Saxon, is a professional interior designer. When he told his high school career counselor that he wanted to be an interior decorator, the counselor told him he didn't know what that was. A lot of us found our careers in spite of career counseling.

THE CATHEDRAL MODEL

Classroom-based education is sometimes called the "Cathedral Model," which refers to the early centers of classroom learning that were created by church-based institutions in the Middle Ages. Before that, the only model of education was the master-apprentice system. Although that worked well for the manual trades, as education grew to encompass more intellectual activities, it was seen as more efficient to have a number of students congregate around a single teacher. Of course, in today's hectic world, the costs of maintaining classroom space and support services for a large number of students factor into the challenges facing traditional education.

In a field like photography, there are a few other problems with traditional classroom training. First is what I've heard called the "sage on the stage" syndrome. People who stand up in front of a class of impressionable high school–age students, or even callow college students, are motivated

in part by the authority and attention they get. Sure, they want to educate you, but they also may want to persuade you to share their interests, tastes, and philosophy. That can be a problem for some students.

In addition, for degree programs, there's usually a lot of testing that's necessary. That means you may end up having to learn a lot about chemistry (What is the principal chemical in fixer? Hint: There's a reason it used to be called "hypo") or physics (What is the range of wavelength of blue light in the electromagnetic spectrum, measured in angstroms? What is the temperature of candle light in degrees Kelvin?).

I consumed a lot of traditional education, and I can answer each of those questions. But, I have to tell you, I don't (and, more importantly, you don't) need to know those answers in order to become a good photographer. They're just test questions for most of us.

HOME STUDY—DISTANCE EDUCATION

I learned late in life the beauty of home study, or what used to be called "correspondence" education. A field that still has a number of questionable practitioners has now wrapped itself in a new mantle; it's now called "distance education." The old correspondence schools are competing with venerable institutions like New York University, which recently announced plans to create a for-profit (which raised academic eyebrows, since NYU is a well-endowed nonprofit institution) distance education program focused on degree programs taught over the Internet. NYU officials even went so far as to say that if the venture works, they may spin it off in an "IPO" (Initial Public [stock] Offering) and "go public."

Clearly, home study—a.k.a. distance education—has reached a new level of respectability. As well it should. You can work at your own pace. A good course should supply you with training materials in written, audio, and video form, whether delivered in traditional hard-copy fashion or transmitted over the Internet as hypermedia streaming audio and video and downloadable FTP files. You work at your own pace; if you're quick, you can move forward in a way that the classroom won't permit, and if you need to review something several times, you won't be holding anyone up.

Distance education is great for people whose schedules don't fit classroom rhythms, and can also be good for parents with young kids, people who need to polish their English while studying a subject, and people who are recuperating from an accident or illness.

APPRENTICESHIP AND ASSISTING

Working as an assistant is a great way to gain practical experience. It's generally best if you start with some knowledge of your own, so you'll bring more to the mix with the person. As I mentioned earlier, the cathedral model supplanted to a large degree the traditional vocational training sequence of apprentice, journeyman, master. Working as an assistant in many ways harks back to that kind of "hands-on" training. In many fields

it's always been necessary to augment classroom work. For example, in medicine the internship and residency requirements give young doctors hands-on training under supervision.

I suggest that you bring some skill to this kind of work so that you don't get stuck working mostly as a "gofer" and cleaning person. It's also important that you work with someone who is good, who is willing to teach you some things, and who can delegate authority. Otherwise, no matter how skilled you are, you may end up as a gofer.

INTERNSHIP SHOULDN'T EQUAL SLAVERY

By the way, in lots of fields besides photography, the concept of "assistant" or "apprentice" has been subtly altered to "intern." The key seems to be that interns aren't paid. I have a problem with this concept. It seems unfair to young people who are interested in a field, most of whom have spent some serious money on college-level education, to be asked to spend a year or more in a glamorous industry working without getting paid anything at all. I'm seeing this more and more in photography as well as publishing, journalism, and a few other fields. People should be paid a minimum wage regardless of what they do. Just because young people can be made to work for free doesn't mean it's a healthy thing to do.

Not long ago I had the opportunity to interview a photographer who had a B.F.A. degree in photography from one of the best schools in the New York area and who had been working as an intern and assistant for about five years. She felt that her prior educational experiences had left a lot wanting. She felt that her B.F.A. training had given her a good sense of photographic technique and imagery, but little business training. She also felt that her work as an assistant for famous photographers had included little more than filing photographs and tidying up the studio.

Photographers who use assistants, on the other hand, often have their own opinion of how well (or poorly) things work. Particularly in the high-stakes world of commercial and advertising photography, I've heard complaints from pros who find the best assistants highly aggressive and prone toward staying for a few months to learn the photographer's secrets and then quitting to go into competition with the photographer, perhaps taking a few customers (or even the photographer's Rolodex of clients) along with them.

This creates a bit of a dilemma for both the pro and the assistant. If there's reason not to trust the assistant too much, then that mistrust will put a crimp into what the assistant, even the one who harbors no ill intentions, will be taught.

Fortunately, there are lots of assistant jobs in wedding and portrait studios around the country where the photographer will be more than happy to teach the assistant everything about the work that the studio does.

How do you go about finding such a situation? My friend Monte Zucker, who has maintained many studios in his more than fifty years in

the business, once explained it to me very succinctly: "If I wanted to be an assistant to a certain photographer, I would first look at what parts of the studio's work the photographer least likes to do. Then I would present myself to the photographer and offer to handle those jobs. For example, I know a great deal about posing and lighting, but I'm overjoyed if my assistants can make sure the radio-controlled flash equipment we use for candids is working properly and the lighting ratios are set right."

In addition to working with many young photographers as his assistants, Monte spends many hours counseling young photographers about how to improve their jobs assisting other photographers, even offering opinions as to when it is time for an aspiring pro to stop assisting and move on.

A WAKE-UP CALL TO COLLEGES

A few years ago, I attended a seminar given by a successful commercial photographer from the Southwest. His thrust was that in today's evolving world there is more and more business for photographers who are based in places other than New York, Chicago, and Los Angeles. He discussed his major client roster, and the benefits of living where costs were lower. Then he raised one real problem—he had a hard time finding good assistants!

It turns out that not many aspiring photographers were coming to his city. Rather, those with dreams were more likely to head to—of course— New York, Chicago, or Los Angeles.

So he turned to the local university, and the photography department there was more than happy to send over students from its predominantly fine-arts photography department. Each student lasted no more than a day, often leaving the studio in tears and returning to the college with tales of what an awful person the photographer was.

He was, he assured us, not awful, but he was aghast at what these "assistants" didn't know. How to load and mark spare backs for a medium-format camera, how to balance ambient and flash lighting for the right ratios for shooting transparencies for publication, how to anticipate the photographer's needs, when to shut up on the set . . . he could go on and on.

To the university's credit, the department head called this "ogre" to discuss the matter. Upon hearing the photographer's side of the story, the teacher had one question: "Will you come and teach a class here at the university?"

That's a progressive academic. I've spent a lot of time in very high-powered and elite academic settings, and I'm amazed at how many of the people in charge seem dead-set against too much "real life" intrusion. That's a mistake. Just because you go to Harvard or Yale, you still need to learn to deal—how to hustle clients, collect bills, and stall the bill collector when times are tough. I've overheard Ivy League–educated kids ask their parents to make their plane reservations! The sooner you take charge of maintaining your own life, the better off you'll be.

College and university photography departments should take a hard look at the *balance* of what they're teaching. Make sure there's not too much Nan Goldin, Jerry Uelsmann, and deconstructionist theory, and too little Real Life 101 in the curriculum.

PRIVATE STUDY WITH A PHOTOGRAPHER

This can be a great short-term strategy to sharpen your skills in a specific area of photography. Want to learn the tricks of a food photographer? Find one who will teach you, not by hiring you as an assistant, but by sitting down with you and answering your questions and showing you what you need to know while you pay her for the privilege of sharing her knowledge and skills.

This is a tactic that only works if you bring the requisite amount of knowledge and skills to the table. Make sure you have the fundamentals of cameras, exposure, and optics worked out before you approach a professional with this sort of request. If you need training in the fundamentals, this sort of one-to-one training in a specialized area generally won't work.

SPECIFIC VOCATIONAL TRAINING

This category includes various types of job training—military, small newspaper, corporate, and law enforcement being the most common. Sometimes the people selected to become photographers in the workplace aren't necessarily people who pine for the job, but specific vocational training can be a great way to learn basic photography skills. Some fields may be narrow—for example, law enforcement photographic skills cluster around surveillance and forensic documentation—but the chance to immerse yourself in photography in an on-the-job situation can be the least costly way to learn photography.

The military branches all have very active educational programs, and for years, the Navy Photographer's Mate training program has been held in very high regard.

SEMINARS

As I've noted, I love taking in a good photography seminar. You'll find lots of offerings at the annual state and national conventions of the Professional Photographers of America (PPA), an organization I'll discuss in detail later, as well as the national annual conventions of WPPI, Wedding and Portrait Photographers International. The quality of the seminars will vary a bit. You'll find some big egos who only want to show you their photos and tell you war stories about their experiences without teaching you very much. On the other hand, you'll find photographers who are very good teachers and who are willing to share everything they've learned with willing students.

There's one "big-name" photographer (who, here, will remain nameless) whose lecture I attended ten years ago in Atlanta. I was not impressed,

but people kept telling me how much they enjoyed his presentations, so I caught his "act" a decade later in Las Vegas under the auspices of another organization. It hadn't improved. However, I realized that lots of people found his war stories entertaining. They laughed. They were being entertained, but they had confused entertainment with education.

I have nothing against education that is fun. Quite the contrary. I think education should be entertaining, but the laughs should never obscure (or substitute for) the lesson. If it does, it's not education.

Attending state or national conventions can be expensive. Travel, hotels, meals, and the like can really add up. If you make the commitment to attend such events, make sure you put in the time to take in as many seminar programs as possible. Even though you may be in Orlando or Las Vegas or some other entertainment center, plan to take in the sights for a day or two before or after the convention. While there are things to be learned, try to stay in your seat and be prepared to take notes.

There are also a number of organizations that offer seminars at a fixed location. Usually there will be a combination of regular topics offered by the resident staff and special offerings by visiting photographers. The Santa Fe Workshops and the Palm Beach Photo Workshop are among the largest programs.

THE BARNSTORMERS

In the course of any given year, there will be a lot of seminars presented near where you live. Over the past two decades, more and more pros have taken to putting on traveling shows that present information about their photography or their philosophy in six, or twelve, or more different cities in a year.

Sometimes these are low-cost affairs ($29 to $59) for a one- or half-day program; sometimes they are more expensive. There are some great presenters who have worked in this fashion, including my friend Monte Zucker, the legendary Charles (Chuck) Lewis, Ed Pierce, and many others.

If the cost of the seminar is low, expect that you'll be offered the chance to buy some stuff (videotapes, books, or special equipment) at the end of the presentation. That's OK. You don't have to buy the books or tapes if you don't want to. But if you've gotten great benefit from the presentation, you may find the other products worth purchasing.

TO BE AVOIDED

Before we leave the world of seminar presenters, I have to warn you that there are people who only "pretend" to be teachers. There's a problem with teachers who are posers. They may have fun, they may do OK, but if they're not careful, they may seriously harm a student. There's a responsibility to being a teacher, just as in other professional relationships where two people inherently have an unequal status relationship, such as doctor/patient or lawyer/client.

Students have to trust teachers. They should be comfortable being themselves—and revealing themselves—in front of a teacher. A "really, really" big-name photographer launched a "world tour" a few years back. Big, free seminars were offered in half a dozen major cities sponsored by several major photo manufacturing companies. Each program drew hundreds of young photographers. There were multiscreen presentations of beautiful photographs with driving music scores. The big-name photographer and his assistants all had embroidered satin jackets promoting the tour. The equipment overkill required a host of roadies.

Everything starts with flash and splash in the photos. Then Big Name begins his presentation. The pace accelerates and accelerates. He's talking a mile a minute, then he cranks it up to two miles a minute. I'm starting to suspect that chemical copilots are assisting this flight, or maybe it's a natural chemical imbalance in the brain.

Anyway, soon our "sage on the stage" hits the verbal equivalent of Mach 1 and the whole place starts to vibrate. It's not just the pace, but the whole presentation has a loopy, sneering structure all its own. He's lashing out at art directors—as best as I can understand, all of them are congenitally stupid—as well as tasteless clients, incompetent assistants, and poor photographers. I sidle over to a representative of the Major Film Company that is one of the sponsors of this out-of-control spectacle: "Did you really put this guy in front of all these people to knock all the art directors, clients, and photographers who use your products?" I ask.

"No comment," he says. It was obvious that the sponsors had lost control of this dervish. Back on stage, it's approaching time for the intermission. "Are there any questions?" Big Name spits out. One hand timidly rises from the middle of the audience. A woman stands. "Mr. Big Name," she says politely, "Could you possibly speak a little bit more slowly?"

Big Name sucks in a breath, puts the wireless microphone up to his mouth, distorts his face and starts to lurch sideways. It's his best Jim Morrison imitation, complete with sneer. "OOOHHH. W-o-u-l-d t-h-i-s [pause, mouth distorted like a stroke victim] b-e-e-e b-e-t-t-e-r for y-o-u?"

The lout is mocking this young Asian woman who earnestly wants to understand what he is saying. That she can't understand is no fault of hers. He's talking too damn fast. In making fun of her, he's also mocking people with speech disabilities or mental impairments that affect their ability to communicate.

That was the single worst moment I've ever witnessed of a purported teacher taking advantage of a well-meaning student. In fairness, I know photographers who have worked and studied with this Big Name who speak well of him, but that one moment left a lasting impression. I was reminded of it when I saw the videotape of Mike Tyson biting off a chunk of Evander Holyfield's ear. Same out-of-control attempt to hurt. At least Tyson and Holyfield were in the middle of a prize fight. All this woman wanted was for the teacher to speak a little more slowly.

SELF-TAUGHT

There are lots of very successful and talented photographers who are entirely self-taught. This is particularly easy for people who have an intelligence and learning style that allows them to easily find the right questions and then develop the answers. I do find that many self-taught photographers are a little reluctant to admit their lack of formal training. They shouldn't be. However, if you do learn things on your own, you may find it helpful to spend a brief period with a mentor or colleague merely to validate the fact that the way you're doing things is a good, efficient method.

LEARNING ON THE JOB

This is going to happen to you regardless of how much you study in any of the other methods I've listed previously. Recently I heard a marvelous "my first day on the job" story told over the radio. The veteran cop recalled his first day on the job when, against department guidelines, he agreed to help a couple get a squirrel out of the attic of their suburban home. Within moments, the squirrel had bolted past the cop down into the house. The startled cop dropped his flashlight, smashing the nose of the upward-looking husband standing below him on the attic ladder. The squirrel darted under a sofa in the living room. Attempts to coax the squirrel into a box with the officer's nightstick had the unintended result of causing the squirrel to dash into the fireplace. Unfortunately, there was a fire there and the squirrel's fur caught on fire. When the squirrel dashed back under the sofa, the dust accumulated under it caused the entire sofa to burst into flames. Within minutes, the well-intentioned cop had ruined the couple's home.

In addition to the humor of the tale, the cop went on to explain that police work gives ample opportunities to make new mistakes when confronting new situations. It was, in the eyes of this now-veteran law enforcement officer, particularly easy to make mistakes when you undertake things that aren't your responsibility and when you approach it with no plan of action.

That's equally true for most photography jobs. You'll end up moving furniture and playing makeup artist and fashion designer. If the budget (or planning) permitted, you would never undertake these responsibilities, but you won't have the luxury of saying no in most circumstances.

The key is to try to have a reasonable plan of action. If worse comes to worst, you can abandon that plan and reformulate a more modest one, but if you start without any plan, like the hapless cop in the story above, you'll end up with a mess on your hands and unhappy clients.

YOU'LL NEVER LEARN IT ALL

I firmly believe you don't need to know everything there is to know about photography—because you can't. The techniques are constantly being changed, and the scientists constantly make new tools available for our

use. Rather, you need to learn to think like a photographer. That is, just as physicians are trained to think like doctors to solve health problems, or as lawyers are taught to tackle legal questions, it's necessary for you to learn to think like a photographer and learn how to ask the questions that will enable you to solve the problems you encounter.

Once you learn to think like a photographer, you can solve *any* problem because you will have learned one of the most important skills ever: how to ask the right question. NYI Director Don Sheff tells a very interesting story about a now-deceased friend of his, a very successful publisher and extremely rich man whose family has gone on to undertake important humanitarian efforts. As a boy, when he came home from school, his mother, instead of asking him how his day went, or what he studied, always wanted to know: "Izzy, did you ask a good question today?"

Don't dismiss this as a clever saying. If you remember only one thing from reading this book, please remember that anyone can find the right answers; the real trick is learning to ask the right questions.

That's how you know what to study and when to stop. If you learn how to ask the right questions, you can solve any problem. You'll just break it down into individual questions and then find the answer to each individual question until you have the big answer that you need. If you learn to ask questions, you can solve problems. And if you can solve problems, then you'll be able to find out everything you need to know.

The questions to ask aren't just about photography. A photographer is more than just a person who can control tools and techniques to solve visual problems. A photographer is also a human being, with a point of view, strengths, temptations, and weaknesses. That's why it's important to answer the questions I posed in chapter 4. You'll discover that your answers to those questions will give you great insight into thinking like the photographer you wish to become.

Remember: You want to get training (or more training) to be a photographer. You're not learning brain surgery or how to fly an airplane. Those are both areas where there's lots of specific knowledge required and lots of training to learn very complicated procedures, which must be performed quickly and in just the right order or lives will be at stake. Fortunately, in photography, most jobs can be reshot, and it is rarely a matter of life or death. That's not to say you should photograph a wedding if you don't know what you're doing, but there are ample opportunities in photography to take the picture, then process, then look and learn (by asking the right questions) and then to reshoot, process again, and look again.

Just Do It

Not long ago I read an interesting tidbit in an obituary about a man who made a midlife decision to become a novelist. The specifics aren't important, but it's worth noting that he did become a successful writer. While considering this career change, the man happened upon Ernest Hemingway

in a bar in Key West. He had the moxie to approach Hemingway and tell him of his desire to become a writer. While he thought he had the ability, he wondered if Hemingway would advise that he seek formal training of some sort. Hemingway allegedly paused a moment and then gave him a four-word answer: "Just write every day."

Great advice. Just photograph every day. Not long ago a prospective student dropped by NYI seeking advice about residential training programs in New York. As it turned out, she had already earned a B.F.A. and an M.F.A. in photography from a prestigious Midwest school. We were a little tough on her, but it was obvious that she had studied enough. It was time to go to work, either on her own or as an assistant. Enough is enough.

In closing, just remember one thing about studying photography: It never ends. That's because you never know everything there is to know, and even if you did, more stuff that you don't know is always being invented. But, even more important than this, "information overload" is the fact that learning should be a leisurely, lifelong experience.

Notes

1. *Vanity Fair*, February 1992, page 174.

Luxor Hotel, Las Vegas, 1996. Las Vegas flash at its high-tech best. The Mir Cosmonauts reported this was visible from their orbit.

Chapter 10: Digital Present, Digital Future

Ten years ago, when I started thinking about this book, the big talk at photographers' trade shows was "still video." The technology driving those systems was interesting, but it was based on analog recording of still images on videotape or disk. Although it was pitched to pros as a big deal, it didn't really offer that much potential to change the way photography functioned for the photographer, the client, or the audience.

PLEASE PASS THE CHIPS: THE DIGITAL REVOLUTION

Ten years later, the digital photography revolution has been in full swing for a little more than five years. The computer and the camera have collided, and this is a true revolution. The changes are sweeping, and there are clear benefits for photographers, their clients, and the audience that is exposed to new types of visual imagery. Equally interesting is the speed with which this bundle of changes is taking place. There have also been casualties from the collision, as we'll cover shortly.

THE SPEED OF THE CHANGE

In June 1951, the CBS television network transmitted the first color broadcast for television. Admittedly, early color television was crude compared to today's all-color television world and, granted, only special "color TV sets" could receive the benefit of these color broadcasts. Color television spread slowly. It was not until 1971 or 1972 that the sale of color television sets exceeded the sale of black-and-white models.

Twenty years!

FILM TO DISAPPEAR?

I've already mentioned the industry guru who gave film fifty-four months to live in 1996. In early 1999, there was no solid proof that all film would be replaced by digital imaging, but we'll have to wait another couple of years to see for sure. I doubt it.

Not long ago, the *New York Times* reported the initial laboratory development of blue-light LEDs, which will allow the content of digital media that depends on laser-reading technology, such as CDs, DVDs, and laser printers, to be condensed into a much tighter area, allowing for greater storage capacity on the CD or DVD, and a crisper, more photolike image on the print made by a laser printer.

As I write about these two technical points—film's demise and more improvements in laser/CD capability—I'm fully aware that by the time this book gets edited and printed, much less by the time you get around to reading it, these points may have been answered and enthusiasm diverted to other, newer, even more amazing technical innovations.

These are just two of many, many stories of technological development and critical predictions stemming from the rapid onset of digital imaging. The pace is dizzying, the technical jargon being tossed about is enough to cause all but the holder of a doctorate in computer science to feel ignorant and insecure.

Summer 1998: I take a three-step running start and fling the object with all my might. There's a gentle upward arc and then gravity pulls my ink-jet printer down into the large empty metal dumpster a level below me at the local recycling center. When it hits, the crash is satisfying, and I can see the plastic case splinter. The thing probably cost $400 a few years before. It printed black-and-white text fine until it stopped feeding paper reliably.

Sharon Gumerove, photographer and NYI's Web master, had finally convinced me. It wasn't worth trying to fix printers that were so obsolete. Even though the printer probably needed only a few new rubber grommets, a cleaning, and an adjustment or two, the cost of service and shipping might exceed that of a new printer, she patiently explained.

Sure enough, now I have a printer that's four-color, twice as fast, better designed and *half the price* of the one that lies in shreds in the dumpster. Don't expect to find me tossing out my twelve-year-old Nikkon F-3s, my very

old Leica IIIc, my Pentax Spotmatic, or my Omega D-2 enlarger. They're all doing just fine. Besides, their age isn't counted in computer years.

DeLaney's Razor (apologies to Ockham)

A couple chapters back, I compared cameras to razors and analogized that film is like razor blades and shaving cream is like processing. That $200 color printer seems all the more remarkable when you find out that the replacement ink cartridges (you usually need two) run about twenty bucks apiece!

I remember when it was predicted that computers were going to usher in the era of the paperless office. Well, if your office is like mine, there's more paper than ever, and with the profit in ink cartridges so high, I don't see any force out to curtail paper.

Regarding film's demise, here's how the guru figured the numbers— eighteen months is considered a lifetime in the computer field. The computer guru who gave film fifty-four months to live based that calculation on his guess that three more eighteen-month cycles would bring computer images up to par with film-based photography.

As I said, I doubt digital cameras will *ever* completely replace film cameras. I think the computer guru is right about computer innovation, but I don't think he knows that much about photography.

Keep Perspective

There's no reason to buy into this hysteria. Yes, digital imaging has arrived in photography and more and more applications that have been handled with conventional silver-halide–based film will become the realm of digital imaging.

But computer imaging will become increasingly important as a method of manipulating images, and photography will go on. The medium will just become more powerful yet again.

Things didn't always change this fast. The current acceleration is enhanced by the fact that the larger, richer computer industry has consciously taken aim, since about 1995, at the photography industry. That's not a bad thing, because nothing can happen that will damage the power and potential of photography. Rather, as we discussed in chapter 2, these changes will only increase the power of photography, and the basic principles, the technique, for making a good photograph will be little changed by the sweeping innovations in technology.

Photography has endured when other technologies have been superseded. Photography has incorporated new technologies while retaining its essential character. It has only been augmented and enhanced.

Ten years ago I was invited to Washington by the Professional Photographers of America to attend the rededication and unveiling of a monument to Louis Daguerre that had been out of public view for some time. The monument had originally been given to the Smithsonian by the then-called Photographers Association of America in 1890.

At the base of the statue was inscribed the following observation over one hundred years ago: "Photography, the electric telegraph, and the steam engine are the three great discoveries of the age. No five centuries in human progress can show such strides as these."

It's easy to look at all that has happened in the subsequent century and marvel at how off base that inscription seems today. Indeed, around the same time as the original dedication of the statue, the head of the U.S. Patent Office wrote to the president and congress suggesting that the office could be closed soon, because everything that needed to be invented and patented had just about been completed.

That was clearly an age imbued with a sense of its own accomplishments. Yet there were some who had faith in photography and its promise for the future. The program for the rededication reprinted a poem that was written by one Clarence B. Moore of Philadelphia in honor of the occasion of the original dedication. No doubt the poem was read on a hot August day in 1890. The last lines of the poem read:

> We have followed the path that he opened
> To realms then unpictured, unknown;
> But our journey is only commencing—
> An ungathered harvest is sown.
>
> We've a lens which takes in the horizon;
> We have cannon-balls caught in mid-air;
> We shall next take our picture in colors,
> Long life to the Art of Daguerre!"

The electric telegraph and the steam engine have been superseded, but the "Art of Daguerre" only grows more powerful with passing time.

THAT WAS THEN, THIS IS NOW

To understand what's involved, and to offer a few general predictions about where things are headed and how you should prepare to meet the digital revolution, let's start with ten precepts and examine them one by one.

1. The technological developments that make digital photography available to the pro and amateur alike have been made principally for larger, more urgent markets in medicine and the military.

The professional and advanced amateur photography market is not big enough to lure big dollars in research and development. That means that a lot of the new "bells and whistles" that come into the photography market, particularly on hardware, have been developed for other, larger imaging markets.

This appendage of the word "imaging" onto photography is one that the industry is still trying to digest. Personally, I think it's a mistake. In an

era when names mean a lot, and we have "wireless cable," I think photography remains photography and to try to look modern and forward by appending the term "imaging" onto it is a mistake.

There's no question that the big, *imaging* markets in this era are the military and the medical worlds. There's a lot of money and a huge market in both. The eye-control focus mechanisms that have been brought to the SLR market by Canon (and, interestingly, to date only by Canon) originate in military sighting tools. Similarly, predictive auto-focusing mechanisms are related to sighting and delivery systems of military hardware. Who can forget those video clips of the bomb going right down the chimney of some building during the "Operation Desert Storm" bombing of Iraq?

Similarly, digital imaging tools have been of vast value in diagnostic medicine and surgical techniques. The ability to see what's going on inside the human body without invasive surgery and the ability to perform surgery with less invasion all stem from modern-era imaging tools.

2. The people who sell computer products have sold a lot of hardware and software to lots of different industries in the past two decades. Photography is set to play a key role in the next stage of computer sales.

The overwhelming success of computer sales over the past two decades has transpired *despite* the original business plans of lots of key players. If you look back at advertising during the past two decades, some of the blunders are remarkable. I remember when IBM decided to sell what would now be instantly recognized as "PC" type units through retail stores and licensed Charlie Chaplin's tramp as a celebrity endorser. Huge flop. Too soon? Too few applications? Who knows.

Bill Gates's first book, *The Road Ahead,* extols the virtue of a computer-assisted world. I don't think I want to live in the type of "house of the future" he posits, and I don't really need a supersmart credit card, and I don't mind the hassle of airplane tickets. The interesting thing is that despite all these *Jetsonesque* predictions, the first edition of Gates's book lowballed the Internet just as it was coming to the fore of American culture. Does farsightedness justify such an American "visionary" missing what's just beyond people's noses?

In reality, lots of Gates's predictions of big-wall images and domestic comforts in homes the size of airplane hangars appear to be geared only toward the upper classes. That's not who is driving the digital revolution. All "killer applications" become must-haves for the middle class—that's what makes the Web such a major development.

3. Anything you buy today will be outmoded in eighteen months, and possibly obsolete in a few years. Consumer and "prosumer" products now drive the market; high-end professional gear follows.

While I don't think three cycles of eighteen months will make film disappear, the eighteen-month "lifetime" theory is not without validity. Not

long ago I interviewed the owner of a cutting-edge digital darkroom "service bureau" in SoHo that caters to lots of photography clients. How, I wondered, did he find the right equipment to buy, and how did he budget for its obsolescence?

I was interested because this is a major difference between a digital lab and the traditional custom photo lab—the cost and life span of equipment. There are lots of custom "wet" labs with enlargers and copy cameras that may be ten or twenty (or more) years old. The amount of technical innovation has been limited. But when it comes to computers, scanners, and printers, each generation of equipment is "new" for (at most) eighteen months before something faster, better, or completely different comes along.

At his digital lab, the owner figures he's lucky to get three years out of a piece of equipment before it needs to be replaced, and by that time there's little resale value left because everyone is chasing the latest product. The owner told me, "If we purchase wisely, we have an edge over the competition for six to nine months, then we're competitive for at most another year, and then you start to fall behind. If the staff is extraordinarily good in getting results from a piece of equipment, it may be possible to extend the life of that piece of equipment a little longer."

This is a high-stakes game and one that requires a vastly different mindset than that of the photographer who purchases a medium-format camera or an enlarger with the knowledge that it will serve in the studio for a lifetime and could become a legacy to the next generation. When you're buying equipment that costs tens of thousands of dollars and is likely to be obsolete or, at best, outmoded in a few years, you better choose carefully and be sure you have enough customers to make your money back quickly.

How does the lab decide what new equipment to buy? Not so much from trade magazines and trade shows, it turns out, but rather from listening to his employees and checking new products on the Web. As the owner notes, "The buzz comes quickly."

4. Prices are dropping and quality is rising in all areas of photo-related digital imaging equipment.

Back to the Photo Marketing Association: In 1996, there were half a dozen early consumer-level cameras at the show. In 1997, there were over one hundred models. By 1998, speakers told us that all non–mega-pixel cameras would be obsolete by Christmas and retailers stuck with them would have to dump inventory. The current ruler of the category is the "true" mega-pixel camera. (Mega-pixel just means a million or more pixels that are being used to form the image that the camera's CCD chip can capture.) By the time you read this, 2 million–pixel cameras will be the norm.

What lies ahead? C-MOS technology will or won't supplant CCD chips (depends on which expert you talk to) in the next generation or

surely, if not then, in the generation after that. Unless, of course, something comes along and changes the nature of the playing field altogether.

How do you deal with this blistering innovation? Hunker down. Don't buy unless you have to. Don't buy anything unless you have a very specific application for the tool and see a way that you can justify the expenditure over a two- or three-year period.

5. "Plug-and-play" isn't here yet.

I first heard the term "plug-and-play" in 1992. For most people, putting a new piece of equipment into a computer system is still a headache of trial and error and countless calls to technical support. Only a few gifted souls with an intuitive sense of why the computer isn't doing what the manual claims it should be doing, can get this stuff installed without a lot of time and effort. Only a few of us can pop an SCSI expansion board into a computer, close up the box, and have everything work the first time.

Some of us who aren't gifted in making computers behave still like the investment of time and frustration. I don't. If I need it done on a computer, I get someone with the gift to set it up while I watch and express my gratitude. I attended an industry dinner recently where the consumer digital camera market was scrutinized. Sony has grabbed a huge market share with its digital Mavica models, the name a holdover from the old still-video Mavica products of a decade ago. Everyone agrees that the principal pull of the Sony product is the fact that it uses a conventional 3½-inch diskette. The consumer, confronted with a digital camera, didn't want to learn about storage using PCMCIA cards or smart cards or transfer via fire wire. The diskette was a touchstone of familiarity. The fact that the storage capacity was limited didn't matter. It was familiar. It was plug-and-play.

6. Film will be around in some form for many years to come and will continue to have adherents. Hence, learn to scan.

At that same industry dinner that lauded the Sony diskette-based camera, a major dealer stood up and acknowledged that the new mega-pixel cameras are great, but he continued, "They're also lousy."

"Let's be honest," he confided, "the best digital camera is the best film camera you already own. Shoot film and then scan it." Plain talk, and true. Film is still easy to shoot, sort, and store. And any photo can be quickly digitized by having it scanned.

Film is also easy for publishers to handle. At the current time, traditional printing is undergoing its own technical revolution, with CTP (computer to printing plate) the coming rage. But lots of printers can't handle CTP just yet, and there will be lots of smaller printers (and printers in smaller countries) who will be working with traditional film and negatives for a long time to come.

Right now, the photo industry, with its new computer partners, is principally focused on the amateur snapshot market. Will amateur photographers eschew film and go digital? Will granny really want e-mail photos of her new grandchild? Will processing results over the Net catch on? This is another of those questions that may be answered by the time you read this, but it's up for grabs as I write.

Scanning is also a way of preserving images and perhaps the basis of a workable storage and sorting system, depending on the nature of your photography. While color negatives and prints may fade, if the image is scanned, as long as you keep abreast of new technologies and convert your scan from the late 1990s standards of JPEG and GIF files to whatever comes along next, you should be able to keep an image fresh for a long, long time.

Lots of devotees of Photo-CD are letting Kodak or someone else with a CD-burner do their scanning for them. While Photo-CD never caught on with the amateur market, there are still a number of valid professional applications and I suspect those will be around for a long time.

7. The Internet and the Web have created a genuinely new communication and entertainment medium. It may mutate, but it's not going away. Research shows that there are now more Web sites than there are human beings on the planet. How do I know? I read it on some Web site somewhere. Seriously, that's not true, but I'm sure there is some site that is broadcasting exactly that sort of information.

Remember the first time you said "dot com?" It felt funny, didn't it? Now it seems as commonplace as zip codes. There will be lots of mutations in the next few years. I'm reminded of television, which I think of as the most recent new-medium precursor of the Web. They didn't know what they had on their hands at first. Early TV news mimicked the movie newsreels. Live shows imitated vaudeville stage shows. And no one knew what products could be sold on television and how to make an effective commercial. The first televised presidential debate was between Kennedy and Nixon in 1960.

Right now, the Internet is the darling of Wall Street. Firms that are two to five years old and have never made money are able to raise millions by selling stock. However, there are still a lot of wrong turns. The gush over "push" technology of a year ago has given way to interest in "portals," sites where you enter the Internet.

One thing that strikes me about the medium is that it's a quick way to do research, but you can't be sure of the reliability of that research. Anybody can be an "expert-in-this-or-that.com" or ".net" or whatever. I expect we'll start to see associations and "net" works develop that promise the user a certain amount of supervision and oversight of the links within that association.

8. Most of the skills you need to prosper in digital imaging are the same basic skills that you need to succeed with a film camera of this year or even yesteryear.

It's still necessary to know how to capture a great image, and sales and business technique are not diminished in any way. I don't think there's any need to elaborate on this point.

9. Content is still king.

You go to the UPS Web site to see if your package has been delivered. You don't go there for entertainment. Photos are the keystone of many Web sites. More power for photographers, more opportunities, and a whole new market.

In many areas, digital storage and handling have added little to the content. When recorded music switched from vinyl, long-playing records to CDs, some people hailed the lack of surface hiss. I have a CD of Little Richard's early recordings and I have a few of the original pressings on Specialty. When Richard shouts the opening lyric of "Long Tall Sally"— "Gonna tell Aunt Mary, about Uncle John, claims he has the misery but he has a lot of fun"—there's nothing that digital delivery has done to help the content. It was as fresh and vibrant on vinyl over forty years ago as it is when his voice is summoned by a laser.

10. No new medium kills any of its predecessors.

Photography was to be the death of painting. Television was going to kill radio and the movies and did neither. If a communication medium is really a new development, it starts by imitating its predecessors and then finds its own voice. At the same time, the new medium frees up the older media to evolve in ways that weren't possible until the new medium came along. Witness the radical ways that painting has changed since the invention of photography.

THE WEB'S ROLE TODAY

The change took place almost overnight. In February 1996, the annual convention of the Photo Marketing Association in Las Vegas was remarkably different from the 1995 convention for two reasons: First, the Advanced Photo System (APS) was presented to the photo trade and would be debuted to the general public in April 1996, a launch that ended up being a textbook example of a marketing flop. Of greater and lasting impact, however, the terms "Web site" and "Internet" were first uttered by association leaders and photo-industry speakers on the platforms of the convention.

This marked a turning point in the photo industry. One year prior, the term "Web site" and the idea of a company having one was considered so insignificant in this industry (and no doubt many others) that it wasn't even mentioned, much less mentioned and dismissed.

By February 1996, every speaker urged every company that didn't have a Web site to get one pronto or suffer dire consequences. How does such a change come about?

I think every time a new communications medium is invented, this type of major shift takes place. Once it's clear that it's here, it's different, and it's popular, the business world is very quick to adopt it into the fold.

For many big businesses, making money on the Internet is still an open question, but clearly people want to shop for some types of products over the Internet, and take in some types of content over the Internet. And if people are interested in shopping and in content, then along comes advertising, and presto!

Christmas 1998 marked the first year that shopping over the Internet really took a chunk of business away from stores and traditional mail order. Obviously, this trend will grow rapidly in the next decade. I think it makes particular sense to purchase standard items this way. If I want an airplane ticket, why do I want to haul myself down to an airline desk or a travel agent to buy the thing? Why do I want to sit on hold when trying to purchase that ticket over the telephone?

Tickets, books, shares of stock, and other uniform products are ideal for e-commerce transactions. I'm enough of a traditionalist that I like the tactile sensation of feeling an article of clothing before I buy it. Also, I wouldn't dream of purchasing an antique photo over the Internet. But I know that not everyone feels the same way. Our Webmaster is currently making money at night buying and selling vintage photographs through an online auction service. There's something to all this.

DIGITAL FUTURE

Although the Internet had been around in scholarly circles for a period before it came to the attention of the public, it was really the ability to transmit graphics and images with relative ease that provided the breakthrough.

Now, everyone has to have a Web site. My bank statement invites me to visit my bank's Web site. Why, beyond online banking perhaps, would I want to visit them? My parking bill touts the company's Web site!

Chances are, parking companies' Web sites will diminish in importance and perhaps even disappear. As we noted earlier, content is still king. If a Web site can tell me or show me something I want to know, then it has value. If it can put me in touch with people who know something I need to know, then it has value.

To this end, all photographers will probably want to consider having a Web site on which they can show photography to interested viewers. Naturally these already exist, but the methods of display and commerce that will work best are still being refined. I revisit sites and see that they have changed drastically in six months' time. Different business models

are being tested all the time. And, more and more, all these Web sites need photography! The power of photography and the photographer grows!

Let's study one example about which I know a great deal: NYI started its Web site in early 1996, and it has become a monthly magazine that several of us write. Tens of thousands of readers visit every month, and we get millions of hits.

What do the numbers mean? I'll try to explain the computer-based points and terms as we go along, on the assumption that they may be new to some readers. For those readers who are more knowledgeable, just skip the definitions.

Counting traffic on an Internet Web site is still an emerging art. For advertising and sales purposes, these numbers are important, and they will get more precise. A "hit," that is, a request for something from a server, is not equivalent to a single person. A site with lots of graphics may well score hundreds of "hits" from each visitor. Plus, when visiting a Web site, does the visitor travel all around, or just land on the home page and then depart?

Let's delineate a few terms. A visitor (often known as a "pair of eyeballs") is a person who lands on your home page. The question then becomes how many "page views" that visitor enjoys while on your site. Obviously, you want to get people to visit your Web site and, once there, you want them to stay for a while, to see the sights and maybe leave their name or make a purchase.

At NYI, we've attracted the large number of visits we get each month by providing lots of interesting content, all for free. While there are areas that only registered students taking a particular course can visit, the regular Web site is free to all comers. Other sites interested in photography are welcome to link to us, and both electronic and print media are welcome to use our material as long as credit is given and our copyright respected.

And we're one of the lucky businesses really making money on the Internet. We sell some courses over the Web, but mostly we encourage people to request that our full catalog be send to them by mail. Each week, hundreds of people make such a request. We also sell some advertising to the photo industry.

Once we have the Web site designed, the story and pictures put together, then the HTML wonder-workers turn it into stuff that they put up on the Web, which we proofread before it goes out to the general public.

Proofing is one area where I see lots of problems on the Web. Typos and poor grammar are just as bad on a computer screen as on a printed page, and all the java-based flips, jumps, and turns can't fix them.

NO VISIBLE COUNTER

I offer one tip if you plan to have your own Web site. Don't put a counter on it that's visible to the viewer. If you want to track the number of hits

you get, that's fine. But there's no reason to show it to the world. I know a fine young wedding photographer, one of the best known in the country. While I was doing some surfing a few months ago, I came across some listings for his Web site. I visited. It looked great, and he proudly announced that it had been up for over a year. Imagine my surprise when I saw at the bottom of his home page that I was visitor number 117! Obviously, he's doing no promotion. I would have been much more impressed had I not stumbled upon that fact.

WEB CAMS

I've recently found myself intrigued by the Web Cam phenomenon. There are lots of them now, but one of the early pioneers was *www.jennicam.org,* a site that shows the every-so-often activities of a twenty-something woman named Jenni. You can join and see more, but watching her bourgeois lifestyle and setting is mildly interesting. A lot of the time the image suffers from excessive back lighting, excess junk in the frame, and other standard photo blunders; but the concept is fresh and new. At least for now.

There's already a New York taxi driver with a Web Cam in the back of his cab, and cameras that look out over the downtown of various world capitals. Even when streaming video is fully functional on the Web, I think there will still be an interest in sites that present frequent samples of still photographs.

How this revolution will work best for photographers is still unclear. As one well-known, assignment-oriented photographer said to me, "I don't know that my Web site has made one sale on its own, but it is wonderful background music to my other marketing efforts."

DIGITAL DRIVEL

One thing to guard against is the creation of images that show technical mastery but no insight or thought process—images I call "digital drivel." It's true that with Photoshop or other image manipulation software you can put a cracked desert surface on a woman's face or a transistor-printed circuit pattern on the wings of a butterfly, but why would you?

There's been a certain amount of "surrealistic" manipulation possible in the darkroom for years. Fox example, I have always found Jerry Uelsmann's work a little devoid of meaningful content—sure the silhouetted female torso eases into the form of a tree or a lily pad or some other organic form. But what does it mean? Many love Uelsmann's work; and his craftsmanship, all would agree, is superb. Now, with Photoshop and its competitors, anyone can combine, merge, and manipulate images. But content and meaning still require a plan, an image vocabulary, and the application of intelligence.

A lot of digital special effects have been shown to the public without much thought given to the meaning of the images that have been manipulated. To my eye, a lot of the best uses first cropped up in advertis-

ing rather than in more artistically oriented images. The auto billboard that demonstrates the size of the back doors of a minivan by showing an Orca whale caught in midair, jumping through the two open doors in the rear of the vehicle is imaginative. The cigarette ad showing smokers sitting on the shoulders and crown of the Statue of Liberty shows the same inventiveness.

Can you imagine trying to make either of those photographs using conventional methods? It couldn't be done. Nowadays, if an art director can imagine it, a "photographic" image can be manufactured that looks real. Who are you going to trust—me or your own eyes?

POMPOUS PIXELS

The new possibilities of digital photography haven't put an end to rigid thinking. Not long ago, we ran an all-digital photography contest on the NYI Web site. Shortly after the winning photos were posted, I received an angry e-mail from a doctor of some sort, who told me that our contest judging encouraged "digital drivel" because there were "standards" for digital photography. The writer told me that good digital photography should have "an idea that stridulates the mind," (I had to look up "stridulates"— I initially thought it was a typo, but it's a real word), that the use of digital filters "should be concealed as much as possible" and that "digital photography must contain an element of integration between photography and other forms of art."

Well there's a load. These may be rules for a school or movement that the good doctor might wish to establish, but I don't think they stand up in the general universe where a variety of opinions and reactions are elicited by almost any image.

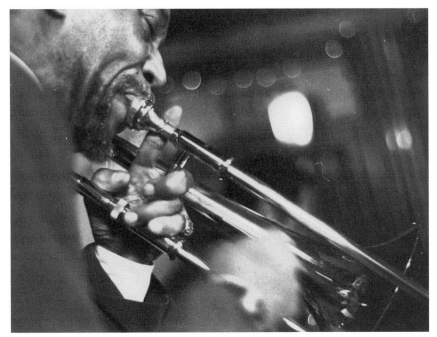

Benny Powell, New York, 1994.

Chapter 11: Reward Yourself!

This chapter is short and sweet. I am firmly convinced that we all need to reward ourselves by spending time and money on things that represent the treats of life. Some of them might even be necessities, but they feel like treats.

One shouldn't overindulge, but cultivating an interest in the finer things in life has a way of both rewarding us and sharpening our senses as well. Here are some of the things I think are "essentials" for people working in a visual field such as photography.

MUSIC AND LIVE THEATER

For many of us, music becomes the background of our lives. I write while listening to my favorite jazz and classical radio stations. The radio is always on when I'm in the darkroom or hunched over a still-life project. It behooves you to expand your interests in music and to take the time to explore what's available that you might be missing.

Like most people who came of age in the 1960s, my first fascination with music was with rock and roll and rhythm and blues. A little later, I

began listening to jazz, which I still find the best music for writing. Then, someone introduced me to show tunes; classical music and opera came later.

This may seem obvious: Reward yourself! Listen to music. I started here intentionally; It's one way many people indulge themselves. It's cheap and easy. And if it feels good, then why not reach a little further?

My daughter's favorite musician, at age two, is Little Richard. This without any parental steering or coaching. It started because he made a very well-produced CD of children's songs, but now she's crossed over to his regular music. If it hadn't been for that children's music, I doubt that she would have found Little Richard for years. It appears that it would have been a big loss: That led her to the Beatles and the Everly Brothers and we bypassed Barney and Raffi.

Suspension of Disbelief

Theater shares something very important with photography. It requires that you believe what you're seeing. Spending time and money going to live theater may seem a little more of a challenge, and hard to find in some places, but it's definitely worthwhile. Even so-so theater is a lot better than no theater. Here's why: At the core of the magic of live theater is the concept of the audience's "willing suspension of disbelief." When the lights go down and the characters come out on stage, it would seem almost impossible to forget that they're actors and we're sitting in the audience portion of a darkened theater.

But we do. When it's great theater, or great acting, or we're in the mood, we can forget that this is all a performance for the duration of the show. With lesser fare, it may be only ten or twenty minutes before your mind wanders to the fact that your seat is uncomfortable or that someone behind you has a cough or one of the cast is really terrible or whatever. But still, you've been taken to a place that doesn't exist.

Groucho Marx used to pose a question to guests on his quiz show: "Who are you going to believe? Me or your own eyes?" That's not as absurd as it sounds. I sit in the theater. I see the stage, the curtains on either side, the people in front of me. Yet, with good theater, I forget all that. I ignore what my eyes see; I "believe" what's on the stage.

The suspension of disbelief is central not only to theater but also to photography, to what makes photographs work. In some ways I think understanding this suspension can be the springboard to developing a personal style in your work. Remember: A photograph is just a bunch of silver molecules or color couplers or ink-jet dots or various other electro/thermo bits on a piece of paper. It's two dimensional but it makes us think, feel, and see a rendition of three-dimensional subjects. And if the mere seduction of theater weren't enough, there are three other aspects that directly relate photography and theater: props, lighting, and acting.

Good theater makes great use of props. Photographers should too. Lots of good portraits and commercial shots "work" because of the proper

use of props. A lot of my studio work has been inspired by the awe I feel when there are great sets in theater. Sets can be elaborate—I recall a Broadway production of *Dracula* some years ago that featured Frank Langella and sets by Edward Gorey. When the production started, the lights went down and the curtain rose to a bare stage; only after a pause did Gorey's painted backdrops descend into view. The audience gave the set a rousing ovation—before a single individual came into view. Wouldn't you like to have powerful sets like that for your photographs?

I'm not advocating elaborate props, just effective ones. If you think simple can't be profound, and you find yourself in New York before it closes, spend an evening in Greenwich Village at the Off-Broadway production of *The Fantasticks*. It's been running for over thirty years, and the simplicity of the props and their effectiveness is one of the reasons why. Catchy music and savvy lyrics that haven't aged badly don't hurt either.

Think there's nothing you can learn from theater? Think again. Even the average high school or college theater has far more dollars invested in lighting equipment than you'll probably ever own. A live theatrical show is not merely an enjoyable form of entertainment, but you might also get some ideas that you can apply to your photography, either just by attending a show or by volunteering to work on the lighting for a local theatrical production. That's a way to reward yourself as well.

Theatrical lighting is well worth your study. The traditional proscenium setting for theater (and dance, opera, and ballet) gives the lighting designer a full range of lighting that any studio photographer would envy. Think about it—lights above, below, to the side, and in front of the subjects; powerful spotlights at the back of the theater; all kinds of scrims and gels; hard lighting; soft lighting; lighting in color; unlimited wattage; lots and lots of lighting instruments.

My friend Richard Rader, who, with his wife Betty, runs a successful studio just outside Omaha, Nebraska, always wants to go to the theater anytime he and his wife visit New York. Having accompanied him to all manner of shows over the years, he makes me see things in a new light. After the show, as everyone else is leaving the theater, Richard heads right down to the front of the stage and studies the way all the lighting, movement, and special effects were created.

If he has questions, he'll ask the technicians wandering around the stage how things were done. At first, I found it surprising that he got answers. Union stagehands stopping to answer a question from some Midwestern tourist? Doesn't sound right, but I realized that these people recognized Richard as someone who was genuinely interested in their work, and they were happy to take the time to give serious answers to his serious questions. Richard has managed to preserve that childish sense of wonder along with an adult interest in how the magic "works." No one way of being.

Would that more of us could keep that sense of curiosity and wonder. There are so many forces that conspire to drain it from us or, for the unfortunate, perhaps beat it out of us. Consider this situation: I once had a photography student by the name of Sweetwater, in one of the prison programs run by the Floating Foundation of Photography. In a maximum security prison, fifty acres inside four thirty-foot walls that formed a perfect square (that is wryly named Green Haven), there was one yard where we were allowed to take students to photograph outdoors without having to get prior clearance and without danger of getting shot. It was called the "garbage yard" since that's where all the refuse from the two thousand inmates was collected.

Sweetwater and I were out there one December afternoon in that magic time just before dusk, when on a clear winter afternoon, the sky takes on that special blue and the moon and Venus can often be seen bright and low in the southern sky.

I suggested that Sweetwater consider working the moon into the composition he was setting up with prison walls and bars.

"What do you mean?" he asked. "It's daytime. The moon only comes out at night." I pointed to the moon and explained that it rose at different times of day depending on its phase. Sweetwater refused to accept any of this. For him, the moon wasn't there. It couldn't be. It only appears at night, after the sun goes down. I insisted. Now I felt like Groucho Marx.

Sweetwater, a huge fellow who towered over me, would have none of it. It was day, and while the sun might have gone down, there could be no moon until it was dark. I dropped the matter, but I never forgot it. Sweetwater had been taught, and taught with great conviction, something that wasn't so, and he had also lost his sense of wonder and curiosity along the way. Obviously, what he had been taught had been drilled into him and he wasn't about to let it go. The moon only came up at night. It just wasn't there. And he wasn't remotely curious about what that "thing that looks a lot like the moon" was. Sweetwater's point of view was just the opposite of my friend Richard.

I've discussed props and lighting, but not acting. While we tend to associate acting with plays and films, I think that good acting often contributes to good photographs. I want to postpone that topic for the next chapter.

Perhaps the most important thing about theater is that it helps stir our sense of curiosity and wonder, and tests our ability to suspend disbelief. In fact, I suspect that the ability to suspend disbelief upon occasion is an index of good health. I can't get enough of it, and no production is without its pleasures. Reward yourself.

ART AND MUSEUMS

I was very lucky in that I stumbled onto art history in college. Without it, I really am not sure I would have ever managed to stay in college. What a spectacular way to learn and get grounded about the world, its peoples, its culture, and its history.

No one way of being, but for me, lots of aspects of history made little sense until I was able to spend hours and hours sitting in the dark listening to a series of great professors show me two slides at time, and discuss the difference between two objects, or between periods. From this compare-and-contrast method, you can learn lots about the development of the work of a single artist or a movement or a civilization.

Not only were the objects I got to view wonderful to look at, but the men and women who taught me were brilliant—the best group of teachers I've ever had the good fortune to study with.

I can't really suggest that you take a few years out of your life and study art history—you probably don't have that luxury. But I do suggest that you treat yourself to as much as you can of the visual arts wherever you go. There are major holdings in museums in most large cities in this country and in all the world's capitals. If you live in a small town but your work takes you somewhere bigger, try to reward yourself with a day set aside for visiting galleries and museums.

FLEA MARKETS

As much as I love museums and galleries, I love flea markets more, and I find them to be more interesting and educational than some museums. Here's why: In the museum everything has been sorted and identified and captioned and 'splained to you. You can even rent an acoustical recorded tour that will tell you a lot of stuff about what you're going to see. And what's more, in the museum you can't touch the goods and they aren't for sale. There are no market forces.

But in a good flea market, everything's all jumbled and tossed together and it's up to you to sort things out. Now, let me caution you: I'm not talking about flea markets where they sell new stuff—tube socks and socket wrenches and "maybe" designer jeans. I'm talking about flea markets where most people are selling collectibles, antiques, curios, and junk. The more junk the better because that gives the good stuff places to hide and improves the likelihood that I'll be able to find a few good things that I can buy for just a few dollars.

My hunting list, based on my personal inventory of interests, includes the following: old photos, framed and unframed; odd, old photo equipment; lightning rods; garden ornaments; and folk-art paintings. I'm particularly keen on old photographs. As I've mentioned, we are privileged to belong to the second century of a new art form. Try buying ancient artifacts of sculpture and painting. You'll find they're few and far between, and either expensive or expensive and stolen or expensive and not authentic.

I once studied Old Master drawings in the atelier of the late cellist Janos Scholz. At the time, he had the finest collection of drawings by Renaissance masters that was privately held, and his collection was considered the fourth best in the world! He had started buying drawings in

Europe in the beginning of the century. He hadn't paid much for many of them, because collectors mainly fancied paintings at that time, and preparatory drawings were of little interest to most of them. The market has certainly changed since then.

But we belong to just the second century of photography's progress, and when the shopping is good, I can by tintypes, albumen prints, and even daguerreotypes with intact seals for just a few dollars. I might find a full family album for less than $100.

I buy photo albums, from the old Victorian jobs with velvet covers to the albums assembled by kids from the thirties and forties. Also any panoramic photo, old knickknacks such as flash-powder holders, and on and on. I'm also on the lookout for Popsicle-stick lamps, Mission and Old Hickory furniture, several types of rugs, spherical objects of all types, sculptures made from coconuts, and anything else that strikes my eye. But that's just the stuff I buy. I'm also out to touch and admire lots of things that I wouldn't buy—hobnail glass, musical instruments, art books, and anything else that calls out to me. I can pick it up, hold it to the light, ask the price, haggle, do whatever I want. It's a time to dabble and a great opportunity for role playing. And, flea markets provide the possibility of discovering the unknown.

And usually, there's not even an admission charge! There are some good flea markets in most major cities, although you may have to do some asking around. In New York City, there are two parking lots at Twenty-sixth Street and Sixth Avenue where flea markets are held every Sunday. There's a great one in the Los Angeles area in the Rose Bowl parking lot one Sunday a month. In Paris, it's the Marché aux Puces every day of the week. But it could be any Sunday in any church parking lot anywhere in the country, or a roadside tag sale on a summer weekend anywhere. The objects are waiting for you to admire and appreciate.

There's also a lot to be learned by haggling over prices and learning to shop. In the business portion, we'll discuss the notion that price is in the salesperson's mind, and that's certainly the case at a flea market. It's common to ask the seller, "Can you do a little better on the price?" or you can toss out a lowball counteroffer. Either way, if you hit a price that the salesman OKs, that's the sale price. It can be anything if it's OK with the seller. This is relevant to photographers because often you'll end up being the seller of your services or your images in a discussion that isn't so different from flea-market negotiations. If you learn how to shop, it will help you learn how to sell. As I said, that's for the business section.

AUCTIONS

I've saved the best for last. I love auctions, and if you've never attended one, change your ways! Again, let me clarify that I'm not talking about high-roller art or antique auctions at some fancy New York auction

house—I'm talking about country antique and estate auctions, or even auctions for failed businesses and the like.

I've furnished two homes and bought wedding presents at auctions. I've bought a lawnmower, a 300-pound dock cleat that could secure an ocean liner, and lots of other crazy things at auctions. So the simple reason you should give one a try is that it is an inexpensive way to buy things you need and things you don't need. But there are two deeper levels that cause me to recommend visiting a few auctions even if you don't buy.

The first is that it is an extension of the flea market in terms of training your eye on objects, their condition, and their appearance. Most auction houses give you time to look at the goods before they are put up for auction. There are a few places where you can continue to walk among the merchandise and study it while the auction is taking place, but in most joints you have to look it over and then wait until the object comes up for auction.

No matter how long I study the merchandise that is up for auction, I'm always surprised by the number of things that turn up on the block that I didn't see. And of the ones I did, it's a fascinating exercise to learn to size up an object quickly. Is it broken? Is it well made? Is it damaged or dirty? How does it compare to other similar things that I've seen?

The other aspect that you need to observe is the behavior of the auctioneer and the bidders. You don't even have to be involved. In fact, sometimes it's easier to study the auction process when you're not shopping. I spent a morning on location with a film crew in the famous Tsukiji fish auction market in Tokyo. Some of the best sushi-quality fish ends on the block there, having been flown in from all around the world. I had no use for a large tuna, but to watch the performance and body language without wanting to buy anything and without even understanding the language in which the auction was being conducted was interesting because so much of the action and gesturing was the same as back home.

Andy Warhol once said, "Everyone is famous for fifteen minutes." People love auctions because they get to perform a bit. A good auctioneer understands this aspect of working an audience and, in some subtle way, manages to create a party atmosphere.

PLANTS AND ANIMALS

Whether you tend a border bed of perennials or just a few houseplants, I can't recommended gardening enough. It's relaxing, all involving, and very good exercise for people with a visual bent. There are subtle differences to be studied almost daily, and scratching, weeding, and pruning all call into play aesthetic choice.

I won't devote space to extolling the joy I get from house pets. Either you share this passion or you don't. But I do want to add the thought that there are some interesting, out-of-the-way options that most people never consider. At a convention a few years back I met an interesting couple, both

photographers, who had spent years photographing butterflies and had, literally, thousands of stock transparencies of various varieties of butterflies.

After a number of years, they grew frustrated by the fact that the most exotic butterflies were hard to find, and oftentimes had flaws that interfered with the photographs. If the subject was a common variety, they would have no problem finding a perfect specimen. But they found it upsetting to wait years to come upon the thus-and-such only to discover that one of its wings had an unsightly nick.

Their solution? They started raising butterflies so they could have a constant supply of those varieties that they wished to photograph. Of course, if you raise butterflies, you need to grow the flowers that appeal to them, so they did that too. You never know where your camera can lead you.

Don't limit your company to plants and pets. There's a lot of joy to be had meeting people on the odd hop. Talk to strangers. Try things you don't think you can do, maybe even things you don't want to do. Take chances.

I could detail half a dozen other areas that I think are rich veins of satisfaction and reward, but I hope you get the idea. Photographers deserve, or rather, photographers must cultivate, the enjoyment and stimulation of all their senses. That's an assignment!

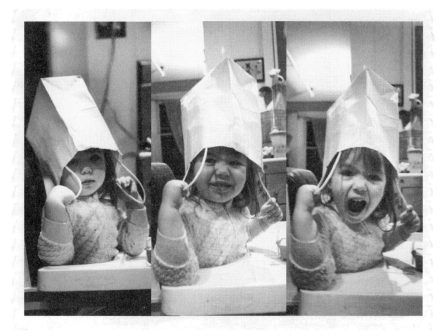

Lily Mira Mason DeLaney, 1997. Left image is with 105mm, other two "in her face" 24mm.

Chapter 12: Subjects—Selecting and Connecting

There's very little new anyone can bring to a discussion of subject matter. I've already mentioned my pleasure at the description of photography as a "Scrapbook of the World." Literally anything can be valid and exciting subject matter.

There are photographers attracted to people, animals, scenics, and inanimate stuff. The German couple, Hilla and Bernd Becher, have built a life's work out of large-format studies of deserted industrial landscapes. Their place in the general history of photography is secured. Felice Beato took some of the most fascinating travel photographs of all time, as one of the first photographers to work extensively in India and the Orient.

Sometimes, a photographer works so extensively with a limited subject that she seems to "own" it. For the foreseeable future, all photographers of weimaraner dogs will undoubtedly follow in the paws of Man Ray, Faye Ray, and the other members of the breed immortalized in the photographs of William Wegman. (Back in the 1970s, I actually met the canine Man Ray, although not his photographer.)

The basic advice I have to offer really breaks down into two sequential categories—how to select subject matter to photograph, and then the issue of how to approach that subject matter.

DON'T THINK YOU NEED TO BE LIMITED

One of my gripes about photography survey histories is that they tend to "pigeonhole" photographers by their best-known subject matter. There are portraitists, war photographers, fashion photographers, and the like. I read one history that led me to think (based on just a few photographs) that the work of Roman Vishniac was noteworthy because of his technically excellent microphotographs. As I discovered years later, plucking a book out of a friend's library, Vishniac, a Soviet exile in Germany, also produced an intense body of documentary and portrait work in little more than a year's time on the Eastern European Jews in the Warsaw and Cracow ghettos just before the Holocaust. He recorded approximately five thousand images—mostly candid street scenes, all in black-and-white—in a period of about two years. These candid photographs record a world that no longer exists.

This portion of Vishniac's work has been published as *A Vanished World* (Farrar, Straus, Giroux, 1983). I recommend that you look at it. It records the mundane, daily existence of a world that would soon be destroyed by the Nazi death camps.

I think that it is not only possible for a photographer to work intensively on more than one type of subject matter in a career, I believe that for most of us it is good if we are working on several types of projects at the same time. I find that diverse photographic interests of mine often yield ideas that apply to something else that I'm also toying with.

When it comes time to show your photographs, knowing what constitutes your subject matter is a key part of assembling a body of work. When we turn to building a portfolio in chapter 19, you'll see that a clear definition of what constitutes your subject matter will go a long way toward giving a sense of completeness to a portfolio, a book, or a picture story.

Let me give you an example. When I fell in love at first exposure with the work of many of the then-acknowledged "Masters" of photography in the late 1960s and early 1970s, the appeal of Henri Cartier-Bresson was very strong. I think his work gave many photographers a sense of possibilities with fast (ASA 400!) Tri-X and a 35mm SLR or rangefinder camera with a f/2.8 lens. Cartier-Bresson's photos were unique in the way in which they captured the critical split second of an occurrence. He called his subject matter the *decisive moment.*

The notion of a decisive moment had legions of photographers stalking the street in search of decisiveness. The problem is that there are no maps that lead you to a decisive moment. I realized a lot of things that I was poised to capture were poorly digested imitations of those great Cartier-Bresson photographs. I didn't really know what there was to be

decisive about. Somewhere there are a few boxes of my prints—too many of them a tad soft, of couples in parks, old people on stoops, people on crutches. Frankly, at that age, I don't think I knew what "decisive" really meant in terms of real life.

Teaching in the prisons took me away from my interest in street photography. When the teachers in the Floating Foundation of Photography set up photography programs and darkrooms in the New York State prison system in the mid-1970s, the teachers had to sign statements, in order to get into the joint, that they acknowledged that the State of New York did not recognize volunteers working in prisons as hostages. We were just as happy to avoid anything resembling a decisive moment.

Rarely did I have to work harder with beginning photography students to find subject matter than in those prison classes. There was very little available to the inmates in the basement and yard where we could take photographs. We would try to bring in props and material for still lifes. Maggie Sherwood actually managed to get permission to bring some farm animals into the program she ran for the women inmates at Bedford Hills.

PICTURE STORIES

When we speak of a body of work, I think it's important to emphasize that there are different ways that photographs fit together. Let's liken that for a moment to a deck of cards. You can organize those cards into four suits or into thirteen sets of four-of-a-kind or into "face cards" and "number cards." Depending on the game, some cards can be "wild."

Now, let's say your idea of a body of work is formal portraits of athletes. The same kind of groupings could be structured as with a deck of cards. You could restrict yourself to one sport, even to one gender. You could cover all kinds of sports and focus on one age group of players. You could take one team and follow it through an entire season. You could contrast young players just getting started with seasoned veterans. Imagine portraits of ten fifteen-year-old ice hockey players contrasted with ten thirty-year-old pros.

What's important is not so much your choice, but that you make a choice and that some sort of structure and organization shows through in your work. A sense of classification and order is very helpful to the viewer.

Consider, for example, the work of W. Eugene Smith. Few of us will ever have the satisfaction of compiling such a great body of work. Anyone who has seen Smith's many extensive photo essays that ran in *Life* magazine can think of many memorable Smith images from the greatest of those series, which would probably include Spanish Village, Country Doctor, a photo profile of Albert Schweitzer, among others.

Smith started working on a part-time contract with *Life* before he was twenty, and his stormy relationship with the magazine was respected by many of his contemporaries. Smith was adamant about having control

of the final published layouts of his work. His later projects—such as his study of the pollution in Minimata, Japan—were undertaken without sponsorship.

Now, if you were to assemble a body of work from Smith's output, there would be all kinds of ways to go about it. W. Eugene Smith's Ten Greatest (or Twenty-five Greatest or One Hundred Greatest, for that matter) images would be a body of work, but each of his classic picture stories can also stand alone. Combining images from those stories, one could pull out subsets, such as Smith's photographs of working men.

The place for you to start is with the idea of a picture story, perhaps use that concept to give structure to the photographs you've already taken. Before we start, let's just take a moment to put one idea in place. I use the terms "picture story" and "photo essay" interchangeably. This drives some teachers and photographers up a wall. To them, a picture story could be anything—for example, ten photographs that show you how to assemble a piece of furniture. I agree. A "photo essay," by contrast, aspires to more lofty purposes. It should educate, it should inspire. It should reveal.

I think this is a slippery slope. I prefer to consider every set of photographs that is presented, whether taken as a batch for a purpose, or whether assembled later out of different images, to be a picture story or a photo essay. I've read great essays and great stories, and I don't think one form is "better" than the other. In fact, one person's story may well be another's "essay."

Approaching a subject as a candidate for a story suggests that you should give some thought to what story it is that you wish to tell. What is the subject of your photograph? How can each photograph that you take reflect the subject? How can each photograph that you take either advance or refine the story that you're trying to tell?

You may select a subject and by that selection impose a story on the subject matter. For example, if I want to photograph senior citizens, I could focus on only those who looked healthy and who projected an upbeat personality. On the other hand, I could produce a body of work that highlighted older people who have been ravaged by war, illness, depression, and drink.

APPROACH AND POINT OF VIEW

You need to give some thought to your point of view on your subject matter. An interesting example of point of view is the work of the short-lived Diane Arbus, who killed herself at age forty-eight. Her first published photographs appeared in *Harper's Bazaar* in 1961, when she was in her late thirties in a collection entitled "Portraits of Eccentrics."

Throughout her life, Arbus was attracted to unusual people. In the Aperture monograph that brought her a wide audience, she is quoted on her attraction: "There's a quality of legend about freaks. Like a person in a fairy tale who stops you and demands that you answer a riddle. Most peo-

ple go through life dreading they'll have a traumatic experience. Freaks were born with their trauma. They've already passed their test in life. They're aristocrats."

WHAT ATTRACTS YOU?

I've mentioned the advice that you should photograph things you feel strongly about. I've heard many a teacher deliver a real stem-winder about photographing what you love or hate, but "never, never what you're indifferent about." I'm not so sure that advice should be carved in stone.

That may work for you, but, as I've suggested, it doesn't have to. One thing I've learned is that I often screw up and don't photograph things that strike me as odd or that I find confusing or don't understand. Then, once I learn what they're about, I've lost the viewpoint I would have had originally.

Let me give you an example. When I was on assignment with a news crew in Japan in the "bubble" year of 1989—that is, the peak of the Japanese economic boom of the late 1980s—I photographed lots of people, places, and things. However, when I got back to New York and described my experiences being there a month, I found myself talking of two phenomena that I hadn't bothered to photograph. I certainly wouldn't have described myself as feeling strongly about either. Admittedly, both subjects would have been difficult, but I didn't even think of what interesting photographs they would make.

Vending Machines and Alcohol in Japan

Japan is crazy about vending machines. You can buy all manner of items (including film and single-use cameras) from vending machines—beverages, cigarettes, even sushi. But the most amazing thing to me was that there were vending machines on the street that sold beer.

Now, can you imagine American society if any kid could drop a bunch of quarters in a vending machine and get an ice-cold beer? I can't. I'm not even sure whether Japan sets a legal age for alcohol purchase. But I do know that I don't expect to see anything like that in this country. I could go a lot further, because there's a lot that's interesting about the culture of alcohol in Japan. Until you've seen Japanese corporate executives staggering drunk midweek in their business suits on the avenues of Tokyo or Osaka, you haven't seen the full range of Japanese corporate life. There's a whole story here, or maybe a whole bunch of stories.

Tokyo Taxicabs

In Tokyo (and Osaka, which I visited on a later trip), taxicabs are immaculate, well-tended vehicles. The passenger area is spacious and comfortable, the drivers are very knowledgeable—they have to be since many streets aren't named—and the drivers are respected as professionals. I should digress just to note that I find most taxis and taxicab drivers in New

York to be either good or satisfactory. But in the big Japanese cities the environment inside the taxi is striking. You feel like you're in someone's home.

So what? Well, at night, when taxicab drivers pull up to a red light, they turn off the taxi's headlights, so they won't shine into the mirror of the car in front of them!

Now to me, that's class. In the next chapter, one of my proposed story subjects is the rudeness and the death of manners in big city life. Again, I don't get very upset about this most of the time, but there is a certain amount of bump and jostle in American big cities.

Can you imagine American cab drivers, or any American drivers, turning off their headlights whenever they stop at an intersection at night out of consideration of the people in front of them? Quite the contrary, we're concerned with a rising tide of road rage.

Think of what a great subject this would make, and how easy it would be to pick a nice urban intersection in Tokyo or Osaka with three or four rows of traffic, each row being five, six, or more cars deep, and with all the taxis' headlights being turned off? I would make lots of long, slow exposures and use a large-format camera on a tripod.

Now why didn't I do that? Think what a great set of contrasting photos I could take of heavy nighttime automobile traffic in the big cities of the world. By the way, feel free to steal the idea. I doubt I'll ever get to it.

ORIGINALITY COUNTS BECAUSE IT MEANS YOU HAVE THE ABILITY TO BE ORIGINAL

Once you have a few ideas, don't get too worried if someone else has similar interests or if someone copies you. I remember one of my best photography students in one of the maximum-security prison programs where I taught. In the basic class, this guy really caught on. He saw that a rich juxtaposition of light and dark tones in a black-and-white image can give a sense of power and texture to many different kinds of subjects. He learned how to expose black-and-white film perfectly and how to make tasty, rich prints.

Despite the paucity of subject matter, he made a great study of a sunlit fence that enclosed a walkway toward an area of the prison that was off-limits to inmates. At that time of year, the afternoon sun not only lit the fence, but it poured into the yard at the other end of the walkway, which was about twenty yards back and separated by a narrow corridor and a set of cement steps. There was enough ambient light on the corridor to allow a good print to be made from a properly exposed negative and show stark shadow detail in the corridor that led to a happier sunlit yard at the end of the tunnel.

He was very proud of the print when he finished it in class later in the week that it had been taken. The next week he came to class very upset, and promising a fight with another inmate. It seems the other stu-

dent had seen the print in the darkroom and had gone out and taken a very similar image from the same spot.

It took me some time to console my student. Not only did I remind him of the cliché about imitation being the sincerest form of flattery, but I also told him that his ability to find images was the important thing, and that getting angry or upset ran the risk of causing him to see red, rather than pictures.

Nothing Wrong with Sharing

I was never a deadhead, but one of the things I always liked best about the Grateful Dead was that they didn't mind their fans making bootleg tapes of their concerts. In fact, at most Dead concerts there was a spot set aside near the stage to allow fans to set up their recorders. Contrast that with today's standard concert policy of no cameras, no camcorders, no tape recorders. Many (but not all) of the people who worry the most about having their ideas stolen, borrowed, or appropriated, are the ones with the least to offer.

I firmly believe that if you have the vision and the touch to get the photographs, the most important thing to do is to keep moving forward and working on your vision. Sure, if you develop a unique look such as Anne Geddes (discussed below), you will probably devote some time and resources to making sure that your commercial success and your photographic vision aren't ruined by others' knockoffs, but that type of highly commercial situation is an extreme example.

Don't Shade Your Eyes

I think it's a good idea for you to look into the work of other photographers who have worked with subjects that interest you. It's good to see what's been done and to ponder whether you see the subject differently, or whether you see the subject in a similar fashion, but have a different idea about how to approach that sort of subject.

Anne Geddes' work is instructive. You may not know her name, but you have seen her work. She burst upon the scene several years back with her photographs of infants (mostly around six to eight months old) costumed as flowers, insects, or pea pods. Many, many people have photographed infants, but Geddes' approach to costume, propping, and lighting, coupled with her preference for chubby, cuddly infants, allowed her to create great-looking photographs that struck viewers as new and different. Her work has enjoyed absolutely massive success in the greeting card and postcard market, and her images also sell well in book form, as calendars, and in other paper markets such as wrapping paper.

I heard Anne Geddes give her first speech in America to professional photographers, and we'll get back to her work in chapter 20. First, I want to turn away from originality to the opposite, to the photo cliché. My *Webster's Collegiate Dictionary* offers three meanings of "cliché": a trite

phrase or expression, a hackneyed theme or situation, something that has become overly familiar or commonplace.

CLICHÉS SURROUND US

You are surrounded by clichés. We all are. There's no escaping. Our society has its fair share of original ideas, but it also has a superabundance of hackneyed themes and situations and things that have become overly familiar or commonplace.

All teachers warn students, as they should, to beware of the postcard view of a well-known cityscape or monument. Not that there's anything wrong with a postcard view of the Washington Monument or Niagara Falls, but it certainly makes sense to try to convince the student to look beyond that obvious "set" shot and try to find something new or exciting in an often-photographed object.

If you own stock in Kodak or Fuji and want to feel good, take the ferry from New York's Battery Park to the Statue of Liberty. Watch the amount of film that the tourists use in their point-and-shoot cameras before they get within five hundred yards of the island. Watch tourists take pictures of each other right after they get off the boat and pose with the Statue of Liberty's backside as the background of the photo.

CALENDAR VIEWS

As a matter of fact, although it is a subject for a different day, getting truly perfect postcard photographs is often a lot harder than you think. If you've ever been hired to do it, you soon learn that there's an ideal time of year, time of day, and type of climactic conditions required. In fact, now that the Grand Canyon is masked in a haze almost all the time, the days for the standard postcard photo of that monument may have come and gone.

But what do I mean by a "calendar cliché?" This is something that I only recently noticed. After a number of years of seeing great outdoor scenics published in *Outdoor Photographer* or the Sierra Club calendars, I started to notice that certain locations tend to turn up over and over again in the work of different photographers.

When I drove through Death Valley in California for the first time, I noticed there were a few key lookout points marked in the maps. Indeed, I saw a few places where, at the times I happened to visit, there were three or four people with large-format cameras and tripods working within a few dozen yards of each other.

For settings of outstanding natural grandeur, even if you manage to take a photograph that is a little different than that which has gone before, you run the risk that your viewers' eyes have been inoculated with a kind of visual vaccine—they've seen so many photos of that area that it's hard for them to see something new in your work if you indeed have managed to find something.

I'm sure the following comments will strike some as intemperate, and I also realize that my "looking" in this area is limited, but I've seen too many portrait photos taken by people in the Santa Fe/Taos, New Mexico area of people that call attention to sun-weathered skin and turquoise jewelry. It's going to be very hard for anyone to get me to see something really new in that type of image.

Obviously, the magazines and tour operators are in part responsible for this type of overworking. I understand why a magazine will want to run "So-and-so's Ten Favorite Scenic Spots in America" or "The Fifty Best Locations in America." Don't rely exclusively on other people's ideas for subject matter.

There's some type of little red-eyed frog in South America or Central America that I've seen far too much of as well. I agree that there are some animal subjects that are inherently photogenic—for example, cats, to my eye, are far more so than dogs. This, I realize, is a totally incendiary statement to many dog lovers, but I have gone out of my way to argue that there's no one way of being or seeing. I would definitely add koala bears and baby elephants to that list. Hard to take a picture of either that people won't like.

I think there's a lot you can do—and a lot left to be done—with cats and dogs and koala bears. The problem with those red-eyed frogs is that they're tiny and they only come out at night. Hence, the photos I see of them tend to be close-up photos by flash. This makes it hard to find novelty.

As an aside, I want to go back to the Grand Canyon for a moment. A number of years ago, in conjunction with a promotion idea for NYI, we were looking for a single, truly powerful photograph of the Grand Canyon. We were looking for an image that said it all in a single frame. We ended up using a photograph by David Muench, but we looked at hundreds, if not thousands, of images by many different photographers before we settled on the one we chose.

I spoke with David Muench, who told me that he had visited the Grand Canyon for the purpose of taking photographs of it over a hundred times. This was, you'll recall, some years ago. I suspect the total number of his visits has increased since that time. Muench told me that the Grand Canyon was tough to photograph, first because it's so big and you have to choose whether to approach it from the north side or the south, but mainly because it's a "Hole in the ground."

When you think about it, he's right. Many wonders of the West are rock formations and mountain ranges that stick up above eye level and they're much easier to photograph. If part of your goal in taking a photograph of the Grand Canyon is to show it as a canyon, you are indeed photographing a hole in the ground.

I don't know if David Muench has ever captured what he considers the definitive image.

RELATING TO PEOPLE

One of the big differences between portrait photos and movies is that movies use actors. How rarely we photographers really encourage people to act rather than pose. We expect people to be able to smile, to look proud, but there's little request for expanding on emotions or showing "acted" emotions, which are so common for the movies. In fact, the movies wouldn't be much good without acting. Plain folks, standing around acting "normal," is what kills most home movies and home video.

As I've mentioned, most home video is so bad that it isn't even viewed once. Contrast that with a popular movie that people are willing to watch over and over again. Where I live, it seems that *Lethal Weapon* is on almost every night on some channel. I never tire of watching Mel Gibson in the role of frazzled cop contemplating suicide with his service revolver in his mouth. The range of emotions that he can project in his face make me envious. I wish I had more models who could project strong emotions.

CONNECTING WITH YOUR SUBJECT

What about family subjects, kids, parties, and travel?

These are very valid subjects for professionals as well as amateurs and should not be shrugged off. There are many great photographers who have based their careers on this type of domestic subject matter: photographers as diverse as Sally Mann, whose portraits of her children helped her establish a style that has become the source of considerable controversy, and William Wegman, who, as we've noted, made a large body of work built around weimaraner dogs, starting with Man Ray, a dog named after the Dadaist artist (who himself dabbled in photography).

Not long ago, the NYI staff created a training video that was designed to help amateur photographers take better photographs. I spent over a year working with two other professionals from the staff planning and executing the type of photographs mentioned above, the family-centered images that are of the greatest interest to the vast majority of nonprofessional photographers.

In working on this project, I discovered a key thing that separates the professional's outlook from the amateur's—the amount of time the photographer is willing to put into setting up a photograph. Over and over we discussed setting up situations for taping that would be typical of an amateur—kids playing in a swimming pool, a picture of "Uncle Frank," and the like. Over and over again, we kept thinking of things to do—changing lighting, moving furniture, waiting for a different time of day for better lighting—that seemed natural to the professional but that are never considered by the amateur.

It's also true that family snapshooters aren't as demanding in looking at their results as professional photographers and serious amateur photographers are. When I snoop and look at people viewing the pictures they've just gotten back from the processing desk at my local photo store, I'm

always aghast when people point to some ineptly cropped three-quarter-length photo of two people mugging at the camera in a room where the vertical lines are tilted and remarking, "That's a really good picture of Eddie." The standard is not very high.

Working with Models

Suppose you want to work with someone as a model. If your intended subject is a family member or good friend, you can probably work things out with no problem. But what about strangers, or people you don't know well? Someone with whom you might wish to conduct a photography session of some sort.

Your motive might be commercial. Perhaps the local department store wants a photo of a man in his thirties in an overcoat. Perhaps it's just an idea in your head. Perhaps you have an idea for a photograph—let's say a man pushing a woman on a swing, shot from an unusual angle and lit in an interesting fashion.

If you haven't had much experience working with models, and particularly if you don't have a big budget, I suggest that the way to get started on the right footing is to strike a fair business deal. This can be done by answering just three simple questions, which I suggest you discuss forthrightly with your model. When you've reached agreement on these, you can make a deal that works for the both of you.

- What use do you each plan for the resulting photographs?
- What rights are you giving each other for use of the photographs?
- Are there limits on the rights granted to each other for use of the photographs?

Regarding use, you may be the only person planning any use at all for these photographs. But that's not always the case. Often, the people you work with will be aspiring models or actors or dancers or painters or whoever. Many people need good photographs of themselves, and possibly of their acting or dancing. Almost everyone else would like a good photograph. So you should consider your model's needs and make a deal that works accordingly.

Second is the question of rights. Even if there is no written agreement between you and your model, you each have established rights. You, the photographer who clicks the shutter (or, in some instances, your employer, if you're working for someone else), have the right to copyright a photograph. However, your ability to use even a copyrighted photo is limited by the rights of the recognizable people in the photograph, all of whom retain significant rights to privacy and restrictions on your commercial use of their likeness, unless their explicit permission is spelled out in some form of release. Actually, use and rights are closely bound together. Once you've determined what use is intended, you need to make certain that the user

has the proper rights. (The rights of celebrities and public figures is a separate topic, as is the bundle of rights tied up with what constitutes news and the freedom of the press under the First Amendment.)

Get It in Writing

The details aren't important; you should be able to work those out and you should do so before the shooting session. The important part is that you discuss what is planned before some undiscussed use takes place. For example, major men's magazines only publish photographs with good releases and proof that the models are not minors.

By the way, the agreement should be a written document, either in the form of a signed release or as a letter of agreement. The best way to prevent future misunderstandings in detailing use and rights is to have a written agreement. Anything that's not covered by the written agreement should be the subject of a separate negotiation.

RELEASE FORMS

There's a lot of confusion among photographers, particularly those who are just starting to sell their work, with regard to releases. For detailed releases on a variety of topics and relatively easy-to-understand explanations of how to use the releases, I recommend *Business and Legal Forms for Photographers* by Allworth Press publisher Tad Crawford. See appendix II for details.

I'm not going to go into detail on release, but I do want to cover a few fundamentals. First and foremost, any signed release is better than no signed release. If your subject signed a release acknowledging that you have the right to use photos taken of him on a given date, then you've covered the single most important point. Let's cover some of the basics of when and why you need a release. If you're going to sell an image of a person (and sometimes pets and property as well) for commercial use, then you definitely need a release. If you're going to sell an image of a person to a newspaper that plans to use the photo for a news story, then you probably don't need a release.

Here's a sample of a very simple release form that might suit your purposes:

Model Release

In exchange for consideration received, I hereby give permission to

_____ to use my name and photographic likeness in all
(your name here)

forms and media for advertising, trade, and any other lawful purposes.

Print Name:
Signature:
Date:

If Model is under 18:
I, _____, am the parent/legal guardian of the individual named above, I have read this release and approve of its terms.

Print Name:
Signature:
Date:

That's about as simple a release as you can get. There's a lot you can do to make it more thorough and more complicated, but, as I said before, a simple release is much better than no release.

BEYOND BUSINESS

Beyond the business arrangements between you and your subject, there are a host of other issues and questions. One of the most theoretical is the application of Werner Heisenberg's Uncertainty Principle to the field of photography.

Heisenberg was a physicist who tripped upon a principle that suggests (Warning: this is a simplification by a scientific simpleton) that the outcome of the experiment may be affected by the fact that it is an experiment and the subject of the experiment knows it's being watched!

Heisenberg raised the quirky possibility that the electrons in a given physics experiment were behaving the way they were in part because they were being watched. Hence, all scientific observation and conclusion may be skewed by the fact that things don't behave the same way they would if they were not being watched.

Does this sound a little like the riddle about whether a tree falling in the forest actually makes a noise if no one hears it? If you think about it, this is a very interesting proposition, and it raises some big questions about photography. (The implications of Heisenberg's Uncertainty Principle to human activities have been touched upon in a few of Tom Stoppard's plays.)

I don't care whether the subject is a supermodel, a spotted owl, or a paramecium under a microscope. Can we really be certain that we're making a candid observation of our subject? How does the presence of a camera and a photographer alter our subject?

A Day in the Life . . .

A few years ago, there was a popular book series called *A Day in the Life of* There were volumes on America, Australia, the Soviet Union, and other countries. This was a series of photo books that were very popular, and the approach became a formula: Round up a bunch of hotshot

photojournalists, get a lot of sponsors to supply film and air travel, and send one photographer to one city, another to another. These books offered a certain surface appeal, but I found they lacked depth. The visiting pro didn't have much time to spend in the area, and time was of the essence. The mission was: Fly in, get the shot, fly out. A glossy book and a prime example of Heisenberg's Principle.

THE INFINITE SCRAPBOOK

In closing, I realize this chapter itself just skims the surface of subject matter, which certainly merits an entire book in its own right. We have not, for example, covered supermodels, the strange life of Kate Moss, the sordid "looks" of heroin chic, the taste of Calvin Klein, or a host of other "hot" topics. Nor have we delved into posing, ethics and the First Amendment, nor the fact that some subjects, such as supermarket food as portrayed in newspaper advertisements, look better when drawn than when photographed.

I toss out this barrage of stones left unturned to give you an idea of how many subjects and topics there are that you might consider capturing for your scrapbook of the world.

Berlin Wall and East Berlin, 1969.

Chapter 13: Inspiration—Show Me!

This chapter is perhaps the loosest one in the book, and that's by design. I don't know for sure what might be of interest to any single reader, so I've taken the shotgun approach. In this chapter I will offer up some suggestions that are intended to give you ideas for self-assignments. As I've already stressed, I think self-assignments are very important.

Some of the self-assignments in this chapter are presented in the form of exercises, others are presented as topics that I think might lend themselves to picture stories. Some of the exercises only require using your eyes and not your camera. Review this chapter with an eye toward what strikes your interest. Jot those items down. Leave the rest. Perhaps a few years from now, you'll visit these lists again and find that some of the things that didn't appeal to you before now pique your interest. No one way.

If any of these exercises appeal to you or if you come up with variations or if these ideas get you percolating, please let me know the results. Send me a picture!

SELF-PORTRAITS

You can, if you choose to do so, become your most accessible subject. I have made self-portraits regularly for close to thirty years. I love making them. A few are very good. Cindy Sherman has made a large body of work out of self-portraits in which she disguises herself as some other character.

I use the camera's self-timer, an air release bulb, or any other tactic. I've tied my camera to a tree, put it on the ground, or given it to strangers and asked them to take the photo of me. Anything goes.

I once made a self-portrait at a slow shutter speed in my loft. The image had lots of blur and shadow. I had it lying around when a society matron came to visit to discuss having me make her portrait. She spied the photo, picked it up, and asked me what it was. I explained. She told me—I swear I'm not making this up!—"I love it. It looks like jism. I want you to make my portrait."

CONTACT SHEET PATCHWORK

Whether it's the traditional custom lab contact sheet of six rows of six frames each or its vertical cousin with seven rows of five frames each or the digitized snapshot version, use the contact sheet matrix to build a composite of your subject. Instead of trying to make every picture tell a story, try to make a jigsaw puzzle out of the aggregate. Neatness does not count, and overlap and distortion are encouraged. Make a photo that truly is the sum of its parts.

For examples of what is possible, look at the work of painter David Hockney or the 1970s photographs of photographer Carl Toth.

PINHOLE, PLASTIC, AND DISPOSABLE CAMERAS

I love all kinds of cheap cameras. I have shot hundreds of rolls of film in the Diana, a plastic model that takes 120 film, and I have half a case of vintage Diana cameras that I plan to sell to fund my retirement. The benefit of these cameras is that they're fun to use, their low-tech feel will relax both you and your subject, and you'll feel like a kid at the Soap-box Derby.

I suggest high-speed film, which makes these "1/60 shutter speed with an f/8 or f/11 aperture" jobs fully functional. Building your own pinhole camera is fun and, I find, relaxing. Pinhole aficionados should search the Web for the latest information—there's a lot going on out there.

Just this year at PMA, I discovered that the Beseler photo company is going to introduce a prefabricated pinhole camera developed by a Swiss photography professor. Apparently he has been making his students use pinhole cameras for a number of years, and collectively, they developed a "standardized" model that takes 120 roll film. Great idea, and Beseler's bringing it to the market for about $45. You can make a pinhole camera out of any decent-size box or can. I use aluminum foil and a simple sewing needle to make the pinhole. I've used sheet film, photographic paper, and

even high-contrast graphic arts film in my pinhole cameras. Want color prints? Try using color printing paper that's designed for printing photos from slides rather than negatives. You can get a one-of-a-kind color image.

PANORAMIC PHOTOS AND PANORAMIC PICTURES

As soon as the single-use cameras hit the market, I found people were thrilled when I gave them a panoramic snapshot print. "This is great," I heard over and over again. Years ago, you either made a panoramic print by cropping the negative in the darkroom or buying a very expensive panoramic camera such as the Widelux.

Now, you can use a disposable camera, an APS 35mm point-and-shoot or SLR, or all kinds of regular SLRs and medium-format cameras that have panoramic gizmos. I enjoy them all. If you're looking for something new to challenge your sense of any "ideal" photographic format, try playing with some sort of panoramic camera. One hint: I shoot as many vertical "panoramas" as horizontal ones.

BLINDFOLD SHOOTING

Let chance take control. Play pin the tail on the subject. Place yourself in a busy location and rack your zoom out to its longest focal length. Shoot by intuition. Try to feel the vibes. Memorialize the scene at the end with a few wide-angle frames when you're done photographing so when you look at the film ten years later you'll know where you were when you shot it.

DRAW WHAT YOU WANT TO PHOTOGRAPH

Perhaps your writing skills are nonexistent. No one way of being. Chances are, if you can't write, you might be able to draw. Drawings and sketches are particularly helpful for still life and tabletop photographs of the type that are the basis for advertisements.

Even if you haven't drawn in years, if you play around with pastels or charcoal, try sketching some scenics and some figure studies. During the Renaissance, it was common for a painter to begin a work with a series of drawings that were studies for the final image. I spent a period of time in graduate school studying drawings by the Old Masters, and it was very interesting to see how an image was transformed during the process of making studies. Obviously, drawings will only get you so far when you're preparing to take a photograph, but for some readers this will turn out to be a surprisingly interesting exercise.

To appreciate the difference between light and dark shades, I suggest that you steal another trick from the Old Masters. They would often use gray paper, about the same as Zone V or 18 percent neutral gray, and then use charcoal for black and darker tones and a white crayon for highlights. From childhood, we usually start with white paper and add colors and darker things. Working on a middle-gray background can be very liberating.

FLEA MARKET STILL LIFES

I've already told you how much fun I have in flea markets. In addition to being a great place to shop, haggle, and improve your negotiating skills, it's also a great place to buy a bunch of junk that you can use to make still-life photographs.

At NYI, we give students an assignment to photograph a still life using several different lighting techniques. Most of the time, they grab some piece of bric-a-brac from around the house. We get pictures of little kitschy folk-art statues of elves and the like. Not too exciting most of the time.

Be creative. Play with still-life materials. Too many photographers never try their hand at this sort of work. Everyone wants to take portraits, or scenics, but very few people want to try making a photo out of stuff. I'm not out to kid you—it's hard. But, the fact that it's hard is terrific, because if you have skill in this area, you could become a highly rewarded commercial photographer, and you won't know unless you give it a try.

To find interesting stuff for still lifes, you don't have to go shopping at a flea market if you don't want too. Just don't use those bloody elves. All you're really doing in that case is photographing an artwork, and usually a bad artwork at that. Go to the garage and get a bunch of tools, nails, and screws. Or use fruit and food.

A popular scene from classical painting is what was known as a "memento mori" or reminder of death. Skulls, dead animals, that sort of thing, complete with a candle. Joel Peter Witkin has taken this genre to the extreme, combined it with (to my eye) exceedingly bad taste and made a career out of it. There was an assault case in New York recently where the victim testified that the first thing that happened on the date was that the person she was visiting showed her a book of Joel Peter Witkin's photographs. This is not something that would lead me to feel very comfortable on a first date.

MIMIC THE GREAT PAINTERS

From 1840 to about 1910, a lot of painters were reacting to photography. After all, until photography came along, the goal in painting and sculpture was to make things that looked realistic. Impressionism, post-impressionism, pointillism, and all kinds of styles up to the watershed of cubism and abstract expressionism tried to show the world in a semi-realistic way that photography could not mimic. What can you do to inject some of those looks into your work? Nowadays, with the use of Photoshop, technicians and art directors can manipulate an image in ways that far exceed the possibilities afforded by shooting through super-clumpy grain or fog filters and the like, but it's still fun to experiment while *taking* the photo.

REVISIT THE WORLD OF VAN GOGH
OR MONET OR ANYONE ELSE

A photographer friend of mine recently went to France and gave himself the self-assignment of tracing Van Gogh's path through southern France and photographing scenes that Van Gogh painted. When I visited Monet's gardens and home at Giverny, it was great fun to photograph the scenes that he painted in his later years. There's no reason you couldn't pick a painter or other historic subject and do the same thing.

If you want to try to put some expressionism into your portrait photos, study Van Gogh's portraits. Look at the wild colors he puts on the walls behind his subjects. Watch the way that he often uses strong horizontal elements, such as a chair rail or wainscoting, to bisect the background behind the subject's head. Powerful stuff that runs contrary to most of the general assumptions regarding photographic portraiture.

Let's turn to some exercises that don't require a camera.

OBSERVE THE SEASONS

Almost everywhere, there are seasonal changes that are subtle and well worth watching. Since I live in the Northeast, I see the full range of fall, winter, spring, and summer, but even in Texas or Louisiana or California, there are subtle differences. Get out in nature at least once every single week, visit the same spot over and over, and observe how things change. It's subtle, but good practice for your eyes.

WATCH IT GET DARK

Even if you're not the fidgety type, it takes a little effort to sit quietly and watch daylight go through dusk and twilight and finally turn to darkness. I'm fortunate to have a patch of land where there is a white birch tree that sits on a sloping hillside. As it gets darker and darker, that birch stays luminously white. Even when all the browns, grays, and greens have turned to black, that birch still glows.

If you've ever studied the subtleties of black-and-white film and prints, if you've ever pondered contrast and the zone system, if you've ever wondered why 18 percent gray is so dark, just look at a bright white object and see how long it remains visible even on the darkest night.

WATCH GREAT MOVIES

Study the lighting and photography in *Casablanca* and *The Hustler*, to give you just two examples. Watch either movie several times in a row, so you get beyond the plot and the action. Look at the way the shots are constructed, framed, and lit. Watch them with the sound off.

PICK SOMETHING TO EXPLORE

I've spent a lot of time in the last two decades exploring the upper Delaware River Valley. The first time I really stopped to look at the Delaware Water

Gap where Interstate 80 crosses the Delaware, I realized that there was something special about that place for me. Since that time, I've worked my way up the river to its headwaters, and quite a way downstream as well.

It doesn't have to be a river, but it should be somewhere with a strong sense of place, where you feel comfortable, and where you might want to make some photographs someday. It's a great thing to see a lot of the world, and I travel every chance I get, but it's also important to find a place or two that you really get to know and where you revisit and experience things in different seasons, when you're in different moods, or in different stages of your life.

LOOK AT COMICS THAT USE PHOTOGRAPHIC TECHNIQUES

The great R. Crumb comics and Garry Trudeau's *Doonesbury* strip share one key point—a lot of the illustration is governed by a sensibility that borders on photographic. The angles, tonality, and contrasty scenes always make me think of photography. Children's picture books also often have a hyper-reality that could be converted into a photographic style. Listening to my wife read *Good Night Moon*—written by Margaret Wise Brown and illustrated by Clement Hurd—to my daughter caused me to marvel at the subtlety of the illustration, and the shift between color and black-and-white seems very contemporary.

LOOK AT PAINTERS WHO PLAY WITH REALITY

If you study any period of art even briefly, you will see that there is always a cycle starting with rough, archaic work, followed by a breakthrough where the "classic" style is achieved, and then an over-the-top phase where people with great skill but no real vision embrace the style but fail to move things to the next level. Rather, the classic achievements are turned into something very ornate.

Two examples:

• Greek sculptors mastered the human torso. The sequence starts with archaic sculptural figures that don't look real, then classic ones that do, and finally later, Hellenistic versions that have the human torso down pat but in which the wavy locks of hair carved in stone start to take on a pattern and shape all their own.

• In the 1400s, the Renaissance painters figured out how to paint realistic figures in spaces that had plausible one-point perspective. The relatively crude painted figures of Giotto gave way to true spatial images painted by Masaccio, and beautiful classic work by painters such as Raphael and Michelangelo. Over-the-top time comes when you look at the complicated work of Botticelli, or the kind of bombast that fills the work of many painters working after 1550.

To suggest just a few painters that you might enjoy studying in depth, I would choose Masaccio, who is generally credited with being the first painter to master the one-point perspective that propelled quattrocento painting, and Raphael, because his work is both real looking and beautiful. They both had the luxury of working before photography, even though Masaccio had a very short life, hitting full stride in his early twenties and dying at either twenty-seven or twenty-eight.

To look at the work of two artists in the postphotography era, I suggest Vincent Van Gogh and Chuck Close. Everyone knows a lot about the former, but if you're unfamiliar with Chuck Close you're in for a treat. His large paintings are made from photographs that he has taken of his friends. Over the past thirty years, his work has gone through considerable changes while still drawing on the same sort of inspiration. His work has also been affected by the fact that he has been physically disabled to a large degree by illness. Anytime I start feeling sorry for myself, I look at Chuck Close's work and reflect on what he has gone through and what he has accomplished. His work is well worth your attention.

TEN RANDOM RULES FOR INSPIRATION

These are a few things that I've decided are exercises in the sense that they keep you limber. These are things I think you should do all your life, regardless of how big or famous you get. And, since people are getting rich nowadays writing books about rules, I've entitled these, "Rules for Inspiration."

I'm not going to expound at great length, but let me give you some idea as to why I think each of the following is important.

1. No matter how big you get, do at least some of your own legwork.

Remember the 1992 Presidential election? I thought George Bush was dead meat from the day he visited a supermarket and evinced surprise that they had scanners at the checkout counter. Then a reporter asked if Bush knew how much a quart of milk cost. Road kill. With the line, "It's the economy, stupid," coined by his opponent, lots of people figured that some guy who didn't know the first thing about the supermarket was incapable of doing much to help the regular citizen.

So, too, if you don't at least occasionally take your film to the lab or answer the telephone, you won't know for sure what's going on with your customers and vendors. Whatever this means in your business, make sure you do some of your own legwork. That's the key to being street smart: If you're not in touch with what's going on, someone else is and you're likely to pay a big price.

This legwork requirement goes to your business behavior as well. A business associate of mine recently noted that one photo-industry big who sought to have lunch with him never called him directly. Instead, Big's secretary would call and set the date, even ask what restaurant would be

good. Secretaries and go-betweens are a thing of the past. No matter how big you become, no matter how rich and busy you are, don't forget to do some of your own legwork.

2. Talk to strangers.
Your family and friends are predictable most of the time. If you want to get a new perspective on the world, learn to talk to strangers. If I'm waiting in line, walking down the street, or killing time in an airport, I'm always ready to try to strike up a conversation.

3. Collect something.
I've already discussed my love of flea markets and auctions. If you collect something, it will always give you a subject to photograph, a topic you can broach with strangers, and a reason to do your own legwork.

4. Eat your own dog food.
Hang some of your photographs, even if they're of a client's wedding, in your home or office. How do they hold up when you view them every day? Do you start to see things you really like? Do you see things that bother you? Do you see things that you could change for the better?

5. Be nice to the little people you meet on the way up.
Why? Because you'll meet them on the way down or need their help some-day. The VIP—Very Important Photographer—can be an insufferable pain in the ass. Don't let it happen to you.

The Greeks had a saying: "Whom the Gods would destroy, they first make great." Don't give people a hard time unless it's warranted. You may very well need their help later on.

6. Always carry a camera.
If you don't, someday you'll kick yourself.

7. Read voraciously.
Whether your mind is more attracted to books, newspapers, magazines, or poems, reading is essential to appreciating the world. Just because photographers are generally visual people, that's no reason not to read as much as you can.

For example, even on a day when I'm too busy to spend more than a few minutes with the *New York Times*, I always read the obituaries. There are so many interesting people that you'll only hear about when they die. For example, did you know that there was a man who was credited with inventing the football huddle? I read his obit. I never really thought about it, but if a stranger had asked me, I would have guessed that the huddle always existed, kind of like stealing second base or the spitball, or that it just evolved. Nope, some guy actually invented it.

Similarly, I always thought that Rockola jukeboxes were named by a company that saw the future of jukeboxes tied to rock music. One day, I saw a small obit in the *Times* for David Rockola, a leader in the jukebox industry.

8. Read aloud—to yourself and to others.

Reading aloud gives a whole new dimension to the written word. Chances are you'll never be an actor, but don't let that stop you. I once read the entire *Odyssey* aloud to myself during a trip to Mexico. One particularly quiet summer in my life, I read most of *Moby Dick* aloud. In fact, with *Moby Dick*, the only way I was able to read the book at all was to read it aloud. I found that if I read it silently, my mind would wander too frequently and too easily. Someday I may tackle James Joyce's works by reading them aloud.

9. Learn to run numbers in your head.

They've got your number—whoever *they* are. Don't be afraid of that. It's a fact. The trick is for you to become comfortable with numbers. That way, you'll have their number too.

Monte Zucker says anytime you want to convince people of something, throw a statistic at them. People accept numbers. They're impressed by statistics. If need be, Monte jokes, make up the numbers.

Some people put a lot of stock in numbers. Look at all the lists I've included in this book. Read the Bible's Book of Revelations. Read the speeches by Minister Louis Farrakhan.

Too many people feel uncomfortable working with numbers. You can't afford to be one of them. I'm not talking about high school and college-level mathematics—personally I enjoyed algebra and geometry, but I found trigonometry and calculus hard and boring. In fact, I don't think anyone other than engineers really use much more than basic mathematics in their adult lives.

If you can do rough addition, multiplication, subtraction, and percentages in your head and get close to the right answer, you'll have a real advantage in the business world. So don't leave the world of numbers to the mathematicians.

Part of feeling comfortable with numbers is related to your business. Having a sense of costs on a job and being able to add them quickly in your head so that off-the-cuff quotes won't be too far afield will be very helpful. But numbers also govern markets and opportunities, and with a little study you'll have a chance to see where it might make sense to look for a market niche. You'll also learn that the numbers sometime show places where the odds are against you, so you'll have an idea when it makes sense to pass on certain opportunities.

10. Read a tabloid and a magazine intended for the opposite sex.
Tabloids use photographs in ways that no other type of publication does.
The *New York Post,* a tabloid with lots of celebrity coverage, is strongly
picture-driven. I also enjoy glancing through an occasional copy of the
Enquirer or the *Globe.* This is where you'll see the marketplace for pictures
of celebrity cellulite, the oddities of nature, and the seemingly unsolvable
mystery of who killed child beauty queen Jon-Benet Ramsay and left her
body in the basement of her parents' home.

If you're a man, read a copy of *Cosmopolitan* or *Vogue* occasionally.
You'll be surprised by the intense interest in sexuality and the amount of
female nudity you'll see. A current cover of *Cosmo* includes the following
teasers: "Cosmo's Hot New Sex Position. You've Got to Try the
'Butterfly'—a Move So Erotic You'll Wear Out the Mattress Springs This
Month; The Confessions Issue; and Brides Behaving Badly, Why They
Cheated Just Weeks After the Wedding."

Look here: a six-page spread of Kate Moss stark naked! Nipples erect
and neatly trimmed pubic area for all to admire. *Penthouse? Details?* No,
British Vogue, which also features a cover article titled "Sex with the Ex."

This is not an unusual month. Consider this service article in anoth-
er recent issue of *Cosmopolitan:* "The Secrets to Sizzling (Solo) Sex. Tell
your roommate to take a hike and test-drive these four make-yourself-
moan maneuvers."

Compared to what's being shown and written about in women's mag-
azines, the world of men's magazines seems tame and repetitive. But, if
you've never looked at *Penthouse* or one of the burgeoning category of men's
titles such as *Details* or *Maxim,* you might want to check out *Maxim's* Babe
of the Month and see how little men's vision of women seems to change.

PICTURE STORIES: SHOW ME!

Enough with exercises and rules. Let's get down to some sink-your-teeth-
into-them suggestions that will give you ideas for self-assignments. This is a
list of topics and assignments that will yield photos that I would like to see.

I look at lots of photographs; more, I suspect, than most people. I
realize there are a few specialists—photo editors, curators, and the like—
who look at far more photographs than I do. I'm sure that some of the fol-
lowing assertions will result in someone writing me that I never saw the
great photo essay on chicken farms that ran in such and such magazine last
month or last year or what have you. Sorry, I missed it.

That's an inherent danger in making the kind of wish list that I've
constructed here. I take the position that if I didn't see it, most of the
world didn't see it, so therefore it might make a good self-assignment for
me or you or some other photographer.

Here, then, in no particular order, are some of the subjects that I
have yet to see covered in detail that I would find interesting to see. After
all, we're poised on the cusp of a new millennium—the first "happy new

millennium" that photographers will have a chance to record from its beginning. If this book goes into later editions, I promise I'll revisit and update this chapter as necessary. Feel free to send me any comments.

SKATEBOARDING

Excuse me. Skateboarding has been a serious subculture for three decades, but in New York City it seems to be almost exclusively the domain of teen and immediate postteen males who can spend hours maneuvering their boards over small curbs, down short flights of stairs, and perhaps along the side of a wooden bench for a foot or two.

What is so damn exciting about that? I understand the contests and the sloped ramps and going up in the air. I'm talking about urban skateboarding in public spaces, turning stairs and benches into a bunch of hazards where the payoff seems weeney and the risk of losing a tooth, getting scarred, or wracking up a knee seems high. Unlike a long ride on a wave, when these skateboarders actually succeed in doing what they're attempting, the ride is mighty short.

The risk part I also understand, but hell kid, get a motorcycle if what you want to do is hurt yourself. I asked Elliot Hendler, a then–nine-year-old acquaintance of mine, whether he felt the allure of the skateboard and he said absolutely—it's the feeling of big space. I kept asking for specifics, but he didn't have any.

I'm sure it's there. Show me the excitement. Show me why.

OUR FOOD SUPPLY

If I get a chance to come back in another life, I sure hope it's not as a chicken. Or, for that matter as a farm-raised salmon or catfish, because I think it's a short life to get fattened up and sent to the slaughterhouse.

In the old days, you might get a few years in the barnyard, and I guess some hens still get diverted to egg detail. But how long does the chicken that's headed straight for the dinner table get? What are the experiences from hatching out of the egg until it's time to get slaughtered? How's the food? How's the company? What does the chicken do for kicks?

Can you imagine how many chickens get raised and slaughtered in this country? We're a nation where large scales and big numbers are part of what swing the stick. This chicken business is a giant market. How many chickens a year do we eat? I frankly have no idea, although I'm sure there's a Chicken Information Institute, or someone with help at chicken.com. Let's just figure for openers that Thanksgiving Day alone we're probably talking 75 million turkeys (figure 270 million Americans in 100 million households, so if 75 percent of the households have turkey on Thanksgiving, there's your 75 million). But turkeys are a specialty item. You don't see turkey nuggets at fast food joints, and no Buffalo turkey wings at the local tavern. We must go through 400 or 500 million chickens a year, perhaps many more than that.

Between the Chesapeake Bay and the Atlantic Ocean is a finger of land called the Delmarva Peninsula because it is a peninsula and three states—Delaware, Maryland, and Virginia—divide the land. It's also the East Coast Bermuda triangle for chickens. There are lots of chicken farms and processing houses. Probably a lot of chickens start and end right on the Delmarva peninsula and only make the trip to New York or Boston on board a truck as a fryer or a bunch of parts.

Show me the chicken's eye view. In the start of this century, there were several painters who were interested in trying to paint from an animal's point of view. Show me the salmon or catfish perspective.

Also, show me the lives of the workers on the chicken farm or the processing plant. What's it like to spend your day killing, plucking, or dismembering chickens? What do these workers do on their time off? Do they ever eat chicken?

Don't think I'm being critical of the workers. I'm not. But I don't know anything about them and would like to. Show me.

Same thing goes for farm-raised shrimp and salmon. Show me what's going on for the creatures and the humans who harvest and process them.

MUSLIMS IN AMERICA

Ever since the World Trade Center bombing in New York in 1993, there's been an uneasy relationship between most American citizens and the Muslim world. We know quite a bit about Christianity, the religious right, Baptists, and Catholics. In most of America, we have some idea about the faith and practice of Jews. But Muslims? Most of us are clueless despite the fact that this is one of the world's largest and most influential religions.

Show me the life of Muslims in your community. I might add that this may present some difficulties since certain sects prohibit the taking of various types of images. However, I would definitely not propose that this be undertaken on a surveillance or candid basis. To show me something, this would require getting permission from the leaders of a spiritual or ethnic Muslim group and working with them over a sustained period of time.

THE DEATH OF MANNERS

Recently, it's gotten more uncivil than ever in New York. I'm not talking about felonies, just the little day-to-day stuff. I understand why people push into the subway car before letting the people who want to get out at that stop exit the car. If you get in first, you might get a seat, so there's a prize that makes it worth pushing in ahead of all the other people trying to enter and those trying to leave.

But now people are doing this with elevators! There are no seats, and you can be sure that the people who want to get off on the ground floor are going to do so whether some lout barges into the elevator before they get off or not.

In short, there's absolutely no reason not to "let 'em off" first, but the pace has picked up to the extent that we plunge headfirst into that opening. How are things where you live? What can you show me about the way people treat each other? Is there still civility where you are, or is it, like New York, to quote a lyric of Mose Allison, "Too many pigs living in the same trough?"

Men and Women

Years ago, Maggie Sherwood mounted a group show at the Floating Foundation suggested by photographer Bob D'Allesandro on the topic that men and women often don't get along so well. In the last two decades, we've seen changes in the way that both men and women define themselves, how they deal with equal rights, and their concepts of feminism. Now there are books of "rules" and all kinds of formalized behavior.

What can you show me about the ups and downs of relations between men and women? There are lots of positive and negative topics to pick from. How about portraits of former couples? How about the way people look at the other sex in the street? What about changes in the workplace? Or take a page out of *British Vogue* and show me "Sex with Your Ex."

Prisons

The headline is stark: "1.1M inmates in U.S. prisons." That was up 10 percent from five years earlier. And that headline was ripped out of a newspaper almost four years ago. As you've read, I've spent some time inside prisons. But most of law-abiding America has never set a toe inside the joint. Show them. After all, a lot of those 1.1 million people are going to get out and rejoin society, and others are going to go to jail later. That means a measurable percentage of Americans have had an experience that almost no one else can even imagine.

That's dangerous. That divides us. Can you make images that help bridge the gap? I warn you that you'll have to come up with photos that really grab your viewer by the nose, because a lot of people don't want to be bothered with knowing about this stuff. Years ago, one of the places the Floating Foundation put up an exhibit of prison inmates' work was in an elementary school in the very posh Westchester town of Rye, New York. One third grader wrote, "Why are you showing us these photographs since none of us will ever go there?"

I wish I had the opportunity to give this pampered kid's teacher a thump on the head. I've got news for you—there are inmates doing serious time from some of America's finer families. Jail isn't just for losers and the lower classes.

The Death Penalty

While we're on the subject, it's about time that photographers got access to that last taboo: The state, in the name of the people, killing someone.

Let me admit my bias up front—I don't believe in the death penalty. I believe that if you want to punish somebody, you put them in jail and let them rot. I think you can't teach society that killing is wrong by killing people. But, I'm also a realist and the battle to end the death penalty in this country has been lost, at least for the time being. The majority of people want it, they just don't want to see it.

Many years ago one of the New York tabloids, the *Daily News*, snuck a concealed camera into Sing Sing and attempted to photograph the execution of a woman who had been involved in a notorious murder.

My friend Doug Magee, who is a screenwriter as well as an activist for abolition of the death penalty, wrote a screenplay ten years ago titled *Somebody Has to Take the Picture*. It became an HBO film. The premise was that an inmate facing execution made a last request that a glamour photographer be allowed to photograph his execution. Roy Scheider played the photographer, who ends up getting involved in the case that convicted the man in the first place.

Whether you're for or against the death penalty, I concede that there have been some fiendish criminals in the past few years who make it very understandable why the average citizen may want to see them killed. Regardless of your stance, let's get this dramatic activity recorded on film. Show me the person to be executed, show me the agents of death and the warden. Show me the witnesses. Show me the governor hundreds of miles away in the state house. After all, if CBS's news program *60 Minutes* can videotape Jack Kevorkian administering a lethal dose of poison to a person who wants to end his life, why can't we photograph the state using taxpayers' money to kill someone as a form of state-sanctioned punishment?

Killing people is serious business. Show me.

TATTOO THIS

On a lighter note, show me the new iconography of tattoos. Years ago when only pirates and tough guys wore tattoos, the subject matter was pretty straightforward: dames, devils, and the like. Now we have supermodels and people of all ages and both sexes getting tattooed everywhere. In addition to butterflies and flowers, we have lots of strange ring-around things—encircling arms, legs, and even toes—that look like ersatz writing or hieroglyphics.

Show me what people are putting where. Show me the choices of folks who seek to add spice to their genitals with proximate tattoos intended only for the eyes of their intimates. Show me what's bad today, what's hot today, what's not today.

Show me what it's like getting the work done. For that matter, show me what it's like having laser treatment to have the tattoo removed.

BUSKERS

I love musicians. Not long ago, waiting for an errant subway train, I spent perhaps twenty minutes listening to the gentle music of two buskers who

were clearly Indians from one of the countries in the highlands of the Andes—one with guitar and a drum yoked to his ankle, the other with something that looked a lot like a mandolin. Both also played those ethereal reed pipes that characterize the music of the region. People pushed past, trains roared in and out, and this beautiful music wafted into the silent moments.

Years ago, the subways didn't permit photography or music. Somewhere along the line, the First Amendment worked its magic, and now there are even sanctioned areas for musicians in the subway.

But it could be mimes in Times Square, acrobats at the Battery, the buskers outside London's theaters, or the variety of performers who work the squares in front of the church in Cologne. Show me the passion and dedication of buskers who work amid hordes of people, many of whom take no notice.

CHILD ABUSE

A friend of mine who runs a stock photo business and has a mordant sense of humor once said to me, "If you ever abuse a child, make sure to photograph it." What he meant was that there's very little illustrative material of this subject. As child abuse becomes a topic of greater concern to more and more people, how can we tell the story? What is there that can be shown?

SHOPPING MALLS

I sure hope online shopping doesn't destroy the American shopping mall. Last Christmas I stopped at a big indoor mall in the New Jersey suburbs on my way back to New York City because I wanted to look for a specific children's book as a present for my daughter.

It had been a while since I'd been in a big mall by the highway. Without them, where would teenagers hang? I saw good kids, tough kids, bad kids, and hip-hop kids, all with their own places to congregate and with their own specialized behaviors, dresses, and rituals. If I were going to do a book or photo story about being a teenager, I'd start in the mall. Where else can you go to get away from your parents, be near food and shopping, and act out in a crowd? If things seem out of control in America's high schools, what potential exists in the malls?

POLLUTION'S TOLL ON US

As much as pollution has been a concern in recent decades, there is still only a limited range of imagery that documents the subject. A few years back, many miles of New Jersey's magnificent beaches were closed because of needles and other medical waste washing up on the beaches. The image of one needle sticking out of an expanse of shoreline is something, but how can we get inside the story? I want to see polluters in the act of polluting. I want to see stories that get people even more angry than they already are.

Whether it's depletion of the rain forest or threats to endangered species, show me new ways of looking at these subjects.

OVERPAID ATHLETES AND THE PUBLIC TRUST

The front page of the tabloid showed a then New York Knick, John Starks, giving the finger to the fans in some arena. I've made it clear that I'm not much of a sports fan, but I think there's a lot to uncover in this world where multimillion dollar corporations hire multimillion dollar athletes in their twenties and thirties and allow them to act out in front of lots of kids who idolize them.

When Dennis Rodman kicks a photographer in the balls, it's hard to entirely dismiss the fact that there are a bunch of big corporate entities involved: the arena, the team, the television station broadcasting the event, the news agency that hired the photographer, Rodman's management agency. Now, I promise you that if an airline pilot or flight attendant found reason to get so aggravated that he either kicked a passenger in the groin or gave the finger to all of the passengers, there would be lawsuits, firings, and fines. The FAA would come in and raise hell.

Why do the companies that run sports get a free ride? It used to be that kids were told, "Crime doesn't pay." Lots of kids doubt this. They see the neighborhood thug or crack dealer as a successful person. That image has to be combated.

Forget about Dennis Rodman—he already appears to be on the way toward self-destruction. But let's consider the likes of John Starks. You don't like the way the fans are treating you. Maybe you don't like the town you're in. Maybe you're playing for the visiting team. So, with 15,000 or 20,000 people looking down at you, you give them the finger and smile. Perhaps a few hundred or a thousand of the people there actually deserve your gesture, which, after all, means, "Fuck you." But there are probably hundreds of well-behaved eight-, nine-, and ten-year-olds who did nothing. Some of them root for you. Many of them look up to you.

Professional sports in this country appears to me to be out of control. Show me the direction it's headed in. Show me the commissioners and team owners who will happily make sure homeless people get tossed off their property but who coddle and reward these millionaire players who choose not to behave.

STATE GOVERNMENT

The focus in politics tends to be on the national and local level. But, if you live in the United States, the chances are that a lot of circumstances that govern your life turn on the acts of the members of your state legislature. In junior high school we all suffer though civics class, most of us learn the names of the fifty state capitals, and that Nebraska has the only unicameral legislature.

But there's more to it than that. State government controls your local budgets and a lot of money that comes from the feds. In New York State, the 211 legislators who spend a few days a week for six months of the year in Albany, 140 miles north of New York City, have tremendous power. They preside over a budget of approximately $80 billion, and they often end up doing a lot of business in the middle of the night just before the close of session. I doubt things are much different in Trenton, Sacramento, Austin, or in any of the other state capitals. Some of the legislators are hardworking, dedicated souls who deserve a better reputation than most politicians enjoy today. Others are power-hungry morons who have risen higher in life than their talents merit. Show me who's who.

A Personal Story

You could show me something about your family, or some other family. An intimate story or a personal tale that might be poignant, sad, or happy. They're all around us.

Here's an example: Not long ago, as I got out of a car in a supermarket parking lot, a yellow *Post-It* that was floating in a puddle stuck to the sole of my shoe. I decided this was a portent, so I picked up the note. It was written in ballpoint pen and the text was still legible. It read:

8-20-97

Dan,
Got your message & here is a copy of your birth certificate. Re money—sorry, but I haven't had any income in several months and am in a very difficult situation myself.

Love,

Dad

That leaves me with a lot of questions. How did Dan leave a message for his Dad? Why does he need a copy of his birth certificate? How old is Dad and how difficult is his situation? How long since Dan and Dad have seen each other in person?

Show me how people relate, how families are held together. Show me where the stress points are and how the good times compete with the tough times. I don't need to see moments of big drama—someone dying of AIDS or a POW returning to the family home. Big stories are fine, but that's when people put on their public faces. Show me the drama in the small stories.

Regionalism in America

Back in the 1950s, there were a lot of differences in America. For a lot of products, prices were "slightly higher west of the Rockies." Listen to the

nasal twang and mind-set of the songs of the Everly Brothers, Little Richard, or Elvis. When we watched the kids on *American Bandstand*, we knew they were sharp in a way that came out of Philadelphia.

Now, things are a lot more homogenized. There's little difference between a supermarket in California and one in Alabama. Yet, there are pockets where there's still a local culture that's different from what I'll call Standard America. New Orleans and the Louisiana Bayou country have an accent, music, and cuisine that's all their own. There are ethnic enclaves in New York, and I recently visited San Francisco's Fisherman's Wharf for the first time in thirty years and discovered to my delight that lots of unique stores and restaurants still remain.

Contrast that with Santa Fe. Not so many years ago, a friend of mine who lives there assured me there were "ten-cent beers and cowboys pissing off wooden sidewalks in the middle of town." Now it's Baskin Robbins, the Gap, or something like it, and a lot of art stores selling reproductions and turquoise jewelry.

Show me something that's unique about the region where you live. It's still there, you just have to look hard. For example, along the banks of the Delaware River, less than one hundred miles from New York City, there are people who still build eel weirs in the river and capture hundreds of eels in the fall. I'm told that smoked eel accompanied with a lot of beer, is a tasty treat. On the southern banks of the Delaware, in Pike County, Pennsylvania, there is an autumn two-day hunting season where over two hundred black bears are killed. Have you ever seen a black bear in the wild? I have, and it will fill you with adrenaline and make your heart pound.

Show me what's left of the regions of America before the information highway flattens more of what used to make these a bunch of individual, united states.

Aging Rockers

Forget the superstars. We'll all hear about Mick's operation. What about all the middle-magnitude stars who are approaching old age? Where are they now? What do they do? Do they express any regrets?

Made in China

China—a vast market where communist leaders promote "enterprise zones" and occupy and demoralize the people of Tibet. It's a culture that is at once rich and bankrupt. It used to be that China was a faraway place, and the only things that came from China were little toys and odd knick-knacks.

If you don't have a young child, let me alert you to something—virtually every toy a toddler owns, every stuffed bear, and lots of clothes and shoes are all made in China. A friend of mine who is particularly angry about the overall human rights abuses in China and the Chinese occupa-

tion of Tibet makes it a point to only purchase presents for my daughter that aren't made in China. Hard to find.

Show me what's going on in China. Show me how we reconcile our concerns about human rights with the joys of cheap labor. Show me what's going on with the rapid economic expansion and the growing pollution.

IRELAND

For years, Ireland was the most economically disadvantaged country in Western Europe. The stagnated world of the lower classes in Dublin, immortalized in *The Commitments*, has changed. Now lots of high-tech companies are building plants in Ireland. Kodak recently built a CD manufacturing plant there.

Show me how life has changed for the Irish now that prosperity has been brought to a land best known for "troubles." Also, show me what's going on with those troubles. Remember when someone blew away the entire front wall of a hotel where British Prime Minister Maggie Thatcher was attending a meeting? Remember when Lord Montbatten's yacht blew sky-high with the lord aboard? Only a few weeks ago, an Irish attorney who also happened to be the mother of three young children was blown to smithereens by a bomb placed in her car. Show me how to make sense of all that.

DID HE WHO MADE THE LAMB MAKE THEE?

William Blake's poem "The Tiger" from his *Songs of Innocence* poses a question about the wide range of behavior in our world. There is some really bad stuff. Show me what's really scary—the world of the sociopath and the warmonger, or the punishment of poverty and drugs. If you've never looked at Eugene Richard's photo essay "Cocaine True, Cocaine Blue," make sure you do.

LAS VEGAS

I've saved the best for last. I love Las Vegas. I first went there in the early 1960s with my dad when McCarran Field was the airport and the Thunderbird Motel and the Sands were at the end of the Strip. Now, the Thunderbird is a $99-a-week dump just outside downtown, McCarran Field is some sort of aviation museum, and the Strip runs for miles to the south of renovated downtown.

In the past decade, Las Vegas has been the fastest growing city in America. Not only have gambling and convention development fueled the growth, but people looking for a California-like climate without the threat of earthquake disasters have also settled here. There are loads of people who live in Las Vegas and have nothing to do with the hotels, casinos, or the Strip. There is still sleaze and hookers, along with zany theme hotels. Currently they're building Paris and Venezia. There's a three-quarter–size version of the Eiffel Tower going up in front of Paris. The new Bellagio

hotel features a multimillion dollar collection of art that is proving to be a huge draw.

Everything that can be covered with sequins or flashing lights is covered. Microchips make the slot machines make noises and talk. It is the most ornate city in America, dedicated to the flashy proposition that you're in a city where sin is winked at and anything goes.

In reality, it's a fairly normal place and the rapid growth has created huge traffic jams at the city's periphery. How there is enough water to keep the place going is a mystery to me.

Show me Las Vegas. Show me how it works for the outsiders, the insiders, the winners, and the losers. Show me the surreal scene of Christmas in Las Vegas. Show me the vast emptiness just outside city limits. Show me the housing developments that have just been built. Show me the old stuff that's about to get torn down. Show me the keno runner wearing a push-up bra and thong bottom with a big crucifix around her neck and a giant wedding ring on one finger and nail tips on all ten. Show me how she balances the contradictions in her life.

I'll stop here, but I could go on forever. Every day I notice things that I would like to know more about, things that make me want to have photographs to add to my "Scrapbook of the World."

Show me!

This is a Diana-F print I made about twenty years ago and filed. I ran across it sorting photos for this book and decided I like it. I cannot remember where it was taken.

Chapter 14: The Way to Win Contests and Get Grants

I've judged hundreds of photo contests of all sizes. I enjoy doing it, but it's hard work running a photo contest, and that hard work is a big part of the reason that there are special tricks you must follow. But I get ahead of myself. Follow the advice in this chapter, and I guarantee you that you'll increase your chance of winning whatever you define as a "contest" by a factor of ten!

Naturally, you have to have a good idea for a picture that fits the subject matter of the contest, or you may have a picture on hand that you made for another purpose that would make a good entry. Originality and inventiveness are always important, but no matter how great your photo, you have to make certain that it comes to the attention of the judges.

WHAT IS A CONTEST?

There are different ways to define a contest. Perhaps you're dying to see your photo published as a winner in one of the photo contests run by a major magazine. Perhaps you're taken with the big cash prize offered in a photo contest run by a national manufacturer.

Maybe, you're not interested in professional photography as a way to earn a living and you're not that keen on entering contests, but you would like to approach another type of photo project—say, getting your photos published in a major magazine, or calling local attention to an issue that's important to you by putting your photos in front of the decision makers.

I view all these situations as contests. And when you need to get the attention of someone who's not awaiting your photographs, it makes sense to approach the task of getting your photographs viewed by the right person and given proper consideration as a contest. The job is to send off your images in a way that will get maximum impact.

PHOTO CONTESTS ARE POPULAR AGAIN

Let's start with the question of where you find contests. Those run by publications are generally announced in the magazine or newspaper that is sponsoring the contest. There are contests run by companies because they need photos for advertising, packaging, or promotion. These companies see a contest as a way to take in a lot of photographs and also boost consumer interest and loyalty.

Then there are state fairs and civic organizations that run contests because they see that sort of activity as part of their function.

Just as there are lots of different reasons a sponsor may hold a contest, there are different types of prizes. Perhaps the company you work for has an annual calendar and holds a contest for employee photo submissions to be considered for the calendar. If there's a publication involved, the prize is usually tied up with the satisfaction of seeing your work published and the recognition that follows from that. There are also contests with large cash prizes.

HOW DO YOU FIND CONTESTS?

Any entity that plans a photo contest will want to get a lot of publicity and will try to promote it. So if you pay attention, you'll hear about photo contests that might be of interest to you. Keep your eyes open.

You will also find that doing a little searching on the Web will lead to all kinds of contest information. For example, although some of them are outdated, a simple search today on Yahoo! lists 2,398 photo contest–related Web sites.

IS IT EXPENSIVE TO ENTER PHOTO CONTESTS?

As a rule, no. There are some contests that charge a high entry fee, but many of those are really businesses posing as contests. Those contests are designed to make money from the entry fees for the entity holding the contest. I suggest that you avoid those.

For most contests, expect that entering is free or that the fee is a few dollars to defray handling costs. Whatever the cost, even if the contest is free, it is going cost you a few dollars to prepare your entry.

READ THE INSTRUCTIONS

If you find contests that are of interest to you, one of your first questions may be how many pictures you should submit. When you get down to the details of any contest, read the instructions carefully. There will be a provision regarding the number of photos you can submit. If the contest limits photos to three per entrant, should you submit one or two or three?

The answer depends on what you have to submit. If the contest seeks great horse photos, and you have only one great photo of a horse, submit that one photo. Don't dilute your entry with lesser images. If, on the other hand, you specialize in taking photos of horses and have dozens of great horse photos, then, by all means, submit your three best photos.

Here's how it looks from the inside. In any contest that attracts a lot of entries, the judges—and perhaps the staffers who process the incoming photos—are looking for a way to cut down the number of entries that must be given final consideration. There are a variety of things that can cause your entry to be tossed into the reject pile. One of your objectives is to avoid all those things.

If you send in a mediocre photo to round out your entry to the maximum number of prints allowed, someone may see that mediocre image in the presort and reject your entry without even seeing your best image! By the same token, if you send in too many photos, or if your photos don't meet the size and presentation requirements printed in the contest rules, your entry will probably get tossed.

In very big contests, the handlers who initially open the submissions are instructed to reject entries with photos that don't meet the guidelines. Processing a photo contest is difficult under the best conditions. Everyone handling contest entries is looking for a way to make the job simpler. One way to do that is to eliminate as many entries as quickly as possible.

After the photo entries are opened, it's possible that administrative staff may make another cut of the contest based on image quality before any of the actual judges look at a single photograph. And believe me, even if you get rejected for a poor reason, you're rejected. As almost every contest states, "The decision of the judges is final." There's no second chance. You need to get it right the first time. You can't go to court and appeal.

You must also bear in mind that some of the entities that hold contests don't know what they're getting into. They may be swamped with far more entries than they expected. If that happens, the contest handlers may feel overwhelmed. You need to make your entry stand out, while avoiding violating any rules.

It makes sense to read the contest rules several times, so you're sure you have everything straight.

PUT YOUR NAME ON EACH PHOTO

Unless the rules express some other requirement, put your name on the back of each photo. And do it right. You would be astounded at the num-

ber of photos that are ruined because an inexperienced photographer uses a ballpoint pen or some type of ink pen to write his name on each photo and then stacks the photos before the ink is dry. With today's resin-coated papers, the ink is not absorbed into the paper. This means that the writing will be transmitted from the back of the photo onto the front of the photo upon which it is stacked.

Time and time again, in every contest I judge, I see well-executed photos ruined by smeared ink. Old, fiber-based photo paper could absorb ink and it would dry quickly. On some plastic-coated papers, some types of ink will never dry completely. No matter how long you wait, the ink will smear.

The solution? Either write or type your name on a self-adhesive label, allow time for the ink to dry, and then affix that to the back of the photograph, or else use one of those fast-drying "permanent" markers such as a Sharpie. It's easy to recognize these pens because they are the kind that dry out if you leave the top off. Those pens will write on the back of any photograph and dry quickly.

SUBMISSION OF YOUR PHOTOS

Once you've picked your best photos and labeled them properly, you're not going to simply toss them in an envelope. They might get mangled. Put some sort of stiffener into the envelope, or use a rigid envelope, such as the type used for mailing documents. If your photos get bent or damaged in the mail, they'll likely end up in the reject pile. Make sure to address the envelope exactly as requested in the contest rules. At NYI, we always have at least two contests running simultaneously on our Web site. One is open to students only, the other is open to all Web visitors. Our rules specify that each contest entry come in an envelope with a one-word contest name listed on the front. You'd be surprised how many people don't follow that simple instruction.

People will spend ten dollars or more to rush photos to us via some sort of express mail delivery in order to make the contest deadline, but they won't address that expensive envelope properly. While we try to compensate for this shortcoming, sometimes very promising entries get misrouted and aren't discovered until way past the time the contest has been judged.

HOW BIG SHOULD YOUR PHOTOS BE?

This is easy. I suggest you submit prints, even if the contest permits slides, and that you make the prints the largest size—or close to the largest size—permitted under the contest rules.

Here's an instance where bigger is better. Judges are human. And they're going to look at lots of photographs, so don't make it hard for them to see your work. Many contests permit a maximum size of 8″ × 10″. That means you have to go to the trouble of getting enlargements made, and

they have to be good enlargements. We'll discuss labs in some detail in chapter 21. But if you haven't learned this already, be advised that some labs make great enlargements and some don't. Find one that does, and keep after the lab staff until you get a great enlargement that does your photo justice.

WHY AVOID SLIDES?

Slides are hard to view. Many contests don't even permit them. Of those that do, sometimes the judges will give slides full consideration, but other times, particularly if they've already seen a lot of great prints, some judges are apt to give slides short shrift.

I know of one very big, international contest where the five judges got into a dispute over viewing the slides. The judges had been flown to an Asian capital from various points around the world. They were tired. They had jet lag. They had seen hundreds of great prints. Some didn't want to be bothered even looking at the slides that the staff had selected.

If you have a great slide, go to the trouble of having a great print made from the slide. Whether you use a traditional process such as Ilfochrome (which most people still call Cibachrome) or use digital services to convert the slide to either a negative or a digital print of some sort, submit your image as a print.

Most contests don't seem to prohibit computer prints from digital files, even though some contests prohibit computer-assisted enhancement or manipulation of the image.

THREE GUIDELINES FOR GREAT PHOTOS

Anyone holding a contest isn't going to give an award to any photo that doesn't have all the aspects of technical excellence. I didn't mention this earlier because it should go without saying that any photo that you would spend money to have enlarged, much less take the effort to enter in a contest, should be a perfect image. It should be sharp, well exposed, well focused, and composed in a pleasing way. There may be reasons that a portion of your photograph is blurred, or that the background is out of focus, but overall, technical excellence is essential and expected by the judges.

We're going to cover technical excellence and image selection when we get to creating a portfolio in chapter 19. But technical excellence is just the starting point. A winning picture must have a plan, a plan to show the subject in its best possible light. If the contest calls for cute dog pictures, and you have a cute dog, don't expect the judges to know that unless you submit a photo that shows them that your dog is cute. At NYI, we stress to every student our Three Guidelines for Great Photos. They're simple. In a way, they're obvious. But if you can train yourself to ask these three simple questions every time you look into your camera's viewfinder, you'll take better photos every time.

Guideline One: What is the subject of my photograph?

Most amateurs fail right here. They stumble out of their hotel room in downtown Paris, put the kids in front of the building and take a photograph. Half the picture ends up being the cement of the sidewalk in front of the hotel. The kids and the hotel are small in the background, and if the sun is shining into the kids' eyes, they're probably squinting!

In a contest situation, the subject is dictated by the theme of the contest. If the subject of the contest is "Paris," you're going to have to come up with subject matter in your frame that says "Paris" loud and clear. Even if you're not thinking about a contest, if all you want is a photo of your kids in Paris to show the folks back home, you have to get Paris into your photo.

Guideline Two: How can I emphasize my subject?

Most often, we give our subjects emphasis by making them large and up-front in the frame. There are other ways to draw the eye of the viewer to your subject, such as framing or repetition, but you'll never miss if you make your subject large and up-front.

The fabled war photographer Robert Capa is credited with saying, "If your photographs aren't working, get closer to your subject." In truth, there were probably many others who said something similar before Capa. Regardless, it's almost always good advice.

Guideline Three: Is there anything I can do to simplify my photograph?

Don't be so fixed on the subject in your viewfinder that you don't check to make sure there aren't things that you should omit from your photo. Make sure there isn't a telephone pole that appears to be sticking out of someone's head. If you're photographing a street scene and there's a discarded paper cup in the foreground, it's going to be very distracting in your photo. Get rid of it. Either physically remove the object or crop your photo in a way that it won't be in the picture. There should be nothing extraneous or distracting either on, near, in front of, or behind your subject.

UPBEAT HELPS

These three guidelines will help you make better subjects for all your photographs. With contests, you need to give some added thought to what the people holding the contest want to see. For example, if the theme of the contest is "Party Time," you can bet the winning images will show a fun party, a celebration. It's unlikely that a scary Halloween party photo will win. Similarly, it's unlikely that a sympathetic portrait of a young child who's having an anxious moment at a party will win. Most of the time, contests are looking for upbeat subjects.

Humor, when appropriate, can work well in many types of contests. People, including judges, like to laugh.

DO I GET MY PICTURE(S) BACK?

Read the rules. In many contests, all entries become the property of the entity holding the contest. In other contests, you may submit a self-addressed, stamped envelope to get your photos returned. Still other contests *require* that you submit a return mailer.

If you have a choice, I suggest that you do ask for your photos to be returned to you. This will take a little more work and cost you a little more money in postage. I recommend this because it shows that you care about your photos. And if you don't care about your photos, why should the judges?

I know a guy who is an unsuccessful playwright. To make ends meet, he drives a taxi. He writes and continues to submit his work to agents and producers. And if he doesn't hear from them in a few weeks, he goes and gets the manuscript back. Not, he explained to me, because he needs it for another submission, but rather because he feels he needs to show the agents and producers that he takes his work seriously. If he doesn't, he reasons, why should they? I feel the same way about return envelopes.

SHOULD I GIVE UP ALL MY RIGHTS TO MY PHOTO?

You have to read the rules carefully to determine exactly what rights, if any, you forfeit when you enter the contest. Do the folks running the contest have the right to use any photo that is entered in the contest, or do they only have rights to limited uses of the winning images? There are lots of different possibilities on this one. You'll have to weigh the benefits of entering the contest—and possibly winning—against the rights you relinquish.

WHAT IF, DESPITE ALL THIS ADVICE, YOU LOSE?

It happens. I actually talked to one student who told me he entered his first photo contest and when he didn't win, he grew so disenchanted with photography that he stopped taking photographs altogether for three years.

That's ridiculous. After all, there are lots of entries in every contest, so it's possible that there are a few photos that are better than yours. If the winning images are published, before you get too discouraged, look at the photos that did win the contest.

This is not just an exercise in jealousy. Rather, it's a chance for you to hone your skills for the next contest. What elements did the winning photos have that your photos lacked? What elements did the winners have that yours had also? Did you interpret the theme as accurately, or as inventively, as the winners?

If your photos were weaker than the winners', take heart. Learn from the experience. And look at the winning photos and compare them with your images several times. Treat this as a learning experience. If your photos were as good as the winning entries, then that means you're getting close. Next time out, you may end up in the winner's circle.

If your photos are *better* than the winners, take heart in the fact that the decision of the judges is final, but that doesn't mean it's the right decision. Besides, there are sometimes factors that are beyond your control.

HIDDEN CONTEST AGENDAS

If you enter a baby food "Beautiful Baby" photo contest with a photo of your six-month-old daughter with her shock of bright red hair, you stand a slim chance of winning, no matter how good your photo, if last year's winner was a baby girl (or, for that matter, a baby boy) with bright red hair. Chances are, the judges are going to pick a child with blonde hair, black hair, or no hair this time out. They don't want to proudly announce the winning photo and run it on their packaging or advertisements and have people remark that it looks "a lot like last year's."

Similarly, there may be a hidden agenda. If you enter the popcorn maker's "Party Time" contest with a great photo from a Fourth-of-July barbecue, but the popcorn people want a photo with a Christmas theme to win, then you will lose and it does not reflect on the quality of your photo.

There's no way that you can know for certain what's going on in the "inside" where the judging takes place. All you can do is give the contest your best shot and learn from the experience. And above all, bear in mind that all photo contests are very subjective. In a swimming race, the contestants compete against one another and the clock. It is easy for all to see and measure who won and who lost.

In entering a contest in the visual arts, there's no race and no clock. The judging is bound to be highly subjective. It's worth paying heed to what went into the winning photographs, but it's not worth your while to feel that your photos that did not win "lost."

LOOKING AT YOUR PHOTOS

The most important advice I can give to any photographer who wants to improve the quality of the images she produces is that she must invest time in looking at her own images, studying them, and learning to evaluate them with an open mind. Years ago, when most amateur and professional enlargements were made by the photographer in the darkroom, there was ample time to study the strengths and weaknesses of a print as it sloshed around in the fixer and wash. Today, it's easy to get a roll of film back from the lab and flip through it quickly and cull the selects and toss the rest.

You'll benefit if you linger over the images you've made. Study the good ones, but also study the others. What were you thinking about when you made those images? Were you following the Three Guidelines I mentioned above? How could each image have been made better? Are there some you shouldn't have even tried to make? Can you take better photographs by taking fewer pictures? When it comes to evaluating your own photographs after processing, the more you can develop your own insights, the more rapid and dramatic your growth as a photographer will be.

However you define a contest—whether the contest is a sponsored competition, or your own personal effort to get your photographs noticed by the right person—attention to details, attention to the guidelines for presentation, and making sure you put only your best work forward will improve your odds of being a winner.

GRANTS, PRIZES, AND AWARDS IN PHOTOGRAPHY

There are a few institutions that regularly award various prizes and grants to photographers. Some of these are set up by nonprofit institutions that have a particular interest in photography. Others, such as the Guggenheim Fellowships, give awards to artists, some of whom happen to be photographers.

Then, there's always the Pulitzer Prize for photojournalism and other "prestige" awards that don't yield cash but will boost your resume and probably your future earnings as well.

These organizations change policies, and sometimes a new one crops up or an old one disappears. Several of the book guides to grants, contests, and prizes that used to exist have gone out of print. I think this sort of reference information will henceforth be available most efficiently (although perhaps not always more reliably) over the Internet.

Unfortunately, not only are all the available grants and prizes fairly easy to research, they're also relatively few and far between. This means that there's a long line of people waiting to apply for every program. The competition is fierce, and even if you're very deserving, the numbers don't lie—the odds are against you.

So, give up. All ye of little self-esteem, abandon hope. Wait. There's another way.

THE BACK DOOR

If you believe in today's admonition to "Follow the Money," then please also consider this corollary: When you find the money, there's generally a shorter line at the back door than at the front door.

Let me offer an example. Years ago, my friend Ed Gray, who makes documentary films, produced his first major film called *Different Drummer—Elvin Jones*, celebrating the life and work of jazz giant Elvin Jones, who gained notoriety playing with the legendary saxophonist John Coltrane. Elvin, like his brothers Hank and Thad, had his own reputation as a musician independent of Coltrane. The brothers were raised in the Detroit area and had a strong background in church gospel music. Ed's film set out to document Elvin's views on music. Particularly, it focused on the form of polyrhythmic drumming that Elvin brought to the jazz mainstream.

I'm not out to delve into the life and work of Elvin Jones, although his description of how he "sees" drum and cymbal sounds as various colors is one of the most interesting visual descriptions of the interplay of the human senses that I've ever heard.

Ed's problem was how to raise money for such a project. The National Endowment for the Humanities had offered funding, but Ed needed matching grants. At that time, I used to freelance a bit as a grant writer for filmmakers, photographers, and other types of artists. I found that this was a great way to find photography clients as well as help people raise money to realize worthwhile projects.

If you think finding grants for photographers is tough, it's even worse for filmmakers. After all, films are very expensive to produce and there are lots of people with deserving ideas for interesting films. At any time, there are thousands of filmmakers seeking to make "grant films."

We applied to all the known agencies and foundations that funded film, but I held little hope for getting money through this channel. There are always far too many people standing in line and at that point, Ed didn't have the strong credentials he's built up since then.

We hit upon the idea of seeking support from foundations and corporations that were based in the Detroit area. We did a little research, and sent out a lot of query letters. Most of those were quickly rejected. A few foundations were even a bit abrupt, suggesting that we shouldn't have bothered them since there was no program for funding films in the descriptions of what interests existed for that grant-making agency. We knew that. We were sorry to have perturbed a few foundations, but after all, we were looking for an unmarked back door.

Then, one day, we got the letter we were waiting for, from the Dayton Hudson Foundation. In essence, it said that although it had never funded a film project, this sounded like a worthy undertaking and the Dayton Hudson department store chain did have a giant distribution center very close to where the Jones family had grown up, so, if Mr. Gray were inclined to contact the Foundation's secretary, they would like to discuss the matter further.

That was just what we had been hoping for. Ed was able to finish his film in relatively short order. In later years I think the Dayton Hudson Foundation may have had to endure a lot of query letters from other filmmakers seeking support for all types of films, who noted that they had made one grant to one film and didn't understand the special nature of the connection.

But I don't blame those filmmakers for trying—they thought they had found a new front door. Of course, they hadn't, and they would have been better off putting that research time into finding their own back door.

Where's the Backdoor for Your Project?

A friend of mine used to say, back in the sixties, that Chairman Mao once said: "The enemy's rear is our front!" I have no idea whether that's an accurate quote, but in addition to always getting a laugh, it's not bad advice.

Nowadays there are a lot of "guerrilla marketing" books and seminar series. It's really the same notion—don't try for funding or other types of

project support by taking obvious steps. You'll find the lines are long, and the competition is tough. Think hard and try to discover whether there's a tie-in to your idea that isn't obvious. Work the periphery.

Many times I have found that I get good ideas for this type of undertaking by discussing my idea and my quandary with a good friend who knows nothing about the subject. That person's lack of understanding of the field makes it easier for him to come up with free-form, free-association ideas that can sometimes lead to finding a real back door.

PREPARATION AND STRATEGY

A wise friend of mine claims that most of life is preparation and maintenance. I think that's right, and I've found that, personally, I'm willing to skimp a bit on maintenance in an effort to enjoy more variety in life.

But I agree that preparation is essential. In fact, the subjects of this chapter, winning contests and grants, turn on the right kind of preparation—namely strategic thinking coupled with plain old hard work.

WORTHWHILE MAINTENANCE

While I think a lot of maintenance is not worth my time, there is one type of maintenance that is very important. Don't ever skimp on saying "Thanks" to people who help you in any manner, shape, or form. It's easy, quick, and simple. Filing negatives may or may not be worth the time you have to invest. Saying thanks when it is deserved is always worth the effort.

By the way, don't limit your thanks to people who help you. It's a very good idea to convey that same sentiment to any organization or entity that gives you a grant or award. Years ago, I spoke to the director of an arts agency who said it was amazing to her how few of the artists to whom they gave grants ever took the time to say thanks or file a report on how the money was used or how the award helped further the artist's career. She told me that sometimes prior winners would contact them to inquire whether they could apply for another grant. Don't you think it would make sense to say thanks for the first time before you ask for a second helping?

Unknown photographer, National Association of Broadcasters, 1939 Convention, Atlantic City, New Jersey. My father, C. Glover DeLaney, is on the right.

Part Three

BUSINESS AND BEYOND

"Pass the dynamite, 'cause the fuse is lit!"—The Coasters, "Riot in Cell Block Number Nine," lyrics by Jerry Lieber and Mike Stoller

Unknown photographer, C. Glover and Dorothy DeLaney and family, 1948. This was an executive portrait with family at home. It was popular in the 40s and 50s. Whatever everyone else is looking at was not interesting enough to attract my attention.

Chapter 15: Setting Up Your Business

When we turn to the business issues of photography, the principles are the same whether you're pursuing photography as a primary source of income or not. Either way, if you're considering "turning pro," chances are, you already have. It's a matter of degree, and photography is a business into which it's easy to slide.

It's my conviction that it's easy to get your bearings in the business side of photography. You don't need to know everything about photography, and you don't need thousands and thousands of dollars of equipment. You just have to take a few businesslike steps.

You're equipped to get started in the photography business if you make three resolutions and one simple decision:

1. Resolve to work hard.
2. Resolve to be honest and ethical in your work.
3. Resolve not to take on jobs that you're reasonably sure you can't do well.

Then you simply need to decide whether you want to work from home or not.

WHERE TO LOCATE YOUR STUDIO

The question of whether to locate your studio in your home or in some other location requires a little thought. If your economic situation is shaky, then you probably have little choice but to start at home. That's fine. In fact, I think a home studio is the best choice for most photographers, even if you don't have room to photograph subjects in your home.

Let's say you're interested in portrait work. You can base your operation in your home but conduct your portrait sessions on location, in the client's home, or in some other photographically pleasing location.

If you live near a big city, you may even be able to rent a studio for certain photographic jobs, when it's necessary. There are a number of different combinations you can work out. The two major questions are whether you are disciplined enough to get in a serious period of work despite the distractions of home. Can you put in the time setting up a tabletop shot, getting out your bills, and sorting and storing images at home? Or will the refrigerator, television, or a sunny backyard claim too much of your time and attention?

This is one of those questions where there is no one right way. In recent years, there's been a big growth in SOHO (small office, home office) businesses. Some of us (including me) prosper with the disciplined environment of a workplace that is separate from home.

For a lot of photographers who are getting started, a good approach is to have one room in the home where business records are kept, equipment is stored, and potential clients can visit and view your photographs.

DO THE CLIENTS COME TO YOU, OR VICE VERSA?

Having clients visit is not something I always recommend. In fact, for many types of work, you're better off if you can visit the client's home or office. You'll learn more about her, and it's harder for her to get rid of you. That can be important if you want to push a client toward making a decision about your services at the first meeting. We'll talk more about selling techniques later in chapters 17 and 18.

Plus, looking around your client's home or office, you may get ideas for other photographic services you can supply in the future. In addition, you'll get a sense of the client's style and level of success. This may be helpful in proposing fees or setting prices.

CAN YOU DO THE JOB?

I do want to backtrack for a moment. The last in my list of three resolves for getting into business is the resolve to turn down jobs where you're relatively certain that you won't be able to do a good job. Avoid getting into this situation. You may get lucky every now and then and pull off a job in an area where you have no experience, but too often, things won't come out well. You'll end up with an angry client, and there's the added danger

that the client will bad-mouth you or that, in other ways, your reputation will be damaged by the job gone bad.

For example, if you've never shot a wedding, you run the risk of failing to record the meaningful moments of one of the most special days in the life of two people and their families. Before you hire out to shoot weddings, learn as much as you can about the subject. Try to assist a working wedding photographer on a number of jobs. If, on the other hand, you want to get started and there are no opportunities to assist, find a couple that doesn't have much money, and level with them—explain that you're just getting started, and offer to shoot their wedding for free if they'll pay for the film and processing.

This way, they will know the risk they're running, but if they don't have any money, it may be an acceptable risk for them and for you. Plus, you and the couple will go into the event with your eyes wide open.

You Must Keep Records

Although I don't view this as an essential in terms of qualities that you must bring to the profession, you must learn to keep records in some form. Whether you want to make money or not, you must keep track of the business side to avoid losing money—even for the artist in today's world that's unacceptable.

Some photographers sell their photographs, others sell themselves as photographers to produce photographs for clients. Either way, it's the same—it's business. There are just a few basic rules that all photographers should follow. As you specialize, you may need to cover other items, but if you follow these guidelines, you'll be fine.

- You need to understand the money flow in your photography. You may invest in your work, but you should not lose money pursuing your work.
- You need a business card, even if you're not "in business."
- The basic principles that make business work are the same whether you are your own client or you work as a freelancer or even if you get hired for a staff photography job. Learn to communicate your business practices clearly. Make sure you're comfortable with them and then go forward with confidence.
- Selling your photography and your services and delivering on deals in a timely fashion is fun. If you're screwing up, there's a reason why and you must address that.
- Learn how to present yourself and your work by resume, portfolio, and personal interview.

In the next few chapters I'm going to review all these issues with the aim of setting forth the simplest systems that I know will work for you. If your business gets highly specialized—let's say you expand your studio and start

to hire employees, or perhaps you start to specialize in advertising photography and you rent lots of elaborately painted props or even hire someone to paint them—then you'll need to develop more elaborate systems and should consult with a good accountant or attorney, or both.

June 1984: The interior decorator leans toward me. "Listen," he says. "You're a photographer, and you think you know about business. If you use 35mm equipment, you might have five or ten thousand dollars' worth of equipment in your studio. If you use medium format, perhaps twenty thousand dollars. I can have that much money tied up in a single custom sofa that I'm having made for a customer."

My friend, the late Bill Turner, was a great interior designer and a very talented businessman. His point was right. Most photographers don't have that much money tied up in any project. We don't need to be capitalized the way other professionals do. But that doesn't mean there's no need to keep track of things.

UNDERSTANDING MONEY FLOW

The first thing you need to do is save all those receipts and copies of invoices. You don't need an elaborate filing system. Just keep them in folders or even envelopes, marked by category. On the expense side, have one folder for film and processing, another for equipment repair and rental, another for payments to assistants, another for general offices supplies and expenses like postage and messengers. Toss in cash receipts, credit card receipts, and canceled checks. This way, at the end of the year, you'll have your records ready for tally and reporting to your accountant or for preparation of your own income taxes.

Even if you have a full-time job outside the photography world, if you start making a measurable amount of income from your photographic freelance work, say $1,000 or more, you should investigate the requirements for completing a Schedule C: Profit or Loss From Business on your annual federal income taxes.

If you are taking on a lot of work, there may be reasons for you to consider taking the step of incorporating your business, or taking on some sort of limited liability status. If you think this makes sense, then you absolutely must consult professional advisors, either an attorney, an accountant, or both.

Incorporating has a lot of benefits, but there are also expenses and a lot of paperwork that comes with the territory. You need to weigh whether the benefits outweigh the work involved. In recent years, lots of small businesses have opted for various sorts of limited liability status. These provisions tend to vary from state to state, so it is essential that you check with competent professional advisors.

If you have a set of business rules and ethics, and if you set up a basic record-keeping system, you're on your way. But before we get into the meat of your business in the next few chapters—that is, selling your photographs and selling your services—let's look at a few basic business necessities in more detail.

BUSINESS RULE ONE: MAKE A BUSINESS CARD.

Some readers may ask: "I don't intend to become a professional photographer. Why do I need a card?"

That's simple. There are two main reasons. First, as we've noted earlier, photography is one of those fields of human endeavor where the line dividing professional and amateur is thin and ill-defined. Almost every photographer is asked sooner or later whether or not she will take a picture for a friend, or sell a photo, or in some other way, take money for her photography.

Second, you should create a business card simply to identify yourself as a photographer—even if you never intend to seek a paying photography job, or wouldn't sell one of your photographs under any circumstances, and even if you have a business card for some other aspect of your life.

Why create a business card that identifies you as a photographer? Simple. Because you *are* one. You never know when a card that lists your name and the word "photographer" will pay off. You may find it's just the ticket to gain early admission to a museum in a foreign country or the necessary leverage to persuade the proud owner of a scenic horse farm to allow you to take some photos on that property or the passport to easing your way into the front row of a big parade.

Your card shows that you're a serious photographer, serious enough that you want to identify yourself as such and be able to leave people with a legible record of your name and how to contact you. In essence, it makes you look "legitimate."

As an aside, there are jobs where it may be necessary to look "not legitimate," but that's rare. Most of the time, in most of our endeavors in life, all of us want to look like we belong, like we know what we're doing, like we have an identity. So, why not have a business card?

At the national stationery chain stores, you can probably get a few hundred business cards printed for $20 or less. The cost isn't prohibitive.

Now you may have lots of "but-I-can'ts": But I can't have a card because I don't have a business name; I don't know what to say on the card; I don't know what specialties I should list; or, even, I don't have a permanent address.

Let me put your mind to rest—there's no "but I can't . . ." that can't be overcome.

Let's start with the simplest possible card. You do have a name, and you are a photographer. That's the key to the whole thing—identifying yourself as a photographer—so you can certainly list:

You could stop there. In the nineteenth century, calling cards often had just the person's name. It's only in today's highly specific world that we expect to see address, telephone number, fax number, e-mail address, and so on.

Now what if you're in college and you're going to graduate in a few months and change your address and all your current numbers? What if you're going to move soon?

This leads to Business Rule One: Nothing looks worse than a card, or letterhead, where information has been crossed out and changed to new information by handwriting or typewriting. The same goes for invoices, letters of agreement, and, for that matter, menus. This sort of thing suggests complete amateurishness, an unprofessional approach, and, frankly, that you're too cheap to have your cards, stationery, and the like, reprinted.

Plus you're in the image business. We expect the tailor to be well tailored, and the banker to appear to be well-to-do and trustworthy. Your visual image has to be perfect.

What to do? Well, unless you plan to change your name, I suggest you have a card printed with just your name and the word "photographer." You can always write in the other information when you have cause to present your card to someone. That way, the information will be current.

Of course, if your contact information is likely to remain constant for a time, have it printed. Include telephone and fax numbers and a mailing address, so that people can send you mail—including checks!

Depending on your interests, beeper and pager numbers may be a good idea. If, for example, you're interested in spot news, fires, and other emergency situations, such an immediate contact number makes good sense. Similarly, if you're into the world of computers and the Web, then an e-mail address or even the URL of your Web site may be a good idea.

What about not having a business name? Don't worry, it's not necessary. There are many successful freelance photographers, including some very big names, who don't have a business name. There are also lots of businesses with names and no business. It doesn't matter.

Business Rule Two: Dumb is dumber.

That brings us to Business Rule Two. Part One: No name is better than a dumb name. Part Two: Most of the time, no name is better than a "cute" name.

This is a rule that a large segment of America does not comprehend. It's not that they consciously break it. They just don't get it. How many times have you driven through a town and seen a local hairdresser's shop named: "So-and-so's Klip and Kurl." Spelling "clip" and "curl" with a "K" is cute, but at least we know what service the business provides. It's a little harder to muster any enthusiasm for the number of well-meaning souls who have used an obvious pun and named their hair salon "Shear Magic."

But in the same vein, I've seen photography businesses with names like "Memory Maker," "Precious Memories by Bonnie," even one that said something about "Kidnapper of Images." These names are a little vague and don't communicate clearly what you do. I vastly prefer, "Bonnie Jones Photography," or "Bonnie Jones Studio," to names with "memories" or "precious memories."

In all likelihood, this is the way others will also refer to your business. Few people are going to tell their friends that their daughter's wedding is going to be shot by "Precious Memories by You-Name-It." Rather, they'll say that they've hired Bonnie Jones.

Photographic Specialties

So, getting back to your card, you don't need to have a business name. Similarly, there's no need to list photographic specialties. In fact, there's no good reason to do so most of the time. Most people don't think of photographers as having specialties, so why limit yourself by imposing them on your work? If you're so successful you want to limit your practice to food photography or underwater photography, by all means do so. But most of us are willing to be generalists to some degree.

Let's go on to the other business rules:

Business Rule Three: Learn to write.

From the quill pen to movable type, the typewriter, and the word processor, the ability to express your thoughts and ideas in writing has remained extremely valuable. There are a lot of photographers who are highly talented in a visual way but who are not good at expressing themselves verbally or in writing. Learn to be a good communicator. Not every one has the same skill level, but work to be the best that you can be.

And above all, learn to communicate your ideas in writing. You can't get everyone on the telephone or have a chance to pitch to them in person, but if you can put your ideas down on paper or in digital word form in a computer, you stand a much better chance of getting those ideas in front of the person or people you wish to reach. It's possible that an inter-

mediary may read and evaluate your writing first, but if your ideas are on point and well expressed, your written words stand a good chance of being brought to the attention of Ms. or Mr. Big.

There's another reason to learn to write: It will make you more employable as a photographer! That's right. For many assignments, editors will cheerfully spend a little more to send one individual who can take the photographs and report the story rather than incur the cost of putting two people on the road.

BUSINESS RULE FOUR: LEARN TO TYPE.

I took typing in high school, and it was one of the most beneficial subjects I ever studied. The old IBM Selectric had just come out, and it was a joy to learn to cruise along at fifty or sixty words a minute on that exquisite tool.

Naturally in today's computer-dominated world, being able to bang out your thoughts on a keyboard makes typing an even more important skill than ever before. Plus, you've got to be able to hit the control and escape buttons often while avoiding the tricky "windows" key that takes you away from your work.

I have one of those speak-and-the-computer-will-type-your-words programs loaded on my computer, but I don't use it. If you've ever compared your written and verbal communication—perhaps by seeing a transcript of your words—you've found that there's a big difference between the way we speak and the way things should be written down.

There's a great benefit to being able to organize your thoughts and move them around using your hands on a keyboard.

BUSINESS RULE FIVE: THERE'S ALWAYS ANOTHER ROUTE.

Here's a precept that applies to life as well as business. We are, for the most part, creatures of habit. Habits help us cope with the challenges of the world and get through many situations without having to expend a lot of thought or anxiety on trivial things. It's good that breathing is, for the most part, a reflex.

But there are times when you must be able to think outside the box.

For example, there's a two-lane country road I often travel through northern New Jersey. If there's a lot of traffic, I usually just suffer with it. One morning, I really had to get back to New York City and traffic had come to a dead halt. There was no choice but to turn off at the next intersection and wend my way though farms and suburban subdivisions trying to find a route that ran parallel to Route 15. Lo and behold, it was easy, and I chanced to return back to the main road just one hundred feet beyond the obstruction, which was an overturned tractor trailer rig. Had I sat in traffic, I would have been stuck for hours.

Don't be afraid to think outside the box in your photography work. I once got a portrait assignment for a dancer who had just been appointed a principal in one of the world's best-known modern dance companies.

Great assignment, one small problem. This woman was, without a doubt, the most camera-shy person I have ever, *ever* encountered. I couldn't put a camera to my eye without her wincing and tensing her shoulders and looking fraught with terror.

How was it, I wondered, that someone who could dance and use her body so expressively before a large and admiring audience could be in such stark terror when a camera appeared on the scene?

I asked if she was comfortable looking at herself in a mirror. She assured me she was. So, I hit upon a solution that I thought might work. I would leave a camera with her, mounted on a tripod, and set up for a portrait session in her own home. She would sit on a stool in a preestablished location, turn on the lights that I left set up and balanced, and use an air release bulb to trip the shutter on the camera, after she composed herself in a mirror that I mounted adjacent to the camera. In essence, I set up a complete studio in her home that would allow her to take her own self-portrait. I set the exposure and showed her how to advance the film between frames. I trusted her with my equipment. It took her a week to shoot fifteen frames of film in four different sittings. She confided in me that for several of the sittings she braced herself with a shot or two of Scotch before getting started. There were two very good images, and one satisfied the art director and went into the company's program.

BUSINESS RULE SIX: FIND A WAY TO STORE YOUR PHOTOGRAPHS.

Try to make sure that you have some sort of filing system that allows you to find images quickly. Here's an example of why that's important. Several years ago, I shot a job for a mural painter who had designed and painted a series of murals on the walls of a high-security sector of a large Manhattan bank where transactions involving gold, other precious metals, and negotiable securities were processed.

Behind bars, checkpoints, and locked doors, the work area had a somewhat prisonlike feeling, and the painter had been hired to create murals that would lighten the overall atmosphere. While I was not an avid admirer of his work, it certainly improved the environment. He was so proud of the commission that he called me in to photograph his work extensively, so that he could use it in his portfolio. I did, but he was a very difficult client; there were lots of security problems, and I had to have a guard with me at all times. After the job was finished, I went to the trouble of filing the negatives. I didn't expect any further use from the negatives, I was sick of the job and didn't like the painter or his work, but I didn't discard them.

Years later, I got a call from a large Manhattan architectural firm that had gotten my name from that client. They had designed the walls and corridors that he had painted. They wanted to know if I had slides avail-

able of the murals. If I did, they wanted to use them to show to a prospective client who was considering a large job along the same lines.

As is all too often the case, they had waited to contact me until just a few days before the presentation. Since I had shot the job in color negative, in order to make prints for the painter's portfolio, I needed to make slides from the negatives to supply to the architect's office.

I don't know why they had waited so close to the deadline to call me, but when I spoke to the managing partner of the architectural firm, I explained that unfortunately I had shot the murals in color negative and would now have to have rush transparencies made of the images. My lab charges a 100 percent premium for rush work, not unusual in the field.

Obviously, the firm's manager felt the staff really needed these pictures to help make a meaningful presentation to their prospective client. But going back to my files, sorting through the contacts, pulling the right negatives, making a special trip to the lab to order duplicate transparencies, and another trip to pick them up meant that this job was going to take up a lot of my time and cause me to juggle other commitments.

I told the managing partner that lab costs on each dupe would be $40 or more, and that my charge for each slide would be $100 plus the lab processing fee.

Without hesitation, he said, "That's fine." The end result was that because I could find the images quickly, and had the time to hustle them to my lab, I made a very handsome profit selling two dozen slides to an architectural firm. This truly was, as it's called, "found money."

Charging the Desperate Client

Let's digress for a moment since this story presents a situation where I accidentally fell into a position where I had the client by the throat. How much money is substantial? What is fair? There are probably a few readers who think that charging $100 plus costs for each slide was too little, and some who think it sounds like a fine sum indeed, more than they might have asked. There is no simple answer. Obviously, I had this architect over a barrel. There was no other way he could have gotten those slides and because of the high security in the area, he probably could not get another photographer cleared to work in there in time.

Should I have asked $250 or $500 for each slide? Maybe, but I think not. As my friend Michael Citron says, "Hogs get fat, but pigs get slaughtered." Perhaps I could have gotten more, but the architect would have ranted and raved to all within earshot that I had held him up. I don't need people talking about me that way. In fact, I left my card with the architect and told him that I would be happy to do work for his firm in the future.

Should I have asked *less* for each slide? I don't think so. They were the product of a lot of work, and I felt my price was fair. But understand that this is a judgment call and not everyone would feel the same way.

Another approach might have been to quote less for the slide and mark up the lab fee more. Would the architect have felt better if I charged him $65 for each slide and claimed the lab fee for each slide was $75? He might have, but if he talked to a lab owner, he'd find out that I had lied to him about the cost for lab work, and, again, I would rather give the appearance of charging in a manner that seems both explainable and honest.

YOUR OWN SYSTEM

I said that you should have some sort of storage system. I was able to make the sale because I kept the negatives from the original job and could find them quickly. Does that mean that I went to my pristine storage room and looked them up in the alphabetical file under the name of the client? Not at all. It means I remembered when I had done the job and where I was stacking completed jobs at that time, moved some more recent stuff out of the way, and after about ten minutes of flipping and searching (making a mess while doing so, I might add) I found the right sets of negatives.

Anyone who knows me will tell you that my method of ordering the physical things in my life is sloppy, at best. But you know what? It's OK. No one way of being. At home, I keep all my footwear under a sofa bed; not in the closet, not in shoe bags, not sorted by color or type. For years, I would dig around in the dark under the bed feeling bad. I should have my shoes more organized, I fretted, so I wouldn't have to fumble in the dark. I should this, I should that. I should be neater, I should be a better person.

But once I stopped fretting, I realized that I am the way I am and that I'm not likely to change, so I decided that my method had worked reasonably well for so long that the trick was to improve it. Now I keep a flashlight under the bed as well, so when I'm looking for a particular pair of shoes it's easy to find them.

Does it work for me? Yes. Would I get high housekeeping marks from your mother? Probably not.

So there's my storage tip. Find a way that works for you.

Quarter In/Quarters Out game, Coney Island, New York 1999.

Chapter 16: What to Charge for Your Photography

Now let's turn to one of the questions I hear most often from students and other emerging photographers—how and what to charge. Let's suppose that you've been asked to take a portrait photo for a friend, or to photograph your nephew's wedding. You want to do the job, and you're confident you can take great photos, but you've never charged anyone for your work in photography. The question is: "What's a fair and easy way to charge someone—even a friend—for my photographic work?"

In the world of the professional photographer, there are lots of ways to charge for photographic services, depending on the type of client, the use planned for the photographs, and the stature of the photographer: There are day rates, bids based on a price-per-shot, and a host of other approaches. But the question facing you is simpler.

Until you develop a profitable, market-driven "day rate"—if you ever do—I advise most beginners to use one of two methods to price a job: either use a multiple of your costs or estimate the job based on time and materials. Bear in mind that these methods are appropriate for most basic assignments. If you happen to take a highly newsworthy photo, then

you're working with a different commodity and one that's worth its own discussion.

Let's look at the two basic job examples mentioned above in detail. First, we'll price out a portrait photograph for a friend. Then, we'll examine how you might charge to photograph a wedding for a relative or friend.

MULTIPLE-OF-COST METHOD

For small jobs, you can take your cost for materials, such as film and processing, and your expenses for things like travel, assistants, and props, and multiply that total by a figure. Since the premise of the following examples is that you are working for friends, I've used multiples of two and four. If you're working for strangers and building your business, the multiples might be five, ten, or more.

Let's suppose you conduct a portrait session with a friend and use two rolls of color film. Film and processing comes to $48, and your friend asks you to make 11″ × 14″ enlargements of three photos. Your lab charges $15 for each enlargement. You have no other expenses for the job. You've spent $48 for film and processing, and $45 for the enlargements, for a total of $93. You can charge your friend the cost, or double the cost, $186, or any other factor you agree upon. You should be able to estimate your expenses with a high degree of accuracy, so there should be no surprises.

Here's a slightly more complicated example: You are asked to photograph your nephew's wedding. You use six rolls of film and with processing your cost is $134. You also had expenses for batteries and trips to the lab for processing that totaled $17, so your total cost is $151. Once again, you might agree to charge 1× your expenses, or $151, or 2×: $300 (since it's family, we'll round $302 to $300), or even 4×: $600. Since there will be lots of prints to be ordered and possibly an album, you might use the same factor for those costs or use a lower figure or give the film and proof prints to the happy couple and let them take the time and do the work to get the enlargements and album made.

The beauty of these examples is that you can work everything out with your customer ahead of time. As long as expenses are carefully estimated, there should be no surprises.

I must point out that in these examples you are selling someone a product. Unless you are strictly getting reimbursed for your expenses, there may be a need to take sales tax into account. You may want to check with your accountant or tax advisor who is familiar with the rules that apply where you live and work.

When you start to offer your services to the general public, you can use this same method and simply start at a figure that's comfortable for you, and raise it from time to time if you're having little difficulty booking jobs.

Time-out to elaborate on that last comment. Why do I say raise your rate from time to time if you're having little difficulty booking jobs? Because if you're booking a very large percentage of the people who come

to see you about work, you're probably offering your services for too little money. It's time to raise rates.

If you think about it, at this point, you've started to develop a day rate. If you charge $600 (or $900 or $1,200) for a day shooting a wedding, should you charge that same amount for a day photographing something else? The answer to that is maybe yes, maybe no.

Your decision on that question would be based on several factors: Can you do that job? Is it dangerous? Is there a prevailing higher price tag in that field? If the answer to the second or third question is yes, then you have to think about raising your rate for the job.

On the other hand, is the client a charitable one that deserves a price cut? In that case, you might drop your rate. Similarly, if it's an area that interests you, but one in which you have little or no experience, you might also drop your rate a bit.

It's worth noting that the multiple of materials approach only works if you're going to shoot a fair amount of film. If I hire you to drive around my town and take photographs of famous people doing embarrassing things, you're not likely to shoot much film and those good frames you do shoot will be worth much more than a simple multiple of your expenses. I'll discuss such situations in the "Day Rate Against Use" section later in this chapter.

RATE-BY-DAY OR -HOUR METHOD

Method two is a little different. Once again, you want to figure your expenses and charge for those, but instead of charging for your services as a multiple of your expenses, you charge for your time, on a dollars-per-hour basis. And you don't just charge for the time you have the camera in your hand. Rather, you charge for all the time you put into the job.

Let's look at how method two works using the same two examples we covered in method one:

Your portrait session still used two rolls of film and you made three enlargements. Your expenses remain $93. You spent half an hour planning the session with your friend, it took 1½ hours to set up and shoot. Afterwards, getting the film processed, reviewing the proofs, ordering the enlargements, and delivering them to your friend took another 1½ hours. That means you spent 3½ hours on the job.

If you don't want to charge your friend for your services, you can value your services at $0/hour and charge $93 for the job. If you value your services at $10/hour, then you would charge $93 plus $35 (3½ hours at $10 hour), or $128. At $20/hour, you would charge $93 for expenses and $70 for your time, or $163.

For your nephew's wedding, the expenses are still $151. But on this job, you probably spent a lot of time. For example, you met with your nephew and his bride for 1½ hours to plan what they wanted photographed, you went to the bride's house before the wedding, and photographed the entire ceremony and the reception. You didn't sit at a table

with the other guests, you worked! In fact, on the wedding, day you worked 7 hours, and in the following week you spent 3 more hours getting the film processed and discussing the proofs with the newlyweds. You worked a total of 11½ hours. So, at $10/hour that would be $115 for services added to $151 in materials for a total of $266. If you charge $20/hour for your services, the charge would be $230 plus $151 for a total of $381.

Once again, remember that you may have to collect sales tax.

Professional portrait and wedding photographers often derive more complicated methods for charging, but if you use either of these simple techniques for charging friends and acquaintances for your photographic services, you'll be able to explain what you will charge and why, in a way that is simple, clear, and unlikely to result in any misunderstandings.

SELLING REPRODUCTION RIGHTS

Thanks to the nature of copyright law in this country, you own the copyright to the photos you take just by pressing the shutter, unless perhaps you're an employee who has been supplied with a camera, film, and explicit instructions for what to photograph by your employer, in which case the copyright will probably reside with the employer. These situations are called "work for hire." If you think this situation might apply to you, check one of the legal guides in appendix II, and, if warranted, consult an attorney.

For copyright protection, you do not need to register your photos with the government unless there are extraordinary reasons to do so. If you're ready to learn more about copyright, there are some books in appendix II that I suggest you read. Suffice it to say that you need only register images that have a high probability of being stolen and used widely. Rare images of celebrities exemplify the type of images that it might make sense to formally copyright.

Since you own the copyright, you have the right to sell various rights. You could sell all your rights to a photograph, but it doesn't make sense to do that unless you need to do so.

Most of the time, if someone wants to publish your photo, whether in a newspaper, magazine, calendar, or greeting card, or use your photo on the Internet or on television, you should sell her a limited *reproduction right*—that is, the right to reproduce your photo for a stated purpose, and only that stated purpose, for a limited amount of time, and for a certain amount of dollars. See—it's easy.

Let's use an example. You take a news photograph as a freelancer and contact the local paper. The editors look at your photo and tell you they want to print your photo in tomorrow's issue of the paper. I suggest you offer them "one-time reproduction rights." That means, for the amount you charge, they have the right to publish your photo one time, in one issue of the paper. If they wish to run it again in a later issue, perhaps in a year-end, wrap-up story, they will have to pay you again for the right to use your photo a second time.

Some newspapers may wish to buy the right to use the photo several times at the outset. That's their prerogative and you can negotiate for that, and then explicitly grant them that expanded right. But, whether you're dealing with a magazine, newspaper, or other type of publisher, you're generally best off initially offering "one-time reproduction rights." That way, if your photo gets used again, you get paid again. Nothing wrong with that, is there?

Before I continue, I should point out that larger publishers of major publications are pushing to make drastic changes to the concept of one-time reproduction rights. Although photographers have lamented the onset of these changes, many major magazines now demand that rights for foreign editions and for electronic Web site purposes be built into the initial payment. Regardless of these changing trends at the top of the industry, lots of smaller publications continue to purchase one-time rights of the basic type. It's still the best proposition for a photographer to start with when discussing sales with a new client.

WHAT IS A ONE-TIME RIGHT?

Depending on the type of publication planned for your photo, this may require some clarification. Newspapers and magazines generally have one press run per issue. A newspaper that has a circulation of 100,000, for example, prints all those papers at one shot. Similarly, a monthly magazine with a circulation of 400,000 prints all those copies at one time.

But what if you sell your photo to a greeting card publishing company that plans to print 1,000 cards initially, but may print more if that first run sells well? Generally, you need to discuss the matter in sufficient detail so that you and the publisher both understand what is contemplated. For example, if a scenic is to be used on a condolence card, the right you sell may be for multiple printings of your image with a set group of words that appear on that card. If the publisher then desires to use your same photo for an upbeat birthday greeting card, that might be a separate negotiation and an added payment.

As a rule, publishers want wider rights while photographers want to keep the rights that they sell narrow and well-defined. As an example, if you sell a photo to a magazine published by one of the airlines to accompany a specific travel article, you don't want to give the airline the right to use that same photo for a poster or a billboard advertisement without the airline or advertising agency paying you additional money for those added rights. That means you need to spell out both the fact that the right you are granting is for one-time reproduction and also that the intended use is for the airline magazine only.

YOUR PHOTOS ON THE WEB

On the Internet, since photos aren't actually "published" in the traditional sense of a printing press run, I find that it makes sense to define use in

the context of an article and a period of time. For example, if you have a photo of a celebrity, you might negotiate that it can be used in one article that will be up on the Web for two months' time, with the understanding that if the Web site wants to keep the article up longer, then you will have to be paid again based on a subsequent negotiation.

For photos that I send to newspapers and magazines for consideration, I mark each with a label or stamp that reads: "Photograph copyright by [my name and telephone number], all rights reserved. This photo may not be published without the photographer's permission."

Some people use slightly different wording. The important thing is that you've put all editors on notice that it is your photo, that you claim the rights to it, and you've given them a way to contact you.

Similarly, when sending a bill for a photograph, I make up an invoice along these lines:

Photographer's Name
Address
Telephone
Date
Invoice Number *(only necessary if you do a lot of invoicing annually)*

INVOICE

One-time reproduction rights of [number] photograph(s) of [describe image or subject matter] for use in [name of publication and issue]. Original image(s) must be returned to photographer at above address.

Amount for rights Expenses *(if applicable)*

TOTAL DUE THIS INVOICE $[Total amount charged]

EXPENSES

In your invoice, you may also charge for any necessary expenses that you incurred taking the photo, having it processed and printed, or shipping it to the user.

It's a good idea to discuss the fact that you intend to bill for expenses before you strike a deal to sell rights. You should also be able to give the purchaser a fairly clear idea of how much those expenses will run. If you're going to charge a couple of bucks for gas for your car, that's one thing. If you are going to charge $45 for three taxi rides, or $800 for a round-trip airfare, that's a different matter.

In your invoice, you can also specify other points that you've discussed with the publisher purchasing your photograph. For example, "credit must appear adjacent to photograph," or "North American rights only."

NORTH AMERICAN RIGHTS

The notion of limiting the rights that you've sold to North America stems from the magazine and book publishing world. If you've sold a photo to a large magazine that has foreign editions, such as *Playboy* or *Cosmopolitan*, you should be paid separately for those editions if your photo is used in them, or that right should have been part of the original negotiation.

Similarly, book publishers generally bring a work out in the United States and Canada, while an English-language version published in England, India, Australia, or some other country with a sizable English-speaking market should be the subject of a separate negotiation.

NO INVOICE TOO SMALL

One final point: Even if you're selling your photo to a small weekly paper, you should try to get paid something for it, and try to get an adjacent photo credit. Even if you end up charging $10 or $15, you'll feel better and you'll be taken more seriously if you seek payment for your work. Most publications have some budget for photography, and you deserve compensation as well as the satisfaction of seeing your work in print. Having your name run as a photo credit will also make you feel good, and when you start to assemble a portfolio of your work as clip sheets, having your name printed in the credit is very helpful.

If your photo appears in a book, magazine, or newspaper, you do not really need a copyright symbol in the photo credit. This is because the publisher generally copyrights everything in the publication and that protection extends to you. However, as stated earlier, if you have very rare and valuable photographs—for example, images of someone like Elvis Presley or Princess Diana that have never been published—then you might want to press for an explicit copyright notice with your name running adjacent to the image. Such a notice may give you added legal clout in case your photograph is reproduced without your permission.

CHARGING FOR AN ASSIGNMENT

But what if an editor is taken with your work and you're given an assignment to photograph an event or a person for the publication? How should you go about charging for that type of work?

Let's be clear at the start, the examples that follow are for simple jobs. I'm not going to cover how to charge for a three-month assignment to photograph seals underwater at the South Pole for *National Geographic*, or a three-week swimsuit shoot for *Sports Illustrated*. By the time you're offered those assignments, you'll have lots of experience negotiating fees, or have a pro to do it for you, and there are lots of special requirements for big assignments.

Rather, I'm concerned here with assignments that you might get from the editor of a small newspaper or a small-circulation, special-interest magazine. For example, let's say you sold a photo of a traffic accident to

the local paper and now the editor has called you to see if you can help out because the photo staff is shorthanded due to illness or the vacation schedule. Perhaps there's a parade or a volleyball tournament or a big family reunion, and the paper needs photographs.

The editor asks if you're available this coming Saturday to cover the event. You are. The next question, obviously, is how will you get paid for covering this assignment?

Most papers have ongoing relationships with freelancers who are called to assist when the paper's regular staff of photographers cannot cover every event that is happening in the paper's area of circulation. These photographers are called "stringers." Chances are, the paper has an established "day rate" for stringers. Some papers have a half-day rate for short events and a full-day rate for longer ones. We suggest that you simply tell the editor that you're available for the assignment and inquire whether there is a "standard day rate" for stringers. If there is, and if you want the assignment, I suggest you accept that rate. There's no reason to take less, but there's also no reason for you to expect to be able to demand more than the standard rate—at least for your first few assignments. When and if you become a "star," then you can ask about a raise.

However, don't think that the day rate covers everything. You may need to ask for additional adjustments for extra time, travel, and expenses. Let's look at each of these separately.

CHARGING FOR TIME

If you're going to cover a really long event, such as a marathon race or the county fair from dawn to dusk, a simple day rate may not be fair to you. Generally, the paper (or magazine) has a policy that a "day" is six, eight, or perhaps ten hours long. If the assignment will run longer than that, it is appropriate for you to discuss added compensation.

It's also possible that the duration of the assignment cannot be accurately predicted. If you're asked to cover the jury deliberations in a criminal trial that has piqued the town's interest, you have no way of knowing how long you will have to wait for the jury to make up its collective mind. You'll have to sort the time charge out after the event, although it makes sense to keep in contact with the paper so the editor knows what's going on and how long you've been on location.

I also think that a straight day rate doesn't make sense for an assignment that is in the middle of the night. If the hours are strange, probably the pay should be better.

TRAVEL

If the assignment requires that you spend two hours driving your car a hundred miles—for example, first forty miles from your home to the event, then thirty-five miles to the paper to drop off your film, and then twenty-five miles home—ask the editor what the standard policy is for travel of

this type. Often, a rate such as twenty-five or thirty cents a mile is paid to photographers who use their own automobiles.

In addition, make it clear with the editor whether travel time fits into the "day" that you're working. It may or it may not. For example, if you spend eight or nine hours on location and two hours driving, the drive time is additional time you've worked and you should inquire of the editor what type of compensation is appropriate. You can also check with other photographers who work for the paper to find out what is standard practice.

EXPENSES

We've already mentioned tolls and parking. If you need to take taxis or buy your own film, those are expenses for which you should be reimbursed. Batteries for a job that uses a lot of flash might also be included as an expense.

However, if you splurge before the assignment and buy a new wide-angle lens, that isn't an expense for which the publication should reimburse you. Rather, that's your investment in your equipment. The only way to recoup an investment of that type is to consider setting up a depreciation schedule on your income taxes if you do enough professional photography work to qualify. That's a matter that you should discuss with your tax advisor or accountant.

DAY RATE AGAINST USE

Lots of magazines pay for photography by the number of photos used and the size of the photos they run in the magazine. For example, it is not uncommon for a magazine to have a "standard" rate for a cover photo, as well as different rates for photos that run a full page and photos that run less than full page but larger than half a page, a smaller rate for photos that run between half a page and a quarter-page, and then the lowest rate for photos that run less than a quarter-page. Generally speaking, magazines with larger circulation pay higher rates; magazines with smaller circulation pay smaller rates.

If you're going to cover a big story, let's say a celebrity fund-raiser for a prominent charity, the paper or magazine editors may offer you a day rate but agree to pay you more if the number and size of the photos they actually end up running would result in payment of a larger dollar amount, based on the publication's "page rate."

This type of arrangement can benefit both parties, since it gives you an incentive to take as many great photos as possible in the hopes that they'll use lots of them and run those photos in large sizes so that you'll make more money. The publication, on the other hand, is protected so that if you don't come up with that many great images, you get paid the agreed-upon day rate and there's still a little money left over to buy supplementary images from freelancers if necessary.

BREAKING NEWS PHOTOS

What about the rare and really valuable shot? Let's take the example of the NYI student, described in an earlier chapter, who took photos of a dramatic airport accident. He took his photos to a local television station that processed them, but the station opted to use television footage shot by one of the camera crews from a boat outside the portion of the airport that was closed by the FAA investigation. The local papers used a photo provided by the wire services taken from a helicopter and the national news magazines had several days before their deadlines so they planned to wait until the FAA opened the airport.

One of the editors the student contacted suggested he get in touch with a particular photo agency that had clients around the world. He did, and the rest is history. The photo agency found national and international buyers for his images and they split the payments with him.

Working with an agency is a good way to make sure you get adequate compensation for a "big story." The agency knows whom to contact and how to negotiate. Most of the time, big story photos are part of a breaking news situation and time is of the essence. You don't have time to learn the ropes. Get in touch with a major photo agency.

CELEBRITY EXCLUSIVE

Back in the 1980s, when pop star Michael Jackson was at the peak of his stardom, NYI graduate Eli Ordaz was the only photographer to record Jackson's surprise visit to a California elementary school where a crazed gunman had killed five school kids the week before. Since he was the only photographer, he had an exclusive on a big story and the benefit of a little time to find the best way to market his photos.

Ordaz had his photos processed at a local lab, making sure that no extra prints were made of his exclusive story. He contacted a national news magazine, but the editor was unwilling to make an immediate commitment. Next, he contacted the *National Enquirer*, and the editors there requested that a contact sheet be overnighted to them. When they saw the photos, the tabloid offered to purchase two-week exclusive rights for the U.S. market. Ordaz took that deal, and then contacted an agency to market the photos overseas. Ordaz earned nearly $14,000 from the photographs. For "hot" celebrities, the payoff can be six or seven figures.

In this chapter, we've covered how to charge for various kinds of photographs and photographic services. Now it's time to turn to one of the most interesting topics in any business: How to make the sale.

Choreography teacher Bessie Schoenberg and student, Sarah Lawrence College, Bronxville, New York, 1974.

Chapter 17: Eight Rules for Selling Yourself and Your Photography

EFFECTIVE SELLING: *"What kind of bottled water can I bring you? Or will you be drinking . . . tap water?"*
—WAITER AT NEW YORK'S UNION SQUARE CAFE

Sooner or later you have to face up to the fact that photography may be both an art and a science, but unless you are one of the very select few, you won't just spend your time taking photographs. There will be lots of other tasks that come your way. You'll be a technician, a secretary, a bookkeeper, a messenger, a furniture mover, a bill collector, and most importantly, a salesperson.

But, you protest, "I don't want to be a salesperson, I want to be a photographer!" Believe me, if you want to be a photographer, you have to be at least a part-time salesperson. You will get time off to take photographs.

ON SELLING

Yes, you're going to have to sell yourself and your work. And if you free-lance, you're going to have to sell yourself over and over again to each new client. Even if you become a big-name fashion or advertising photographer and hire a rep to do some of the selling, you'll still have to get involved on a regular basis. And selling, like photography, is both an art and a science. In fact, it's one that scares a lot of people.

I think selling is one of the activities that stirs up more fear, anxiety, and anger in many photographers (and artists in general) than any other business-related part of the undertaking. Relax, I'm going to clear it all up for you. And once you learn how to sell, you'll find that it's fun and you make more money.

There was a period when I carried upwards of twenty active clients at any given time. I had to, since each one paid me at most a few thousand dollars each year. That meant, to earn a living from photography, I had to sell my services to a lot of different people, and when I lost a client, I had to go out and find at least one new one who was as good or better than the one I had lost.

But even now, when I can pick and choose clients, I still do a lot of selling. If NYI is trying to put together a deal with a major online company, or work more closely with a photo publisher or manufacturer, there are ideas and concepts to be sold, and I do some of the selling.

I've also continued to study selling at every level. Whenever I get the chance, I sit in to watch acknowledged sales masters share their tips and techniques. I also see lots of examples of good and bad sales techniques in retail stores, restaurants, and anywhere else that people offer goods or services to others.

It's safe to say that I know a lot about selling and I'm good at it. Do you really want to be able to sell your photographs and your photography services? Would you like to have more customers? Oh, you have enough customers? Well, then, would you like to have better customers? Customers who are easier to work for, who pay you more and give you interesting assignments?

SOME BASIC QUESTIONS

Do your really want to improve your sales technique? Now, let me ask a few more questions. Do you think I know how to sell? Do you think I can teach you how to sell? Do you think that even if you're good at selling, I can give you some ideas that will make you even better?

Do you think so? Do you really believe I can help you? Good. You're sold. Next.

First, I had to sell myself.

When I was in college, the idea of selling anything to anyone was repugnant to me. Whether it was my perception, or based on the collective wisdom of the sixties, I was convinced that selling was for squares;

"sales" was a career for morons and burnouts, tragic figures, boozed-out guys who felt they had wasted their lives—"drummers" as my father sometimes called them. The stuff of the plays of Arthur Miller or Eugene O'Neill.

SELLING IS FUN

Now I have a very different attitude toward selling. I do a lot of selling, I'm good at it, and, most surprisingly, I enjoy it. I don't think my viewpoint on "salespeople" changed; rather, I've come to see that selling is a basic human activity, not just some sweaty guy trying to sell you a set of auto tires or an insurance policy.

Without selling, goods wouldn't get exchanged and buildings wouldn't get built. Advertising, for better or worse, would not exist. Plus, we do a lot of personal selling—I've come to see that selling is the way we navigate adult life, make choices, find a mate, earn money, advance in a career, and even structure the system of laws and leaders that govern our democratic society.

Whew! Guess that stuff from the sixties finally wore off.

Or did it? You can still look around and see those sweaty guys, and they're not just trying to sell tires and insurance. You name it, you'll find them trying to sell it. You'll even find them trying to sell photography! That's why I think it's my viewpoint that has changed. Bad salespeople are far from extinct.

Notice I said *trying* to sell. Now, I realize that those squares for whom I held such disdain as a kid merited that disdain not because they were salespeople, but because they were *bad* salespeople. In fact, they were so bad at selling that they took your mind off the product they were selling and called attention to themselves. That's almost always a big mistake.

You need to learn to study good sales technique as well as bad. You'll find you can learn from salespeople everywhere, from the top studio to the deli where you get your lunchtime sandwich.

Good selling isn't so much selling to customers, it's more a case of helping customers sell to themselves. That requires, first and foremost, the ability to listen.

Let me give you my functional definition of the term:

"Selling" is supplying accurate information about a product or service that you hold in high regard and giving potential customers the opportunity to decide whether that product or service is right for them.

"Selling" is gently leading prospective customers up the ladder of knowledge to the status of informed consumer. Selling is openly sharing information, patiently listening, honestly answering questions and objections, and then, when your customer has reached the top of the consumer ladder . . .

"Selling" is taking a momentary pause to relish your work, and then ruthlessly shoving the customer down the slippery slope to purchase. This last step is so much fun it has its own name: "closing the sale."

If you've done the job right, only a gentle tap is needed to send your prospects over the edge down the slope direct to the close. Then, your only task is to decide whether to upsell them on the way down, or wait until they've reached bottom and then upsell them and perhaps sell them again, presuming you wish to do so.

I should define the term "upsell." That's when you *add* to the initial sale and *increase your total profit* by either selling more of what you sold your customer in the first place, or adding some other related items. For a wedding photographer, an upsell might be more prints in the albums, or it might be some large, framed portraits to display in the home. To the camera dealer, it's an additional lens, a set of filters, or an expensive camera bag.

You see, once you gain control of your sales technique, you have a lot of power over your customers. Depending on how much you like your customers, you may *permit* them to buy from you again. If they've been difficult, perhaps you'll send them packing. Possibly, if they're real nightmares, you'll send them forth with the suggestion that they visit your closest competitor.

Is it any wonder I love selling? Selling is touchy-feely, it's empowering people, it's helping them, and it's also blood sport. When you sell, you learn a lot about human nature, it's far more exciting, interesting—and instructive—to watch than, say, televised sports. And, the best part—the better you are at it, the more money you make!

So, How Do You Sell?

Step one is to relax. Step two is to find your own style.

The unsuccessful salesperson is the uptight one. I've spent a number of years on the road at trade shows, both working in show booths and shopping and visiting shows. One day, a great salesman by the name of Dale, who worked for a photo lab that exhibited at the same trade shows we did, paid us the ultimate compliment, telling me that we (my road partner and I, NYI teacher and photographer Joe Billera) had mastered selling to people around the country by working with our New York attitude.

We were casual, fast talking, and a little flip—but honest. Dale said it was clear we loved our product, we believed in it, and it showed. Also, we didn't try to hide the fact that we were from New York. And when we had to, we could put on the pressure and "sell down their throats."

Dale, from a small town in Tennessee, took a much more casual approach to his work. No jitterbugging and jumping around for him. He wouldn't buttonhole people the way we did. He explained that he'd learned his technique from studying the way his four-year-old son "sold" his father on buying him toys and certain types of treats in the grocery store. Dale was friendly and laid-back; he smiled a lot, and before you

knew it, just as his son "worked" him, Dale had worked you. In fact, he sold me and Joe on taking him to dinner after he paid us that compliment.

To celebrate our mutual admiration, we went out on the town—some town—I think it was Orlando, and by the time we closed the last joint we visited, a number of things had happened: Dale, Joe, and I had become fast friends; a hell of a good saleswoman had sold Dale a $300 bowler hat that he never wore again; Joe and I had sold a training program to a photographer who worked in the nightclub; and, in admiration of her unique style, we all sold the saleswoman who had sold the bowler to Dale on the idea of joining our party.

NO ONE WAY OF SELLING

The point is that we each sell well because we do it our own way, consistent with our own style and personality. We don't feel bad that we don't sell someone else's way, or feel constrained to do it the "right" way.

Don't get the idea that there are no rules, or that anything goes when it comes to selling. There are a number of rules, tricks, and techniques, and I guarantee that: (1) if you keep the contents of this chapter and the next in mind; (2) if you have taken a reasonable inventory of yourself as suggested earlier in this book; and (3) if you are presentable and don't smell bad—you can be a successful salesperson too.

THE EIGHT RULES FOR SELLING SUCCESS

Overall: Relax, study your customer, plan your approach.

RULE ONE: PEOPLE BUY FROM PEOPLE.

Except for the supermarket, gas station, and a few items that sell themselves, in our society we have not only a vast choice of goods but also a vast choice of outlets where we can purchase the same goods. So we almost always make our decisions on what to buy and where to buy it based on three things: price, the people we encounter, and the service they give us.

Let me give a few basic examples. There used to be two principal delis in the mid-Manhattan neighborhood near NYI. Now there are more, but that's a different story. Of the two, one had obviously trained all its staff. Each person wore a pressed and starched, red-and-white–striped shirt with the shop's name on it. They had been instructed to be friendly with the customers and to give prompt service. The other shop had nice staff, but they dressed as they wished, and the service, except during rush hour, could be a little laid-back. They both had the same offerings, the coffee was about the same in both places, and the cost was the same. And the locations were equally good.

The place with the red-and-white shirts and the snap-to-it service did more business. Is it any surprise?

As a salesperson, you need to like people, or at least like your customers. You need to give them good service, be polite, listen to them,

return their phone calls promptly, dress well, wash your face, and brush your teeth.

Since people buy from people, don't give your customers any reason to want to buy from someone other than you.

Rule Two: Suspects aren't prospects.

Not everyone who calls you up or visits your shop is going to buy. Maybe they're spies test shopping for the competition. Maybe they're just amusing themselves and can't afford your services. Maybe they're killing time waiting to go to a dentist appointment. This means that you have to sort out *suspects*—let's define them as anyone who might be eligible for your services—from *prospects*, people who are definitely interested in your services, ready to buy, and able to afford them.

The best way to sort them out is to ask questions to determine whether an individual is a suspect or a prospect. The best single question is: "How can I help you?" or "What can I do for you?"

Notice that I specifically did not suggest the question "Can I help you?" because it is too easy for the suspect to just answer "no." Good salespeople never ask "yes/no" questions; in fact that is Sales Trick 1, which I will discuss more fully later. If you ask "How may I help you?" the possible client has to utter a sentence such as, "Well, I came in because I'm thinking of buying a sweater," in response or appear impolite. Once a suspect starts talking, you'll be able to get an idea whether the suspect is serious about buying your photographs or service, thereby becoming a serious prospect.

You'll also get an idea whether the suspect even understands what you do, and whether she can afford your services. Also, after you've had some experience, you can determine not only whether the suspect is really a prospect, but also whether you really want to work for this person or undertake the job she might have in mind.

For example, suppose someone calls me up and says: "Chuck, I understand you do a lot of architectural and location work, and I manage a vast hazardous waste site that must be photographed as evidence for an upcoming federal trial. I would like to know if you're available next week and what is your day rate?"

From that opening statement, I know the following: This person is a real prospect, has a real need that I can fill, and sounds ready to buy. But I also think: Wait a minute, a hazardous waste site? How hazardous? What wastes? After all, Baby may need a new pair of shoes, but Chuck doesn't want to need a new pair of lungs.

I can either turn down the job outright, or ask more questions about the risk involved in the job. But, if I'm going to ask questions and possibly take the job, let me name a day rate *so high* that if I end up taking the job I'll be satisfied that the reward is acceptable in relation to the risk. We'll cover this topic shortly when I turn to price conditioners.

It isn't always easy to separate suspects from prospects, particularly in a field such as photography where esthetics are involved. Let's say you shoot portraits—whether it's high school seniors, children, executives, or head shots for actors. You may well know that you're the best around. But chances are, your suspects don't. They may not even know how to tell. They may not have enough money to afford your services, they may be looking for a bargain, seeking a price that would be unacceptable to you.

How do you sort all that out and decide whether the subject is a serious prospect? The overall answer is slowly, and you must decide, based on your schedule, whether you have the time to devote to the job. When in doubt, presume your suspect is a prospect and move on to the next step. Let's qualify the prospect.

RULE THREE: PROSPECTS MUST BE QUALIFIED AND YOU HAVE TO LISTEN TO THEM.

Qualification of prospects simply means determining that the prospects are ready to buy, are aware of what you offer, and are able to meet your price. Try to get them to be specific about their need and their time frame, and then educate them about what you do, the way you go about it, and how you charge for your services.

As you're qualifying your prospects, you're starting to lead them up that ladder to the status of educated consumer. You have to listen, really listen, and understand precisely what it is that they need. You may need to ask them some questions along the way.

With portrait prospects, I have developed a useful trick. Lots of times someone would ask me about taking his portrait with a comment such as: "I have some photographs, but I don't like any of them." Or, "No one has ever taken a good portrait of me." I would explain that I would meet with him in my studio at no charge, but that I wanted him to bring the photos he didn't like so we could look at them and discuss what it was that he didn't like. Only if we agreed to a sitting would I charge him.

Invariably, this offer was accepted. I booked the consultation at my convenience, the prospects came to me, and they brought material for us to discuss. After all, I can show them lots of nice photos I've taken of other people, but unless they know the other subjects, how do they know what kind of job I've done?

Lots of times, I could see right away what it was that was lacking in the photos prospects showed me. We could talk about those photos, I could explain how I would handle certain things differently, and they would grow to trust me and feel confident.

From there, it was easy to shift to a discussion of how I charge, and to determine what the prospects really needed. I had helped them learn a little bit about photography, listened to them, reassured them that I would help them, and then, given them one little push to the close.

Rule Four: Price is in the salesperson's mind.

This is the most cosmic of the Eight Rules. It's one I still ponder and, as time passes, grow to appreciate even more.

It means, in its simplest form, that if you think the price is a good, fair price, it is. No matter how high, no matter how outrageous.

Huh? The best example I can give is how I was afraid of dogs when I was a little kid. If any dog, big or small, came up for a sniff, I recoiled. My father would coach me. He would say, "The dog can tell you're afraid. Don't let the dog know you're afraid."

It took me a long time to figure out how to do that, since I *was* afraid of the dog. Ultimately, it's a psychic bluff. I can name a price and give you my "game face" (a poker face) and you won't know if it's the same price I've always charged for that type of job or a number so high I've never had the guts to ask for that price before. At that moment, when I quote it to you, that's my price. It's not low, it's not high. It's a fair price.

In fact, I even use the same game face when I quote a low price. Let's say I *really want* to work for someone. An arts group or a civic group that does stuff I admire. I name a price and I don't tell them it's low or discounted because I admire them or feel sorry for them or whatever. That's my price. Period.

I see bad salespeople stumble on this one all the time. When the moment comes and the prospect asks, "How much?" they stumble, hesitate, blink, or start to dither. Gong. They've blown the sale. The prospect knows the price is too much, that you're stumbling and there's something else going on. They're going to check with someone else before they buy, and if that someone else is any good, he is going to close the sale. You've blown it. You lost the sale.

Silence Can Be Golden

Here's another trick: Sometimes you are asked a price for the use of a photograph or you bid on a job when it's something you don't know about. In this instance, I've found that meditating silently on an "upset price" and letting the prospect name a price works well.

Here's an example. I get a call from a musician whose photo I took for a newspaper. He doesn't have any good photos of himself, and a German record executive is in town to sign him to a deal to put out a CD in Germany. The musician is a good musician, but hardly a star, and the music he plays is traditional stuff, nothing I can imagine being a big seller.

Would I, the musician asks, be willing to sell the photo to the record executive? Of course I would. How much, he wonders, would I charge? That, I tell him, I will have to discuss with the record executive. The musician says he'll have the executive call me.

Notice that I didn't talk price with the musician. He's not the client in this case, so nothing good can come from getting started with discussions with him.

As it happened, I was in the middle of finishing a big project at NYI at the time the musician called. I didn't have much time to consider the price I would charge. The next morning the record executive called, and since he was leaving for Germany that afternoon, he wanted to close the deal.

Well, there was no need to qualify him. He was ready to buy. But what would I charge? I'd already been paid for the portrait job, so again, this was found money. I liked the musician and I didn't want to foul up his CD, so I didn't want to name too high a price, and, since I don't sell photos of musicians for CD covers, I had no idea what the going rate was in the United States, much less Germany.

So, I decided on an "upset price" in my mind: $250. In auction terms, an upset price is a minimum. If I put up a painting for auction and tell the auctioneer $250 is the upset price, the bidding must reach at least that level or the painting won't be sold, it will be "called in." An upset price is also sometimes known as a reserve price.

OK, now I've got an upset price in my head and I'm ready to make the sale. I use a neutral technique: "Herr Executive, I really like the musician you're recording, and I want to provide you with a good photograph of him. In fact, in addition to the one photo of mine that you've seen published, I have several others. I'll be happy to send you several so you can make a selection. By the way, although they were published in black-and-white, I shot the job in color."

"Color? That's good. But I'm in a rush, the photo I've seen in the paper is fine. How much do you want for it?"

Do I blurt out "I'll take $250!"? No. Instead, I ask a question. "Herr Executive, is your company a big record publisher in Germany?"

He replies: "Well, we're medium-sized and we specialize in classical music. There are many far bigger, but why do you ask?"

"Because, since you are an established company, I'm sure there is an established rate that you are accustomed to paying for photos of musicians that you use on the CDs you release. I assume you're using this photo on the front cover."

Notice I haven't said I'll take the established rate—that would be surrender. Instead, I've put the ball back in his court with a question.

"No, there will be a painting on the cover. This photo will run on the back cover . . ."

(Now I'm expecting to hear a really low offer—this is like an author photo on the back of a book jacket, except this is a CD to be released in Germany of classical music as played by a musician who I don't think is particularly well-known.)

" . . . and our standard price for musician's portraits we commission is $500 U.S. Will you accept the same?"

Bingo, the sale is closed, the deal is done! Herr Executive is no dummy, and had he put the ball back in my court I can't imagine that I

would have opened asking for more than $300. But, he was in a rush, and he's used to paying a certain figure, and I can only presume it wasn't worth his time to beat around the bush.

The close was quick, but I did get him to agree to pay for express shipment of the negative to Germany. I also told him that I had lots of photos of other New York–based musicians and I would be happy to work with him in the future.

I should also add that I trusted him and sent the negative with no written commitment. I received a check for $500 U.S. by airmail two weeks later.

RULE FIVE: NEVER OFFER ANYTHING "FREE."

To close a sale, you may be tempted to throw something in "for free." You're barking up a good tree, but you're coming at it from the wrong side. Nothing is ever "free." Everything has a value. If I give you a "free" gift, I'm an idiot, because it means nothing. If, on the other hand, I'm visiting you and your family because you're interested in my photographing your wedding, and I want to close the deal tonight so some other photographer won't take advantage of everything I've taught you this evening and sell you her services tomorrow night, I might be willing to sweeten the deal.

For example, I might be willing to "give" you a "valuable" 11″ × 14″ bridal portrait. But here's what I'm going to say:

"You know, I think this is going to be a beautiful wedding and I'm so happy for all of you. You two are going to make a lovely couple, and I already feel like I know your families. I really want to photograph your wedding, and if we can strike an agreement tonight, as my gift to you, I would like to present you with an 11″ × 14″ print of the bride and groom that I normally sell for $250."

It's not free, it's a $250 present! Who could resist? Will I charge them for framing? Perhaps. When they see that print, naturally I'll suggest they might want to purchase two more for their parents, or perhaps they will want to get a 16″ × 20″ for $400 for their house and give the 11″ × 14″ $250 "present" to one of their parents. That's a hidden upsell on a "valuable" gift.

Whether I make an upsell or not doesn't matter. I have given them a valuable present, not a free gift.

RULE SIX: SELL THE BENEFITS, NOT THE PRODUCT.

This is a cardinal rule of selling any product. Your customer may care about what the photograph is made of, how long it will last, why your retouching is the best, why your lab is the cleanest, and so on and so on. But what you really need to stress is the benefit to the customer. How much everyone will marvel at his portrait when they see it in the newspaper, how touched his family will be at seeing this wonderful portrait of him hanging on the wall in the living room.

There's an old saying, "Sell the sizzle, not the steak." If you appreciate what that means and if you can apply it to your photography and your services, then you'll never starve.

Let's start with that steak. It's a great source of protein, and a lean cut doesn't contain that much fat. You can freeze it, you can enjoy leftovers, and you can have it rare, medium, or well-done. And steak has less danger of disease transmission than pork. Perhaps the cow only ate organic grain. So what? A steak is just a piece of meat, sitting there on the plate. You look at it. It used to be part of a cow. It's just a steak.

Ah, but can you smell the delicious odor of that steak cooking on an open fire? Can you smell that steak when it's put before you on a fine china dinner plate with a baked potato, your favorite green vegetable, and an attractive garnish? Can you imagine how well that steak is going to taste along with a glass of your favorite Cabernet Sauvignon?

That's sizzle. Sizzle sells.

RULE SEVEN: DON'T FORGET TO ASK FOR THE SALE—THE CLOSE.

You have talked to your suspect and determined that he or she is indeed a prospect. You've listened and you understand what your prospect wants. You've extolled the virtues and benefits of your photography product or service. You've injected sizzle where possible.

Some customers close for themselves. They say, "OK, I'm sold," or words to that effect.

But every now and then, the prospect lingers at the top of the slide. It's your job to get him moving. After all, your time is precious. Three examples come to mind, and each illustrates a way to ask for the sale, and get the close going.

Example One: Cut to the chase.

The printer who used to print NYI's lesson texts told me one day that he had purchased a new press, but only after an extended series of sales calls by the sales representative of the press manufacturer. The sales rep had studied the printer's business and listened endlessly to what type of jobs the printer did, what the maximum press runs were, and what kind of deadlines and price margins applied to the printer's business.

The rep had extolled the virtues of the press model that he felt was right for the printer. He had explained how this press would save money, speed delivery time on rush jobs, and do better printing. Finally, in near exasperation, the sales rep got a little testy. He told the printer that he just didn't understand why the printer hadn't expressed a desire to finalize the deal and buy the press.

"I've studied your business, I selected the perfect press for you, and I've told you at great length how this press will benefit your business. Why haven't you placed the order?" the beleaguered rep moaned.

"Because you haven't asked," the printer cheerfully explained.

Don't get so caught up in your sales pitch that you miss the opportunity to ask for the order. If you don't ask, with some customers, you'll never get the order. So you may as well ask early, since if the deal is ready to close, why not move forward and save your energy for the next sales job?

On the other hand, what if the customer says "no"? That raises a key point: The selling begins when the customer says no.

This is such an important concept that it really should be listed as a rule, but I left it out of my Eight Rules because it doesn't always come up. Here's the concept—you ask for the sale and your prospect says "no." That doesn't mean your job is over, nor does it mean that you won't be able to make the sale.

What it does mean is that you have to prod your customer to explain to you why she has said "no." Chances are, if she gives you a real reason, you can work around her objection and still close the sale. If she doesn't like the price, perhaps you can refigure the price. If she doesn't like the frame, you can change it. If she doesn't like the schedule, you can change that. In fact, there's very little you can't change once you understand what the customer really wants.

Example Two: "I just don't know."

I know someone who used to sell insurance. In his training days, he was one of a number of salespeople who were being supervised by a master salesman. The crew was involved in taking the company's aging policy holders and trying to convert them from whole life insurance policies to some form of annuity.

One young salesman came back to the training group and explained that he was having trouble with this one elderly woman. He had visited her several times, studied her situation, and explained the benefits of making the switch to her several times. Yet she refused to move ahead, and she kept saying, "I just don't know."

The sales guru said he would accompany the trainee the next day and close the sale, which he did. He explained to the group at their next meeting what had happened.

The beleaguered salesman had repeated the entire sales pitch again. He reviewed the size of the woman's policy, the benefits of switching to an annuity, and the security the switch would give her. Then, with a slight tone of exasperation, he reminded her that she kept saying she "just didn't know."

"That's right," she said. "I just don't know."

The master salesman, who had been silent until this point, stepped to the fore. The woman was seated, as was the junior salesperson. The guru, standing over the woman, kneeled down slightly, took both her hands firmly in his, looked her in the eye and said, "Take it. It's good."

"Okay," she responded. "I will."

Sometimes, you have to tell the customer what to do. If you think it's a good deal, tell the customer so. Even though you're on the other side, you're still a human being, so your opinion counts.

Example Three: How about four in the morning and three in the afternoon?

If you like reading philosophy, I recommend to you one of my favorites, the Chinese Taoist Chuang-Tzu. Most people who have had any exposure to Taoist thought have read a bit of Lao-Tse, who is often identified as the leading proponent of Taoism in roughly the sixth century B.C. With almost all of the Chinese philosophers, unless you read Chinese, your appreciation of the wisdom conveyed turns on the talent of the person who does the translation. There are some horrid translations of Chuang-Tzu and Lao-Tse (and Confucius and Hsun-Tze and Han Fei Tzu, too, for that matter). I heartily recommend the translation of Chuang-Tzu by Burton Watson that is listed in appendix II.

Here's the gist of one of Chuang-Tzu's parables. The monkeys come to Chuang-Tzu one day. They're dissatisfied with their food. They get three nuts in the morning and four in the evening. Things have to change, they insist. Chuang-Tzu reflects on this for a bit and offers a proposal: How about four nuts in the morning and three in the evening? The monkeys are happy. That will be fine.

Let's put this into modern terms. Not long ago, NYI leased a new van. Because we're good shoppers, we found a deal in a small Ford dealership one hundred miles outside New York, in a very small town. This dealership beat the prices of other dealers by more than $100 per month over the entire lease term with a smaller down payment. A great deal.

But it meant that I had to take a bus to the small town to pick up the van. When I got there, the salesperson with whom I had struck the deal was out on a family emergency. I would have to wait for an hour or so.

I don't know about you, but for me killing time in a car showroom, particularly a small showroom, is a grueling experience. I had already read most of the newspaper on the bus, and it was raining, so I couldn't go for a walk and look for something to photograph.

There was, however, one benefit to this particular showroom—the other salesperson, Roger, was very good. Roger had a couple sitting at his desk. He obviously knew them well. They were considering trading in their current leased car for a new one. This area has a lot of farms, and as I eavesdropped on their conversation, it became evident that this couple ran a farm. And, since it was mid-November, it was abundantly clear that they had little else to do that day other than ponder whether or not to make this deal. It was also clear that they had leased or purchased their last several cars from Roger.

Roger listened patiently and answered all their questions. How much money would they need to put down to make the change? How would it

affect their insurance payments? How would it affect their monthly lease payments?

The clock in the showroom ticked, an old windup model you could actually hear. Tick. Tock. The pace of their conversation was agonizingly slow. I stepped outside and stood under the porch and watched the rain for a while.

I returned to the showroom. They were still going over the same points, again and again. A fly buzzed in the corner. It was, in a word, tedium. Tick. Tock.

I wondered, would Roger close this thing, and how and when? I've never had to sell anyone a car. It sounded like these folk were reasonably happy with their current car. Were they just killing time making Roger crunch numbers, or was there a real desire on their part? I couldn't tell.

Finally, Roger took the initiative. He reminded them that he had sold them their last three or four cars. He reviewed the cost of the current proposal, right down to the fee for a new vehicle registration. "What are you going to do to make a decision about whether to go forward?" Roger asked.

"Well," said the farmer, "I guess me and the Mrs. will go home and talk it over." (I promise this happened just as I'm recording it. I know it sounds unbelievable, but it can get like this in a small-town car showroom.)

Now, if the salesperson misinterprets what has just been said, the sale falls through. They're going to go home and discuss it? You folks have wasted an hour of my time talking over every aspect of a piddling deal and you're going to go home and discuss it? Kaboom! This sale isn't going to happen today.

But Roger heard the key point. Or rather, he probably knew the key point all along but he had to wait for the point in this dance (which moved at the pace of a minuet) when he could strike.

What the man had really said was that his wife was going to make the decision. He was going to go home and discuss it with her, even though they had both discussed it to death with Roger right now. She would make the decision whether this upgrade made sense for the family budget.

From that moment until the handshake, which occurred ten minutes later, Roger talked only to the woman. What were her objections, he wondered? In the end it came down to the monthly lease payments. She could accept a little higher insurance payment because it was a nicer car, but it seemed extravagant to her to pay that much a month.

The objection was on the table. Roger asked if he could get the monthly payments down, would she say yes right then and there and not wait until she and her husband went home and talked about the matter over dinner. She agreed that she would.

Roger solved their problem just like Chuang-Tzu fixed up the monkeys. He fiddled with the front-end payment and increased it a tad, and

left a little more residual value at the end of the lease. As far as he and the dealership were concerned, it was the same deal, but to the customers, it was better.

He closed. I never could have done it. But I don't have to do it. I don't live in that community, I don't sell cars, and I'm not Roger. But he did a great job, and saved himself another round or two with these people.

No one way of selling.

Now, I've illustrated Rule Seven with three examples, none of which have to do with photography. I suppose I could have selected examples that did deal with photography, but these stories exemplify the points I want to get across.

Selling techniques can apply to any product. Learn to sell, learn to love to sell, and you can sell anything.

RULE EIGHT: KNOW WHEN TO STOP TALKING.

This is essential in every sale. I've already stressed that you shouldn't get so hung up in reciting the benefits of your product that you forget to stop and see if it's time to close. In addition, you have to stop talking during the sales process in order to listen to your prospect's needs, fears, and desires. If there's an objection, you have to stop talking long enough to assess whether there's a buying signal and, if there is, to redirect your sales pitch to address that signal.

In photography, particularly when you're selling a contract for your future services, there's a point where a deal must be struck without immediate gratification. If someone is interested in buying your photograph, when they say yes, they get the photo. But if they're hiring you to photograph a wedding that is a year away, there's no particular time pressure and no reason to stop shopping right now. We'll cover some tricks to help this situation a little later, but it's key to realize that there is a time when you have to stop making your presentation and see whether the deal is ready to close.

Particularly if you're dealing with a wedding or other type of job where there are several people who must make a decision, it may make sense to excuse yourself for a few moments so that they can discuss the matter without you. Go get them coffee. Excuse yourself to visit the bathroom, even if you don't actually need to do so. Stop talking (and selling) and give the prospects a chance to assess the situation.

After you name a price for the first time, or present your letter of agreement (isn't that a much nicer term than contract?), it's very important not to keep talking. Give the prospect a moment to absorb and reflect.

I know one very successful wedding photographer who presents his letter of agreement with a flourish and then waits in silence. "The first person who speaks, loses," he likes to say. What he means, of course, is that if he were to start trying to explain or apologize for his terms (price, percentage of deposit, and the like) he's likely to have to modify things. He'll

sit silently until the customer says yes or no, or asks about a specific provision. Then it's time to resume discussions and push for the close.

THE ONE SECRET RULE: THE CUSTOMER IS OFTEN WRONG.

I know this is a long chapter and I spent a lot of time covering the Eight Rules for Selling Success, but I also know this is crucial stuff that far too many photographers don't really understand.

Let me repeat the One Secret Rule: The customer is often wrong.

But, wait a minute, haven't we all heard, that the customer is always right? Sure, and it's true. The customer is always right because the customer has the right to say "yes" or "no" to the selling proposition or to the service that is being offered.

But the truth of the matter is that the customer is often wrong. Not always wrong, but often wrong. The customer could get a better deal from you, or a better deal elsewhere. The customer could pick a better-looking frame, or choose the images you prefer as opposed to the one she prefers.

Yet the customer is the boss, and, therefore, even when you know customers are wrong, unless they're making a decision that you cannot ethically allow them to make or that you know will end up backfiring on you later on, let them make their decision and let them feel good about it.

In the next chapter, I'm going to share some selling tricks I've learned along the way.

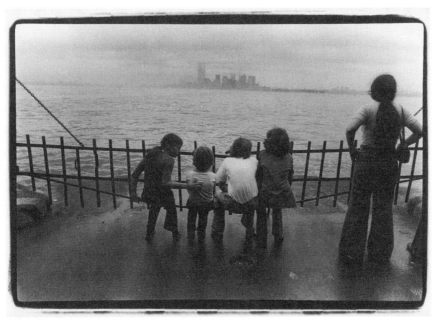

Staten Island Ferry approaching South Ferry Terminal, Manhattan, New York, 1976.

Chapter 18: More Selling: Tricks, Techniques, and Attitude

In the process of explaining the Eight Rules in the previous chapter, I've mentioned a few of these techniques for dealing with customers already. There are five important sales tricks, and we'll look at each of them here.

TRICK ONE: DON'T ASK QUESTIONS THAT HAVE "YES" OR "NO" ANSWERS.

Getting your suspect or prospect talking is the first step to making a sale. As discussed, if you ask a question that can be answered, or perhaps is even best answered, by a simple yes or no, you're going to have a hard time getting your subject to tell you what he is thinking about.

Therefore, "How may I help you?" is far preferable to "May I help you?" But there are lots of ways to extend and advance the sales conversation. Let me give you some other ideas.

A lot of photographers answer the telephone and simply say, "Studio." Or the assistant answers and says, "Hello, this is the Chuck DeLaney studio."

Answering the telephone gives you a chance to learn your suspect's name if you handle it right. I prefer, "Hello, this is Chuck," or "Chuck DeLaney studio, this is Jane Jones." If you make the last words of your standard telephone answer a name, many times callers will give you their names right away.

"Oh. This is James Rodgers. I got your name from Alice Adams. I need to have a portrait photograph taken."

Whenever anyone calls, I jot down the caller's name so I have it in front of me when we talk. I'll worry about getting the name spelled right and gathering a telephone number and address later. At this point, I don't want to interrupt the flow of our initial conversation with details. I just want to be able to address my suspect by name every now and then during our conversation.

Depending on how things go, I may call him "James" or I may call him "Mr. Rogers." But at least I know his name. Right now, I want to build a relationship. The particulars can follow.

Remember the well-run deli I mentioned earlier? The people behind the counter had obviously been trained to propose alternatives rather than say no. If I ask for a poppy seed bagel, for example, rather than say, "We're out of poppy seed," and wait for me to react, they say, "We're out of poppy seed right now, how about a sesame or an onion bagel?"

Much better response. They've given me an alternative and a simple choice, and they've reduced the likelihood that I'll exit their store and visit the place across the street in hopes of finding a poppy seed bagel. However, the way the question is asked still permits you to answer yes or no. Better yet would be, "We don't have poppy seed, would you prefer a sesame bagel or an onion bagel?"

You'll have to study exactly what you sell and whom you usually sell to in order to find the ways to translate your end of the conversation into the most probing sentences possible. Consider phrases such as, "Tell me a little bit more about what you have in mind," or "If you could wear any outfit for your portrait what would you choose?"

Consider how much better those two questions are than the following statements. I could have said, "I don't understand what you want," or asked "Have you given any thought to clothing?"

Calling Other People

One other point: I am a firm believer, in regard to both business and personal telephone calls, that it is good manners to ask the person you've reached on the telephone whether this is a convenient time to talk. After all, I can read a letter, fax, or e-mail at my convenience. But if you're calling me, it may not be a good moment for me to focus on what's on your mind. I have friends and business associates who take no notice of me and my needs. They get me on the telephone and they're off, talking a mile a minute about what's on their minds, without taking a moment to be

thoughtful and inquire whether I have anything on my mind, or whether this is a good time for me.

However, when it's sales time, telephone questions such as "Have I caught you at a convenient time?" or "Is this a good time to talk?" are too likely to evoke an answer of "no."

If it's a big sale and/or a good customer, I may give her a chance to defer the pitch, but not to an uncertain date sometime in the future. Rather, my opening would go something like this: "Hello. It's Chuck calling, and I have something really important I want to discuss with you. If now isn't a good time to talk, when can I call you later in the day that would work for you?"

Not later in the week or later in the month. Later in the day. If today is a terrible day for the person I've called, I'll let her tell me that, and I'll let her suggest an alternative time on a later day when it would be good for me to call her. Not the other way around.

TRICK TWO: USE A TIME HAMMER WHENEVER POSSIBLE.

A time hammer is a reason for the prospect to act now. Most of the consumer public never notices these, but they're everywhere. The one-day sale, the President's Day sale, the limited time offer for collectors' plates. All these are devices to get the consumer to act—to decide, to buy, to close.

There's no real reason most things are cheaper on a given day. There's no magic price cut in effect on President's Day, and the people who make collectors' plates would be happy to sell you a plate any old time, but these time hammers are put in place to give the buyer a sense of urgency. To get you to go forward and buy.

What kind of time hammers are available to photographers? First and foremost, your calendar. You're a professional, and your time gets filled up. Let your customer know that.

Most wedding photography studios, when they get started on a telephone conversation about wedding photography with someone who's just gotten engaged, will make a point of inquiring about the wedding date and then take a brief moment to check to make sure they "still have that date available." They will do this even if they know full well they do have that date available. By taking the time to check, they plant the thought in the prospect's mind that their studio is very busy, and that if the prospect doesn't act in the near future, someone else may take that date that is "still available."

I remember the first car I bought. It was a used car that ended up costing me a lot in repairs. I bought it too quickly because as soon as I spotted the thing on the lot, someone else popped up and expressed keen interest in the same car. I bought the car in a hurry because I was sure if I didn't, he would.

When I went back to pick up the car several days later, I saw the same person pop up twice in the span of an hour, each time, suddenly

interested in another used car that someone else was looking at. I don't know if this walking time hammer worked for the dealership or lived next door and was available at the push of a buzzer, but he was very effective.

You can try to motivate sales by stressing an economy of scale. "Since I'll have to take your negative into the lab to discuss what I want the lab staff to do when they enlarge it, maybe it would make sense to order some additional prints as presents now. If you wait, I'll have to charge you for another trip to the lab."

Or, "As long as I'm going to set up on location to photograph the president of your company, wouldn't it make sense to photograph the three vice presidents at the same time? That way, I would only have to charge you one location fee."

TRICK THREE: EVERYONE LOVES A PRESENT.

We've covered the "If you sign tonight, I'll give you a $250 print as my present," in the last chapter. In that example, the gift is used as a time hammer. I also pointed out that no present is ever free. Quite the contrary, every present's value is made explicitly clear.

Buyer's Remorse

Even if you don't need to offer a present as a time hammer or other form of motivator, there's another reason to consider leaving the customer with a little something to remember you by, particularly if you're booking customers for future events such as weddings or parties.

Even if you get a signed agreement and a deposit, sometimes customers suffer what's known as *buyer's remorse*. This is particularly likely to happen when you get to be a great seller, because sometimes you'll succeed in selling something to someone that they really didn't intend to buy. Afterwards, if there's a period where the purchase can be returned for refund or if there's a period when the deposit is refundable upon prompt notice of cancellation, every now and then the customer will get concerned. It was really too expensive. They don't need that thing anyway. Yes, they need a portrait, and they're prepared to pay for the sitting, but they hadn't planned to order six enlargements before the sitting even commenced.

A present—something they can take with them to remind them of you, the pleasant experience they had dealing with you, your generosity and professionalism—can help ward off buyer's remorse. If you've taken some great scenic photos of your area, give a print to every wedding couple you book who comes from the same area.

Some photographers have deals with local jewelry stores and other purveyors—caterers, florists, wedding boutiques, and the like. If the engaged couple buy a ring that costs more than $1,000 (or whatever number works where you live), they get a certificate that gives them a 25 percent (or 50 percent) discount on a sitting with you for an engagement portrait suitable for the local newspaper. In fact, you even know the specs and

deadlines for all the local newspapers. You're going to be very helpful and give them a great deal on an engagement portrait. And, unless you're a total idiot, you'll have their wedding contract signed before they leave after the engagement sitting. Don't wait until they pick up the print, because by then some other photographer may have landed the job. Here's a place where some digital proofs on the spot might be a way to convince them of the quality of your work when you take the photographs.

TRICK FOUR: HAVE A PRICE CONDITIONER.

Whenever I lecture beginning professionals about sales technique, I ask for a show of hands with regard to who can define the terms *time hammer* and *price conditioner*. Very few people understand these terms, and, in particular, the use of a price conditioner is one thing (besides learning to upsell) that can help boost your business.

Simply put, a price conditioner is an item or service that you supply that conditions the prospect to a comfortable price range for you.

If I enter a men's store with the idea of buying a suit and there are $300 suits and $600 suits on display, I, like most people, will start by looking at the $300 suits. If I find something to my liking, and I'm only looking to purchase one suit, I'll never even look at the $600 suits.

However, if the store offers suits for $300, $600, and $1,200, then I'm much more likely to start by looking at the $600 suits. They seem to be in the middle. Not cheap, not extravagantly expensive. Hmm. There's a nice suit, and while it is a little more than I had thought about spending, it looks to be very well made and the fabric is very pleasing to the eye.

I've just bought a $600 suit, and I did so because I was *conditioned* to the price.

If you conduct portrait sessions and you charge a sitting fee, figure a way to make a deluxe version that costs twice as much as you would like to charge the average customer. Maybe a sitting is $250, but for $400 the subject gets an extra change of clothes for a more formal (or less formal) portrait. You don't care. You want the customers to feel OK about the $250 fee, and if for some reason they want the more expensive treatment, you'll be happy to give it to them.

Keep the Offer Simple

I find a lot of photographers have too many packages. You should have no more than two, or at most three, basic packages. Any more options and you're just going to confuse the prospect. Remember: Your job is to educate the prospect to the degree necessary to make the sale. It's very hard to close the deal if the customer is more confused after your sales pitch than he was before you started.

For example, if you want to book your average wedding for a $1,500 package, then I suggest you offer a $1,500 package and a $3,000 (or $4,000) deluxe package as a price conditioner.

Remember: I suggested two, or possibly three packages. The reason I prefer just two in this instance is because if you offer an $800, a $1,500 and a $4,000 package, some people will gravitate toward the $800 package. If I can compare suits at three price levels, I can see and feel the differences between them. Some consumers can't appreciate that comparison in an abstract concept such as a package of photography. For that reason, I think it's safer to keep the budget offer (your "minimum upset price" that I covered earlier) under wraps.

TRICK FIVE: UPSELL THEM
(THE OLD TIE-OVER-THE-SHOULDER TRICK).

I guess one of the reasons I cite so many selling examples from retail salespeople is that we all buy a lot more stuff in retail settings so we're more likely to see good and bad examples of sales technique.

Upselling simply refers to any method you use to increase the sale. After all, the prospect is ready to buy. Why not add to the package?

I buy that $600 suit, and any salesperson should try to sell me a few shirts and ties "that will look great with that new suit." Assuming that I'm going to have a few simple alterations done on the suit, the clerk may get another shot at me when I'm picking up the suit once the alterations are finished, but since I'm ready to buy now, the best time to upsell is right now.

A master salesperson will just assume I'll make some additional purchases. Do I agree this tie would look great with the pattern in the fabric of the suit I just bought? I agree. The tie goes over the salesperson's shoulder. So does another "perfect" tie. The shirt that I also agree would be perfect, he holds in his hand. Off we go to the sales counter, where the ties and shirt are added to the ticket. He never even asked me. He just assumed that I would buy them.

I don't have to. I can object at the counter. But he's maneuvered me into a position where instead of his having to get me to say "yes," now I've got to be a bit stubborn (after all, I already agreed they were perfect) and tell him "no."

How can you upsell your goods and services? If you're selling wedding photography and portraits, you can sell thank you cards, portraits (sometimes called "wall art"), frames, and display portfolios. You can have higher-quality leather albums, you can offer name imprinting, extra albums (or prints) for parents, grandparents, and other relatives. You can offer to shoot portraits of other family members at the same time you schedule a location sitting for one person.

Many wedding photographers don't start the upsell until the happy couple view the proofs after they return from their honeymoon. Particularly if your work is good, and if they had a lovely wedding, it is not uncommon to double or even triple the original package price with some couples. This is done by adding prints to the album, selling added enlargements and additional albums that weren't included in the package price.

Upselling is particularly profitable because you've already invested the time in booking the couple and shooting the event. Now you will have to expend time placing the order, but if you place a bigger order it won't take much added time, so there's a lot of pure profit packed into this type of upsell.

If I don't mention it, I'm sure photographers will contact me to fault my not including some hints about a "memories" preview session. Simply put, in the past fifteen years or so, lots of wedding photographers have taken to presenting the wedding proofs as a slide show or other sort of multimedia presentation, complete with music and pacing. This sometimes results in a dramatic upsell, and if the images are projected, it can help push a couple toward purchasing a really large print, for which you will try to charge a "really large" price.

This may be worth the effort, or it may not. For one thing, you need to set up an area where you can make this presentation in a setting that's under your total control. You can't show up at the happy couple's apartment with a slide projector and expect to pull this off. You need electricity, a good viewing area, comfortable chairs, isolation from the telephone, and a good sound system—it's quite an investment.

It will also work best with a certain type of client base. I know of a large wedding studio in Westchester. Now, a lot of very well-to-do families live in Westchester because someone in the family commutes to a high-paying corporate job in Manhattan. But this studio's highest-paying jobs don't come from those well-to-do families and their college- and profession-bound children. Rather, the best jobs come from ethnic Italian and Hispanic middle-class families in the Bronx for whom the marriage of their children is a very big event indeed, and hiring a studio with a prestigious Westchester address is part of making everything "the best."

Study your market. Know which part of your client base is most likely to respond to your upsell efforts.

Publications and Assignments

It's hard to upsell a client who is purchasing your photographs for publication in a newspaper or magazine, and hard to upsell an ad agency that is giving you an assignment for a still life.

That doesn't mean you can't try. If you're being sent somewhere on a journalism assignment, inquire whether there's anything else "out that way" that should be photographed. If an ad agency presents you with a sketch of the way the client wants the photo to look, offer to try a variation for just a small additional charge.

ATTITUDE

To close out our study of sales technique, we have to look at the implications of various sorts of attitude expressed by the salesperson. There are

natural reasons for different attitudes. You may behave differently if you're selling wedding photography to rich people as opposed to head shots to aspiring actors. On the other hand, you may not. It's really up to you. No one way of being.

I've classified these attitudes by giving each a degree of "up" or "down." This just reflects the attitude, or status, that the salesperson is taking on in approaching a prospect in order to provoke a response (and, hopefully, a sale). The "up" approaches imply that you're above the job you're being offered. Often these "superior" approaches allow you to command higher rates. Since price is in the salesperson's mind, these can be helpful if you can master the proper attitude. The number, for example, "3 UP," simply represents the relative amount of attitude you are adding—3 UP would be a lot of attitude. Be careful about trying anything higher than 1 UP or lower than 1 DOWN.

Let's start with the top.

3 UP: "I'm the best in the field."

There are people out there who can charge way above the going market rate for their work because they are who they are. You can hire a piano player for your party for a few hundred dollars. You can hire a darn good piano player for $500. But if you want Bobby Short, it's going to cost you thousands. He can name his price.

Now there aren't too many celebrities in photography, and as we've discussed in other parts of this book, some big-name photographers deserve that reputation and others don't.

I know a wedding photographer who has a "basic" package that starts at $3,500. There's another studio on his same street in the suburbs where the basic package is $600. When he's asked how he compares his package or his work or anything else with the $600 studio, his answer is simple: "I don't. Come look at my work and you'll see why."

No begging, no explaining, no attempt to justify.

2 UP: " You really need me and I'm doing you a favor."

I often get calls from people with real photography jobs where the photographer became unavailable at the last minute. They call NYI because they're desperate and don't know where to turn. They really do need me, and I'm going to do them a favor. If I'm interested in the job they offer, I'm going to take it for just a slight premium over market, but I'm not going to gouge them the way some people would.

I also use this attitude when I'm pitching a job to a corporate client who has been getting mediocre service in the past. I really see a way that I can change the company's image and give it a big boost. Those executives really do need me, or at least they need to dump that other photographer and get someone who will give them a fresh look. Why not me?

1 UP: "I'm really very busy, but . . ."

This is evident. Yes, we still have that date available. I'm successful, and I can pick and choose whom I work for. There's no harm in letting you know that in the most polite possible terms. I'm not suggesting bragging. Quite the contrary. You've worked hard and if you're busy, you can be frank about that without flaunting it.

There are customers who actually want you to flaunt how good you are, how busy you are. As I discussed in an earlier chapter, I'm not against a little role playing if it will help me get the job, but for the most part, people who want flaunting aren't people I like to work for. But there are a lot of photographers who like that stuff. No one way of being.

½ UP: "I really want this job."

If you want the job, let them know it. The up attitude stems from the fact that you want the job because of the nature of the job. Even if the real deal is you really want—really gotta have—the job because you don't have another job in sight and you're desperate for money, don't let it show. You want the job because you like the client and the job sounds interesting.

Now let's consider a neutral sales attitude, one I'll call "even."

EVEN: "I understand what you want and I can do the job."

This kind of pitch is straight ahead, neither up nor down. You understand the job and you can do it. This is how mechanics accept your request to give your car a lube job. Neutral. Even.

Now, here are some subservient attitudes you can consider. Be careful. Don't use these unless you have to.

1 DOWN: "You want it fast, good, and cheap? Pick two and call me back."

Nothing wrong with this approach. The customer will feel comfortable. You're ready to deal, and quality, speed, and a good price are all up for grabs. This type of attitude works well in very competitive fields. It does suggest that you're willing to compromise your sense of quality, if necessary. For this reason, some people rightly refuse to do this.

2 DOWN: "I can do as good a job as the competition and it will cost you less."

This is lowballing. You're after the job based on price. You're probably undercutting some other photographer, and you're undoubtedly in a competitive field. You wouldn't negotiate price with yourself, so if you're selling based on price, you're negotiating with your customer with one eye on the competition. This may be inevitable, but there's certainly danger there.

Let's explore this a little more deeply.

First of all, realize that there is no photographer's union. There are some photographers who work at full-time jobs, perhaps for a newspaper

or a law enforcement agency or a hospital, where the photographer is a member of a union by virtue of the enterprise being a union shop.

One of the benefits of a union is that it sets pay levels based on some kind of scale. Need a union plumber for a plumbing job? Don't expect to negotiate price too much.

With photographers, particularly in lucrative and competitive commercial areas, competition on price rather than quality is a sad fact of life. There is little in the way of a set price for anything. The market controls price.

Let's examine the core of this issue. Many photographers lament the "good old days," now at least two decades gone, when ad budgets were bigger, stock photography was used less, and long assignments at healthy day rates were the norm. When stock photography paid better than it does now. When there weren't so many photographers. When there was no digital retouching, so that if the client decided the model should have short hair instead of long hair a reshoot was required, instead of half an hour of electronic manipulation.

But the world has changed. As photography has become more important to communications and many more photographers emerge from colleges and other types of training, competition has undeniably increased more rapidly than the market has grown. I recently read an article in a new magazine for professional photographers. A columnist wrote that he had a lead on an assignment to make head shots of 250 doctors under rushed conditions at a big medical event. He was too busy to take the job, so he posted the job with an online referral service. He figured he would have charged $25,000 for the job. The winning bidder landed the job for $5,400!

In the columnist's mind, this lowball bid gave away the store. There weren't enough details in his column to allow me to make up my mind either way. What kind of photographs did the client want? Was the client looking for a simple head shot, or something that gave a "look" to each physician. It's not clear. Was travel involved? Again, it's not clear.

Actually, the lack of clarity makes this a good example. In the columnist's mind, his bid worked out to "$100 a head." He felt someone could have bid $20,000, or even $15,000 without upsetting him. But $5,400? That was less than "$25 a head!"

To the columnist, the company sponsoring the event was spending a fortune flying in the doctors, covering their expenses, and giving each an honorarium. Since they were spending a fortune anyway, they would probably spend $25,000 on photographs.

I'm not so sure. Again, without knowing more specs on the job, it's not possible to say for certain. In some instances, in days gone by, photographers used to make money because their services were an accessory to some big event with a lot of big expenditures and a high dollar figure for photography went unnoticed.

Well, those days are over. Maybe the client wanted great 11″ × 14″ prints, properly lit and posed for each doctor. Then "$100 a head" is one thing. On the other hand, maybe they wanted 250 "head shots" to use as mug shots in an advertising brochure. Regardless, the argument that clients should spend a lot on photography just because they're spending a lot on their events doesn't hold water.

Sure, the client may be spending a lot to fly in doctors and feed and house them. But doctors' time is valuable and most of them make a lot of money. Just because the client is spending a lot on the event, I guarantee that if the caterer charges $15 a shrimp because the client is "spending a lot," the bill will be questioned.

If I were going to visit 250 doctors' offices and take portraits, or even take location portraits of the doctor at work, it would be a very big job, easily $25,000, maybe three or four times that. But the columnist in this instance concluded that the photographer who got the job for $5,400 will never get a $25,000 assignment because he's "afraid" to ask for it and is building a reputation as a "cut-rate shooter."[1]

Without drawing a conclusion, it's safe to say that the profit margin for some types of photography work is down. There's a lot more competition out there for corporate and editorial work. But I don't hear wedding photographers complaining much, and for the local portrait studio, the lowballing "villain" is not another photographer but, rather, the local discount store.

The Big Discount Store

The big discounters are a threat to all the businesses in a small- or medium-size community. Often, they can sell popular cameras and film cheaper than the local photo specialty store. I've heard photo retailers lament that the local discount chain store can sell Kodak film to the public for less than the specialty store must pay to buy it from Kodak.

They can also offer wild lowball prices on portraits as a way to get customers to enter the store, since after the portrait "session," the customers will (I guarantee) have to wait a while or come back another day to pick up their package. So the discounter is offering the portrait deal as a "loss leader" to get people into the store.

For those who don't know the term, a "loss leader" is a price-sensitive item that the retailer is willing to sell at breakeven or perhaps a slight loss in order to increase store traffic. Sure, a few cheapskates may come in just to buy that one item, but most customers will shop while they're there.

I saw a loss leader for one of the big chains the other day that offered something like "Three large prints, 250 postage-stamp prints and a floppy disc with your child's portrait on it for $4.99!"

How can you compete with that?

You can't compete. And you certainly can't lowball that deal either.

But, before you close up shop, I have a suggestion. Go have your portrait (or a family member's) taken at the local Sears, then go to Wal-Mart, Sam's Club, or any of the other outfits in your area. Go to each. See what they do, get samples of their work. See how long you wait. Takes notes on how you're treated and what options you're offered. Most important of all, see all the things they don't do. Then, flip back in this chapter to the selling attitudes for 3 UP and 2 UP. I don't think showing examples or your work to contrast with theirs would be a mistake in most circumstances.

I also wouldn't argue with anyone who calls and asks you to justify your fees in relation to the discounters and chains. You can't. Don't try to talk them out of going to the chain. Explain your benefits and let them know that when they're ready for an individualized portrait sitting, you'll be happy to accommodate them. You could always give them a helpful tip such as, "Since it sounds like you're going to take your child to [name the store], I do have a couple of suggestions. Try to get there very early, since the wait at midday is very long and will be hard on your child. I also suggest the plain backgrounds, they're not very creative, but they're much better than those hideous plaid ones. Good luck."

NOTES

1. Steven Sint. Sint City: "Kick Me." *Working Photographer*, Winter 1998, Volume 1, Number 1, page 4.

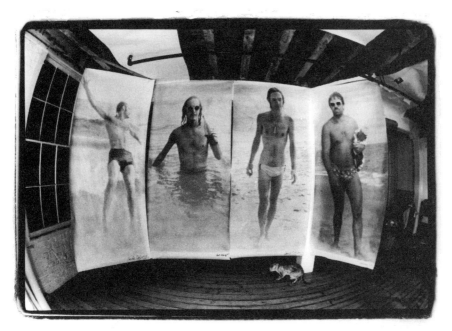

Giant murals being prepared for show, New York, 1978. Taken with fisheye lens.

Chapter 19: Creating Your Portfolio

As you go forward in your career in photography, you will probably encounter a variety of employment opportunities. In order to land some of these jobs, you will need what the best job seekers in every field need: a succinct, targeted resume, poise under fire, the right clothes, and good interview skills. In many cases, having a command of the rules and techniques of selling, explained in the previous chapters, will help ensure your success. However, you're a photographer and, most of the time, you will be asked to show your work. That means you need a portfolio.

Now, if the idea of a portfolio conjures up images of photographers, artists, and models struggling down the street lugging a three-by-four-foot black behemoth of a portfolio (known by some as a "pizza box"), dismiss the idea from your mind.

It's possible that you may need some large, impressive display of your work, but chances are, right now, you don't. Depending on the type of photographs you make, your portfolio may be as simple as a dozen 4″ × 6″ color prints in a small booklet.

On the grandiose level, I've seen portfolios encased in stainless steel, in cowhide, and in all manner of diverse packaging that strives to set that particular photographer "apart from the pack." If you ever start to compete for very high-ticket advertising assignments, that type of portfolio may be necessary for you. However, for most purposes, you can create a great portfolio that's a lot simpler and a lot less expensive than that. After all, when someone is looking at your work, all the packaging is of little consequence. What counts are your images.

There are a few thousand photographers, perhaps ten thousand tops, who really need to produce "killer" portfolios designed to "blow away" art buyers for big corporate accounts. For most of us mere mortals, a presentation that presents our work in the best possible light will suffice. Bombast is rarely necessary.

DOES EVERY PHOTOGRAPHER NEED A PORTFOLIO?

Yes. Even if you never see yourself seeking a professional assignment, it makes sense to have six to twelve of your best photographs available in a format that allows someone who is interested in you and your photography (whether for a possible job or for any other reason), to look at your photos easily and conveniently.

"Easily" and "conveniently" are the key words in the last sentence.

Some of those extravagant portfolios that get lugged around to top-flight advertising agencies may seem really cool to the photographers who spent fortunes constructing them, but for a photography buyer who needs to look at a lot of portfolios, the cumbersome, oversized portfolio can actually work against the photographer.

That means our first question should be, what is essential to a portfolio? Or, more fundamentally, what is a portfolio?

WHAT IS A PORTFOLIO?

Webster's Collegiate Dictionary offers a number of definitions of the word "portfolio." After all, there are stock portfolios and portfolios for ministers of state—but *Webster's* definition number four reads: "A set of pictures (as drawings or photographs) either bound in book form or loose in a folder."

That's a little vague, but it's a good starting point and up until fifteen or twenty years ago, it would have pretty well covered the field of photographers' portfolios. However, thanks to several generations of technological innovation, today the physical format of a portfolio could be any of the following five types.

1. A book or folder of photographs or printed versions of photographs as they ran in magazines or newspapers.
2. A set of transparencies, either in book format or contained on a page or two of polyethylene plastic pockets.

3. A slide tray of transparencies that are either original images or slide versions of photographic prints or published images.
4. A set of images on a CD-ROM or DVD or whatever follows the DVD.
5. A set of images on the photographer's Web site, or a Web site that hosts the photographer's work.

These are the five basic ways to present a portfolio. There are also a few recent formats that have fallen by the technical wayside: At this point, not many photographers would assemble a portfolio on videotape or laser disc. Although both were hyped ten years ago, and they're great technologies, they're not practical today.

Before looking at each of the physical formats listed above, there are more important issues that must be considered. Let's start with the most basic question of all.

PORTFOLIO CONTENT

What type of images should you put in your portfolio?

This is a question that's not unlike the photographer's version of: "What is the meaning of life?" The answer is simple:

Put photographs in your portfolio that will give the viewer a positive view of your work and a secure sense that you can handle any job that might be assigned to you. Or, if you're seeking artistic acknowledgment, your portfolio should present a positive view of your work and convince a publisher or gallery owner that it would be worth his while to share your work with a larger audience.

That's a little vague, so let's dig into the details. First and foremost, don't put too many images in a portfolio. For most types of portfolios, somewhere between twelve and twenty photos will probably suffice. Rather than one big portfolio, I use three slim portfolios: one that features my work as a photojournalist for magazine and newspaper clients, a portfolio of portraits and people pictures for clients interested in having a photographic portrait made of them, and a portfolio of travel and scenic images for clients with travel assignments or who need travel photographs for editorial or catalog illustration.

Why don't I blend all three portfolios into one big one? Because people looking for a photographer's ability to do one type of work are probably not that interested in other areas. I may bring all three portfolios with me, since each is only 9″ × 12″. I show the one that's directly related to the work the client has in mind. After that, I would rather get the client talking about the proposed job and head toward closing the sale. If there's a need—or benefit—to showing one of the other portfolios I may do so, but I would rather move on to the client's needs as soon as possible.

In other words, keep it simple. Beginners' portfolios tend to have two basic faults: There are too many photographs and the photographs lack a

focus. The beginners who present portfolios also make common mistakes that I'll get to later.

To keep your portfolio short, first eliminate all photographs that aren't technically excellent, and then get rid of all photographs that you don't think are representative of your best work.

For example, if you're creating a portfolio of scenic images and you have six photos that you (and your friends) think are great and another four that are almost as good, you're probably better off eliminating all four that are "almost as good." It's always best to present only images that are as perfect as you can make them. There will undoubtedly be two or three that you love "except for" some little flaw. You're welcome to love those photos, but don't put them in your portfolio. Only the best will do.

When I look at beginners' portfolios, too often I see two people pictures, a couple of nice scenic photographs, a great animal photo, and a few other things. The problem with this type of portfolio is that it doesn't show a comprehensive body of work. If you're into people photos, make your entire portfolio (even if it's only six photos) people photos—or architecture or wildlife or photojournalism or whatever type of subject is of interest to you.

I'll get back to some other points about content later in this chapter. First, let's review some points about each type of portfolio.

THE CLASSIC PORTFOLIO: A FOLDER OR A BOOK OF IMAGES

I call this the classic portfolio because it will always be used, and it will always be a valid way to present photos. It's a physical record of your work and provides for the possibility of a warm exchange. You can open your "book" and show it to a person. Sometimes you may leave the portfolio for the interested person to inspect when you're not there, but if you do get to view your portfolio with a potential customer, you will be able to use the portfolio to your best advantage and control how the viewer progresses through it.

It's a very good idea to try to show your portfolio in person as much as possible, because it gives you the opportunity to influence the viewer's experience. If she likes a given image, you can linger on it and tell her how and why you went about making it, as well as answer any questions. If she doesn't seem to respond to a particular image, you can move quickly on to the next one.

A simple portfolio folder may be just a pair of paper-covered cardboard sheets, with a tape joint on one side and a tie on the other. Other versions, as I've noted, are more like books, in that they have pages and permit you to assemble your photos in album form.

Which is better—loose set of photographs or photos ordered in an album? I leave that to you. In part it depends on what you have to show.

A Folder or Box of Photographs

If you have a set of photographs that are all the same size, presentation of them one by one may make a lot of sense. I know one very successful wedding photographer who never brings a wedding album to an interview with a prospective bride. Rather, he brings one box of twenty 20″ × 24″ color prints and creates a "gallery" in the home where he interviews for the job. He pulls out photos, shows them to the happy couple (and the bride's family, if they are present), and then he starts to prop the prints up on the mantle or on a convenient table or anywhere. Pretty soon, the client's house is filled with his beautiful photos. It's hard for the dazzled customer to say "no" after such a presentation.

You don't have to use huge photographs. I've seen very effective portfolio presentations where the photographer produces a box of photographic printing paper in which there are ten to twenty perfect prints of the photographer's best work. That type of presentation is more than adequate for most purposes.

Notice that I said this kind of presentation in a box or a folder works best if you have a group of prints that are of uniform size. What if you don't? What if you have some 8″ × 10″s and some 5″ × 7″s? One approach is to pick the most common size and have all the other prints redone in that same size.

Another approach, if you have prints of different sizes, is to mount them all on matte boards of a uniform size. For example, if you have some 5″ × 7″ prints, some 8″ × 10″s, and a few in-between sizes, you could mount them all on 9″ × 12″ or 11″ × 14″ boards and have a very effective presentation.

A box or folder of prints and/or tear sheets is also good for the news photographer. If you're showing your work to a photo editor for a newspaper or magazine, he is interested in looking at your work quickly, and determining how good a storyteller you are. Editors don't care in the slightest about flashy portfolios. For them, fast and easy is the only way to go.

As we'll discuss later on, this type of portfolio is ideal for showing prints of your work or published versions of your photos, which are called "tear sheets." That term, by the way, comes from the notion that you've torn the printed sheets out of the newspaper or magazine in which they were published.

Another benefit to presenting your work as loose prints in a box or folder is that you can easily change your portfolio around and make substitutions. However, be careful. Make sure you review your portfolio carefully every time you're about to present it. I can't tell you how many tense moments I've spent waiting while nervous photographers paw through their portfolio looking for the photo they want to show me, unaware that it's not in there. Don't make your portfolio a guessing game. Review it every time you plan to use it. Make sure it's ready before you show it.

Whether you're using prints, tear sheets, or photos mounted on boards, make sure that the work you show is clean and fresh. Fingerprints

on boards, dog-eared prints, or sloppy tear sheets all detract from a presentation. One tip if you use boards for mounting either photos or tear sheets: Consider using boards that are either dark gray or black, since they won't show fingerprints and smudges as readily as a white board will.

An Album or Book of Photographs

Presenting your work in album or book form is a little more formal than working with individual prints in a box. Some wedding photographers find that showing a sample album gives their potential customers a sense of how they lay out a wedding album to tell the story to a maximum effect.

The book form also means that you have to have your portfolio planned and organized. If you're the type of photographer who likes to make a lot of changes in your presentation, it may be easier to work with a box full of pictures rather than an album where the order is harder to change.

Portfolio albums generally fall into two categories—books with pages inside an acetate plastic pocket, and books with plain paper pages. With the former, you slip your photos into the pages. If the photos are smaller than the pages, you may need a little bit of tape or adhesive to hold the photo in place, but the plastic keeps the photos flat. With plain paper books, you need to carefully mount the photos onto the paper using either tape, photo mounting tissue, or some other type of adhesive.

I recommend that you use the plastic pages unless you're certain that your portfolio isn't going to change much, in which case it may make sense to go to the effort of affixing your photos neatly to the paper pages. The main drawback to plastic pages is that there may be a glare on your work, but most viewers of portfolios will know to tilt your portfolio to an angle where the glare from the light source won't be a problem.

As with any portfolio, make sure you know what's in the portfolio and that your images are clean and in good condition.

Also, a portfolio should be complete. I think it's a mistake to keep extra blank pages at the back of your portfolio. If you show twenty photos, you may display them with an image on each side of each page, or you may put one image on the front of each page and leave the back of the page blank. In the first instance, you'll have ten pages and show two photos on each spread of pages. In the second, you'll have twenty pages and show twenty different photographs. But don't have your viewer reach the end of your photos and face a sea of blank pages. Take the blanks out. Most portfolios that take plastic pages have rings that hold the pages, so adding or removing pages is easy. For paper portfolios, look for a version that will allow you to add or remove pages easily.

While I firmly believe that fancy presentations don't add that much, photos that are mounted crookedly, or are in poor condition will inevitably detract. In the NYI Complete Course in Professional Photography, we have an entire section on how to mount and mat prints, and it's far more than I can cover in this chapter. If you don't know how to go

about mounting photographs in a professional way, get help. Once someone shows you how it's done, you'll see that it is easy and you may decide to do your own framing and mounting. There's a lot of upsell possible for any photographer who can offer framing and mounting services.

SLIDES PRESENTED IN PAGES OR MOUNTS

Chances are, if your work hasn't been published widely, and most of your images are shot in transparency form, you're better off showing the transparencies rather than prints.

That's because getting good prints made from existing slides is a task, and it's very easy to end up spending a fortune, or ending up with less-than-perfect images, or, worst of all, both of the above.

It's possible that scanning slides and then producing high-resolution prints could let you make a portfolio of prints, even though your work originated in transparency form, but, as a rule, if you shoot transparencies, it will probably make sense to show them that way.

The basic way many photographers and stock agencies store slides is in transparent plastic pages that have twenty slots, each of which snugly holds a slide that is in a regular 2″ × 2″ cardboard or plastic mount. You can get plastic pages for medium-format and 4″ × 5″ transparencies as well.

The only plastic pages you should use for storing or showing slides are ones made from polyethylene, since this form of plastic is considered "archival." In photographic terms, archival means that the pages are acceptable for long-term storage of photographic materials. This is because polyethylene does not give off any chemical fumes that can damage silver-halide–based film.

Understanding archival products and storage standards in photography is an entire topic unto itself. For our purposes here, just remember to use only polyethylene pages. Avoid the cheaper acetate pages.

Lots of photo professionals are accustomed to viewing slides in plastic pages. Art directors, photo editors, and buyers at stock agencies also have the necessary tools at the ready—a loupe, or magnifier of some sort, and a light table to place behind the slides to give an even illumination to the images. Some grizzled veterans just hold the page of slides up to the window and view them that way. However, the bride and groom or a portrait client won't have the tools or the experience to view slides in this format. I strongly suggest that you use pages of slides only for presentations to professionals.

There is one variation on slides in plastic pages that is worth mentioning. That is when a photographer mounts slides or large transparencies in special cardboard viewing mounts.

These mounts are precut to display various sizes of transparencies, and have two benefits over plastic pages: (1) the cardboard surface that surrounds each image is opaque, so there's less stray light to detract from the image, and (2) some brands have a milky-white diffusion layer that fits

between the back of your transparency and the backside of the mount. This light-diffusion layer makes it easy to hold the mount up to any light source and get relatively well-balanced illumination across the image.

I find these cardboard viewing mounts effective when they are used to show larger transparencies made with medium-format cameras or view cameras. Unfortunately, for many viewers, it's hard to look at a 35mm transparency without a light box and a magnifier of some sort. I suggest that you investigate these cardboard mounts if you use a large-format camera.

SLIDES IN A PROJECTION TRAY

Not so long ago, many photographers liked to present their work in a round slide tray that would fit the basic slide projectors made by Kodak, principally the Carousel series. Now, I think that approach is a bit dated. Here's why.

Slide projection is still a very valuable teaching tool. While there will probably come a time when all images are projected using computer-based digital processes such as PowerPoint, the classic slide projector display still provides a very sharp, easy-to-control image using hardware that is generally reliable and easy to transport. Using multiple slide projectors controlled by a programming device that allows images to fade into one another and to be synchronized to music or narration, it's relatively easy to make a marvelous photographic presentation.

However, not that many art directors or art buyers still have a slide projector hanging around the office. Like the typewriter, the slide projector is becoming a rare bird in today's computer-based office. For illustrated lectures or showing your work to a large audience, projectors are still great, but for showing your work in a portfolio setting, I suggest you pass.

I digress for one point you should bear in mind any time you use a slide projector to show an image—make sure the slide is clean. A good sharp projector with a bright projection lamp throws a great image on the screen, but that image will include every speck of dust or hair that's settled on the transparency while the slide has been in the slide tray. Beware!

IMAGES ON A PHOTO-CD, CD-ROM, OR DVD

If you and your viewers are technically inclined, then using CD technology to show your work may be a good option.

Back in the early 1990s, Kodak introduced Photo-CD as a consumer product and it flopped badly. Amateurs didn't see much benefit to being able to show their snapshots on a TV screen or computer monitor. However, there are many professional photographers who have found ways to use various types of CD-ROM image technology, particularly since CD-ROM "burners" (those are devices that can record CD-ROMs) came on the market a few years ago.

If you want to show your work on a CD or the successor format, DVD, you will confront two principal problems:

There are people who will need Macintosh-based files and others who can only read PC-based files. One technically minded NYI grad is showing his work on a CD where each image is available in two separate files, one for Mac users and one for their PC counterparts. While everyone touts the benefits of true "cross platform," that day hasn't arrived yet.

Another caveat. If you circulate your work widely, you should only create low-resolution files so your work is not "appropriated" and used without your permission. While there are some protection systems that have been devised that give you the opportunity to "watermark" your digital photo file, they are not 100 percent effective.

Even if you're not worried about piracy, sending someone a CD with large, high-resolution files is likely to slow down their computer when they try to load and view your image. Stick to low- and medium-resolution files.

YOUR PORTFOLIO ON THE INTERNET

Lots of photographers are creating Web sites to display their work or are renting space on someone else's Web site for the same purpose. There's no doubt that the Internet is here to stay, and, as we discussed earlier, it has become a communication medium in its own right.

For photographers interested in showing their work, it can be a great way to give an interested person the opportunity to have a "peek" at your portfolio at any time, night or day. As more and more American homes and offices become wired for Internet access, and as modems get faster and bandwidth increases to make it easier to download large image files, I think portfolios on the Web will become very common.

This is not the place for us to discuss how you could go about creating your own Web site. That's a big subject and as technology and service providers continue to change rapidly, the "how-to" will evolve rapidly. I do warn against spending thousands of dollars to develop a Web site. Keep it simple and keep it (relatively) cheap.

I do offer one guideline: Television producers have a saying, "Television is a close-up medium." That's relevant to computer monitors as well. Perhaps when the world of high-definition television and computer monitors arrives in the distant future (that is, two or three years from now), this will change. But since TV arrived on the scene, it has presented not-so-sharp images on not-so-big screens. That means that wide shots, vistas, and panoramas don't pack the punch that close-up images do. That's a key reason why television producers stress the value of close-ups.

Whatever format you choose for your portfolio, what counts the most is the content you present.

PORTFOLIO CONTENT

"Photographers are lousy editors."—Maggie Sherwood

The need for help from others in selecting the photos for your portfolio was never stated more concisely than by the late photographer and founder of the Floating Foundation of Photography, Maggie Sherwood.

Most of the time, when young photographers brought their work for her to view at the gallery on board the Floating Foundation, she would end up helping them redesign their portfolios. After a session with Maggie, the portfolio would contain fewer images and those images would be re-ordered to give a sense of beginning, middle, and end.

I suggest that you start by selecting all your favorite photographs. Eliminate any that have any technical shortcomings. Now select the photographs that work together: landscapes and scenics, portraits, close-ups.

Even after this cut, chances are you still have too many images. The trick is to get rid of the excess prints and then take the remaining "selects" and put them in the right order.

It sounds easy, but it's not. This is where you need some feedback from other people who aren't as close to your photos as you are. Believe it or not, you suffer from associations with the photos that won't strike other viewers. You like a portrait photo more than you should because you like the person who was your subject. You love that photo of a Parisian fountain because you had such a great time on that trip to France.

Your associations are valid, but they won't transfer to the stranger who looks at your portfolio. This is where your friends, as well as other photographers or artists who are willing to help without being overly critical, can help you lay out your portfolio in a way that works.

One other crucial piece of advice. When you sit down with anyone, whether it's a friend evaluating your portfolio or a potential customer, when it comes time to actually pick up the portfolio and open it, or hand it to the other person for her to open, close your mouth. The time for talking is over and it's imperative that you let your portfolio speak for you at this point.

Time and again, when a young photographer starts to show me his book, he starts to apologize or explain. That's a big mistake. Let me look at your portfolio without reservations. If there is something to apologize for, you should have corrected it ahead of time. Maybe I won't notice, or it won't bother me. But at this key moment, don't take anything away from your portfolio. It's time for it to work for you.

I once interviewed a photographer for a job at NYI. She announced that she had just hired "So-and-so," who was going to help her redo her portfolio. She was surprised that I had never heard of "So-and-so," who apparently performs this service for photographers. I found out that the redo that "So-and-so" had outlined for her would take six months, would require spending a lot of money on new prints, and that "So-and-so" charged $2,500 for his services! Wow! Now there's a line of work—portfolio consultant.

I don't think you need to go to those extremes. By the way, a couple of years later the same photographer stopped by and showed me her "redone" portfolio. It was okay, but for all the buildup I couldn't really see what the consultant had done that she couldn't have done herself.

I suggest that you let the real world be your portfolio consultant. The more people you get to give you some feedback, the better your portfolio will become.

As I noted earlier, it makes sense to set up your portfolio in a format that allows changes to be made relatively easily. Don't get locked into an expensive format that is hard to alter. Let your portfolio evolve as you evolve. Every day you have the chance to make a photo that might become a gem in your collection.

So, get out those prints and slides and get to work. I hope that one day, I'll get to look at your portfolio!

Otto Hillig, Roscoe High School Basketball Team, 1927, Roscoe, New York.

Chapter 20: Finding Your Customers

In the world of professional photography, there are two basic types of customers—those who know what they want to purchase and what it should cost, and those who have no clue.

Customers who know what they want and have a sense of the cost are usually institutional purchasers, such as photo editors for magazines and newspapers, art buyers for advertising agencies, and the like. (There are also individuals who frequently buy photographs or the services of photographers and therefore understand about quality and cost, but they are the exception.)

With the knowledgeable buyer, a sale is likely to move more quickly and you're not likely to spend as much time explaining and educating the customer. If the client knows what is needed, and you have that kind of work, you'll move on to the terms of the job quite quickly. If on the other

hand, you don't have the right kind of work, the interview will be short and you'll be on your way without the job.

With the individual clients who don't know too much about photography—whether they seek a portrait, a wedding album, or an advertising photo for their new small business—your main task will be to figure out what they really need and sell them your services to provide that product.

With bigger clients, and particularly corporate clients with an established image, there's likely to be a lot of focus on whether you can deliver a product that fits into their image.

WHAT IS IMAGE?

Not long ago, I attended the first talk photographer Anne Geddes presented in America, at a convention of the Professional Photographers of America (PPA). Now even in July, when PPA holds its national convention, there are lots of things to do on a Saturday night in Las Vegas, but over one thousand photographers showed up to hear her speak, as big a crowd as I've ever seen any photographer draw at PPA.

Anne Geddes is the photographer discussed in chapter 12, whose images of costumed infants were ubiquitous a few years ago. Most PPA members photograph families and kids and they were all interested to learn more about this sudden success story. Geddes had a lot to say that evening, but a few points are most important to cover here. First of all, she noted that she became an "overnight sensation after fifteen years of hard work." When she started out working with just children and infants, she was advised that the market was too small and she should seek adult clients as well. She declined. She trusted her vision. Now she turns work away.

With regard to the style of her work, she cautioned her audience not to try to take photographs like hers for several reasons. First of all, she stressed the need for tremendous safety precautions when working with young children. This is a very important point. Particularly when you're working with lights on a set, along with props and costumes, you must be very careful with infants who won't have the awareness and reflexes to duck if something does tumble.

Regarding Anne Geddes' style, she noted that she has several people who work full-time protecting her copyright from people who try to grab a share of her market by knocking off similar-looking photographs. She is, with good reason, very aggressive about protecting her work.

The interesting point here is that her work is highly recognizable. It has a very strong style, which she referred to as her "signature."

A sense of signature is hard to come by in photography. There aren't too many of us who can consistently produce images that look like they were made by us and no one else. Thinking back over the past century of photographers, Ansel Adams, Diane Arbus, Karsh and Helmut Newton come to mind immediately as photographers who produced work that is instantly recognizable as their own.

Signature is more common in the works of painters. If you know just a little bit about modern art, it would be hard to confuse a Cézanne with a Picasso or a Mondrian painting. Everyone can spot the jumpy brush stroke and vivid colors that typify all Van Gogh's paintings.

On the other hand, it's not always possible to tell whether a color photo from the 1970s was made by Pete Turner, Eric Meola, or Jay Maisel, or maybe even Art Kane. They all produced a lot of great color images in that period, but, to my eye, none of them had such a distinctive signature that anyone other than a real expert can immediately attribute a photo to one of them.

It's certainly easier to create a signature look in fine-art photography. Cindy Sherman, Nan Goldin, and Jerry Uelsmann all produce work that is readily identifiable as theirs. Joel Peter Witkin's work is hard to mistake for anyone else's.

Perhaps it makes more sense to think of this in terms of "brand" rather than signature. Are there elements you can impart to your work that will make it recognizable, and desirable? Can you concentrate on a limited area of subject matter? Can you develop a printing style or a format that is uniquely yours?

If you can make your work into a brand, then it's worth considering doing so. At least for a period, if you can make your work popular, it will give you an opportunity to cash in. Realize, though, that the public's attention span is short. The "look" that is in today will probably be "out" tomorrow.

This is a paradox. As hot as Anne Geddes' work was from 1995 through 1997 in the U.S. market, her market share appears to have diminished a bit since then. Will she be able to come up with a new look?

Also bear in mind that a sense of brand is partially created through advertising. Take Calvin Klein, for example. His company markets designer fashions, jeans, socks, underwear for men and women, housewares and accessories, even scents. Each bears Klein's name and logo. The budget for promotion and advertising is tremendous. Models are under exclusive contract to the designer and his product lines.

I visit my local discount men's store. I need a new wallet. There are lots on sale for $15 to $30. They are not by name designers. The Calvin Klein wallets at discount start at $69! Physically, they appear to my eye no different than the others. Can a few bits of leather sewn together somewhere in the Third World have double or triple the value because they bear Calvin Klein's name? If enough people believe in the luster of a designer's name, the price (not the inherent value) can be increased.

Don't confuse brand-name recognition with quality. A few years back I bought a pair of shoes on a trip to Florence. Style-conscious friends of mine kept asking me if they were made by So-and-so, a high-end American shoe manufacturer. They did look slightly similar to many of So-and-so's styles. I answered that they weren't made by So-and-so. I

always felt a little let down that they weren't. I'd never owned a pair of So-and-so's shoes.

Then, lo and behold, at my local discount store I stumbled upon a pair of genuine So-and-so's in my size. They did resemble the shoes I owned, but they weren't as well made. Mine were better!

Price is in the salesperson's mind, but brand identification is in the consumer's mind. If consumers fancy the brand, then it's a fancy brand.

EXPAND THE BRAND

Today's marketing strategy is to back proven winners. It's too expensive not to do so. That's part of the reason we get so many sequels of movies and remakes of classics on stage and screen. Years ago, Arm and Hammer made baking soda. Now the Arm and Hammer brand has been expanded to toothpaste, deodorant, and other products that include baking soda as an ingredient. They had a great brand name—well-known and trusted, but too little product.

In the same way, Tropicana has been a brand name for orange juice throughout the United States. It used to be that the company made just one juice. Now there's juice with orange pulp and without, orange juice with added vitamin C, orange juice with added calcium, a splash of tangerine juice, a splash of grapefruit juice, and a host of other Tropicana juice products. Tropicana products occupy a whole section of the juice counter at your local supermarket. The brand has been expanded.

Find ways to expand your brand as well. If you sell your photographs, also sell them framed. Consider plates or sweatshirts with your photos printed on them.

PHOTO MARKETS

There are a host of special photo markets that might be worth investigating. There are also a number of good, comprehensive guides to these markets that are updated regularly. Refer to the books and guides I've listed in appendix II.

We have discussed newspapers and magazines in general terms. Chances are, you'll deal with the newspapers in your community and magazines that are devoted to interests that match the subjects you have photographed.

There are lots of magazines, thousands of them, published in the United States. Many are specialty publications devoted to a specific interest. Some are trade magazines aimed at the people in a certain business rather than to a general audience. But almost all the magazines use photographs, and many of them use lots of them.

In addition to looking at guides designed especially for photographers, you should visit a big magazine store of the sort you find in major cities such as New York, Chicago, and Los Angeles. Poke around to see if there are magazines that might be potential customers for your pho-

tographs. There are several publications that list magazines with information about their content and the names of editorial and business employees. These publications are often very expensive, so try finding one in your local library.

Photographers' guides, such as *Photographer's Marketplace*, also list buyers for trade journals, calendars, and cards. In addition, there are stock agencies, public relations firms, and corporate clients that publish quarterly or annual reports illustrated with photos.

Stock photo agencies, as I've noted, have been in constant transition for the past decade. Before you submit anything to any agencies, it makes sense to contact them and get their submission guidelines and inquire whether they have a "want list." Some agencies publish a regular list of types of images they think they could market more effectively if they had more (or perhaps better) images in their files.

Some photographers trying to build a stock business make it their business to shoot specifically for the "want list" of a dozen or more stock houses.

Other places to hunt for customers include hotels and resorts, which always need new images, along with real estate developers and chains of any sort—health clubs, bookstores, and the like.

But, generally speaking, markets for photography have been well researched by existing photographers, so there aren't many crying clients out there waiting for you to come along, find them, and supply the images they desperately need. Rather, finding people to buy your photographs is a little like looking for a parking spot in mid-Manhattan. You never find a spot, but rather you find a parked car that is about to be entered by the driver, who will turn on the ignition and drive off, leaving a spot that you promptly fill.

In the same way, you're more likely to spot the need for a new type of image as that need is evolving, rather than get notice that the need exists.

For example, now that digital cameras and the Web have burst upon the scene, stock houses and other photo users have need for a variety of photos of digital images, single pixels, people using digital cameras, families using the Web, kids seeing the wrong stuff on the Web, bored college kids wasting their time surfing the Web.

A few years ago, when the cigar and cigar bar craze hit, there was a need for "untypical" cigar smokers—mostly women. By the time you read this book, I would hope that the cigar movement was merely a thing of the past.

Things that are in evolution always need new pictures. As fashion trends come and go, the photo market is constantly hot. As teenagers find new crazes and new looks, needs for certain types of photos are generated.

If you want to sell to these markets, match your skills and interests to one or more types of buyers and then do your research and use your sell-

ing skills. One place you're not likely to find a job (or freelance customers) is in the classified ads of your local newspaper. You may see a few offers for people with a car to learn to become child photographers, or an ad for a lab technician or retail salesperson, but you're not likely to see people searching for photographers for real jobs. You have to go find them. Bear in mind that taking a counter job in a retail operation might be a good short-term strategy to help you meet people and make contacts while you get paid.

PUBLISHING YOUR OWN PHOTOGRAPHS

Producing postcards is a terrific way to showcase the quality and range of your work. If you take your portfolio to a new client, you may spend upwards of an hour showing your photos to one or two people. While potential clients may be impressed with your work, if they don't hire you, you and your pictures are history. Postcards, on the other hand, may always be visible, making an ongoing statement about your professionalism and creative ability, rather than being tucked away in a drawer waiting for the next interview.

Your postcards are always working for you. Round-the-clock, world-wide, your portfolio of cards is selling itself. In fact, many photographers regularly send cards featuring their work to customers and potential customers, just to keep in touch. Quality pictures sell themselves. You don't have to pay an agent or rep to sell your work for you. And, best of all, you are free to spend your time making more pictures!

In sum, there will always be lots of customers and lots of photographers, and natural selection will prevail. Photographers seeking to make money from their photography, whether they want to make just a little or make a lot, will have to compete with others, and those who succeed will be the ones who have good interpersonal skills, good selling technique, and the intelligence and drive to do the necessary research and planning.

I want to close this chapter with two important points that relate to customers—using and creating lists to find them, and practicing anticipation when you work with them.

LISTS

We aren't born with customers. We have to find them. The things I've done to find my customers are not likely to work for you, so I'm not going to take the time to describe them.

Obviously, some of your work will come from word of mouth and referral. That's great. But there may also be times, depending on the nature of your photography, where you should either consider buying or creating a list of prospects.

Advertising and self-promotion will vary widely based on your interests and the area in which you live. But it makes sense to build a list of prospective customers or try to purchase one.

For example, I know a photographer who has created a series of interesting, artistic, black-and-white scenics that he wanted to market to hotels and motels for use in decorating guest rooms. He could sit down with a yellow pages, or with a host of online yellow pages, call each hotel, motel, and chain operator and try to make individual sales. Another approach would be to purchase a list, either on labels or on disk, CD-ROM, or some other medium, and do a mass mailing to possible purchasers.

The numbers of different types of businesses and institutions are pretty easy to round up, and there are list brokers who will sell this information to you for some number of dollars per thousand names. For example, there are a finite number of hospitals, hotels, college-level libraries, post offices, and the like. If you have a service that would be of interest to travel agencies in big cities, you can find a list of them.

Particularly when you want to reach out to an identifiable market, buying a list and then mailing a printed piece that shows samples of your work is a very effective way to reach a large number of people for 50¢ to $1 per mailing.

The same technique can be used for individuals as well. There are, for example, about 50,000 Civil War reenactors in America—that is, people who have as their hobby getting dressed in Civil War uniforms and re-creating famous battles. They are a great market for photographs taken of this sort of activity. Want a list of horse owners, horse trainers, organizations that run dog shows? Lists of all sorts exist. This is an area that's worth investigating if you have the proper product.

BUILD YOUR OWN LIST

Everyone loves a free prize or present. There are lots of lunch places in New York that offer little tickets to regular customers—buy ten lunches, get one free—that sort of thing. This is really not much more than a bartender rewarding a frequent customer with an occasional drink "on the house."

A more effective method is to capture names by offering a free prize. For example, not far from my loft are several upscale take-out restaurants that cater to the Wall Street crowd. Two of them have a weekly drawing for a free lunch—just put your business card in the fish bowl. Whenever I visit either place, I look in the bowl to see who has dropped in a card.

The names (or actually the titles) are staggering. These people are Masters of the Universe, to borrow the phrase from Tom Wolfe's 1980s novel, *Bonfire of the Vanities*. Brokers, traders, senior vice presidents for finance. A lot of these people could buy the building that houses the restaurant just from their Christmas bonus, but here they are depositing their name, title, and direct-dial telephone number into a fish bowl to win a $6 bowl of soup or a $7 sprout-and-avocado sandwich on sourdough!

Find a way that you can offer a free portrait sitting in a local store, perhaps a jewelry store or a high-end clothing store. Collect the names of

people who have money and would like a free portrait. Every month collect the names and send them a letter. Let them know the good news that So-and-so won the free portrait and the even better news that you're holding a 20 percent–off sale next month.

There's one key rule to holding a contest. Limit the prize to something that relates to what you sell. For example, every time the New York Institute of Photography exhibits at a photography trade show, we always have a drawing for a free course. We get the names of people who are sufficiently interested in winning a free course that they take the time to enter.

Lots of people pass us by and don't bother to enter. They say things like, "I don't need to study more," or "I'm only here with my wife; she's the photographer."

It's fine that they don't enter. We actually prefer that they don't, because we would then end up spending money sending them information about our program when they are probably not really interested. That's a waste.

Now, if we offered a free top-of-the-line camera, or even a fancy computer, almost everyone would enter. But we would end up with a list of names of people who want a free camera or computer—and who doesn't?

By offering a course, we've *qualified* the names we get to a degree. If we were offering a free Sinar view camera, we wouldn't have qualified the names.

You'll have to figure out how to make this idea work for you. If you can do it, you can generate a great customer list.

ANTICIPATION

Anticipation is easy. Willie Mays once said that the trick to playing the outfield was to make the hard catches look easy and the easy ones look hard.

Anticipation is the same in the sense that you're out to make certain your customer feels that you have prepared her for the possible problems that crop up, and if you can make things run more smoothly, you look like an ace.

I first learned this concept from the late Bill Turner, the very talented interior designer quoted in chapter 15, Setting Up Your Business. Bill used this example—the customer wants to put a chandelier over the dining room table in a room with a plaster ceiling and no existing electrical outlet over the table. The contractor is going to have to chisel a channel for the electric in the plaster, run the wiring, and then seal the whole thing up and repaint the ceiling.

Bill would tell the client: "Honestly, I've hired the best contractor I know, but this is going to be a very messy job and there's likely to be fine dust that will spread throughout your house. You should make sure that anything that could be damaged is carefully wrapped. I think the worst of it will be over in two days."

Bill knew that the contractor could probably finish the job in one day, and that the mess would be considerable, but not as bad as the picture he'd painted for his client. However, by describing the possibilities as he had, he'd given himself some leeway in case something did go wrong, in which case the client would think that things were proceeding at a normal pace. On the other hand, if things went well, he and the contractor would finish the job, as far as the client was concerned, ahead of schedule and with less than the "anticipated" mess.

A lot of beginners make the mistake of suggesting just the opposite. They tell the client that things will be easier and quicker than is possible. This can only lead to the client concluding that you're a boob. Take the opposite tack. Describe a situation that sounds hard, and then make it look easy.

The things you can learn from customers will keep you fascinated for a lifetime in business as long as you stay attuned to what's going on. You'll also discover that the good ones are great. Many businesses subscribe to the so-called "80-20 Rule," which postulates that you make 80 percent of your profit from 20 percent of your customers.

Now if you could just identify that 20 percent and avoid all the rest, think how easy life would be! Good luck.

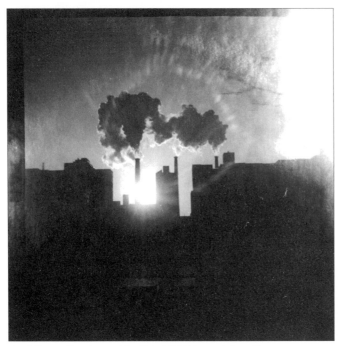

Con Ed Power Plant, Queens, New York, 1976, Taken with Diana-F.

Chapter 21: Working with Labs and Service Bureaus

As you get involved with photography, the chances are that there will be several labs you'll use regularly, depending on the nature of the photographic services you need.

Let's start with the suppliers of traditional photographic services—film processing and printing. Then we'll take up the new "service bureaus" that offer digital photography services such as scanning photos into digital form and printing digital files as photographs or film or other types of output. While there are some labs that offer both traditional and digital services, there's enough difference between the two types of services that we'll address them separately.

We can divide traditional photo labs into three broad categories: large, commercial processors; custom labs; and one-hour labs. Each type will process and print color negative film, but custom labs are more likely to provide additional services you'll need such as processing slides and black-and-white film, making enlargements, and the like. One-hour labs, as their name implies, provide a limited range of services but feature quick turnaround. Many pros end up using all three types of labs, depending on the job they're doing.

COMMERCIAL PROCESSORS

Commercial processors tend to run large operations, usually with no direct access to individual customers. Whether you drop your film at the local photo store, or at a processing stand at a drugstore, supermarket, or discount store, it's likely to go to a commercial processor. Commercial processors tend to be cheaper and faster than custom or one-hour labs, and your film is processed and prints are made on an assembly line controlled by a computer. For some large runs of 4" × 6" prints, you can trust the job to a good commercial processor. The key word in the last sentence is "good."

My advice is to experiment. Send out some not-too-important film to a few different commercial processors, and then compare results. Since Kodak generally gives very good results, use Kodak processing as your standard. Judge the others against it. If another processor matches Kodak's quality at a lower price, by all means consider the other processor. Similarly, if another processor does a better job than Kodak for the same price, use that lab.

In their efforts to appeal to the mass amateur market, many commercial labs have started to offer services such as returning photos in digital form on a floppy disk or allowing you to view your pictures over the Internet as soon as they've been processed. These basic computer-driven benefits are evolving so quickly it's hard to comment on them at this time other than to note that the photo industry is watching keenly to see whether the general public is really interested in viewing photos on the computer and ordering prints over the Internet.

We'll have to wait a while to gauge consumer acceptance, but it's clear that the leading commercial processors are rushing to make sure they're able to offer such services just in case they catch on. Also, we're about to see another big push by Kodak to get consumers to order a Picture CD when they take film in for processing. This means the customer will get back negatives, prints, and a CD with their photographs in digital form and an interactive set of options that will make it easy for them to correct flaws, crop the image, and e-mail the photographs to someone.

Another cautionary note about commercial processors: Just because a processor advertises, "We use Kodak paper," does not mean that the lab processes your prints at a Kodak lab. Lots of labs buy Kodak or Fuji paper and chemicals, but that doesn't mean that either of these major companies exercises direct control over the quality of the processing you'll receive.

What should you look for in the work you get back from a commercial lab? Any large lab with sophisticated automatic processing and printing should deliver well-exposed prints with good color balance and freedom from dust spots or other signs of poor handling.

CUSTOM LABS

The bulk of your professional work will probably go to some sort of custom lab. At a custom lab, your work will be handled by a person, presumably a

skilled technician. A good custom lab should have people behind the counter who are highly knowledgeable about photography and willing to take the time to talk with you about your needs and preferences, and technicians in the lab who care about making certain that you get what you requested.

There are several benefits to using a custom lab:

First, within the physical limits set by the quality of your original negative or slide, you should be able to get exactly the image that you want. You will have a wide selection of print sizes, paper finishes, cropping, and manipulation from which to choose.

Second, particularly for enlargements, you usually end up with a better print! The personal care and attention lavished on your print should be visible in the finished product.

You can find one or more custom labs in almost any city of fifty thousand people or more. Look in the yellow pages, make some calls, and request price lists. But, customs labs aren't cheap.

All custom labs are more expensive than commercial processors. They have to be, because they have to hire skilled technicians and considerable time is spent on each job. But in big cities, watch out. There are some custom labs that specialize in working with advertising agencies where not only is cost no object but the agency actually adds a percentage to the cost of a photo job and bills the cost of the job to the client! That means that the bigger the bill the lab hands the agency, the more the agency can mark up that bill when it gets passed along to the client. Why pay $100 and add 15 percent for $115, if I can find a lab that will bill $200 so I can tack on $30?

Labs that do a lot of work for ad agencies tend to charge very high prices. You must do some comparison shopping. You don't necessarily have to physically take your work to a custom lab. There are fine custom labs, many of which cater to wedding, school, and portrait photographers, that work with their clients through the mail. Some telephoning is required to establish a good working relationship, but many successful pros work with custom labs that are hundreds or thousands of miles away from their homes.

When you're looking for a new lab, call and speak with either the owner, the manager, or someone in customer service. See what kind of job they do selling you. If they're a well-run business, that's a good sign. If everyone you speak with sounds rushed and resentful of taking the time to talk to you, that's a sign that you may be at the wrong lab.

Many custom labs offer a combination of automated printmaking and custom work so that all the needs of a professional can be handled under one roof. A good mail-order lab for a wedding professional can grind out hundreds of automated prints for school portraits and also make a custom 20″ × 24″ print on canvas with extensive retouching that will sell to a bride for $1,000 or more.

If you're looking for a custom lab, how do you find one? I recommend checking in one of the professional photographers' magazines, such as *Rangefinder; Professional Photographer;* published by the Professional Photographers of America; or *PDN*, also known as *Photo District News*. In addition, talk with other photographers in your area. Ask what labs they've used and what their experience has been with each one. But make sure you pay most attention to people who have used a lab recently. Things change.

There's one important point to realize with all types of labs: Whether it's the top custom lab or a busy commercial processor, there are a few key people who are responsible for maintaining the quality of the operation, and if those people move on to other places, the quality of the lab may dip. Like a restaurant that has a new owner or chef, even though the lab looks the same and has the same name, if the people running the place change, the quality may be affected.

ONE-HOUR LABS

One-hour labs survive by providing quick commercial processing on a retail basis. The bulk of their customers are amateur photographers. They offer virtually no services other than making 3″ × 5″ and 4″ × 6″ prints from color negative film. Some are very good, some are not so good. As with all other types of labs, quality depends on the commitment of the management, the skill of the people running the equipment, and the quality control exercised over the equipment.

It's important to realize that there are one-hour labs that are very good. Walter Karling, a busy pro who's also an NYI teacher, has a high-volume freelance business that includes making lots of public relations photos of New York area political and civic leaders. He swears by his one-hour lab and uses it for all his color work, including 8″ × 10″s. He makes his own black-and-white prints in his darkroom.

There are a few one-hour labs that offer services bordering on those of a custom lab. If the shop has two or more processing machines, the lab may offer black-and-white film or color transparency processing, and possibly custom enlarging.

Since the services and quality of one-hour establishments vary widely, try a few of the one-hour labs in your area. You should expect, as always, good professional-looking prints, along with quick turnaround and relatively low prices.

There are a lot of options out there for the serious photographer. It's up to you to visit as many different types of labs as you can and compare their quality, service, and price. If you do, you should end up with several that you can rely on for good service, fair prices, and limited headaches.

PROBLEMS

Even with good labs, can things still go wrong? Of course. Every lab comprises machinery that is run by human beings. Both machines and people

are prone to breakdown and error. Mistakes will happen, but when they do, you should expect an honest explanation, an offer to redo the job, if necessary, and a willingness on the part of both parties to learn from the experience. That's all you can expect from any relationship.

Also, if there is no offer to redo any enlargement that doesn't meet your expectations, make it your business to ask for one. I've never had a lab refuse to remake a print. After all, they want to keep you as a customer.

LOST FILM

There's one thing a lab can do that's much worse than anything else—lose your film. Here's a tip on how to protect against lost film.

One Christmas season past, the Really Big Photo Processing Company lost three rolls of my film. Not work for clients, just family photos. After I lamented this loss publicly on the NYI Web site, an NYI student e-mailed me a fine tip to help guard against the disaster of having an important roll of film get lost in a mix-up.

Let's clarify what "lost" means. Very little missing film is destroyed by mishandling and other mishaps. Most lost film is actually "mixed-up," that is, your name (or the numbered tag that is keyed to your name) gets separated from the film at some point in the developing and printing process. If this happens, by the time the film and prints are dry, the lab might have one hundred sets of negatives and prints and one hundred names, yet may not know which prints belong to which customer. Some get matched, others don't. If your photos don't get matched, your photos aren't technically "lost," but they might as well be, because they're missing in action.

They did look for my film at the Really Big Photo Processing Company. They'd find a roll that might be mine and call the woman who runs the desk at my local camera store, which is also a film drop for the Really Big Photo Processing Company. She'd call me with crazy questions like, "Did you have photos on your roll of someone who looks like a transvestite standing in front of an office supply store?"

The answer to that one was "no," but it sounds like an interesting photo. I advise anyone who mails film in for processing or who drops film at a new lab or a lab in a foreign county, to put your name and address on the actual film cassette with either an address label or written with a marker. That way, even if your film gets separated from the information you write on the bag, your name is still known, until the film is taken out of the cassette. From then on, you have to hope that your film is tagged properly and matched up with your order at the final end of the process.

But, if you take one extra step, even losing your tag won't result in a mix-up. The student's suggestion was to just shoot one frame of film of a sign (or your business card) that shows your name and address. So simple! Why didn't I think of that?

SERVICE BUREAUS

Just as the computer has become a more integral part of making many types of photographic images, businesses have sprung up in all parts of the country that offer a host of digital services for photographers. Originally, these were known as "service bureaus," a rather nondescript term that could cover a host of things. While the terminology is still in flux, I think "digital photo lab" is more accurate and descriptive.

There are a number of labs that offer traditional photographic services alongside digital ones, but the all-digital lab and the entrepreneurs who run them are bringing a whole new concept of service and relationship to the industry.

Not long ago, I visited a digital lab based in downtown New York to check it out for an article on the NYI Web site.

The lab was located in SoHo and as I stepped out of the building's elevator into the loft space where the lab was located, I entered a large open area. Lots of computer equipment was visible at the front of the space, desks ran along all the loft's walls and a large freestanding conference room had been built in the middle of the floor. There wasn't a counter in sight!

It turns out the lab had started six years ago with a single Canon Fiery Laser Copier. The business, then located in mid-Manhattan, soon began to attract photographers who wanted promotional cards and other materials. They were attracted to the color copier because it offered a sensible alternative to traditional color printing, which photographers and models used for promotional pieces.

Unfortunately, with traditional printing, a photographer (or model) would print five thousand promotional pieces, use a few hundred, and then throw out the remainder in order to switch to a new promotional piece to promote a better image or design, or to add a fax number or change an address. It wasn't cost-effective to print less than one thousand or five thousand pieces using traditional printing methods.

From the time the lab opened, the business put an emphasis on working directly with the customers. As the owner explained, "We sought to merge technical know-how with creative ideas supplied by the photographers. There's always been a barrier between creative and production functions, but we wanted to overcome that."

This instinct is right on the money. Photo industry studies have shown that with the rise of digital technology the old divisions between photographer, art director, and production people in the graphics industry have broken down. It used to be that the photographer handed over an image and if that image was acceptable to the client and the art director, the photographer's role was finished. If the printed piece didn't look perfect, it was the fault of the printer or the separator or someone else.

But in today's world, where printers work with digital files, and photographers fiddle with scanners, the photographer is likely to be involved

right up until the image goes to press. There's no way photographers can wash their hands of the job prior to completion. That means photographers need some technical know-how and a lot of intelligent and capable technical assistance, particularly for what is known as "color management"—a way to make sure that the photo, the comp, and the proof all end up having the same colors as the final printed product.

In addition, customer service at this lab was handled very differently from the way it was done in most traditional custom labs. As I had noticed when I entered, there was no counter to separate customers from staff. In most custom labs, a photographer places an order with a salesperson at the front counter. It's rare that photographers meet, much less work with, the technicians that actually make the images.

That lack of a counter was no accident. The owner wanted the sales staff and administrators to get out of the way and let the photographers work with the technical staff as soon as possible! And who are those technical people? "We strive to have the best equipment and the most talented operators, and every one of our operators has an advanced degree in fine art," he noted with pride.

And what about the conference room? Granted, digital labs don't have a darkroom, but a conference room? It turns out that the lab offers seminars for students and photographers so they learn how to handle files and present them to the lab in a way that guarantees the best results. They even have a glossary of digital photographic terms to help newcomers get up to speed without having to ask what various specialized terms mean.

What kind of work do photographers bring to this lab? A lot of work is retouching and enhancement—"massaging and tweaking" as the owner calls it.

Another key service is making custom Iris digital prints. The term "Iris print" has entered the photographer's vocabulary to denote prints made by ink-jet printers manufactured by Iris Graphics, a company that was one of the first developers of large ink-jet printers for fine-art applications. Iris prints have been made by many well-known photographers from photographs that have been made into digital files. Many museums with photography collections now acquire Iris prints in addition to traditional silver-based prints.

The Iris printers can handle a variety of flexible materials that are mounted on a circular drum, including archival-quality watercolor papers, vellum, acetate, fabrics, and plastic. If you've never seen photographic images produced on an Iris printer, you should make it your business to do so. The range of effects possible using different inks and papers adds a new dimension to photographic prints.

Iris printing had become such a big part of the business that the old Canon Fiery printers and other types of laser printing services have been pushed out of the lab, and customers seeking those services are referred to another nearby company.

As we saw with digital cameras and equipment, that meant that the Canon CLC copier that was cutting edge six years before is now history. Digital labs are offering exciting new services for photographers that expand our options. It's clear that the number of labs offering digital services will continue to grow and that more and more photographers will find reason to use them. I hope that the ideas that such labs have promoted—commitment to customer service and education, and the notion of having technicians and photographers collaborate—become industry standards.

KEEPING VENDORS HONEST

At the start of this section, I suggested that you might use several labs because you'll need to use more than one type of lab. If you're spending $1,000 or more per year on lab services, you may well want to cultivate a relationship with more than one lab in the same category as well, so that you can monitor the relation between quality and price.

Any business that gives all its work to one vendor runs the risk of missing a better deal offered by some other vendor. If you do give all your work to one lab, you might consider asking for a discount off the posted rates since you're a good customer. Even with that discount, you're under no obligation to give all your work to one lab. Every now and then, check out the competition. If you find a lab that does a better job, switch. If you find a lab that does as good a job at a lower price with comparable service, consider switching. See if you can use that opportunity to persuade your current vendor to lower the prices you're currently paying.

Sometimes, it pays to complain a little bit even if you don't have information about the competitor. Not long ago, I called my telephone company just to check something about my bill. I wasn't complaining so much as confused. The customer service person pointed out that there was a better rate available from the phone company for all customers who asked. It had been developed in recent years and marketed to new customers, but the lower price structure wasn't offered to existing customers like me, unless the customer asked. Every now and then, with all your vendors, ask. The worst that can happen is that the vendor will say no.

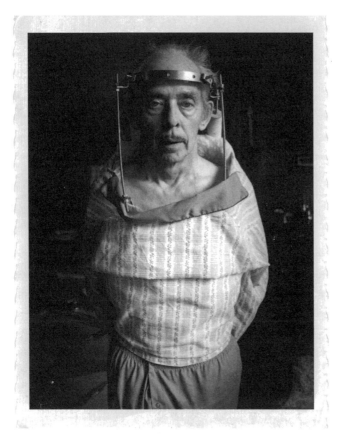

C. Glover DeLaney in Halo Cast, Rochester, New York, 1974.

Epilogue

Way back in the early chapters, I cited the most important lifetime in photography—yours. As one of my photography students, R. Ratton Hall, once reminded me, "We're all doing life."

As I live mine, I often think that in some ways it would be nice if humans had an expiration date for their lives rather than just a starting date. After all, a carton of milk has an expiration date, and nowadays even batteries have a "best if used by" date on them, but humans are still stuck with only a birth date and a bunch of gloomy actuarial statistics.

I don't long to know exactly when I'll die, but I would like to know whether I should plan for sixty, eighty, or a hundred or more years. If I knew I was going out in my mid-sixties, say, then I wouldn't really need to worry about pension and retirement. In fact, I could ignore all that. I

would like that, because if those rocking-chair days are not in my cards, I'd like to spend that money on some travel and new equipment right now.

On the other hand, I would hate to have too much fun now and end up eating dog food in my eighties for lack of funds.

I'm told Bill Gates, the world's richest human, has said that if what could be won in Las Vegas were time rather than money, he would be a regular player. We might all have our wishes, but ultimately, we're stuck more or less with the cards we're dealt.

Hence, in bidding a fond farewell to any reader who has made it this far in the book, I would like to offer my limited thoughts about living and dying as, among other things, a photographer.

I've already stressed my strong sense that we need to reward ourselves. You're picky. You're a photographer. You will do the best job selecting a few things you really deserve. Others can certainly add their touches along the way, but you really do deserve to give yourself the very best.

Physical Help

I think physical help includes proper medical care for your mind and body, a good bed, good shoes, and the proper kind of carrying tools to help you. You're a photographer and you end up carrying a lot of gear and moving lots of heavy stuff. Be kind to your body. Here's an example.

The Case of the Short Arm

About the time I could afford to purchase suits, I learned that one of my arms was 1½ inches shorter than the other. This, for close to ten years, led to extensive alterations whenever I bought a suit.

Then, prior to leaving for that month-long job in the Philippines, I sought the advice of Dr. Askinasi, a chiropractic kinesiologist. I had been experiencing some neck and back pain and I was concerned that I would be in discomfort carrying a lot of equipment through the jungle.

My M.D. at that time told me that the pain came from tendonitis and I should learn to live with it, as, he observed, tennis stars did. But I wanted relief, not to make a lifelong companion of pain. A friend of a friend recommended her chiropractor, Dr. Askinasi. I made an appointment.

The first visit was unlike any other medical workup I had ever experienced. The Doc's approach considered diet, my exercise habits, and the nature of my work. Over the past decade, I've derived many different benefits from the Doc's treatment, including some very level-headed advice on vitamins and exercise, but on my first visit, he asked about my arms and I told him about the diagnosis I had gleaned from the various tailors who had fitted me for suits.

"That's ridiculous," he told me. He measured my arms. They were the same length. He had me stand and look into a mirror. He pointed out that one of my shoulders was rigid and stuck at a higher angle than the other.

"You carry a heavy bag, always on the same shoulder," he told me. "From now on, use a backpack to distribute the weight evenly or carry a case and switch back and forth so you use both arms evenly."

I felt like I had met Sherlock Holmes. Prior to meeting the Doc, I had held chiropractors in the same category as medicine men. For all I knew, I was going to get chicken bones and magic spells. But I didn't care when I first went to the Doc because I was in pain and I wanted help. Now, it only hurts when I do something stupid. And my suits don't need expensive alterations.

Corollary: There's no one way of being, and there's no one way of healing. In addition to chiropractic care, I have nothing against cutting-edge Western medicine. I've seen it work miracles.

I think there's a lot of healing wisdom in many different approaches to healing, and particularly in approaches that stress wellness in the first place.

I find that chiropractic treatment is kind of like body and fender work for automobiles. There are still lots of reasons to consult an M.D. internist, for example, but, as photographers, we do tend to experience a lot of wear and tear on the muscles in our backs, legs, and arms. There's gear to hump, furniture to move, and cameras to crouch over.

If you're built like an ox and things never ache, you're a lucky devil. If not, I suggest you investigate chiropractic help, but I must caution that there are different schools of training and approach, so you might want to check with a few people before settling on someone for regular treatment.

There are some basic things that I never understood before that I've learned from the Doc, such as when to use ice on an ache and when to use heat.

Other Body Work

I've taken some modern dance classes, indulged in an occasional massage and a touch of yoga, and heard a bit about Alexander technique. I also took half a dozen voice lessons when I first started making video training tapes and I found it a very exciting experience. I learned a lot about breathing.

Many photographers don't realize how physical our work is, and how physically demanding it is on us. Don't make that mistake. Don't work when you're injured unless you really have to. If you're principally a freelancer, it's easy to skimp on health insurance and doctor visits—don't deny yourself help if you feel you need it.

EMOTIONAL HELP

I've gotten help from a lot of friends and a few pros in my time. Among other challenges, I've had to watch some grisly terminal diseases and some other tough stuff. There are times when you may find that you can't really get the help you need from your friends. That's a good reason to consider professional help.

I'm told the country with the greatest number of shrinks per capita is Brazil. I don't think professionals have to be limited to psychologists and psychiatrists. Over the years I've met some very effective religious folk and social workers who have helped lots of people. I also know a lot of individuals who have been helped greatly by twelve-step programs, principally Alcoholics Anonymous.

If there's no one way of being, and no one way of healing, then it follows that there's no one way of getting help. Don't be afraid to ask for help. Also, if possible, don't refrain from offering help if you can.

HAVE SOMETHING SPECIAL

There was one observation my father, Glover DeLaney, repeated to me several times. I heard a lot of wise stuff from him, but this particular insight was very succinct—people have to have something that makes them feel special. This came from a story my father told me:

When he retired, Dad managed television stations. He finished college in 1932, mid-Depression, and then became a disk jockey on that newfangled medium of radio. This was not a status job at the time. He told me that the parents of the radio deejays in Elmira, New York, in the 1930s, joked that they would prefer to brag that their son was "playing piano in a whorehouse" than admit he was involved with radio.

One thing led to another and thirty years later my father managed television stations for major publishing and broadcasting concerns. A few years after he had taken the helm of a station in California, the head engineer asked my Dad for help with an errant employee.

It seems that one of the cameramen had asked for two extra days off. He had already used up his vacation days, his sick days, and his personal days. It was Wednesday. He wanted to have Thursday and Friday off. The engineer, the fellow's supervisor, thought this was too much and felt the man should be fired.

My father asked to speak with the cameraman. When asked why he needed the time off, he explained, "Mr. DeLaney, I know I've used up all my vacation and personal days. But I went to [such-and-such college] fifteen years ago. I played on the football team. Since then, I've attended every football game—home and away—that my college team has played. This weekend they're playing in a tournament nine hundred miles away. I need to leave Thursday so I can drive to the game. If I don't, I'll miss the first game ever."

What, my father asked me, would I do in this situation?

I was eleven at the time. I told my Dad I had no idea.

"I gave him the extra time off," my father explained. "A person has to have something that makes him feel special. It would be wrong to take that away. He can make up the time next month."

Make sure you have special things in your life. Give them the import they deserve. At the same time, acknowledge that it's the same for other people.

Summer 1974: I return to Rochester to see my Dad. The radiation has been successful to the extent that the doctors predicted. It has not reversed the terminal illness from which my father is suffering—metastasized lung cancer—but it has been palliative. He's not, for the moment, in pain. His neck brace has been removed. He is, for the last time in his life, exuberant. "I think," he tells me, "I'll be able to drive a car again."

He won't. In six months, he'll be dead. And the last four or five of those will not, in any manner, shape, or form, be pleasant. But for the moment, the hope of mobility reigns supreme.

THE END

Sooner or later, a pain or a lump, an explosion or a crash, an act of war or the sober words of a doctor, perhaps no more than the first big forgetfulness, will signal for each of us that we face a challenge to our very life.

Sometimes you walk. Sometimes you don't. Perhaps you'll find yourself facing a tough road with little hope and little respite.

I'm as flustered by the human condition as anyone, but, in all likelihood, one hundred years after you read this it won't matter to you, me, or anyone we know. Our time will have passed on.

Dr. Askinasi tells me that in a world free of pollution, bad food, and preservatives, a world with less stress, our bodies might be good for up to 150 years. While we get wiser, things do start to fail. In Florida, octogenarians sometimes get into their cars without realizing that their vision and their reflexes are just a little bit less sharp than they were the day before. At some point, they—we—cross over the line. It's time to live a simpler life. The one time in my life I visited an eye doctor because I had a serious problem, I was struck by the large percentage of elderly patients in the waiting room.

My wish for you—and me—is that our eyes go last. After all, we're photographers.

August 1986: I drive to a hotel at Newark Airport to attend a seminar by Chuck Lewis. I know little about him and have heard nothing about his style. I see many amazing and wonderful things, but one of the most striking is that about ten minutes into his presentation, acting the role of a wedding photographer, Chuck Lewis is toiling one night in the studio to finish an album when he's felled by a heart attack.

This seminar has been going on for only about ten minutes. There are about one hundred young photographers in the room and this guy is pretending to be stretched out on the floor of his studio with his last thoughts running through his head. As the character (for this is truly theater) on stage dies, he rues the hours away from his family, the lack of vacations, the sacrifice, and the worries about income. Next Lewis is up hopping around and reciting the lyrics to the pop song "The Cat's in the Cradle." He proceeds to give buckets of great business advice. The day is a remarkable experience that I'll never forget.

Reread chapter 11. I mean it. This isn't a warm-up. This is your lifetime. Make sure you do the things you want to do and tell the people you know the things you want to tell them, need to tell them.

Similarly, take the photos you want to take. Take them today, if you can.

YOU DID IT YOUR WAY

Not long ago, Frank Sinatra passed away. Now, if there was one guy—based on talent, money, connections, and friends in high and low places—that you might think could have found a way to go on forever, it might have been him. But he couldn't. Ratton's right: "We're all doing life."

After Sinatra died, it seemed as if even the media found itself surprised at the interest his passing attracted. I heard television and radio stories galore that mourned and gave tribute to Sinatra. It struck me how often his signature song, "I Did It My Way" was used in those pieces. On reflection, I guess it isn't that surprising. Sinatra in love or singing the blues is less interesting to the public than the fact that Sinatra did appear to have "done it" his way. How many of us can say that?

My wish for you is that you'll be able to reflect, should you have time, on your way out, that you did it your way. Lived your life your way, and enjoyed Photography Your Way.

Appendix I: Organizations and Resources for Photographers

A. CONVENTIONS AND TRADE SHOWS

Industry Shows

PHOTO MARKETING ASSOCIATION INTERNATIONAL (PMA)
3000 Picture Place
Jackson, MI 49201
Tel: (517) 788-8100
Fax: (517) 788-8371
Web site: *www.pmai.org*

Every February, PMA holds the Photo Industry Convention and Trade Show. If you really want to learn about the entire photo industry and have the guts and stamina to back up that want, attend PMA's convention and trade show. PMA also publishes *Photo Marketing,* which is distributed to all its members. PMA has been on the scene for over seventy-five years, and the principal members are camera store and lab owners and executives in photo manufacturing companies. The PMA gathering features a massive trade show and a host of sessions and special seminars. The organization's slogan used to be, "If you're in photography, you're at PMA." That, I believe, is very true. Currently, as others are, they're struggling with tension between the words "photography" and "imaging." "If you're in imaging, you're at PMA," doesn't have the same punch. What, after all, is "imaging?"

Many professional photographers, photo magazine staffers, and other interesting types descend on PMA as well. Attendance each year averages well over 20,000. Seminars start at 7 A.M., the trade show runs from 10 A.M. to 5 P.M. for three days and for half a day on Sunday. There are "night school" programs that run until 10 P.M. If you want to learn more about the photo industry, there's no better place to be. In recent years, I've attended presentations by the director of photography for the FBI, had a chance to photograph the Kodak CEO, and attended seminars on everything from increasing sales of panoramic prints to guerrilla marketing techniques for photo studios. I've heard, among others, the following speakers: ice cream magnates Ben and Jerry, former Notre Dame football coach Lou Holtz, Solidarity Labor leader Lech Walensa; and, at satellite meetings, photographers Douglas Kirkland, Eddie Adams, Arnold Newman, and Jerry Uelsmann.

A few years back, PMA created an affiliate organization called DIMA—the Digital Imaging Marketing Association—which has a separate day or two of seminars before the PMA show. If you have any interest in where the digital world is headed, this is a great opportunity to get a lot of information in a short period of time.

Best of all, individual memberships in PMA are inexpensive. In the student and school category, a one-year membership is currently less than $50. Not counting travel and lodging, fees to attend the PMA convention might run $100 to $200, depending on how many seminars you take. There's an extra charge for the DIMA convention—currently $250—although DIMA membership is included with PMA membership, if you request it. PMA also runs some other divisions that might be of interest to certain photographers—PSPA, the Professional School Photographers Association; PIEA, Photo Imaging Education Association; and NAPET, National Association of Photography Equipment Technicians.

One of the best things about PMA is that it's geared at photo stores and processors, so photographers who want to get the inside take on the industry can snoop around without necessarily being at center stage.

PHOTOKINA
The Biennial European Photography Trade Show
Web site: *www.koelnmesse.de/photokina*

Every two years, Photokina is held in the awesome exhibition complex of Cologne, Germany. For reasons stemming from medieval times, German cities—particularly Cologne and Frankfurt—have always been big centers for trade shows. The Köln Messe exhibition complex is a marvelous facility that hosts a number of major industry trade shows each year. Every even-numbered year, Photokina is held. This is a massive trade show that fills several floors in each of a dozen buildings with everything related to photography and some stuff—sound equipment, stereos for cars, and the like—that really isn't related to photography at all. Tens of thousands of industry folk and interested consumers attend Photokina. It's an experience, and if you're looking for the little manufacturer from Sri Lanka, here's the place you're likely to find him.

For many years, major manufacturers planned their intoduction of new products to take place at Photokina for maximum exposure to the world-wide photo community. However, in recent years, the PMA annual show has proven to be just as informative and hosts as many new product introductions as Photokina does. It's also less costly and less grueling. One interesting sign of PMA's growth is that now more than half the PMA members are from outside the United States, and many observers consider the PMA show on a par with Photokina. However, autumn in Germany is very pleasant, and this show will definitely endure.

Shows for Photographers

There are a number of major annual conventions and trade shows that directly target professionals and other serious photographers. The three biggest ones are PhotoPlus, the autumn show in New York, held in conjunction with the magazine (*Photo District News*); the annual convention of the Professional Photographers of America (PPA), which is held in July and moves around the country; and the

annual convention of WPPI—Wedding and Portrait Photographers International—which is held every March, usually in Las Vegas. Each has its own distinctive character and benefits.

PHOTOPLUS
Registration Center: BillComm Exposition & Conference Group
Dulles International Airport, P.O. Box 17413
Washington, DC 20041
Web site: *www.pdn-pix.com/photoplusexpo*

About twenty years ago, a show called PHOTO debuted at the old New York Coliseum. In the years that have followed, the show went through a number of changes and is now know as PhotoPlus. The general concept has only shifted slightly. The show, now held at the Jacob Javits Center in New York every autumn—around Halloween—is geared to working professionals in photography and related graphic design fields (that's the "Plus" in the name).

Outside of PMA, the trade show at PhotoPlus is the largest one in America. It is accessible to individual photographers, and it's relatively easy to get passes at no charge from one of the hundreds of exhibitors. There are also dozens of well-conceived seminars each year, costing around $75 each. A smaller version of PhotoPlus is held in California, usually in June, either in the Los Angeles area or in San Francisco.

Both of these shows tend to attract freelancers and other photographers working in all fields, including advertising, corporate, and commercial work. If you're serious about photography, you should definitely try to visit this show. After all, autumn in New York is very pleasant, albeit the beer isn't as good as it is in Germany.

PROFESSIONAL PHOTOGRAPHERS OF AMERICA (PPA)
229 Peachtree Street, NE #2200
Atlanta, GA 30303-2206
Tel: (404) 522-8600
Fax: (404) 614-6400
Web site: *www.ppa-world.org*

Although PPA has divisions for all sorts of photographers, the bulk of this non-profit organization's membership comes from the legions of wedding and portrait studios across America. PPA has affiliate chapters in all fifty states, and there are also regional and metropolitan chapters. For photographers who are interested in meeting other professionals who specialize in wedding and portrait work, joining a state or regional affiliate of PPA is a wise idea. Most affiliates have regular meetings, usually held monthly.

Every July, PPA holds its national convention. In addition to a trade show with lots of exhibitors specifically geared toward small working studios, there are always a host of informative programs presented principally by PPA members. The trade show has lots of interesting vendors of props and other gadgets that you won't find elsewhere. If you need a set of benches for posing high school sports teams or tot-sized wicker divans, you'll find them here.

To attend, you must be a member of PPA. Annual dues run in the area of $200. Members can also take advantage of equipment insurance and indemnification programs for additional fees.

WEDDING AND PORTRAIT PHOTOGRAPHERS INTERNATIONAL (WPPI)
P.O. Box 2003
1312 Lincoln Boulevard
Santa Monica, CA 90406-2003
Tel: (310) 451-0090
Fax: (310) 395-9058
Web site: *www.wppi-online.com*

The annual March convention and trade show put on by WPPI is also a good place to learn more about wedding and portrait work and visit lots of vendors at the trade show, basically the same lot you would find at the PPA national convention. WPPI is run by the same folks who publish *Rangefinder* magazine. Membership is less expensive than PPA, and WPPI doesn't have the bureaucratic organizational structure of PPA. Most years, the show is held in Las Vegas, where food and lodging is inexpensive. Overall, the cost of attending the WPPI convention is less than PPA, and while there are fewer seminars and programs offered, the scope and quality of the presentations is high. If you've never been to one of these national shows, WPPI is a good place to start, if you're interested in portrait and wedding work.

B. ORGANIZATIONS YOU CAN JOIN

As I've mentioned, PMA, PPA, and WPPI are all membership organizations. For people getting started in wedding or portrait photography, I recommend that you consider joining WPPI or your state or local chapter of PPA. You'll find that there are separate dues for your local PPA chapter apart from those charged by the national organization. In addition, the rules, activities, and quality of the PPA chapters vary somewhat from state to state.

AMERICAN SOCIETY OF MEDIA PHOTOGRAPHERS (ASMP)
14 Washington Road, Suite 502
Princeton Junction, NJ 08550-1033
Tel: (609) 799-8300
Fax: (609) 799-2233

ASMP, which started life as the American Society of Magazine Photographers, has mutated and grown into the American Society of Media Photographers. Over the years, ASMP has undertaken a number of campaigns to improve business conditions for photographers working in the media. ASMP publishes a number of books on professional policies and pricing guides that are often of great value to many working photographers besides its members.

ASMP has provided tremendous benefits to its members and to other photographers. In the past decade, the fortunes of this group have wavered at various

times. Like PPA, it is a self-governing body and is subject to all the frustrations of democracy. One important aspect of ASMP's activities has been legal advocacy for photographers. They are currently assisting in the legal battle faced by one photographer who was sued by the Rock and Roll Hall of Fame in Cleveland. It seems the photographer, Chuck Gentile, took a great sunset shot of the Hall from a public sidewalk, which he then started to market as a poster. The Hall sued Gentile, claiming its building was protected as a trademark and that Gentile did not have the Hall's permission to market the poster.

You can imagine the problems this would cause for photographers everywhere, if photographs of buildings that are open to the public and taken from public property can only be marketed with the permission of the buildings' owners. Without the legal and financial support of ASMP, the Hall might have been able to beat Gentile without a full legal debate on the merits of their case. The court battles on this continue on appeal, but, as I write this, Gentile's position is prevailing—a clear victory for all photographers.

C. NARROW-FOCUS ORGANIZATIONS

The groups that I've discussed thus far seek members from among a variety of types of photographers. There are also groups that are very clearly focused on the needs and interests of one type of photographer. Most of these are nonprofit organizations, and it's easy to learn more about each by visiting their Web sites. Well-known and respected groups include:

ADVERTISING PHOTOGRAPHERS OF AMERICA (APA)
APA National Headquarters
7201 Melrose Avenue
Los Angeles, CA 90046
Tel: (800) 272-5254
Fax: (213) 935-3855
Web site: *www.apanational.org*

AMERICAN SOCIETY OF PICTURE PROFESSIONALS (ASPP)
409 South Washington Street
Alexandria, VA 22314
Tel/Fax: (703) 299-0219
Web site: *www.aspp.com*

NATIONAL PRESS PHOTOGRAPHERS ASSOCIATION (NPPA)
Tel: (800) 289-6772
Web site: *www.metalab.unc.edu/nppa*
e-mail: *nppa@mindspring.com*

NORTH AMERICAN NATURE PHOTOGRAPHERS ASSOCIATION (NANPA)
10200 West 44th Avenue, Suite 304
Wheat Ridge, CO 80033-2840
Tel: (303) 422-8527
Fax: (303) 422-8894
Web site: *www.nanpa.org*

There are lots of other associations, some quite informal, for people interested in fire photography, evidence photography, glamour photography, Lomo cameras, and so on. There's even a very active White House News Photographers Association (*www.whnpa.org*).

I'm sure I've overlooked a few organizations that deserve individual mention. I apologize and ask that anyone with information I should consider for revisions or a new edition contact me in care of Allworth Press.

What's important is that you, the individual photographer, consider joining an organization or two that might meet some of your needs and assist you in your growth as a photographer and a businessperson.

D. CAMERA CLUBS

PHOTOGRAPHIC SOCIETY OF AMERICA (PSA)
3000 United Founders Boulevard, Suite 103
Oklahoma City, OK 73112-3940
Web site: *www.psa-photo.org*

PSA is a national organization of camera clubs, but not all local camera clubs are affiliated with it. There are tens of thousands of members of camera clubs around the country. These clubs, which usually hold regular meetings, sponsor photo competitions, and sometimes host guest speakers or hold photo tours, can be a great source of fun and companionship. Some of the clubs have seen a decline in popularity in the last few decades, as photography has lost ground as a hobby. Other clubs are enjoying growth and vigorous leadership. If you're interested in finding out if there is a local camera club near you, you can either contact the PSA or you can check with your local photo specialty store. One word of caution: There are some clubs whose bossy chief-poobahs are like bad teachers—there's one way, and it's *their* way. Don't let such an operation discourage you.

Appendix II: Publications

A. General Photo Magazines

Popular Photography
Published by Hachette Filipacci Magazines, Inc.
1633 Broadway
New York, NY 10019
Tel: (303) 604-1464
Fax: (800) 666-8879

Pop has the largest circulation (approximately 450,000 subscribers) of all photography magazines. It is aimed at hobbyists and amateurs but contains some features that address the needs of professionals as well. In addition to its extensive listings for mail-order photographic supplies and services, *Popular Photography* features equipment bench tests that will tell you everything you need to know about the performance of equipment. It also contains "SLR Notebook," a long-running column of information and opinion written by Herbert Keppler, deservedly the most respected observer of the photo industry today.

Petersen's Photographic
Published by Emap Petersen, Inc.
6420 Wilshire Boulevard
Los Angeles, CA 90048-5515
Tel: (323) 782-2200

This is the second largest photographic magazine, also aimed at amateur photo enthusiasts rather than professionals. It tends to be more "how-to"–oriented than *Pop,* and its equipment reviews are less technical, but still clear and complete. Articles are well-written and tightly edited.

Outdoor Photographer
Published by Werner Publishing Corp.
12121 Wilshire Boulevard, Suite 1200
Los Angeles, CA 90025-1176
Tel: (310) 820-1500
Web site: *www.outdoorphotographer.com*

As the name implies, *Outdoor* is aimed at photographers who have an interest in recording their experiences of nature with a camera. The magazine features stunning images of traditional outdoor subjects—you won't find cityscapes or urban subjects—and it appears ten times a year. *Outdoor* features a number of respected photographers as contributing editors and columnists. Professionals interested in this field are likely to enjoy *Outdoor*.

SHUTTERBUG
Published by Primedia Special Interest Publications
5211 S. Washington Avenue
Titusville, FL 32780
Web site: *www.shutterbug.net*

This publication is very useful if you are interested in selling or buying used equipment.

PC PHOTO
Published by Werner Publishing Corp.
12121 Wilshire Boulevard, Suite 1200
Los Angeles, CA 90025-1176
Tel: (310) 820-1500

PC Photo is a relative newcomer and is devoted to people who are interested in working with photos in their personal computers. It was created by the same people who publish *Outdoor* and is published bi-monthly. It is aimed at amateur digital photography users, and seems to have found its niche in the world of photography magazines.

AMERICAN PHOTO
Published by Hachette Filipacci Magazines, Inc.
1633 Broadway
New York, NY 10019

This glossy bi-monthly appears to be aimed at the professional photographer, but, in recent years, it has veered off on a tangent and serves a narrow segment with slavish devotion to the celebrity and fashion scene. However, if you're interested in that scene you might be better informed by reading *Vanity Fair* or *Interview*. Years ago, in a prior incarnation, the magazine was known as *American Photographer*. It was a monthly that ran interesting biographical articles of established pros. Nowadays, there is usually a celebrity on the cover and, every now and then, a feature called "100 Most Important People in Photography," which is more a testament to the magazines myopic vision and pinched definition of photography than anything else. The magazine is a tamer version of a French Hachette publication, *Photo*, which, if you're looking for sexy advertising and babe photos, is a better investment.

VIEW CAMERA AND CAMERA ARTS
Published by Steve Simmons Publications
1400 S Street, Room 200
Sacramento, California 95814
Tel: (916) 441-2557
Fax: (916) 441-7407
Web sites: *www.viewcamera.com*
www.cameraarts.com

These are both high-quality bi-monthly magazines that were started in the past decade. Both have a small circulation but are worth a look. As the name implies, *View Camera* is designed to appeal to users of large-format cameras and people who want to look at photographs made using those tools. *Camera Arts* stresses high quality images made using 35mm and medium-format equipment. Both are aimed at very serious photographers and tend to focus more on the art of the medium than business issues or commercial imagery.

PHOTO TECHNIQUES
A division of Preston Industries, Inc.
6600 W. Touhy Avenue
Niles, IL 60714-4588
Tel: (847) 647-2900
Fax: (847) 647-1155

This is a small magazine but one that I read with interest. For years, it was *Darkroom Techniques*, but the big decline in interest in darkroom work led the publisher to bow to the inevitable and reposition the magazine. It never seems to grow, but it is a thoughtful alternative to *Popular* and *Petersen's Photographic*.

B. MAGAZINES WRITTEN FOR WORKING PROS

These are all magazines with circulation of 50,000 or less that are targeted at working professional photographers. This means that not only are the articles devised for this audience, but the advertisers are as well. If you're looking for smaller manufacturers of products principally of interest to pros, you're more likely to find them in these magazines than the general interest titles listed in the prior section.

PDN (formerly known as *Photo District News*)
Published by ASM Communications
1515 Broadway
New York, New York 10036
Tel: (212) 536-5222
Fax (212) 536-5224
Web site: *www.pdn-pix.com*

PDN, as it is called, has been around for about twenty years. Published monthly in an oversized format, it presents lots of interesting photos by photographers who

are working in the full range of professional fields, along with news about the industry. Four times a year, it runs a digital supplement called *Pix*. For many pros, particularly those who specialize in advertising and editorial photography, *PDN* is essential reading. In addition to showing readers what's new and who's up and coming, *PDN* covers legal and business issues that affect the pro community and large commercial studios. It is the most expensive of the professional magazines (currently $48/year), but it's worth it.

The *PDN* Web site is updated twice a month and contains lots of good information and links.

RANGEFINDER
P.O. Box 1703
1312 Lincoln Boulevard
Santa Monica, CA 90406
Tel: (310) 451-8506
Fax: (310) 395-9058

Published by the folks who run WPPI, *Rangefinder*'s mission statement is accurate: "A monthly publication dedicated to the advancement of photographers. Features encompass all phases of professional photography, including solutions to technical problems, business practices, handling assignments, digital techniques, equipment test reports, processing techniques, and future trends."

PROFESSIONAL PHOTOGRAPHER
Published by Professional Photographers of America, Inc.
229 Peachtree Street NE, Suite 2200
International Tower
Atlanta, GA 30303-1608
Tel: (404) 522-8600
Fax: (404) 614-6405

Professional Photographer's masthead tells us that it is "the oldest exclusively professional photographic publication in the Western Hemisphere" and goes on to explain that it was founded in 1907 by Charles Abel. It is sent to members of the PPA national organization as part of their membership, but it is also possible to subscribe without being a PPA member.

STUDIO PHOTOGRAPHY AND DESIGN
Cygnus Publishing
445 Broad Hollow Road
Melville, New York 11747
Tel: (516) 845-2700
Fax: (516) 845-7109
Web site: *www.spdonline.com*

Studio competes with *Rangefinder* and *Professional Photographer* and covers similar ground. It is published by a chain of trade magazines that also publishes a major photo retail industry magazine called *Photo Trade News*. *Studio* is completely a controlled circulation magazine, meaning that it is mailed to qualified professionals who request it at no charge. There is no paid subscription or newsstand distribution. Rather, advertisers support the magazine because they want to reach the people who receive the magazine. In recent years, *Studio* has been redesigned and improved. It is a very attractive and interesting magazine.

PHOTO INSIDER
Published by Unique Photo
11 Vreeland Road
Florham Park, NJ 07932
Tel: (973) 337-1003
Fax: (973) 337-2679
Web site: *www.photoinsider.com*

Can a photo sales company start a successful magazine? We'll get an idea of the answer if *Photo Insider* survives. The magazine started as a custom publishing project for Unique Photo a few years back, but the publication is well-written and well-designed, and the folks at Unique are out to see if it can have a life of its own as a bi-monthly. Stay tuned. Right now, it is pegged toward the professional community, but if it succeeds, it could cross over into a more general category.

These are all small magazines. *PDN's* circulation is less than 30,000; *Rangefinder's* is closer to 50,000. These numbers give you an idea of the limited number of full-time, professional photographers working at any time in America.

C. PHOTO INDUSTRY MAGAZINES

Depending on your specific interests in photography, you might want to keep an eye on one of the publications aimed at photo manufacturers, dealers and labs. Some of the best-known are:

PTN, PHOTO TRADE NEWS
Published by Cygnus Publishing
445 Broad Hollow Rd, Suite 21
Melville, NY 11747
Tel: (516) 845-2700
Fax: (516) 845-2797
Web site: *www.ptnonline.com*

PTN, published by the folks who put out *Studio*, bills itself as "the business journal for the imaging market." It is certainly one of the business journals, and there's a lot of information packed into each issue.

PHOTO MARKETING
Published by Photo Marketing Association International
3000 Picture Place
Jackson, MI 49201
Tel: (517) 788-8100
Fax: (517) 788-8371
Web site: *www.photomarketing.com*

This is the official publication of PMA, which I've discussed in various places throughout this book. There's a lot of information in this publication, but it tends to be slanted toward big outfits. It does serve all aspects of the industry, however, and is very comprehensive.

PHOTO INDUSTRY REPORTER
Published by IRM Publications
7600 Jericho Turnpike
Woodbury, NY 11797
Tel: (516) 364-0016
Fax: (516) 364-0140

PIR, which calls itself "The Imaging Industry's Business Paper," is a good, quick read with lots of information. Frankly, it's the business publication I read most often. It was started less than a decade ago by two industry veterans, Ed Wagner and Rudy Maschke, and it covers the same stories as the others. The insightful writing and pithy editing make it easier to read, and there's a monthly column by *Popular's* publishing director, Herbert Keppler, that's aimed at the industry and not the public. It's the first thing I read every month. Keppler knows the industry better than anyone else, and he has the instinct of a journalist. This column gives him a chance to tell insiders what's really on his mind.

D. OTHER PUBLICATIONS

There are other magazines and other publications in the photography field and outside of it that you should look at. Space limits my ability to list contact information for all these publications. These are very different types of publications. I suggest that you visit a big magazine newsstand and check each one that is unfamiliar to you. There are magazines and newsletters specifically devoted to photography. Among the ones you should not miss are: *Afterimage, Aperture,* and *Blind Spot.*

E. MAGAZINES WITH GREAT PHOTOGRAPHY

Also, keep an eye on general-interest magazines with great photography such as *Harper's Bazaar, National Geographic, Vanity Fair, Vogue,* and *Wallpaper.* Look at foreign-language photography and fashion magazines. For example, the big fashion magazines like *Vogue* appear in multiple foreign editions—British, French,

and Italian, each with lots of different images. New magazines are also worth checking since they tend to pop up regularly and often use new photographers and try to experiment while finding the proper tone and voice for the publication's intended audience.

F. WEB SITES

Naturally, every photo manufacturer and major dealer has a Web site. Most of them are online catalogs and little more. If you want product information or spec sheets, you can now get them online. For people interested in photography, there are a number of forums and news groups on the Internet, where you can gather and share information.

There are also sites that function as electronic photo magazines. Some of the ones I enjoy visiting are *www.zonezero.com*, *www.hyperzine.com*, and *photo.net*. I must add that *www.nyip.com*, the Web site of the New York Institute of Photography, provides lots of tips and topics to help both amateur and professional photographers. For the digital enthusiast, we've recently added *www.digitalnyi.com*.

G. BOOKS AND OTHER SOURCES MENTIONED IN THE TEXT

American Society of Media Photographers. ASMP *Professional Business Practices in Photography*, 5th edition. New York: Allworth Press, 1997.

Chuang Tzu. *Basic Writings*, translated by Burton Watson. Columbia University Press, New York and London, 1964

Crawford, Tad. *Business and Legal Forms for Photographers.* New York: Allworth Press, revised edition, 1997.

Crawford, Tad. *Legal Guide for the Visual Artist.* New York: Allworth Press, 1999.

Engh, Rohn. *Sell & Re-Sell Your Photos: How to Sell your Pictures to a World of Markets a Mailbox Away*, 4th edition. Cincinnatti: Writer's Digest, 1997

Gray, Ed, director. *Different Drummer: Elvin Jones.* 1979 color film, 30 minutes. Distributed by Rhapsody Films, Catalog 9014. *www.cinemaweb.com/rhapsody*

Heron, Michael. *How To Shoot Stock Photos That Sell*, revised edition. New York: Allworth Press, 1999.

Lewis, Charles J. (Chuck), Creativity International, 4930 Cascade Road, S.E., Grand Rapids, MI 49546. As I've written, Chuck Lewis is one of the great motivators in the business. He doesn't go out on the road often, but if you get a chance, take in his presentation. My suggestion is to drop him a note and ask to be put on his mailing list. You'll undoubtedly get offers for books and tapes. They're good, but my advice is to try to see him in person.

McCartney, Susan. *Nature and Wildlife Photography, A Practical Guide to How to Shoot and Sell.* New York: Allworth Press, 1994.

McCartney, Susan. *Travel Photography*, second edition. New York: Allworth Press, 1999.

PDN's Photo Source. New York: ASM Communications. A compendium of sources of goods and services needed by professional photographers. Covers equipment, repair, rental, talent, props, location services and much more. Published annually, or almost annually.

Piscopo, Maria. *The Photographer's Guide to Marketing and Self-Promotion*, second edition. New York: Allworth Press, 1995.

Willens, Michael, editor. *Photographer's Market*, current edition. Cincinnati: Writer's Digest Books, 1999. Note: a new edition comes out each year with revisions and updates.

Zucker, Monte. To find out what's doing with my friend Monte, visit *www.montezucker.com*.

H. Galleries and Museums

Years ago, there were only a handful of galleries that specialized in photography in the entire United States. The now-defunct Limelight Gallery run by Helen Gee was legendary in New York City, and even the Witkin Gallery is now gone. However, the good news is you'll find several photo galleries in every major city. If there is a publication such as *Gallery Guide* for any local big town that you visit, check the listings for photography shows. Also, city, state and regional magazines often feature gallery listings.

In New York, for example, not only are there marvelous photography holdings at the Metropolitan Museum and the Museum of Modern Art, but the historical museums, such as the Museum of the City of New York, also have strong collections. New York City also has the good fortune of being home to ICP, the International Center for Photography, which has both a midtown and uptown branch. If you're ever near Rochester, New York, take heart—while there's not much to do there, you can visit George Eastman House, the mansion in which the founder of Kodak lived which has a major historical collection of both photography and photographic equipment, along with a very good library.

Index

Books from Allworth Press

Historic Photographic Processes: A Guide to Creating Handmade Photographic Images by Richard Farber (softcover, 8½ × 11, 256 pages, $29.95)

Travel Photography, Second Edition by Susan McCartney (softcover, 6¾ × 10, 360 pages, $22.95)

Creative Black-and-White Photography: Advanced Camera and Darkroom Techniques by Bernhard J Suess (softcover, 8½ × 11, 192 pages, $24.95)

Mastering Black-and-White Photography: From Camera to Darkroom by Bernhard J Suess (softcover, 6¾ × 10, 240 pages, $18.95)

Business and Legal Forms for Photographers, Revised Edition by Tad Crawford (softcover, 8½ × 11, 224 pages, includes CD-ROM, $24.95)

The Law (in Plain English) for Photographers by Leonard Duboff (softcover, 6 × 9, 208 pages, $18.95)

The Business of Studio Photography: How to Start and Run a Successful Photography Studio by Edward R. Lilley (softcover, 6¾ × 10, 304 pages, $19.95)

ASMP Professional Business Practices in Photography, Fifth Edition by the American Society of Media Photographers (softcover, 6¾ × 10, 416 pages, $24.95)

Pricing Photography: The Complete Guide to Assignment and Stock Prices, Second Edition by Michal Heron and David MacTavish (softcover, 11 × 8½, 152 pages, $24.95)

How to Shoot Stock Photos That Sell, Revised Edition by Michal Heron (softcover, 8 × 10, 208 pages, $19.95)

The Photographer's Guide to Marketing and Self-Promotion, Second Edition by Maria Piscopo (softcover, 6¾ × 10, 176 pages, $18.95)

Re-Engineering the Photo Studio: Bringing Your Studio into the Digital Age by Joe Farace (softcover, 6 × 9, 224 pages, $18.95)

The Photographer's Assistant: Learn the Inside Secrets of Professional Photography—and Get Paid for It by John Kieffer (softcover, 6¾ × 10, 208 pages, $16.95)

Please write to request our free catalog. To order by credit card, call 1-800-491-2808 or send a check or money order to Allworth Press, 10 East 23rd Street, Suite 210, New York, NY 10010. Include $5 for shipping and handling for the first book ordered and $1 for each additional book. Ten dollars plus $1 for each additional book if ordering from Canada. New York State residents must add sales tax.

To see our complete catalog on the World Wide Web, or to order online, you can find us at *www.allworth.com.*